ADVANCE PRAISE FOR

Mediated Girlhoods

"*Mediated Girlhoods* is essential reading for the field of girls' studies—as well as for scholars in other disciplines, parents, and anyone else interested in how girls live in a culture that is permeated by media of all kinds. Ranging widely across time, space and diverse categories of identity, this ambitious book brings together a collection of essays that include studies of representation, reception and media production. Both readable and theoretically sophisticated, *Mediated Girlhoods* offers compelling insights into how girls experience and use the vast array of cultural forms and technologies available to them, from movies, music and dance to cellphones and online videos."

Kathleen Rowe Karlyn, Professor of English and Director
of the Cinema Studies Program, University of Oregon;
Author of Unruly Women: Gender and the Genres of Laughter
and Unruly Girls, Unrepentant Mothers: Redefining Feminism on Screen

"Including historical and contemporary examples; addressing representation, use, and production of media; and insisting on attention to the intersections of gender, race, class, sexuality, and nationality, *Mediated Girlhoods* does nothing short of delineating a growing area of thought called 'girls media studies,' and then challenges that scholarship to reconsider its boundaries and objects of study. A must-read for anyone interested in the nuances and complexities in girls' lives and cultures. A crucial reference for any student or scholar interested in how we might move girls' studies forward."

Sarah Projansky, Associate Professor, Media & Cinema Studies
and Gender & Women's Studies, University of Illinois, Urbana-Champaign

Mediated Girlhoods

mediated youth

Sharon R. Mazzarella
General Editor

Vol. 10

The Mediated Youth series is part of the Peter Lang Media list.
Every volume is peer reviewed and meets
the highest quality standards for content and production.

PETER LANG
New York • Washington, D.C./Baltimore • Bern
Frankfurt • Berlin • Brussels • Vienna • Oxford

Mediated Girlhoods

new explorations of girls' media culture

EDITED BY Mary Celeste Kearney

PETER LANG
New York • Washington, D.C./Baltimore • Bern
Frankfurt • Berlin • Brussels • Vienna • Oxford

Library of Congress Cataloging-in-Publication Data

Mediated girlhoods: new explorations of girls' media culture /
edited by Mary Celeste Kearney.
p. cm. — (Mediated youth; v. 10)
Includes bibliographical references and index.
1. Mass media and girls. 2. Girls in mass media.
3. Girls in popular culture. I. Kearney, Mary Celeste.
P94.5.G57M43 305.23082—dc22 2010033878
ISBN 978-1-4331-0560-9 (hardcover)
ISBN 978-1-4331-0561-6 (paperback)
ISSN 1555-1814

Bibliographic information published by Die Deutsche Nationalbibliothek.
Die Deutsche Nationalbibliothek lists this publication in the "Deutsche
Nationalbibliografie"; detailed bibliographic data is available
on the Internet at http://dnb.d-nb.de/.

FSC
Mixed Sources
Product group from well-managed
forests, controlled sources and
recycled wood or fiber
Cert no. SCS-COC-002464
www.fsc.org
©1996 Forest Stewardship Council

Top cover photo from the Advertising Ephemera Collection—Database #KO529,
Emergence of Advertising On-Line Project, John W. Hartman
Center for Sales, Advertising & Marketing History,
Duke University Rare Book, Manuscript, and Special Collections Library
http://library.duke.edu/digitalcollections/eaa/

The paper in this book meets the guidelines for permanence and durability
of the Committee on Production Guidelines for Book Longevity
of the Council of Library Resources.

© 2011 Peter Lang Publishing, Inc., New York
29 Broadway, 18th floor, New York, NY 10006
www.peterlang.com

Printed in the United States of America

To the girls and women who participated in the various studies included here.

Contents

PART 2: RECEPTION AND USE

PART 3: PRODUCTION AND TECHNOLOGY

Acknowledgments

This book would have never materialized without the generous support and passionate commitment of several individuals. In particular, my heartfelt gratitude goes to Sharon R. Mazzarella, who gave me the opportunity to edit this collection, and to Morgan Blue, whose copyediting skills are nothing less than meticulous. I feel very fortunate to have worked on this project with both of them. Indeed, my role as editor allowed me to have regular interactions with, on the one hand, a leader in girls' media studies today and, on the other, a Ph.D. student whose research on girls' cinema is sure to enrich that subarea of our field.

My thanks also to all of the authors whose work appears here for their insightful and creative thinking as well as their patience with me during the editing process. It has been an honor working with each of them. Their interests in and commitment to female youth and girls' media culture are truly infectious, and their scholarship is bound to push both critical thinking and public discourse about girls, girlhood, and girls' culture in exciting new directions. I am grateful as well for my partner, Michael Kackman, whose nightly insistence that I shut down my computer and join him on the couch for some quality TV and a wee dram surely improved my editorial abilities during the day.

Finally, a very special thanks to all the girls and women who participated in the various ethnographic studies included in this collection. By sharing their thoughts, feelings, and memories about their engagements with media during girlhood, this complex and often contradictory site of culture and form of subjectivity are made a bit less opaque for the rest of us. This book is dedicated to them.

Girls' Media Studies 2.0

Mary Celeste Kearney

Welcome to the Second Generation. As the content of this collection attests, the study of girls' media culture has grown dramatically since the first wave of scholarship in this area took off in the 1990s[1] via such pioneering monographs as Angela McRobbie's *Feminism and Youth Culture: From* Jackie *to* Just Seventeen, Susan Douglas' *Where the Girls Are: Growing Up Female with the Mass Media*, and Dawn Currie's *Girl Talk: Adolescent Magazines and Their Readers,* as well as edited collections like Sherrie Inness' *Delinquents and Debutantes: Twentieth-Century American Girls' Cultures* and Sharon Mazzarella and Norma Pecora's *Growing Up Girls: Popular Culture and the Construction of Identity*.[2] In fact, since the turn of the twenty-first century, girls' media studies has developed into a legitimate area of critical inquiry all its own populated by scholars from multiple disciplines and multiple countries. Nevertheless, no journal or anthology devoted specifically to such scholarship has yet been published. Now is the time. In fact, we're overdue.

The Field

Girls' media studies is a unique area of academic research that has girls' media culture as its overarching object of study. Scholars working in this area analyze a diverse range of media forms, including not only traditional entertainment forms, such as film, radio, television, and magazines, but also music, comics, video games, and contemporary information and communication technologies, such as smart phones, mp3 players, and Web-based social networking sites. Although

many researchers in this field are concerned with how discourses of girlhood are constructed through media images of and stories about female youth, other scholars focus on girls' reception and uses of media, while still others have the production of girls' media as their primary concern.[3] The vast amount of research in this field to date has centered on mainstream commercial media culture; however, some scholars have focused on alternative media cultures, particularly those associated with entrepreneurial youth cultures, such as punk, hip-hop, and riot grrrl. Although attention to younger girls' media culture has increased in recent years, most research in girls' media studies has focused on media texts about, consumed by, and/or produced by female adolescents.

With academic roots in sociology, literary studies, communication studies, film and television studies, and, of course, women's and gender studies,[4] and geographic roots in England, Canada, Australia, and the United States, girls' media studies today is broad both disciplinarily and internationally.[5] Moreover, it is one of the largest and most productive areas of research within the general field of girls' studies.[6] This should come as no surprise, given that popular media have been central to girls' culture since the late nineteenth century. Moreover, the media have long been of interest to feminist researchers and activists interested in the various messages about gender sent to female youth as well as the ways girls use popular culture to form their identities and tastes, relationships and values.

As the term "media culture" in the title of this collection suggests, no matter what our disciplinary training or affiliation, scholars involved in girls' media studies today are indebted to the theories, methods, and values associated with cultural studies, an interdisciplinary field which approaches popular culture as a site of various struggles over power, pleasure, identity, and community.[7] Cultural studies scholars use various qualitative methodologies associated with the humanities and fine arts (e.g., discourse analysis, narrative studies, formal analysis) to examine cultural practices, artifacts, sites, and meanings. They also commonly employ ethnographic methods developed by social scientists (e.g., interviewing, observation, questionnaires) to explore the tastes, values, practices, and responses of everyday people. This focus on the culture of ordinary people is a reaction to traditional approaches in the academy, which prior to the late twentieth century privileged the culture of the social elite at the expense of popular culture. In keeping with poststructuralist theory, cultural studies scholars also question the truth claims of science, opting instead for explorations of the complexity of culture as it is constructed and experienced by different individuals and groups in different historical moments and different geographical places.

In studies of media culture in particular, cultural studies scholars are concerned with not only media texts, but also the users of such texts and their practices of reception, as well as the production context of those texts, be it commercial or subcultural (Kellner). Media-based cultural studies scholars pay close attention

to the sociohistorical specificity of each component of this cultural circuit, as the geographical and temporal location of production and consumption are not always the same, and use, value, and meaning are therefore relative. Although attending to all of these different sites of inquiry can prove difficult for any one research project, particularly those published as a book chapter or journal article, media-based cultural studies scholarship attempts to provide critical reflections on various components of media culture which keep in mind the larger circuit of production/consumption that is always at stake (D'Acci).

Although cultural studies is a primary area of affiliation for girls' media studies scholars today, the most essential discipline for such researchers is the equally interdisciplinary field of women's and gender studies, an academic area grounded in feminist politics.[8] Not all girls' media studies scholars have the same feminist ideologies, however, having come to feminism and gender studies at different times and in different places. Nevertheless, most researchers working on girls' media culture today—the majority of whom are graduate students and junior faculty—have been strongly influenced by poststructuralist feminist epistemologies, particularly the idea that gender and other identities are socially constructed, as well as theories of identity as intersectional, that is, the notion that identity is a complex composite of multiple, interdependent, and unisolatable modes of being. In turn, many contemporary girls' media scholars have been trained in postcolonial, critical race, and queer theories. As a result of such education and perspectives, as well as an understanding of popular culture as an important site for feminist intervention, many scholars associated with girls' media studies consider themselves third wave feminists.[9]

Scholars who examine girls' media from a solely empirical perspective (for example, research psychologists) may be feminists, they are not typically associated with the field of cultural studies and thus are not included in *Mediated Girlhoods*. Rather than understand media culture as sites of agency and pleasure for consumers and users, such researchers more typically construct audience members, particularly youth, as potential victims of mass media, which in turn are assumed to be dangerous, pollutive forces. Moreover, such work commonly lacks attention to sociohistorical context and the complexities of power, pleasure, and play in cultural phenomena.

By contrast, the scholarship in this collection is powerfully inflected by a cultural studies approach that values all of those things, while also championing the third wave feminist perspective that girls are powerful, agential beings. This does not mean, however, that the authors whose work is collected here do not have concerns about girls' critical abilities, not to mention the possibly detrimental effects of some media texts, practices, and policies on female youth. Indeed, in comparison to much of the optimistic and celebratory work to date within girls' media studies, several of the chapters included here foreground some of the less

progressive aspects of girls' media culture and thus challenge us to be mindful of the regressive forces many female youth regularly negotiate, and sometimes reproduce, in their everyday practices.

Goals and Contributions

Mediated Girlhoods has as its primary objective the raising of public awareness and critical thinking about girls' media culture, as well as girls and girlhood. As its subtitle suggests, this collection aims to publicize and support research that examines girls' media culture from new perspectives and thus expands girls' media studies in novel and provocative directions. Indeed, in its effort to complicate what we know about girls, girlhood, and girls' media culture, this collection devotes considerable space to approaches and objects of study that currently exist outside or on the margins of girls' media studies' conventions.

One obvious way some of the studies in *Mediated Girlhoods* can be considered novel is that they explore texts, audiences, and users/producers associated with *contemporary* girls' media culture. Thus, in addition to examining the mediated experiences of girls alive today, several of the studies in this collection are focused on the most recent forms of media technologies and the cultural practices they facilitate, including YouTube, mp3 players, and smart phones.[10] Moreover, some of the authors explore contemporary girls' media through the lens of conglomeration, analyzing properties that are exponentially capitalized on via conglomerates' synergistic production of a broad range of entertainment goods, including films, TV series, and dolls. This is a somewhat new approach for girls' media studies scholars, whose textual analyses heretofore have typically focused on one product at a time.

Despite *Mediated Girlhoods'* attention to some of the most recent phenomena in girls' media culture, another of this anthology's primary contributions is its publication of several studies that consider girls' media texts, audiences, and producers from an *historical* perspective. In other words, this collection resists equating innovative research with a presentist approach, a practice which unfortunately continues to dominate both girls' studies and media studies (Kearney, "New Directions"). By looking backward and investigating the past, the authors of these historical studies not only enrich our understanding of girls' media culture, they chart a path for future historical research and challenge other scholars to follow. In similar ways, the scholars whose analyses look outside the United States, or to refugee experiences within the United States, have further expanded this field by drawing attention to the ethnic and regional diversity of girls' media cultures around the world and thus upsetting the assumed Hollywood-centrism of global media texts, producers, and audiences.

Like media, girls are constructed broadly in this collection also. Many chapters concern young female media characters, performers, producers, and audience members who are adolescents, which is much in keeping with the larger field of girls' studies to date. Nevertheless, several of the projects included here trouble that convention by exploring the media culture of younger girls. Still others consider media characters, consumers, and producers who are young adults. Within this collection, therefore, "girl" and "girlhood" are elastic terms, comprising a range of ages as well as generational subjectivities and performances.

The diversity of girls and girlhoods in this collection is not related to age only, however. In keeping with third wave feminism, all the authors in *Mediated Girlhoods* approach identity intersectionally. Hence, in these analyses, close attention is paid not only to age and gender but also to race, ethnicity, class, sexuality, locality, religion, and/or nationality. Indeed, one of *Mediated Girlhoods'* primary contributions to girls' media studies—and girls' studies at large—is its numerous explorations of girl media characters, producers, and audience members who are not normative—that is, not white, not Anglo, not middle-class, not heterosexual, not suburban, and/or not Western. While hegemonic forms of Western girlhood are in evidence here, they coexist with and are often displaced by the marginalized identities of Israeli girls, young Somali refugees, Japanese schoolgirls, adolescent tomboys, Australian country girls, young lesbians, Latina tweens, Singaporean young women, and working-class African American girls.

Another contribution *Mediated Girlhoods* makes to the field of girls' media studies, and girls' studies at large, is some authors' explicit attention to the role feminism plays in the mediated lives of young females. While many previous research projects on girls' media culture have used feminist theory to understand the construction of gender in media texts, producers, and consumers, few scholars have focused specifically on the role feminist politics plays in girls' media culture. Several chapters here focus on proto-feminist moments in girls' media prior to the mid-twentieth century. Others look to the effects of 1970s' women's liberation discourse on girls' culture. Though not about feminist politics per se, several of the studies concern contemporary Western girls' media culture and thus entail critical reflection on the contradictorily feminist/anti-feminist rhetoric present in today's postfeminist commercial culture.[11]

While none of the theoretical perspectives and methodological approaches in this book is new to academia, some of them are novel within girls' media studies. For example, half of *Mediated Girlhoods* is composed of ethnographic studies that include girls' viewpoints alongside the authors' own. This high level of girls' involvement helps to subvert the common criticism that girls' studies scholars have failed to provide space for the voices and perspectives of female youth, and thus failed to address the imbalance of power in youth-oriented research (Duits and Van Zoonen; Kearney, "Coalescing"; Mazzarella and Pecora, "Revisiting").

More innovative perhaps are some authors' uses of historical self-ethnography and oral history, which requires them to dig deep into their own and others' pasts to understand previous generations' experiences of girls' media culture.

In addition to expanding our understanding of girls' media culture via unconventional methodologies, most of the studies here engage with subjects new to girls' media studies. From feminist themes in teen magazines, to girl-made memory books, to mediated country girlhoods, to girls' explorations of pornography, to the surveillance of girls via new media technologies, to girls' self-branding on YouTube, the studies included in *Mediated Girlhoods* boldly break new ground and clear new paths, forcing this field to expand and grow in provocative new ways. Indeed, what we may be seeing here is not the second wave of girls' media studies, but the beginnings of the third.

Organization

Mediated Girlhoods is organized into three major sections intended to facilitate readers' critical attention to particular sites within girls' media culture: Representation and Identity, Reception and Use, and Production and Technology. That said, most of the chapters include subject material that connects with the book's other sections. Therefore, readers are encouraged to use the index to discover which chapters concern specific themes of interest.

Section 1—Representation and Identity—is devoted to research on depictions of girls in commercial media. Expanding beyond the normative identities privileged in mainstream media culture, the chapters collected here pay specific attention to issues of difference with regard to girls' media representations. These studies primarily involve close analyses of media texts (e.g., magazines, films, performers, television shows), with a particular focus on how discourses of girlhood intersect with those of race, sexuality, ethnicity, and/or political activism. Most of these chapters focus on earlier iterations of girls' media culture and utilize archival materials to explore the past. As with several other chapters that appear in other sections of the book,[12] these historical studies help to push girls' media studies forward by undertaking the seemingly contradictory practice of looking backward.

With a particular focus on cultural texts made for and about schoolgirls between 1910 and 1940, Yuka Kanno's chapter reclaims the queerness of discourses of sisterhood and female friendship in Japan's early *shôjo* (adolescent girls') culture. Arguing for a political reading of this cultural work and the girls with whom it is associated, Kanno demonstrates how the mediated dispersion of such discourses helped to construct a site for the imagination of homoerotic relations between female youth and thus contributed to the development of queer networks in early twentieth-century Japan. Kanno's chapter appears first in this anthology since it challenges so many conventions of girls' media studies to date—particularly

its presentist, heteronormative, and Western perspective—and thus models concretely in one place multiple new directions for this field.

Focusing on U.S. children's media culture during the post-World War II era, Sarah Nilsen's chapter analyzes the discursive construction of Disney Mouseketeer Annette Funicello. As Nilsen demonstrates, the Disney studio effectively exploited Funicello's Italian background and appearance in its development of her star image and in its appeals to suburban youth audiences, for whom ethnicity was still a concern. In foregrounding Funicello's ethnicized persona, Nilsen challenges earlier arguments about postwar media culture's assimiliationist bent while also calling attention to the diversity of postwar girls' culture.

Kirsten Pike's study explores feminist discourse in *Seventeen* magazine during the late 1960s through mid-1970s, the height of the U.S. women's liberation movement. Pike argues that in the midst of considerable commentary about citizenship during this period, *Seventeen's* writers encouraged girls to model an active but not activist form of femininity and consumer citizenship. Nevertheless, Pike reveals that readers were responsible for much of the commentary about women's liberation appearing in the magazine, with some constructing a kind of "do-it-yourself" feminism through ideas and suggestions they shared in opinion essays and letters to the editor.

Examining a period of U.S. film culture just after that discussed by Pike, Kristen Hatch's chapter analyzes depictions of tomboys in Hollywood films of the late 1970s and early 1980s. Through formal and narrative analysis, Hatch demonstrates how tomboy films from that era, such as *The Bad News Bears* and *Little Darlings*, subvert the traditional literary and cinematic representation of tomboys by refusing to transform such girls into feminine creatures worthy of heterosexual male attention. Although Hatch notes that such films do little to celebrate female masculinity since their primary goal is to advocate girls' prolonged abstention from sexual activity, she nevertheless argues for the cultural significance of such texts and their stars for lesbians and other queer women who similarly resist the normative pull of heterosexual femininity.

Employing the metaphor Gloria Anzaldúa and Cherríe Moraga introduced in *This Bridge Called My Back* to explore the burden of symbolic and material connections between girls, Angharad Valdivia avers that Latina girls function in contemporary U.S. media culture as a bridge between hegemonic whiteness and the racial difference most explicitly suggested by African American bodies. Situating this trend within the larger contexts of the recent Latino/a population and cultural boom within the United States, the tweening of girls' culture, and media conglomerates' synergistic practices, Valdivia explores the commercial exploitation of ethnically ambiguous Latina characters in several girl-centered cultural properties, including Bratz dolls, *The Cheetah Girls*, and *The Sisterhood of the Traveling Pants*.

The second section of this collection—Reception and Use—focuses specifically on studies of girls' media consumption. In an effort to expand reception-oriented girls' media studies in new directions, the chapters here include historical analyses of girl consumers produced via autobiography and oral history as well as research with contemporary girl audiences who are non-normative in terms of race, geographic location, cultural heritage, and/or types of media they consume. The chapters in this section strongly privilege the voices of female youths themselves, thus meeting one of the primary goals for contemporary girls' studies as advocated by scholars who have surveyed the field.

The first chapter in this section, co-authored by Rebecca Hains, Shayla Thiel-Stern, and Sharon Mazzarella, is based on oral histories of women who grew up in the U.S. during the 1940s and 1950s. This was a formative period for the commercial development of girls' media culture, and this study is the first to survey girls who lived through it. Part of a larger study, this chapter demonstrates that girls' mediated engagements during the postwar era were as complex and diverse as female youths themselves. (While the majority of the women in this study are white and middle-class, one is African American and several grew up poor.) By attending to such complexity in identity and cultural practice, this study contests the homogenized stereotype of postwar mediated girlhood offered by the media industries.

Catherine Driscoll's study of girls' media culture in 1970s' Australia helps to move us beyond not only the U.S. and presentist focus of much girls' media studies but also the dominant methodology used by scholars in this field—textual analysis. Taking her own teen-girl media experiences as the objects of her research, Driscoll redirects feminist ethnography toward the autobiographical in order to explore the specific cultural experiences of girls living in non-urban locales during a time of considerable media expansion. Through her attention to country life and her own adolescent place in it, Driscoll challenges the urban and suburban perspectives that dominate both girls' studies and media studies.

Shiri Reznik and Dafna Lemish's chapter concerns Israeli girls' reactions to Disney's globally popular *High School Musical* film series, whose plots contemporize Shakespeare's *Romeo and Juliet*. Through interviews, the authors explore girls' various interpretations and negotiations of the movies' dominant theme of romantic love, as well as the localizing of Disney's property for Israeli audiences via a stage version using Hebrew dialog. By attending to differences in viewers' socio-economic status and cultural background, Reznik and Lemish provide a complex portrait of girls' reception of these texts that reveals the degree to which girls must balance the glamorous fantasies of romantic love offered by commercial media culture with their real life experiences and values.

The fourth chapter in this section is by Sarah Baker, who analyzes South Australian pre-teen girls' use of the Internet during after-school care, a liminal site

between home and school. Informed by observation and the girls' own discourse about their practices, Baker's study examines girls' explorations and negotiations of identity, sexuality, and morality via their collective perusal of Web sites devoted to pop stars and pornography. She also discusses an offline incident precipitated by one of the girls, whose ownership of pornographic content disrupted the play of her peers, challenged the cultural stereotype of innocent girlhood, and thus resulted in increased surveillance by the adult staff.

Exploring a cultural site similar to that in Baker's study, Jennifer Woodruff's chapter presents her findings from an ethnographic study of girls' musical activities in an after-school youth club in Durham, North Carolina. Analyzing the dance practices of several pre-teen African American girls at the club, Woodruff demonstrates how they incorporate hip-hop's sounds, lyrics, and movements into their conversations even when music is not playing, thus attesting to both the significance of hip-hop in their lives and the skill with which they observe media texts from this culture. As Woodruff argues, the girls' gestures and dance movements facilitate not only their peer relationships within the club but also their negotiations of discourses of race, gender, sexuality, and morality present in mainstream representations of black female sexuality.

The final section of *Mediated Girlhoods*—Production and Technology—includes scholarship on girl-made media, as well as the various media technologies girls use to entertain themselves and communicate with one another. As a result, many of the chapters here mesh easily with those in Part 2 given their similar attention to girls' media uses. Nevertheless, given that there are so few studies of girls' media production and the media technologies female youth employ in their everyday lives, it is important to separate this work from analyses of girls' media reception. Since research on production and technology entails close attention to both texts and practices, the methodologies utilized by authors in this section are somewhat more mixed than that of others in the book, involving formal analysis, discourse analysis, political economy, and/or interviews. While some of the chapters included here note the considerable agency and confidence many girls have with media technologies and production today, others caution us to be mindful of the ways in which female youth may be complicit in reproducing discourses and values that work to contain them and their cultural practices.

The first chapter in this section is by Jane Greer, whose analysis considers the productive cultural work performed by American schoolgirls during the first decades of the twentieth century. Utilizing commercially manufactured memory albums, the female adolescents in Greer's study transformed such texts into personal archives of their high school experiences via their creative arrangement of drawings, photographs, objects, autographs, and other memorabilia. Through her close attention to the girls' imaginative authoring of such albums via sampling

and mixing, Greer's work challenges scholars interested in contemporary girls' media production to reconsider the historical legacy of such practices.

Moving forward a century, Sun Sun Lim and Jemima Ooi's chapter explores attitudes towards and perceptions of information and communication technologies (ICTs) among a group of adolescent girls and young women in Singapore. Although traditional gender norms discouraged previous generations of female youth from finding mechanical and electrical technologies of interest, Lim and Ooi's ethnographic study demonstrates that contemporary Singaporean girls are avid, confident, and knowledgeable users of ICTs. As a result adoption of and access to media technology is broadly gender-neutral among that nation's youth. Nevertheless, this study also reveals that some girls see boys as more adept with technology while other female youth find the traditional gender scripts prevalent in ICT advertising to be unproblematic. Lim and Ooi's research encourages us to be mindful, therefore, of the diversity of female youth and mediated girlhoods, as well as the resilient nature of traditional gender discourses even within societies rapidly transforming via new technologies.

Leslie Regan Shade's chapter encourages us to reflect critically on the celebratory discourse that often accompanies academic rhetoric about girls' media use. Focusing on mobile telephones with Global Positioning System components as well as social networking sites with biometric identifiers, Shade employs political economic and policy analysis to examine contemporary domestic technologies marketed to parents in order to monitor their children's, especially their daughters', movements and to contain their activities. With a particular focus on the gendered nature of public discourse about "protecting children," Shade encourages scholars to attend to the expanding systems of surveillance developed by corporations and adopted by parents in the name of security at a time of girls' heightened activity and agency as media users and producers.

The final chapter in this collection by Sarah Banet-Weiser is similarly cautious about girls' contemporary engagements with media technology. Banet-Weiser's study focuses on videos produced by adolescent girls and posted to YouTube.com. Connecting this increasingly popular practice to the interactive nature of Web 2.0, celebrity culture, neoliberal brand culture, and postfeminism, this project challenges the optimism found in many earlier feminist studies of girls' media production. While Banet-Weiser acknowledges the progressive possibilities of identity exploration and self-disclosure via digital media, she reveals the limits placed on girls' agency today via sites like YouTube as a result of the contradictory discourses of self-promotion associated with postfeminism and commercial cyberculture. Like Shade, Banet-Weiser cautions us to be wary of ascribing too much progressive potential to girls' media practices given the various disciplinary logics that work to contain young females and their creative expressions.

Onward

Although the growth of academic attention to girls' media culture over the past two decades is certainly worth celebrating, there is still much work left to do, and this book cannot do it all. While *Mediated Girlhoods* addresses some critical gaps in our current understanding of girls' media culture by including work that privileges the lenses of race, ethnicity, sexuality, class, nationality, and politics, considerable research must still be conducted if we are to fully subvert the white, heterosexual, middle-class, Western, and presentist framework that continues to dominate girls' media studies and thus public perceptions of girls' media culture. More attention to issues of girls' differences and diversity globally will not only round out popular knowledge about girls' media culture but also validate marginalized female youth and their media practices. I am proud that this collection has helped to further this project, and I hope it inspires other scholars to take up the charge.

I am also proud that this collection has significantly undermined the historical dominance of textual analysis in girls' media studies to date. Half of the research projects here utilize ethnographic practices to foreground girls' perspectives and voices, thus troubling the notion of who has authority to speak about girls' media culture. In turn, more than half of the chapters in this collection are devoted to analyses of girls' media reception and production, thus helping to expand greatly public knowledge about what female youth *do* with media texts and technologies, and thus to debunk the die-hard stereotype of girls as passive consumers, if not victims, of media.

My only regret with this collection is that it does not contain research on girls' uses and production of subcultural and anti-corporate media, for it risks reproducing the common perception that girls' media culture is always already mainstream and commercial. Perhaps the primary reason for this omission is that I did not receive promising proposals for chapters in this area, which I am hoping was a fluke and not indicative of trends within this field. Scholarship on girls' involvement in mediated subcultures and alternative forms of media production seemed to be on the rise at the turn of the twenty-first century, largely as a result of girls' increased participation in punk, hip-hop, and riot grrrl.[13] Yet girls' media studies scholars seem to have far less interest in, and exposure to, such alternative practices and entrepreneurial subcultures today. Many possible reasons exist for this phenomenon, not the least of which is adolescent girls' decreased engagement in such cultures since the 1990s, particularly in the realm of production, as well as the overwhelming increase in the number of mainstream girl-centered media properties, especially for younger girls. Indeed, as much as it was hard for girls' studies scholars to focus on hip-hop and riot grrrl when the Spice Girls and *Beverly Hills, 90210* were dominating the cultural landscape, it seems all the more

difficult for us to even *locate* alternative girl-centered media texts and performers today in the midst of the global media storms fueled by *Twilight, Hannah Montana*, and the ever-expanding Disney Princess line.

While I certainly don't want to dismiss the many pleasures associated with products from the media industries, or girls' subversive uses of such products, it seems imperative for girls' media studies scholars invested in the progressive politics of both feminism and cultural studies to also explore the media practices of female youth outside this commercial realm. Not only can analyses of girls' alternative media practices tell us much about how female youth negotiate hegemonic systems of identity, representation, leisure, and labor, they also can allow us to explore girls' and boys' collective media engagements given that the commercial industries continue to bifurcate youth and their media into pink and blue. Moreover, attention to girls' alternative media culture can suggest future trends within women's media production. Indeed, a considerable amount of the next generation of feminist media will likely emerge from this non-corporate arena, even if it eventually is hosted on commercial Web sites, like YouTube and MySpace. It is my hope, therefore, that recent studies like Alison Piepmeier's *Girl Zines: Making Media, Doing Feminism*, Helen Reddington's *The Lost Women of Rock Music: Female Musicians of the Punk Era*, Emilie Zaslow's *Feminism, Inc.: Coming of Age in Girl Power Media Culture*, and Anita Harris' recent collection *Next Wave Cultures: Feminism, Subcultures, Activism* will inspire more scholars to explore the margins of girls' media culture past and present, here and abroad.

Notes

1. Angela McRobbie was the original pioneer in girls' media studies, her work on girls' culture and girls' magazines dating back to the late 1970s and early 1980s. Many of those studies did not receive as much attention as they deserved, however, until they were reprinted in her book, *Feminism and Youth Culture*, in 1991.
2. Many pioneering book chapters and journal articles were published during this period also, of course—too many to list here, unfortunately.
3. To date, no study has examined all three of these sites of girls' media culture simultaneously; however, several have undertaken textual analysis and reception studies concurrently, and some have involved textual analysis and production studies.
4. For an exploration of this development, see Mazzarella and Pecora, "Revisiting."
5. Although many scholars studying girls' media culture are associated with media and communication studies, a good number are not, having affiliations in such diverse fields as folklore, music, literature, journalism, and sociology.

6. For an overview of the development of girls' studies as a field, as well as a survey of its various subdivisions, see Kearney, "Coalescing."
7. See Barker for an overview of cultural studies.
8. For a discussion of girls' studies relationship to women's studies, see Kearney, "Coalescing."
9. For explorations of third wave feminism, see Dicker and Piepmeier, Heywood and Drake, and Walker.
10. Although it has resulted in a collection that may not seem up to date, the minimal number of Web-based studies in *Mediated Girlhoods* was a conscious choice, given Peter Lang's concurrent publication of Mazzarella's collection, *Girl Wide Web 2.0.*
11. For studies of postfeminism, see McRobbie, *The Aftermath*, as well as Tasker and Negra, *Interrogating Postfeminism.*
12. In this collection, see Driscoll, Greer, and Hains, Thiel-Stern, and Mazzarella.
13. For example, see Gaunt, Guevarra, Kearney's *Girls Make Media*, Leonard, O'Brien, Perry, and Rose.

Works Cited

Anzaldúa, Gloria and Cherríe Moraga, eds. *This Bridge Called My Back: Writings by Radical Women of Color.* Watertown: Persephone Press, 1981.

Barker, Chris. *Cultural Studies: Theory and Practice.* 2nd ed. Thousand Oaks: Sage, 2003.

Currie, Dawn H. *Girl Talk: Adolescent Magazines and Their Readers.* Toronto: University of Toronto Press, 1995.

D'Acci, Julie. "Cultural Studies, Television Studies, and the Crisis in the Humanities." *Television After TV: Essays on a Medium in Transition.* Eds. Lynn Spigel and Jan Olsson. Durham: Duke University Press, 2004. 418–46.

Dicker, Rory and Alison Piepmeier, eds. *Catching a Wave: Reclaiming Feminism for the 21st Century.* Boston: Northeastern University Press, 2003.

Douglas, Susan. *Where the Girls Are: Growing Up Female with the Mass Media.* New York: Random Books, 1994.

Duits, Linda and Liesbet van Zoonen, "Against Amnesia: 30+ Years of Girls' Studies." *Feminist Media Studies* 9.1 (2009) 111–15.

Gaunt, Kyra. *The Games Black Girls Play: Learning the Ropes from Double-Dutch to Hip-Hop.* New York: New York University Press, 2006.

Guevara, Nancy. "Women Writin' Rappin' Breakin'." *The Year Left 2: An American Socialist Yearbook.* Eds. Mike Davis, Manning Marable, Fred Pfeil, and Michael Sprinker. Stonybrook: Verso, 1987. 160–75.

Harris, Anita, ed. *Next Wave Cultures: Feminism, Subcultures, Activism.* New York: Routledge, 2008.

Heywood, Leslie and Jennifer Drake, eds. *Third Wave Agenda: Being Feminist, Doing Feminism.* Minneapolis: University of Minnesota Press, 1997.

Inness, Sherrie A., ed. *Delinquents and Debutantes: Twentieth-Century American Girls' Cultures*. New York: New York University Press, 1998.

Kearney, Mary Celeste. "Coalescing: The Development of Girls' Studies." *NWSA Journal* 21.1 (2009): 1–28.

———. *Girls Make Media*. New York: Routledge, 2006.

———. "New Directions: Girl-Centered Media Studies for the Twenty-First Century." *Journal of Children and Media* 2.1 (2008): 82–83.

Kellner, Douglas. "Cultural Studies, Multiculturalism and Media Culture." *Gender, Race, and Class in Media: A Text-Reader*. Eds. Gail Dines and Jean M. Humez. Thousand Oaks: Sage, 1995. 5–17.

Leonard, Marion. "'Rebel Girl, You Are the Queen of My World': Feminism, 'Subculture' and Grrrl Power." *Sexing the Groove: Popular Music and Gender*. Ed. Sheila Whiteley. New York: Routledge, 1997. 230–55.

Mazzarella, Sharon, ed. *Girl Wide Web 2.0: Revisiting Girls, the Internet, and the Negotiation of Identity*. New York: Peter Lang, 2010.

Mazzarella, Sharon and Norma Pecora, eds. *Growing Up Girls: Popular Culture and the Construction of Identity*. New York: Peter Lang, 1999.

———. "Revisiting Girls' Studies: Girls Creating Sites for Connection and Action." *Journal of Children and Media* 1.2 (2007): 105–25.

McRobbie, Angela. *The Aftermath of Feminism: Gender, Culture and Social Change*. Los Angeles: Sage, 2009.

———. *Feminism and Youth Culture: From* Jackie *to* Just Seventeen. Boston: Unwin Hyman, 1991.

O'Brien, Lucy. "The Woman Punk Made Me." *Punk Rock: So What?: The Cultural Legacy of Punk*. Ed. Roger Sabin. London: Routledge, 1999. 186–98.

Perry, Imani. "Who(se) Am I?: The Identity and Image of Women in Hip-Hop." *Gender, Race, and Class in Media: A Text-Reader*. 2nd ed. Eds. Gail Dines and Jean M. Humez. Thousand Oaks: Sage, 2003. 136–48.

Piepmeier, Alison. *Girl Zines: Making Media, Doing Feminism*. New York: New York University Press, 2009.

Reddington, Helen. *The Lost Women of Rock Music: Female Musicians of the Punk Era*. Burlington: Ashgate, 2007.

Rose, Tricia. *Black Noise: Rap Music and Black Culture in Contemporary America*. Hanover: Wesleyan University Press, 1994.

Tasker, Yvonne and Diane Negra, eds. *Interrogating Postfeminism: Gender and the Politics of Popular Culture*. Durham: Duke University Press, 2007.

Walker, Rebecca, ed. *To Be Real: Telling the Truth and Changing the Face of Feminism*. New York: Anchor Books, 1995.

Zaslow, Emilie. *Feminism, Inc.: Coming of Age in Girl Power Media Culture*. New York: Palgrave, 2009.

Representation and Identity

Love and Friendship: The Queer Imagination of Japan's Early Girls' Culture

Yuka Kanno

L ooking at the history of girls' culture in early-twentieth-century Japan, one will immediately notice the value given to the word *tomo*, "friend." Girls' culture was not of course the only site where this trope existed; however, it was the one in which friendship thematically and visually prevailed, most emblematically in magazines. Although friendship first maintained a gendered public place in the male domain, girls' and women's magazines began employing the term in their titles, symbolically addressing their readers and becoming for many, literal companions.[1] A look into the readers' pages in *Shôjo no tomo* (*Girls' Friend*), for instance, attests to the ways in which readers anthropomorphized the magazine, treating it as a virtual friend.

This essay will explore the cultural eruption of female friendship as a basis for queer networks and a site of erotic alliance among young women across the visual and literary fields in early-twentieth-century Japan. In doing so I will take up the literary work of women connected with Japan's first feminist group *Seitôsha* (Bluestocking Society), and the imagery of *shôjo*, or the girl in the artistic genre of *jojôga*. The emotional texture and intensity of female friendship will be analyzed as a specific historical and cultural phenomenon but also an unequivocally gendered experience, central to the lives of adolescent girls, and particularly school-girls. The official language of friendship did not merely signify one relationship among many others but provided a code by which girls were expected to develop into properly gendered national subjects. Drawing on the work of feminist, les-

bian, and queer cultural critics and historians in the United States and Japan, I examine the ways in which intense female affections and sexual desires were articulated through the very trope of friendship. Against the common perception of same-sex desire as a mere fantasy without political implication, I argue that these affectionate and intense relationships were a practice of imagination, a new vision of female relationships that opened up a space for social change.

It would not be accurate to claim that the existing scholarship has neglected or underrepresented the issue of same-sex love in the early Japanese girls' culture, for as I will discuss more fully later, homoerotic relationships among young women were one of the most conspicuous aspects of female friendship. Nevertheless, scholarly and critical recognition of female-female intimacy has commonly proceeded with the gradual historical denial and the eventual theoretical erasure of female-female desires rather than indifference and silence. It is as if the omnipresence of homoerotic relationships and their excessive visibility render their meanings all the more invisible and intelligible. In this essay, I attempt to reinsert female same-sex desires and practices back into cultural history, for the female same-sex love fad from the 1910s throughout the 1940s was far from an anomalous or unexpected side effect of modernization but rather a logical extension of modern institutional arrangements and expanding capitalism. The images of ideal femininity promoted by girls' schools as well as those disseminated in magazine culture prepared a queer female culture of a public kind in twentieth-century Japan. Against the view that the prevailing female-female love phenomenon was a mere temporal deviation with no political implications, I argue that female same-sex desire, love, and practices contained far more significant political valence, carving out a path for contemporary queer subjects.

Already in the 1910s, friendship was gaining prominence as a central theme in Japan's modern literary canon. In *Kokoro*, published in 1914, Natsume Sôseki unfolded a multilayered tale of male homosocial bonding. Its narrator (referred to throughout the book as "I"), "the teacher whom 'I' looks up to," along with the "the teacher's" dead friend "K," weave a complex web of friendship and erotic desire. If "I" and "the teacher" swimming at the beach express shared physical pleasure to the extent of erotic euphoria, the exchange of a woman between the teacher and K, along with their deep misogyny, brings homosocial desire to the fore while keeping the homosexual component latent. Five years after *Kokoro*, Mushanokôji Saneatsu published *Yûjô* (*Friendship*), another tale of two close male friends who come to love the same woman. In this story, Nojima loves Sugiko, a woman whom he idealizes and to whom he desperately devotes himself. Sugiko falls in love with Nojima's best friend, Ômiya, who decides, unlike "K" in *Kokoro*, not to step aside, announcing to Nojima his decision to marry her. Sugiko's role is a mediating one, and she is the shared object of the two men. What comes out of this triangulation is the further strengthening of the male bond; the men

exchange philosophical views and inspire each other while putting their beloved aside. The glorification of male friendship in *Yūjō's* narrative closure provides one more textbook example of a homosocial bond "between men," where a woman exists to support and mediate this male homosocial tie (Sedgwick 25–26). The intimate male relationships thematized in the work of these "great authors" have been read in reference to male spiritual superiority in their inner struggle and search for the truth, and it was not until recently that scholars and critics began shedding light on the erotics of homosocial bonding in these works (Ôhashi). Friendship, coded as male, remains a site of honor and virtue, a mirroring of male attributes.

The popularity and gender exclusivity of these early-twentieth-century Japanese novels did not stop female writers from taking up friendship as a central theme, however. Particularly those who became involved, directly and indirectly, in early feminist movements, Tamura Toshiko, Kawada Yoshi, Kanzaki Tsune and Sugawara Hajime explored the vantage point of female-female relationships by problematizing the line between sensual and sexual, love and friendship. Although the question of lesbianism in *Seitô* feminism tends to be reduced to one lesbian relationship, (the eventually pathologized and abandoned affair between Hiratsuka Raichô and Otake Kôkichi), lesbianism in the feminist and women's writing of modern Japan offers much more diverse and richer material for inquiry beyond mere biographical episodes.[2] Each writer grappled with the question of female desire and sexuality through her characters' strong attraction to other women, and these thematic concerns were directly related to the question of form, or how to convey such an affective yet unseen emotional landscape in literary form. Despite differences in style and tone, these writers collectively enunciated the erotic tension in female friendship in a rather explicit manner. Tamura's *Akirame* (*Resignation*), for instance, explores female subjectivity through the inseparable terrain of the emotional and the sexual. Literary critics read such articulation of intimacy, sensuality, and sexuality as peculiar to the "feminine." This critical reaction to *Akirame* exemplifies the subjection of sexuality to gender in women's affections, and hence female friendships became sensual and insignificant surface instances lacking spirituality and inner depth. Attempts by female writers to wrestle with erotic intimacy through the literary trope of friendship were, of course, not isolated, but well anchored in the configuration of a changing sexual epistemology, triggered by the "female same-sex love panic" of the 1910s.

Intimate relationships and affective ties among women are not a particularly early-twentieth-century phenomenon, nor are they specific to Japanese cultural contexts. Nevertheless, a series of incidents occurring in the 1910s had a significant enough effect for the Japanese public to see female same-sex friendship in a new light. In 1911, two young women, Sone Sadako and Okamura Tamae, were found dead on the Oyashirazu coast in Niigata prefecture. Both women were

twenty years old and had graduated from the same girls' school in Tokyo. Their intense affection for each other developed during their school days and continued after graduation, leading one of their fathers to prohibit contact between them, while Sone's family arranged a marriage for her. In response, Sone and Okamura ran away and, after spending a few days together on the coast, ended their sojourn by leaping into the sea.[3] This double suicide, committed by well-educated young women from upper-middle-class families, drew a sharp contrast with existing patterns of same-sex double suicide, most of which were committed by women of the lower-class (factory workers, waitresses, prostitutes, and domestic servants, among others).[4] Unlike the previous cases, where the media and social critics presumed empathy as the main cause of such attempts, this case brought, for the first time, love to the fore as a possible cause of death. The public thereby had no choice but to face love in terms of sexual desire as potentially latent in friendships among girls.

Historians and sociologists alike have situated the Niigata double suicide as not only the starting point of the commonly referred to "female same-sex love panic" that continued into the 1930s, but also a watershed moment in Japan's modern history of homosexuality. If Hiruma Yukiko calls this incident "the discovery of female same-sex love" in Japan (15), Furukawa Makoto points out that the increase in same-sex love among schoolgirls stimulated the coinage of *dôseiai* (same-sex love), by altering the social reception of homosexual practices (115). Although existing Japanese words for homosexual activities were limited to male sexual practices, whose implications were almost exclusively physical, the new term, *dôseiai*, introduced a not-always-physical factor to the concept, and hence, a new meaning surrounding homosexual relationships. This, of course, entailed another problem, a division of female and male same-sex love as "spiritual" and "carnal," respectively. I should hasten to emphasize here that female same-sex love was also constructed as a phenomenon and a practice peculiar to schoolgirls through the media discourse. Another female double suicide happening only two days after the Niigata incident was again attributed to empathy, on the grounds that both women were factory workers. The increasing numbers of female same-sex love suicides occurring during this time certainly contributed to the public recognition of intense female-female affections as a serious and dangerous matter. "If one looks at the social pages of the newspapers these days," prominent sexologist Yasuda Tokutarô wrote in 1935, "how numerous are the double suicides of women. It's as if homosexuality were being monopolized by girls" (150).

Not surprisingly, the female same-sex love panic also coincided with the introduction of sexological knowledge and its rapid dissemination in Japan. The most influential was Richard von Krafft-Ebing's *Psychopathia Sexualis*, translated into Japanese in 1913, which came to provide the central framework for understanding and interpreting same-sex practices in modern Japan. Under the heavy

influence of Krafft-Ebing, Japanese sexologists, such as Sawada Junjirô and Habu-to Eiji, developed their views on female homosexuality as they formulated intense female identification as a major cause of this type of sexual "perversion." Often tolerant, or even supportive, attitudes by Japanese sexologists toward female same-sex love emphasized what Krafft-Ebing called "homosexual feelings as an acquired manifestation" (188). This view in a sense situated female homosexuality as both a temporal and spatial deviation as well as an object of correction through educational means. In its temporality, female homosexuality was defined as a passing "fever" in the female life cycle and a period of adjustment for mature female sexuality (read, heterosexuality). Spatially speaking, it was a kind of infectious disease circulated in all-female environments, such as prison, garrisons, bagnios, and boarding schools, as well as aboard ships. Japanese sexologists identified particular spaces as sites of "infection" for sexual perversion. Claiming that "among the various reasons causing inherent disposition for female homosexuality, the most dominant is the current school system," Kuwatani Teiitsu singled out girls' schools as "the biggest training centers for the artificial homosexual desires" (41). Sexology as a Western-import technology of modern sexual knowledge thus met the institutionalization of girls' education, which facilitated a single-sex environment.

The sexologically informed knowledge of adolescent female sexuality in early twentieth-century Japan led social, cultural, and medical authorities to view the female same-sex love panic friendships as a pronounced "educational" problem, with schools as the locus of sexual perversion. Meanwhile, the institutional reordering of the national school system contributed greatly to the expansion of the same-sex love "disease." In 1899, the Higher Girls' School Act instituted a single-sex learning environment for adolescent girls from middle-class families while installing young women's education as part of public education. The official purpose of such education was to prepare girls for proper womanhood, conceived as instrumental by the expanding militarist state. Although the eligible age for admission, schedule, and course curricula varied according to schools, girls generally matriculated at higher schools at twelve years old after compulsory primary education and attended for three to five years. The average class hours per week were between twenty-five and thirty, and subjects included Moral and Patriotic Education, Japanese, Foreign Language, Mathematics, Science, Sewing and Gymnastics. School was expected to be the foundation of a strong nation, as it would properly gender young women and men as national subjects. Correct womanhood took its concrete form in the infamous state policy of *ryôsai kenbo* ("Good Wife, Wise Mother"), set up as the mission of women's education by the Ministry of Education. Officially a state policy between 1890 and 1910, Good Wife, Wise Mother remained operative until the end of the Pacific War.[5]

Even though the idea of being a good wife or a wise mother was itself nothing new in Japan at this time, the new meanings assumed by this gender ideol-

ogy nonetheless showed significant changes from earlier periods. A new emphasis upon girls' domestic knowledge urged women to take part in the management of the family economy as a helpful mate of the husband or as his substitute in his absence. This ideology then paradoxically pushed women to venture out and seek knowledge rather than stay confined within the house. A woman's place was still in the home, yet her role no longer assumed the Confucian imperative of complete submission to the husband and family, being now informed by modern Western perspectives on the division of labor, which combined Confucianism with agency. Although the adoption of this principle created room enough for women's active control of domestic affairs, the Good Wife, Wise Mother policy demonstrated an aspect of Foucauldian power as simultaneously productive and regulatory.[6] It was state recognition of women's critical role in the building of the nation that also led to the establishment of the girls' school.

When the Higher Girls' School Act was put into effect, a new social category of *jogakusei* (female students) came into being as a prototype of *shôjo* (adolescent girls). *Jogakusei* was a new category in terms of gender, for previously students were not differentiated as female or male. It was these newly institutionalized and gendered young females who immediately became the primary agents of *shôjo* culture. Of course, the schoolgirls did not always comply with the *raison d'être* of the girls' school in serving the national interest. At the very heart of the state institution and its implementation of social norms, values, and behaviors, *jogakusei* began weaving their own network of affections and pleasure. As one *jogakusei* described her experience, "I often stay there [at school] until evening. I spend time doing some after school activity, homework with friends, chatting, and going home at around five o'clock" (qtd. in Inagaki 8). Among young women's friendships of the time, these intensely intimate, and often homoerotic, relationships were widely known as "S" (pronounced as "esu"), as a result of the English term, "sister."[7] The use of an English word bespoke largely middle-class aspirations, a new generation of young women granted both education and the power of consumption.

The "S" relationships usually consisted of older students and their juniors but also students of the same age, and sometimes teachers and students. The "sisters" were recognized by their peers as being in exclusive relationships, and implicit moral codes of the time encouraged girls not to engage in other relationships or to steal another girl's sister. Like any other relationship, however, couples would dissolve these bonds to form new "S" relationships in the course of their school life. Characteristic of "S" was the mediating role of letter writing: The sisters wrote one another almost every day, exchanging their missives at the school lockers. Despite the general portrayal of the "romantic" and "sentimental" nature of their sisterly affections in public discourse, the S-letters more often than not conveyed feverish and powerful erotic feelings through outspoken expressions of impatience, insan-

ity, jealousy, and the desire to be physically close, meshing hyperbolic style and rhetoric. Along with these exchanges, the sisters' matching belongings and colors also constituted a public announcement of their relationship.

Unlike the common assumption, girls' schools were not utopian spaces devoid of any social implications; they formed the very "social space" that permitted new actions and relationships to occur (Lefebvre 73). That is to say, these students reinvented the school as a site of a new economy based on the affective labor, production and consumption of desires, practices, and relationships. Despite its hypervisibility, female-female intimacy generated in the social space of schoolgirls may not have been visible as such, for the semiotics of *shôjo* in such spaces may have differed from those in the dominant arena. Their same-sex love practices might have looked docile and innocuous in that they did not conspicuously challenge the social order, nor manifestly resist the national script of femininity. The tenderness, care, affection, and mutual dependence that these girls exhibited toward their sisters embodied their feminine virtue, signaling that they would behave in the same manner with male partners once they matured. Female same-sex love practices in the "S" relationships, therefore, by no means contradicted the Good Wife, Wise Mother state policy. Keenly aware of such complicity, the key players of schoolgirls' culture slipped same-sex desires into the literary tropes and visual motifs of friendship and sisterhood.

As a pioneer of girls' fiction and an icon of *shôjo* culture, the writer Yoshiya Nobuko is representative of such strategic uses of sisterhood and friendship in the literary field. Referred to as the "schoolgirls' bible" Yoshiya's *Hanamonogatari* (*Flower Tale*) significantly shaped the contours of *shôjo* culture. In the fifty-two short stories of *Hanamonogatari*, the strong bonds of female-female intimacy were treated as central to the lives of the young female protagonists. Throughout her career, Yoshiya grappled with how to articulate intimate female affections and the relationships that dare not speak their names. As her *shôjo* readers grew older, Yoshiya gradually began emphasizing girls' friendship, establishing a new genre, "friendship fiction," of which she is credited as founder. *Onna no yûjô* (*Women's Friendship*), serialized in the magazine *Fujin Kurabu* (*Women's Club*) from 1933 to 1934, is exemplary of such "friendship fiction," depicting the enduring female bonds beyond the girls' school, while strategically displacing, if not disguising, its strong sexual undercurrents in two socially acceptable forms of relationships: friendship and Christian love. The text employs romantic French phrases and dream sequences as means to imply a woman's erotic feelings for another woman, thus skirting any overt expression. The dream scenes in particular dramatize an erotic scenario in which the female protagonist tries to "buy" her friend who has become an entertainer-cum-prostitute, while the text refers to various queer cultural elements of the time, including the jargon "L," for lesbianism, and the all-female theater group Takarazuka, suggesting its formative role in the emerging

lesbian subculture of the 1930s. Yoshiya's work in this way decoded female same-sex desires in friendship, and as a result redefined them, while making it possible for queer feelings to permeate the public arena.

Schoolgirls not only took a great deal of pleasure in reading Yoshiya's girls' fiction but also shaped themselves as writers by appropriating her style. Their letters to one another clearly indicate Yoshiya's influence in the use of elegant prose, the excessively decorative language, sentimental tone, and flower motifs. Yoshiya's influence is also most clearly traceable in their contribution to girls' magazines wherein they imitated Yoshiya's distinctly ornate writing style and the excessive use of textual symbols, such as dashes, six-dotted ellipses, and exclamation marks. As most of Yoshiya's early work appears in the girls' magazines, her writing was quickly circulated among schoolgirls, with the magazines becoming the very site of female friendship, or what Sakuma Rika describes as "a community of girl readers" (118).[8] Sakuma argues that girls' magazines provided a discursive space specific to the *shôjo*, who developed a transnational network from small villages in Japan to colonial Taiwan and Korea. The magazines thus mediated intimately affective ties among girls who attended the same schools and those whom they would never meet.

The fiction in the magazines was usually accompanied by illustrated images of girls and schoolgirls. Called *jojôga*, or lyrical paintings, these illustrations emerged as a new artistic genre in the 1910s and proliferated through the 1950s, becoming the primary site for the visual expression of *shôjo* culture. The success and popularity of these images came during what James Fujii argues was "a transformative moment for Japanese capitalism" in which increasing industrialization, rapidly growing print media, and the urbanization of the 1910s prepared the formation of the new middle class and mass culture of the 1920s and 1930s (108).[9] These aspects contributed to the expansion of *jojôga*, and by extension, *shôjo* culture. More specifically, it was the technological innovations in printing and reprography that pushed the development of the *jojôga* genre by enabling artists to maximize graphic effects and give realistic expression to their work. Such innovations allowed artists to explore new possibilities in color and line without losing their lyrical and romantic tone.

With Takehisa Yumeji as a pioneering figure, the genealogy of the *jojôga* is usually characterized by its thematic focus on young women in general, particularly schoolgirls surrounded with the accoutrements of girlhood in their intimate environment, such as books, letters, flowers, and musical instruments. Despite the common conception of *jojôga* as otherworldly, dreamy, and sentimental, artists in fact demonstrated a great deal of variety in their styles. Trained in *nihonga* (the modern school of Japanese painting as opposed to Western-style oil painting, called *yôga*), each artist simultaneously revealed the inheritance of and departure from the *nihonga* tradition. Takabatake Kashô was among the first generation of

jojôga artists, known particularly for his elegant yet sensual style. Kashô's girls (and boys), characterized by slit eyes with considerable white space, were often described as "androgynous." Meanwhile, Fukiya Kôji drew girls in a modern and Art Nouveau-influenced style, making the best use of the delicate lines he had mastered from his past training in *nihonga*. With finely rendered eyebrows, strong-willed eyes, and beautifully shaped lips, Kôji's girls' images expressed a strong independent sense of self in his highly stylized drawings. The next generation of artists further pushed the diversification of the genre. Matsumoto Katsuji created the girl image via expressive and winsome figures full of vitality, a type of *jojôga* that had not previously existed. Yet most crucial in relation to girls' culture was Nakahara Jun'ichi, who combined the lyricism of *nihonga* with a sentimental and romantic atmosphere connotative of a Western sensibility. Nakahara, whose *shôjo* bore tiny lips, large dreamy eyes, and thin willowy bodies, rapidly became an influential *jojôga* artist.

As a marker of their *nihonga* inheritance, *jojôga* artists often exhibited the visual traces of *bijinga* (literally, "paintings of beautiful women"), a genre that expressed the woman as an ideal or type, but not an individual.[10] Commonality with *bijinga* artists in their decorative and symbolic stylization of women's images aside, the *jojôga* artists largely veered from this tradition in breaking the aesthetic code of femininity and bringing out more modern traits.[11]

It would be naive, however, to consider *jojôga* as a form of visual expression free from its own normalizing force. Its *shôjo* images supported certain girls' images and adolescent femininity as ideal by including some and excluding others.[12] The visuality of *jojôga* that idealized romantic, lyrical, and affectionate as preferable dispositions for the *shôjo* thus inevitably led to the visual inclusion of female-female intimacy as part of the feminine ideal. Coupled with the intense homoeroticism in the girls' fiction, the visual rendition of female-female intimacy became a vital part of *shôjo* culture. Although there is a similar iconographic tradition of female intimacy in *bijinga*, one of the most popular genres in *ukiyo-e* during the Edo era (1603–1867), the visuality of same-sex intimacy in *jojôga* was addressed to and circulated among girls themselves against the background of the proliferating "S" relationships.

The *jojôga* artists frequently played with contrasting pairs of girls to illuminate their erotic dynamics in similarities and differences. While some pairs were identified in terms of social status, physical proximity, or certain feminine traits in behavior, others were differentiated by age or fashions whose semiotics operated oppositionally, such as feminine/masculine and Japanese/Western. These visual contrivances worked to complicate spectatorial experiences rather than anchor them as either identification or desire.

Finally, the contribution of *jojôga* artists to the queer female culture of the *shôjo* expanded beyond magazine illustrations to girls' everyday life and practices.

The *shôjo* visuality was materialized in the array of goods designed by the *jojôga* artists. As mentioned earlier, letters, in particular, were a critical mediating device for the "S" relationship, with stationery sets bearing the names of the artists who designed them. Thus, "Kashô paper" and "Masao paper" were crucial in facilitating the relationships between the school sisters.

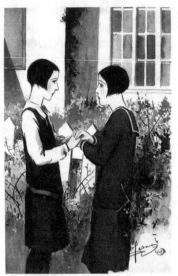

Figure 1.1 "Yakusoku (The Promise)," letter set illustration by Kato Masao, circa late 1920s.

At the time, however, neither girls' fiction writers nor *jojôga* artists enjoyed the cultural status and social recognition of other "serious" male literati and academic painters. For instance, Kobayashi Hideo, one of the most influential literary critics, referred to Yoshiya's *Women's Friendship* as "somewhat hideous" and "calling to mind an illicit affair with children" (qtd. in Yoshitake 251). Yoshiya's response to this criticism is a now-famous episode: "How old do you consider children to be?" she retorted. "*Women's Friendship* was written for *Fujin kurabu* (*Women's Club*), but you seem to equate women with children" (qtd. in Yoshitake 251). Just as official Japanese literary circles have long ignored Yoshiya's work and the girls' fiction genre, *jojôga* was and remains marginal to date unless associated with a more established art movement, as seen in Fukiya Koji's reevaluation as an École de Paris artist. Art historians refer to *jojôga* artists as illustrators to differentiate them from more serious academic painters whose *shôjo* images took their place at respectable government-sponsored art exhibitions. Such cultural locations speak tellingly of that of the *shôjo* herself.

In the 1980s, however, scholars and critics of Japanese girls' culture launched the project of creating a new cultural history with the *shôjo* as its subject. While

suggesting the subversive potential of girls' culture as a resisting force to patriarchy, they have also tended to see its potential as never actualized. At best, they argue, what the *shôjo* did was to form a kind of "imagined community" with no real effects or social consequences (Anderson). Similar to this is scholars' interpretation of the "S" relationship as only romantic and not erotically and politically relevant. Instead, they see it as "a form of sexual desire unmediated by any carnal connections" (Honda 10). Furthermore, they understand the letters addressed to the sisters as constructing a peculiar, intimate world based on adoration and consideration, therefore expressing "compassionate and equal relationship alone" (Inagaki 103). But as Gregory Pflugfelder points out, sisters in Japan were deeply implicated in the power relations of family and the school system, in which, for instance, age differences regulated their relations by imposing a different language and behavioral code (138–9). Moreover, in spite of the consistent scholarly dismissal of the erotic as part of the female-female intimacy, it is not difficult to find evidence of social recognition and the sense of crisis regarding the physical nature of "S" relationships in the media discourse of the time. For example, one article demarcated the carnal intimacy of such relationships as "deeply involved," distinguishing it from "lighter" and "spiritual" intimacy. (*Housewife's Friend* 105).

In the Euro-American context, historical study on women's friendships by Carroll Smith-Rosenberg and Lillian Faderman opened up the debate on female-female desire and relations within homosocial environments. In her seminal 1975 essay, Smith-Rosenberg introduced the problematics of love/friendship among women in "an emotional landscape of 19th century America" where female-female relationships played a central role in women's lives. Furthermore, she points out that such female affections were not only pervasive but also widely accepted by society (4). In a similar vein, Faderman asks us to rethink the history of female romantic friendships, love, and sexuality in the West, arguing, "these romantic friendships were love relationships in every sense except perhaps the genital" (16).

Classified as the "romantic friendship camp," as opposed to the "Butch-Femme camps" of early twentieth century Berlin, Paris, and New York, the work of Smith-Rosenberg and Faderman has been criticized in its desexualizing of lesbianism (Vicinus, "Sexuality and Power" 147–8). Criticism of "romantic friendship," however, often fails to take into consideration Faderman's and Smith-Rosenberg's refusal to narrowly define the sexual in terms of the genital. Although I don't believe that women's romantic friendships in the United States or Japan lacked a physical component, the love/friendship continuum theory nevertheless addresses a critical question of methodology. In fact, more than the "romantic" and "platonic" part of their argument, the keen awareness of difficulty in deciphering "female love" and classifying the sexual and the emotional brings Smith-Rosenberg and Faderman closer.[13] The methodological struggle suggested in their work is even shared by their critics. In her historical examination of adolescent crushes in English board-

ing schools, Vicinus confesses, "I cannot from my evidence answer the question of precisely how sexually aware the participants were in these 'new' crushes" (601–2).

What constitutes evidence of sexual desire and what counts as a "record" of erotically charged intimacy remains a vexing problem, not only because of their often impossible traceability but also because of the different guises they can take. As much as the absence and disarticulation of sexual desire in the letters and diaries of adolescent girls cannot prove the absence of those feelings, abundant and excessive sexual rhetoric can also diffuse the erotic meanings of female-female love. In the hypervisibility and rhetorical abundance of homoerotic feelings in Japanese *shôjo* culture, scholars often read a chaotic pleasure of self-loss (Kawasaki 83), or a narcissistic mirroring (Tsuchiya Dollase 742). A reduction of lesbian sexuality to autoeroticism or an undifferentiated mother-daughter bond equally evacuates same-sex desires and, by extension, lesbian subjectivities. In this sense, the romantic friendship camp offers two useful insights in considering the "female world of love and ritual" in the Japanese *shôjo* culture: first, the pervasiveness of intense female-female intimacy and its positive social acceptance; and second, the various ways in which female-female intimacy can be sustained undetected within the structures of family and school.

What interests me here is not whether a relationship should be called friend-ship or love, romantic or sexual, but what is at stake in the act of drawing the line between them, and what motivates scholars and critics to identify and classify the nature of female intimacy. Modern lesbian historiographers and the Japanese social authorities of the early twentieth century equally share the need to separate the sexual from the friendship, and by doing so make an unexpected alliance in situating the genital as a defining criterion. It was absolutely crucial for Japanese sexologists to dissociate the platonic from the sexual to sustain the legitimacy of heterosexual relationships upon which so many things were built, from the notion of the family-state to the modern medico-scientific knowledge formation. The positive view of female same-sex love thus came from educators and sexologists in their endorsement of heterosexuality, for they considered female same-sex love to be an imitation of or a practice run for heterosexual relationships. For instance, sexologists Yasuda Tokutarô and Ôtsuki Kenji claimed that same-sex love was less harmful than beneficial, even advocating same-sex love among schoolgirls as a kind of apprenticeship for mature heterosexual womanhood. Yet amid inconsis-tent comments by the "experts" and the ubiquity of the same-sex love practices with increasing attention to female double suicides, the public wavered between social acceptance and pathologization. In any case, the former was predicated on its sanctioned goal of heterosexual intimacy, and the "S" relationship was allowed so long as it remained compliant to this end game. "S" relationships, temporally and spatially confined as they were within adolescence and the girls' school, were not considered threatening to the social order.

As Fujii describes, the *shôjo* certainly emerged as "a combined effect of commercial and official imperatives" and "a commodity object" within the logic of the nation, capitalism, and modernization (128). It would be inaccurate, however, to assume the complete submission of those girls to the gender norms prescribed by women's education as well as to their position as objects of consumption. The *shôjo* (re)invented herself as a subject in collaboration with *jojôga* artists and girls' fiction writers whose realistic, imaginative, and exaggerated visual and narrative renditions of *shôjo* inspired, and were inspired by, her. Most importantly, these adolescent girls constructed their subjectivity in and through their sexual desires and imaginations, reshaping *shôjo* culture into what I would call a "queer public female culture." For the *shôjo* was a self-fashioned erotic subject whose implication was, as aptly described by Jennifer Robertson, "heterosexual inexperience and homosexual experience" ("Gender-Bending in Paradise" 56).

In this essay, I have tried to show how female same-sex desires and practices among girls in early-twentieth-century Japan were articulated through the culturally sanctioned ethos of sisterhood and friendship. Tenderness and mutual dependency, which demarcated the "S" relationship, were equally important conditions for young women's heterosexual maturation. The Good Wife, Wise Mother policy of women's education, as well as the national gender script, provided institutional support for female-female intimacy, particularly through the creation of an affective space for girls to commingle and develop their affections. In the work of female writers of the early twentieth century, we can see examples of how female-female intimacy and sexual desires overlapped and were negotiated through the trope of friendship and sisterhood. Such tropes were an effective way of sustaining and publicly circulating same-sex desire in displacement. Commentators on early Japanese girls' culture tend to underestimate the political implications of female-female intimacy by assuming that the "S" relationships were based in pure fantasy with no radical potential. Yet, Yoshiya, the creator of these fantasies, demonstrated this potential in her own life, pointing out alternatives to family and marriage that extended far beyond girlhood. Post-schoolgirl intimacy could further extend itself into the very domestic space of family and marriage, for what better place to maintain and conceal such affections? Thus, freedom from the constraints of family and kinship were, and are, not exclusive conditions allowing female same-sex love to flourish. For instance, in the South Asian context, Gayatri Gopinath has forcefully demonstrated that female homoerotic desire can be generated on a "survival economy of work and pleasure" of middle-class domestic space (147). Japanese *shôjo* culture offers another case of female same-sex desire that emerges in the normative space of home and school, and in complicity with middle-class gender norms and sexual codes: Schoolgirls' intimate relationships survived by coming and going between the invisibility and hypervisibility of same-sex desires. Yet this happened in a different way from the Anglo-American model of mod-

ern lesbianism, which is predicated on an autonomous subjectivity whose sexual identity needs to be separated from family values and roles. Some *shôjo* managed to escape from family and marriage and built their lives together outside of institutionalized intimacy; others contrived to carry on their affections within familial and matrimonial structures.

"Toward friendship," Michel Foucault once pointed out, "people are very polarized" (*Ethics* 137). His conception of friendship as a multiplicity of relationships which one can reach *through* sexuality allows us to consider female homoerotic desire within Japanese girls' culture as such: "relations with multiple intensities, variable colors, imperceptible movements and changing forms" beyond the "either love or friendship" paradigm (137). Furthermore, the "S" relationship as a movement traversing the wide affective spectrum was not a mere fantasy with no possibility of realization but *an imaginary* as "not the image of something else, but without which there cannot be something else" (Joyce 4). Without the work of this imaginary, as Patrick Joyce tells us, even reality and society do not exist. Or we can think of "S" relationships as imagination, if we understand imagination as social practice. Arjun Appadurai's argument that imagination is a constitutive feature of subjectivity as well as "a staging ground for action" is important here (7). Whether it be romantic or sexual, platonic or physical, female friendship within *shôjo* culture was an imaginative social practice, and that collective deviation from and resistance to what was available to them made the *shôjo* a political subject. By redefining friendship, they paved a way to live differently for those who remain their "friends" and "sisters."

Notes

1. The list of those magazines includes *Shôjo no tomo* (*Girl's Friend*), *Shojo no tomo* (*Virgin's Friend*), *Shônen no tomo* (*Boy's Friend*), *Shufu no tomo* (*Housewife's Friend*), *Fujin no tomo* (*Lady's Friend*), *Josei no tomo* (*Women's Friend*), and *Eiga no tomo* (*Film's Friend*), to name a few.
2. *Seitô* (Bluestocking, 1911–1914) was Japan's first feminist journal launched by five women. Its leader Hiratsuka Raichô had a brief yet fervent love affair with another member, Otake Kôkichi. After making this affair public by writing about it in the journal, Hiratsuka later analyzed her ex-lover as a case of pathology, molded on modern sexological knowledge, discarding her same-sex experience with Kôkichi altogether.
3. For more details, see Pflugfelder and Robertson.
4. See Komine (174).
5. For more details on the *ryôsai kenbo* ideology, see Koyama.
6. In *The History of Sexuality*, Foucault argues on the ways in which the law, as an instance of power, produces the desire it represses.

7. Other terms that imply intimate and homoerotic relationships among school-girls include *shisu* ("sis"), *ome* ("Futari no ai natte *omedetai*"—it is *auspicious* that the two girls' love has been fulfilled—, or "*Ome* ni kakkata ga ai no itoguchi"—love began when they met each other), *hando-in* ("hand in"), *gos-hinyû* (honorable best friends), and *onetsu* (fever). For more details on the "S" relationships and these terms, see Inagaki, Pflugfelder, Robertson's "Dying to Tell," and Suzuki.

8. Sakuma conceptualizes "a community of girl readers" by drawing on Anderson's "imagined community."

9. Maeda Ai also points out that "the fact that more girls were completing their middle school education in the late Taishô era, combined with the increase of the new middle class, largely explained the rise of women's magazines. The enrichment of girls' higher education was a primary factor for the expansion of female readership as well as the development of women's magazines" (169–70).

10. In the tradition of *bijinga*, ideal feminine beauty was depicted by the aesthetic coding such as *hikime gagibana* (dashes for eyes and hooks for noses), and thus feminine beauty was expressed according to this code and never depicted individuality in its style.

11. *Nihonga* artists such as Kaburaki Kiyokata also brought in the schoolgirl as subject matter. His portrayal of *jogakusei* produced highly idealized images of schoolgirls for elite male intellectuals (Inoue 460).

12. For instance, *jojôga* artist Sudô Kaoru writes: "the defining characteristic of *jojôga* is the visual representation of the artist's delicate sensibility in a way that combines the artist's imagination with realism. The difference between mere illustrations and *jojôga* is that illustration simply depicts the narrative of the novel, while *jojôga* reflects the emotions of the artist, such as his view of nature or life. . . . I think that *jojôga*, like poetry, conveys the feelings of the artist and provokes an emotional response in its audience" (qtd. in Takahashi 118).

13. Smith-Rosenberg writes: "defining and analyzing same-sex relationships involves the historian in deeply problematical questions of method and interpretations" (2) by pointing out that "paradoxically to twentieth-century minds, their love appears to have been both sensual and platonic" (4). Faderman also addresses the difficulty of tracing sexual patterns of love between women by noting that "lesbian sex leaves no evidence in 'illegitimate' offspring, and there have been few surveys that deal with women's views of lesbian sexuality" (19).

Works Cited

Anderson, Benedict. *Imagined Communities: Reflections on the Origin and Spread of Nationalism.* London: Verso, 1983.

Appadurai, Arjun. *Modernity at Large: Cultural Dimensions of Globalization.* Minneapolis: University of Minnesota Press, 1996.

Faderman, Lillian. *Surpassing the Love of Men: Romantic Friendship and Love between Women from the Renaissance to the Present.* New York: Morrow, 1981.

Foucault, Michel. *Ethics: Subjectivity and Truth. The Essential Works of Michel Foucault 1954–1984.* Ed. Paul Rabinow. Trans. Robert Hurley et al. New York: The New Press, 1997.

————. *The History of Sexuality*, Vol.1. *An Introduction.* Trans. Robert Hurley. New York: Vintage Books, 1978.

Fujii, James A. "Intimate Alienation: Japanese Urban Rail and the Commodification of Urban Subjects." *Differences: A Journal of Feminist Cultural Studies* 11.2 (1999): 106–133.

Furukawa, Makoto. "The Changing Nature of Sexuality: The Three Codes Framing Homosexuality in Modern Japan." *U.S.-Japan Women's Journal* (English Supplement) 7 (1994): 98–127.

Gopinath, Gayatri. *Impossible Desires: Queer Diasporas and South Asian Public Culture.* Durham: Duke University Press, 2005.

Habuto, Eiji and Sawada Junjirô. *Hentai seiyokuron.* Tokyo: Shun' yôdô, 1915.

Hiruma, Yukiko. "Kindai nihon ni okeru josei dôseiai no 'hakken' ('Discovery' of Female Homosexuality in Modern Japan)." *Kaihôshakaigaku kenkyu* 17 (2003): 9–32.

Honda, Masuko. "'S' Taainaku shikamo kongentekina ai no katach ('S': Trifling Yet Fundamental Form of Love)." *Imago* 2.8 (1991): 68–73.

Inagaki, Kyôko. *Jogakkô to jogakusei: Kyôyô, tashinami, modan bunka (Girls School and Schoolgirls: Cultivation, Etiquette, and Modern Culture).* Tokyo: Chûôkoron shinsha, 2007.

Inoue, Mariko. "Kiyokata's Asasuzu: The Emergence of the Jogakusei Image." *Monumenta Nipponica* 51.4 (Winter 1996): 431–60.

Joyce, Patrick. *Democratic Subject: The Self and the Social in Nineteenth-Century England.* Cambridge, UK: Cambridge University Press, 1994.

Kanzaki, Tsune, "Zôkibayashi (Thicket)." *Seitô* 3.1(1913): 129–35.

Kawada, Yoshi. "Onna tomodachi (Female Friend)." *Seito* 5:3 (1915): 73–88.

Kawasaki, Kenko. "Tsuyuoku hana no melancorî (Melancholy of Dewy Flower)." *Imago* 12.8 (1991): 78–83.

Komine, Shigeyuki, *Dôseiai to dôsei shinjûno kenkyû (A Study of Homosexuality and Homosexual Double Suicide).* Tokyo: Komine Makino Shuppan, 1985.

Koyama, Shizuko, *Ryôsai kenbo to iu kihan (The Good Wife, Wise Mother as the Norm).* Tokyo: Keisô shobô, 1991.

Krafft-Ebing, R. von. *Psychopathia Sexualis.* New York: Putnam, 1965.

Kuwatani, Teiitsu. "Senritsu subeki joseikan no tentô seiyoku (Fearful Perversive Sexual Desire among Women)." *Shinkôron* 26.9 (1911). Reprinted in *Senzenki dôseiaikanren bunken shûsei.* 3. Tokyo: Fuji shuppan (2006): 35–48.

Lefebvre, Henri. *The Production of Space.* Oxford: Blackwell, 1991.

Maeda, Ai. *Text and the City: Essays on Japanese Modernity.* Ed. James A. Fujii. Durham: Duke University Press, 2004.

Mushanokôji, Saneatsu. *Yûjô.* 7th ed. Tokyo: Iwanami Shoten, 2008.

Natsume, Sôseki. *Kokoro*. 119th ed. Tokyo: Iwanami Shoten, 2008.

Ôhashi, Yôichi. "Kuia fâzâ no yume, kuia neishon no yume: *Koroko* to homosôsharu (Queer Father's Dream, Queer Nation's Dream: *Kokoro* and Homosocial)." *Sôseki kenkyû* 6 (1996): 46–59.

Ôtsuki, Kenji. *Ren'ai seiyoku no shinri to sono bunseki shochihô*. Tokyo: Tokyo seishin bunsekigaku kenkyûjo, 1936.

Pflugfelder, Gregory M. "'S' is for Sister: Schoolgirl Intimacy and 'Same-Sex Love' in Early Twentieth-Century Japan." *Gendering Modern Japanese History*. Eds. Barbara Molony and Katherine Uno. Cambridge, MA: Harvard University Asia Center, 2005: 133–90.

Robertson, Jennifer. "Dying to Tell: Sexuality and Suicide in Imperial Japan." *Signs: Journal of Women in Culture and Society* 25.1 (1999): 1–35.

———. "Gender-Bending in Paradise: Doing 'Female' and 'Male' in Japan." *Genders* 5 (Summer 1989): 50–69.

Sakuma, Rika, "Kiyoki shijô de gokôsai o: meiji makki shôjo zasshi tôshoran ni miru dokushakyôdôtai no kenkyû (Relationship on the Pure Magazine Pages: Study of Readers' Community in the Girls' Magazine Readers' Columns at the End of Meiji Era)." *Joseigaku* 4 (1996): 114–41.

Sedgwick, Eve Kosofsky. *Between Men: English Literature and Male Homosocial Desire*. New York: Columbia University Press, 1985.

Shufu no tomo (*Housewife's Friend*) 18.9 (Sept. 1934): 105.

Smith-Rosenberg, Carroll. "The Female World of Love and Ritual: Relations between Women in Nineteenth-Century America." *Signs: Journal of Women in Culture and Society* 1.1 (1975): 1–29.

Sugawara, Hajime. "Shunjitsu no tomo (Ten-days Friends)." *Seitô* 5.3 (1915): 42–66.

Suzuki, Michiko. "Writing Same-Sex Love: Sexology and Literary Representation in Yoshiya Nobuko's Early Fiction." *The Journal of Asian Studies* 65.3 (2006): 575–99.

Tamura, Toshiko. *Tamura Toshiko sakuhin shû*. Vol. 1. Tokyo: Origin shuppan sentâ, 1987.

Takahashi, Mizuki. "Opening the Closed World of Shôjo Manga." *Japanese Visual Culture: Exploration in the World of Manga and Anime*. Ed. Mark W. Macwilliams. Armonk: M.E. Sharpe, 2008. 115–36.

Tsuchiya, Dollase, Hiromi. "Early Twentieth Century Japanese Girls' Magazine Stories: Examining Shôjo Voice in *Hanamonogatari* (Flower Tales)." *Journal of Popular Culture* 36.4 (2003): 724–55.

Vicinus, Martha. "Distance and Desire: English Boarding-School Friendship." *Signs: Journal of Women in Culture and Society* 9.4 (1984): 600–22.

———. "Sexuality and Power: A Review of Current Work in the History of Sexuality." *Feminist Studies* 8.1 (1982): 131–56.

Yasuda, Tokutarô. "Dôseiai no rekishikan (Historical Perspectives on Homosexuality)." *Chûô kôron* 50.3 (1935): 150–53.

Yoshitake, Teruko. *Nyonin Yoshiya Nobuko* (*The Woman Yoshiya Nobuko*). Tokyo: Bungei Shunjû, 1986.

Yoshiya, Nobuko. "Onna no yûjô (Women's Friendship)." *Yoshiya Nobuko zenshû*. Vol. 3. Tokyo: Asahi Shinbunsha, 1975.

All-American Girl?:
Annette Funicello and
Suburban Ethnicity

Sarah Nilsen

E very afternoon in the mid-1950s, millions of suburban American children
came home from school and turned on their television sets to watch Walt
Disney's *Mickey Mouse Club*. Immensely popular with both children and adult
audiences alike, *The Mickey Mouse Club* made its debut on Monday, October 3,
1955, ran for four seasons, and aired its final segment in September 1959, before
going into syndication as a half-hour program from 1962 to 1965. In 1956, *The
Mickey Mouse Club* reached more total viewers than any other daytime program.
It reached more children than any other program, day or night, except for Walt
Disney's *Disneyland* series. It was seen four or five times a week by 42 percent of
its weekly audience, and in its first year came in second in the Nielsen ratings to
only the World Series. *The Mickey Mouse Club* proved hugely popular during its
first release. As Steven Watts argues in his cultural history of Walt Disney and his
studio, "This television show, beamed out to a national audience on a daily basis,
was the studio's most noteworthy contribution to the raising of America's children
during the Cold War" (Watts 335). The cast members of *The Mickey Mouse Club*,
the Mouseketeers, served as the main conduit for creating audience identifica-
tion with the show. The original Mouseketeers were all from California, the state
with the most significant suburban growth during the 1950s. Moreover, virtu-
ally all came from the San Fernando Valley area, a blue-collar, lower-middle-class
suburban area just north of Los Angeles. The club members were selected from
auditions and open calls that mined every local dance school and music school for

possible talent. The show's producers intentionally chose Mouseketeers because they looked like average suburban kids. According to Bill Walsh, the producer of the show, Walt Disney stated, "I don't want those kids that tap dance and blow trumpets while they're tap dancing or skip rope or have curly hair like Shirley Temple or nutty mothers and things like that. I just want ordinary kids" (Keller 30). The studio's guidelines for the casting of the show required that "the child had to be well groomed, bright, and have what, in the mid-1950s, was known as the All-American look" (Petersen 41). After extensive auditions in early 1955 in which over 3,000 children auditioned, the studio cast a collection of thirty-nine "talented, precocious kids who eschewed Hollywood slickness for kid-next-door energy, sparkling personalities, and casual charm" (Watts 336).

Wearing black felt Mickey Mouse hats with prominent ears, the Mouseke-teer cast members dressed in uniform costumes that included short-sleeve turtle-necks with each member's name emblazoned in block letters across the front. Girls wore simple navy skirts, and the boys wore blue slacks. Cast members collectively shared the performance space of the show, appearing in song-and-dance routines and comedy skits that were interspersed with newsreels, travelogues, and cartoons. Disney and his producers decided to create the Mouseketeers as club members who were equals with each other and their audience, irrespective of gender or class. As ex-Mouseketeer Annette Funicello recalls,

> We came from a range of backgrounds and experiences, yet at heart we were all just plain kids. In Mr. Disney's eyes, this was the true—perhaps the only—quali-fication for being a Mouseketeer. We were just like the kids next door or down the street. When I say this, I don't mean to slight any of my fellow Mouseketeers But I truly believe that a large part of our appeal derived from the fact that children could watch us every afternoon on television and say to themselves, I could sing as well as Annette, or I bet I could dance like her. We were all very good at what we did, but we were not significantly better than many other chil-dren. (Funicello, *A Dream* 29)

Walt Disney had originally hoped to create a group of kids that would enter millions of homes every day not as stars but rather as part of a regular gang of friends. His attempt at creating a homogeneous club of kids was stymied when Annette almost immediately become American's first teen-girl heartthrob on television. The elevation of Annette to the status of star within the All-American world of the show signaled an acceptance and recognition by audience members of ethnic difference as identifiable and desirable. Her rise out of the ordinary world and into stardom is particularly remarkable because of way in which she deviated so markedly from traditional understandings of femininity during the 1950s and the commonly accepted ideal notion of beauty as defined by Anglo-

Saxon Protestant whiteness, a rendering of femininity perpetuated in many of Walt Disney's most popular animated features. As Wini Breines argues,

> The ideal female image was unattainable by the vast majority of women, who were made miserable as a result It helped to be fair in all ways: skin, hair, eyes, and disposition. It was a white Anglo-Saxon Protestant version of beauty that millions of girls of immigrant background, to say nothing of women of color, could never hope to emulate. The lighter the hair, the straighter the hair, the more attractive one was considered. (95)

How did Annette, who was the antithesis of this idealized version of femininity, become, as Watts argues, the "embodiment of the Disney female ideal" (342) for many young viewers from 1955 to 1959, the years of her appearance on *The Mickey Mouse Club*? Annette's physical differences—her dark eyes, dark bushy eyebrows, coarser features, and curly dark hair—made her stand out from the rest of the Mouseketeers. And the Disney studio immediately seized on Annette's ethnicity as a key part of their promotion of the show and its propagation of traditional family values. Her stardom signaled how ethnic identities had social valence and carried a specific values system that was understood by the suburban children's audience in the 1950s.

Annette was the last Mouseketeer chosen for *The Mickey Mouse Club* and the only one specifically selected by Walt Disney, who had spotted her dancing in *Swan Lake* at the Hollywood Bowl. Annette's fame on the show was immediate and elicited a flood of fan mail. Within months the Disney studio was receiving 6,000 fan letters a month for Annette, more fan letters than Walt Disney. Her fans included both admiring girls and adoring boys, who sent loads of candy, perfume, and "puppy-love" letters. From the start of *The Mickey Mouse Club*, Disney made sure that all fan letters were counted in order to measure popularity, and cast members receiving the fewest notes were terminated. All the contracts for the Mouseketeers were for six months, except for Annette's, who had the only long-term contract with the Disney studio. There was constant pressure placed on the Mouseketeers by their families and the studio to not be terminated. Disney's careful calibration of the Mouseketeers' popularity meant that casting decisions were dependent on audience response. Annette's popularity was sustained throughout the run of the show, and she was the only cast member to obtain star status on the show.

Annette's overwhelming popularity via *The Mickey Mouse Club* led to the Walt Disney Studio's first promotion of a live action star. Walt Disney instructed his many departments to showcase Annette, providing her with a television series all her own, *Walt Disney Presents: Annette* (ABC 1958), and promotional tours apart from the rest of the Mouseketeers, who traveled together. Central to Annette's studio promotion and media publicity was her identity as an Italian American.

The Walt Disney Studio's casting decisions and inclusion of Annette in the *Mickey Mouse Club* are illustrative of the manner in which the categories of whiteness, ethnicity, and race functioned within 1950s' suburban culture. Annette's stardom via this show challenges dominant conceptions of television in the mid- and late 1950s as a bastion for the representation of white, middle-class, suburban life. The complex historical and social forces at work here will be described and investigated further, but the key point is that Annette's enormous popularity—her "all-American quality"—can be understood only in terms of her ethnicity, not in spite of it. And her television appeal, and its suburban reception, can be understood only in terms of how this ethnicity is foregrounded and highlighted as part of integration into dominant culture.

The seminal article for the characterization of 1950s' television programming as solely assimilationist and yielding to the whitebread pedigrees of *Father Knows Best* (CBS 1954–1960) and *The Adventures of Ozzie and Harriet* (ABC 1952–1966) is George Lipsitz's "The Meaning of Memory: Family, Class, and Ethnicity in Early Network Television Programs." According to Lipsitz, television's "most important economic function came from its role as an instrument of legitimation for transformations in values initiated by the new economic imperatives of postwar America" (75). Following his argument, the unprecedented exodus of young veterans and their families into suburbia and their central role in creating and sustaining a consumer-based economy necessitated the radical transformation of both the values of America and the individual identities that espoused and embodied those identities. Television then became, according to Lipsitz, the instrumental discursive tool in the erasure of the American public's linkage to its pre-war, "authentic," and stable ethnic identities that had been centered in vibrant, thriving, urban enclaves. The suburbs become a pathologized built environment in which television became the primary source for identity formation. Lipsitz argued that television as "an advertising instrument under the control of powerful monopolists . . . with its penetration of the family and its incessant propaganda for commodity purchases . . . helped erode the social base for challenges to authority" (104). Lipsitz's historicization of postwar suburbia describes an erasure of identity, where the power of television was instrumental in transforming individuals into homogeneous "white" consumers devoid of any authentic subjectivity or political agency.

Lipsitz's scathing portrayal of early American suburbia typifies broader strands of cultural criticism expressed by social critics beginning in the 1950s. The suburbs became symptomatic of broader social anxieties about modernization, mass society, an emerging, oppressive corporate ethos, the excesses of conformity during the height of the Cold War, and the destructive impact of big government. Typical of this view of suburbanization is Lewis Mumford's infamous critique of the new developments that were beginning to sprawl across the nation:

In the mass movement into suburban areas a new kind of community was pro-
duced, which caricatured both the historic city and the archetypal suburban
refuge: a multitude of uniform, unidentifiable houses, lined up inflexibly, at uni-
form distances, on uniform roads, in a treeless communal wasteland, inhabited
by people of the same class, the same income, the same age group, witnessing
the same television performances, eating the same tasteless pre-fabricated foods,
from the same freezers, conforming in every outward and inward respect to a
common mold, manufactured in the central metropolis. Thus, the ultimate ef-
fect of the suburban escape in our time is, ironically, a low-grade uniform envi-
ronment from which escape is impossible. (486)

Mumford's characterization of suburbanization resonated with widespread con-
cerns regarding the impact of suburbanization on the American psyche and so-
ciety. Not surprisingly, social anxieties about how the radical transformations
caused by the rapid spread of suburbanization affected family structure and com-
munities were conflated with concerns about commercial television's rapid intru-
sion into the family rooms of isolated, nuclear families bereft of kinship ties and
community connections.

The wholesale restructuring of American society that occurred after World
War II was indeed exceptional. By 1950 the national suburban growth rate was
ten times that of central cities, and in 1954 the editors of *Fortune* estimated that
9 million people had moved to the suburbs in the previous decade. Homeown-
ership rose fifty percent between 1940 and 1950 and another fifty percent by
1960. Of the thirteen million homes built in the decade before 1958, eleven
million of them—or eighty-five percent—were built in the suburbs (Jones, *Great
Expectations* 39). Coupled with the mass migration out of the cities and into the
suburbs was a burgeoning birth rate and unprecedented economic growth. The
year-end review in *Time* magazine announced that 1955 showed the "flowering
of American capitalism" ("Business" 79). Between 1935 and 1950, the income
of Americans increased fifty percent. In the four years following the end of the
war, Americans purchased 21.4 million cars, 20 million refrigerators, 5.5 million
stoves, and 11.6 million televisions and moved into over 1 million new housing
units each year. Sales of television sets jumped from three million during the en-
tire decade of the 1940s to over five million a year during the 1950s (Jones, *Great
Expectations* 39).

Recent scholarship on 1950s' U.S. culture by new suburban historians, such
as Becky Nicolaides, has shown that for many of the young families moving into
the new suburbs the opportunities offered by the postwar economic boom were a
boon after the deprivations of the Depression and the war years. As architecture
critic Paul Goldberger explains, the standard, developer-built houses of the early
1950s, from the Levittowns of Long Island, New Jersey and Pennsylvania, to the
tract developments of Daly City and the San Fernando Valley in California "were

social creations more than architectural ones—they turned the detached, single-family house from a distant dream to a real possibility for thousands of middle-class American families" (C10). Practically designed and low cost, these houses were built to be "down-to-earth and unpretentious; their point was not to stir the imagination, but to provide reasonable and decent housing" (Goldberger C10) for a vast population of working-class white ethnics who, a few years previously, would never have had access to homeownership.

Unlike Lipsitz's construction of pre-war and wartime urban living as a joyous and harmonious time of community connectedness, many of the working-class families living in urban, ethnic neighborhoods were first- or second-generation immigrants from Eastern and Southern Europe with minimal kinship ties who had escaped extreme poverty and social upheaval and were driven by the desire to realize the American Dream. Richard Gambino in his history of Italian Americans describes how as a young child his schoolbooks told him that "Europeans immigrated to the United States seeking democracy, religious tolerance, etc." But for many Southern Italians, "the motive was more vital—*pane e lavoro* (bread and work). Immigrate or the family would starve" (Gambino 78). Urban living for many of these families was defined by poverty and segregation. During wartime, these families were required to share cramped apartments that afforded little privacy and respite from the daily struggle to succeed. For these families, a move to the newest suburbs, like Long Island's Levittown, permitted a level of ownership and freedom not previously possible or even imagined. As writer Harry Henderson observed in 1953, "These communities have none of the long-festering social problems of older towns, such as slums, crowded streets, vacant lots that are both neighborhood dumps and playgrounds, or sagging, neon-fronted business districts that sprawl in all directions" ("The Mass Produced Suburbs" 25). These ethnic working-class families did not need or depend on television to transform them into consumers; most of them came to America to achieve just that.

Moreover, the move into suburbia by these ethnic working-class families did not signal the collapse of community. Postwar suburban communities were actually exceptional in the history of suburbanization for their high levels of community involvement and activism. People did not become isolated in their "cookie-cutter" homes when they moved to the suburbs with their television sets as their only steady companions. Rather, as Henderson observed, "Nearly everyone belongs to organizations and, generally, tries to be actively involved. Group activity is fervently believed to be good for all, something you *should* do" ("Rugged American Collectivism" 81). Neighborhood networks were immediately set up by residents, including babysitting co-ops, a multitude of churches and religious organizations, and even political activist groups protesting the Levitt's management of Levittown, including its "Caucasian Only" covenant. As Robert Putnam amply

documents in *Bowling Alone*, "virtually no cohort in America [wa]s more engaged or more tolerant" than the parents of early baby-boomers (357).

Furthermore, the move into suburbia did not signal the erasure of ethnic and family connections. For example, most of the families that moved to Levittown were from the New York City Metropolitan District and, with the vast expansion of car ownership and ready access to public transportation, contact with families still living in the city was easy and frequent. Life in the suburbs did not mean, as Lipsitz described, "isolation from neighborhood and class networks" leaving the nuclear family "subject to extraordinary regulation and manipulation by outside authorities" who relied on commercial television to transform the family into "the egoism of possession" and "stripped of its 'authentic' identity by the selling machine in every room" (85). White ethnics carried with them in their move to the suburbs ethnic identities as a form of social and cultural distinction. The sociologist Herbert Gans, who had moved into Levittown in Willingboro, New Jersey in 1958, to study its social life, reported that

> perhaps the best way to demonstrate that Levittown's homogeneity is more statistical than real is to describe my own nearby neighbors Across the backyard lived a Baptist white collar worker from Philadelphia and his Polish-American wife, who had brought her foreign-born mother with her to Levittown; and an Italian-American tractor operator (whose ambition was to own a junkyard) and his upwardly mobile wife, who restricted their social life to a brother down the street and a host of relatives who came regularly every Sunday in a fleet of Cadillacs. (166)

Gambino, in his description of the movement of Italian American families into suburban neighborhoods, observed that

> those who moved often moved in groups, two or three generations of one family sharing a one- or two-family house on a street or a section of a suburb with other Italian-Americans. As the old *paesi* had been transplanted to the Little Italies of American cities, portions of these tenement communities were transplanted to the American suburbs in the 1950s and 1960s. (104)

One of the primary reasons families moved to the suburbs was to create a new and better life for their children. With the rapid increase in birthrates following the war, the baby boom fueled the desire to provide a space for children to live and grow without the fears of urban living. For many postwar parents, a psychiatrist at the time explained, the "suburbs are places we would have liked to live in our own childhood. I think it's the childhood dream gone wild" (Wyden 80). During this period, the American population was growing twice as fast as before the war, and the rate of increase was the greatest since the first decade of the twentieth century. Seventy-six million baby boomers were born between 1946 and 1964,

and their cohort was fifty percent larger than the generation before them (Jones, "Swinging" 102).

The earliest coterie of postwar baby boomers, born between 1946 and 1955, were the first generation of children to grow up with television, and its impact on their lives cannot be easily discounted. In 1950 barely ten percent of American homes had television sets, but by 1959, ninety percent did, probably the fastest diffusion of a technological innovation ever recorded (Putnam 221). As Annette described,

> To understand the phenomenon of a children's program like *The Mickey Mouse Club*, or the sentimental affection and nostalgia adults still feel for the club . . . it's important to understand that "watching television" in those days, for those kids, was not the same experience it is today. It's difficult to grasp the sense of anticipation, the thrill, that sitting before it inspired then. (42)

Yet, as suburban families in the 1950s were adjusting to incorporating television as part of their lives, their viewing habits tended to be selective and intentional rather than habitual. Audiences turned on television to watch specific programs, and the hours of television viewing were significantly fewer during the 1950s in comparison to the following decades. By 1995 viewing per TV household was more than 50 percent higher than it had been in the 1950s (Putnam 222). Television viewing was just one of a multitude of popular leisure activities that occupied the lives of suburbanites and was not the only cultural force active in the formation of young new suburbanite identities.

Recent scholarship by new suburban historians has begun to challenge many constructions of postwar suburban life as homogeneous and conformist, and has instead sought to portray a set of forces at work during this period that were more nuanced, complex, and often inscrutable. As this research demonstrates, the way that ethnic identity and affiliation functioned in the emerging suburban American experience cannot be adequately characterized in terms of loss or sublimation. When one tries to view this period, like Lipsitz, through the prevailing perspective of a society that is being, in various ways, stripped of its ethnic identity through suburbanization, one finds that this explanatory model fails to account for the manner in which ethnic identities were transported into suburban neighborhoods as a means of social distinction.

The unanticipated fame of Annette in this regard is illustrative. Her unparalleled popularity as a child television star during the 1950s was galvanized by her Italian American identity. As Annette revealed in a 1979 interview on *Good Morning America*, being the only "ethnic Mouseketeer" was the making of her career in show business. Moreover, reading the stardom of Annette in light of new suburban historians' attempts to theorize the complex development of 1950s'

suburban culture challenges the prevailing homogenizing, assimilationist model of suburbia. These newer models apply a contemporary conceptualization of ethnic identification where the very meaning of being ethnic is to stand out and be identifiable as such rather than disappear into a melting pot of homogeneity. However, what we find in Annette's star persona is an attempt at assimilation negotiated through ethnic identity, that is, a conception of being the same or normal by virtue of the fact that one is ethnic and different.

Histories of television in postwar suburbs continue to perpetuate Lipsitz's argument that American commercial television in the 1950s was white and middle-class and thus devoid of ethnicity. As television historian Lynn Spigel writes, "as television became a national medium (by 1955 it was more evenly disseminated throughout the country), producers, networks, and advertisers tried to appeal to a more homogenous, middle-class audience. In addition . . . when the Hollywood majors rigorously entered into television production in the mid-1950s, the ethnic/working-class programs . . . began to wane" (118). Contributing to this vein of interpretation, Matthew Frye Jacobson recently argued in his history of ethnicity in the U.S., ethnicity on television from about 1954 to 1968 was the "exclusive preserve of a handful of culturally isolated—if lovable oddballs: Lucy's husband, Ricky Ricardo; Danny Thomas's uncle, Tonoose; Rob Petrie's co-writer, Buddy Sorrell" (30). Yet, in reality, in millions of homes across the United States ethnicity was continually on display for children viewers every afternoon. Unlike the exceptional oddballs that Jacobson lists, ethnic identity was presented through the cast on *The Mickey Mouse Club* as something of shared social significance that was a central aspect of identification for its audience.

The immense popularity of Annette Funicello, a second-generation Italian American with a working-class background, needs to be understood in terms of what ethnicity signified for 1950s' suburban youth and adults. Ethnicity was a clear marker of social identity for the children watching television from their suburban homes, a marker that was far from erased as a result of families' migration from urban neighborhoods. An examination of the popular discourse surrounding the construction of Funicello's star image reveals the manner in which ethnicity was being mobilized during a time of immense social turmoil created by the civil rights movement. The maintenance of ethnic identities permitted white groups to demarcate their successful acquisition of the American dream and their social acceptance as "white" while upholding their cultural differences. As the historian David Roediger argues in his recent work on the racial status of American ethnic groups in twentieth-century America, many white ethnic groups including Italian Americans, occupied a position of "racial inbetweeness" in which they were initially denied the privilege of white racial identity. An analysis of *The Mickey Mouse Club* in relation to Annette shows how the boundary between white and non-white is permeable and continually contested. The acceptance of Annette's

stardom by white suburban audiences designated a social and historical moment in which her Italian Americanism became equated with whiteness. As Roediger shows, whiteness is not simply or even centrally about skin color, but also a label that is applied to groups and individuals as they negotiate available cultural categories.

The accepted construction of the 1950s' suburb as a stultifying space devoid of difference fails to account for the ways in which ethnicity was mobilized and preserved during this period as both a means for maintaining identity and also for creating distinction and opposition to racialized identities. The conflicts of the civil rights movement, including protest marches, bus boycotts, and desegregation battles, received widespread coverage on suburban television sets and served as a constant reminder to white suburbanites that African Americans were legally excluded from their communities. As Henderson noted, "No other question arouses so much heat, guilt, and dissension as racial discrimination against Negroes, a pattern that residents did not create but which they now sustain. What has been created here is therefore something abnormal and atypical of American life, that is, in deep conflict with democratic American ideals" ("Rugged American Collectivism" 85). The social critics of the suburbs failed to acknowledge that the move to suburbia was seen by many working-class Americans, including African Americans, as their admission and acceptance into mainstream American society. As Nicolaides writes,

> One is left to ponder some basic questions. If the suburbs offered only social anguish and failure, why did Americans keep moving to them in ever-rising numbers? And more pointedly, why was the civil rights movement passionately fighting for access to this suburban life? Why would African Americans be willing to risk vandalism, cross burnings, and violence, for the opportunity to live in these social wastelands? (96)

For white, working-class, ethnic groups, the movement from marginalized status within ethnically segregated urban neighborhoods to assimilated positions within middle-class suburbs marked the successful acquisition of the American Dream. The maintenance of ethnic identifications became a necessary means for these groups to clearly demarcate the lines between ethnicity and race. Thus white ethnic identities helped create distinctions between those minority groups who had struggled and succeeded in opposition to the perceived failings of the black community in their attempts at assimilation. Annette's fame was not a simple or exceptional 1950s' fad, therefore, but rather a striking example of how a romanticized ancestral script was constructed through the popular media in order to help define "the rules of the game by which other groups w[ould] be expected to succeed in American society" (Jacobson 150).

Annette's own family history typified the movement of white, working-class ethnics into suburbia. Both sets of her grandparents had emigrated from southern Italy and had settled in Utica, New York. When Annette was still a baby, her parents moved to the suburbs of the San Fernando Valley in search of better job opportunities for her father, a car mechanic. "My family's heritage was and remains very important to me," Annette explained.

> We attended a local church regularly, and my grandparents spoke Italian around us, so I picked up quite a bit of it. The fact that my parents chose not to keep this up is something I've always regretted. But aside from not speaking the language, we did just about everything else the Italian way. I especially remember the cooking: my Aunt Jo's raviolis, my grandmother's gnocchi, meatballs, and scrambled eggs with fiery-hot peppers—the hotter the better. Even today, when someone asks if I have a beauty secret, I reply, "Olive oil." (Funicello, *A Dream* 10)

The Disney studio utilized Annette's ethnic identity as the central signifier of her star image. Analysis of the promotions and publicity created by the studio to construct her image reveal how specific Italian-American cultural values are central to the narrativization of Annette as a star within the popular press.

The most immediate marker of Annette's ethnic difference occurred at the opening of the *The Mickey Mouse Club*. Every episode began with a roll call in which each Mouseketeer would individually address the audience by calling out their first name, which was emblazoned on their turtlenecks: "Bobby, Mary, Judy, Tommy, Sharon, Annette." Her name immediately set Annette apart. As Karal Ann Marling wrote in the *New York Times*, "Before Cher and Madonna, there was Annette. One name said it all: Annette. It was a real girl's name, with just a hint of garlic and grandmas in black dresses" (292). Walt Disney was adamant about Annette maintaining her Italian surname at a time when anglicizing such names was common practice for many ethnic teen stars, including two other Italian American Mouseketeers, Sherry Alberoni (Allen) and Don Agrati (Grady). Annette recalls in her autobiography that she announced to Disney that she intended to change her name to Annette Turner. Disney looked at her with surprise and replied, "Why would you want to change your name, young lady? You have a beautiful name, but you're not pronouncing it correctly. It isn't Fun-is-sell-o, it's Funicello [the Italian pronunciation] Once they learn your name, they will never forget it. I promise you" (qtd. in Funicello, *A Dream* 62).

On *The Mickey Mouse Club*, Annette was the Mouseketeer called on to play Italian, often occupying an intermediary position between the "old country" and America. During the first season, she was cast as the Correspondent for a special episode on Italy. She also performed a song, "Hi to You" in which she played an Italian girl who spoke in her native language. In order to properly sing the song in Italian, she revealed in the Disney publication, *Walt Disney Annette's Life Story*,

that she needed special coaching (11). In 1960, Buena Vista Records, the Disney record label, released the LP "Italiannette: Annette Sings Songs with an Italian Flavor."[1]

Articles about and interviews with Annette in mainstream publications orchestrated by the Disney studio as part of her promotion campaign made her ethnicity an explicit part of her identity. For example, a *Coronet* article about up and coming starlets, describes Annette as a "relaxed teenager" who "enjoys a 'pals' relationship with her Italian-born parents and her two younger brothers" (Nichols 66). In a personal essay for *Seventeen* written in 1962, Annette explains that her family came from Naples and then relates how her family pronounces their name incorrectly. "In Italian it would be Foon-i-chello. We say Fun-i-sello. I don't know why; that's how my father has always pronounced it" (Funicello, "I'm Just Myself" 117).

The qualities most celebrated in the Disney studio's promotions of Annette were her embodiment of strong traditional values commonly associated with working-class Italian Americans. These were values that were remarkably commensurate with what Watts calls the "Disney Doctrine": "a notion that the nuclear family, with its attendant rituals of marriage, parenthood, emotional and spiritual instruction, and consumption, was the centerpiece of the American way of life" (326). The foremost quality that Annette embodied was the valuation of the family as the foundational and central force in the formation of social relations. The Disney studio's publicists continually positioned Annette's identity within the context of her family relations with her father occupying the central role as a successful working-class man who has dedicated his life to providing for his family. And frequent mention is made of the gas station that her father runs. As Gambino explains, in Italian American families the relationship between the "man and his children is governed by definite responsibilities and . . . by an adult chauvinism. These responsibilities all serve *l'ordine della famiglia* [the Order of the family]" (133). Typical is an article in *Photoplay* that answers the title question "What is an Annette?" by stating, "She's the daughter of Joseph Edward Funicello, who owns his own garage and is proud but sometimes puzzled by his daughter. She has two brothers, Joe, 13, and Michael, 7, who don't understand how a girl can take so long to get dressed. She looks a little like her mother, Virginia, who does understand—most of the time" (Anderson 54–5). Many stories in Disney publications focus on the leisure activities shared by the Funicello family such as going on picnics, attending Little League games, swimming in the pool, and listening to records at home (*Walt Disney Annette's*). The Funicellos' suburban home is also often featured in photospreads as a space for the family to spend quiet time together (*Walt Disney Annette's* 28). Watching television is the one activity that never intrudes into the harmony of this "closely knit" family.

Annette's fervent Roman Catholic faith received frequent mention in the Disney publications and the popular press and was often cited as a cause for family cohesion. *Walt Disney's Magazine* revealed that "one of the factors in the closeness of the Funicello family is the church. The entire family goes to St. Francis de Sales Church every Sunday. Annette is a Roman Catholic, and she takes her religion very seriously" (Gray 9). Even Annette's handwriting was found to show "a strong religious faith" (Gray 6). The significant role that the Roman Catholic Church played in Annette's life was typical of many Italian Americans who had moved to the suburbs. As Gambino explains, "The second-generation parents were instinctively aware of the threat to *la vecchia* [the old ways] presented by the suburbs" (219), and so many turned to the church as a crucial site for the maintenance of their cultural heritage. In 1961, Annette received the Catholic Award of the Year. In an interview for the *Dallas Morning News*, Annette termed the Catholic Award "one of the biggest thrills of my life" (Donaldson 21). Family cohesion and religious faith are cited as the sources for the exceptional strength and decency of Annette's character. As '*Teen* magazine reported, "With fame comes responsibility and Annette has accepted her duty with enthusiasm. Next to her parents and her religion, Annette gives Walt Disney much of the credit for her successful emotional life in a crazy town" (Brenner 22).

An important element in Disney's construction of Annette's character was the foregrounding of her restraint. Though Lipsitz argues that "the entry of television into the American home disrupted previous patterns of family life and encouraged fragmentation of the family into separate segments of the consumer market" (75), the coverage of Annette in the popular press celebrated her constraint as a teenager consumer, emphasizing the working-class status of her family and the parental supervision of her consumption habits. The single extravagant purchase made by Annette that is repeatedly mentioned in the Disney publicity is a two-seater Thunderbird. It is described as a car that her parents "allowed her to buy" for graduation ("I'm Just Myself" 117) and which she can "drive only within a few blocks of home" (Anderson 55). Within the discourse of the Disney publicity, the Thunderbird is not a frivolous and impulsive purchase, but instead a product of her domestic orientation and dedicated work ethic. Frequent mention was made of the amount of work that Annette put into the production of the show and also her family's financial support and the personal sacrifices made for the pursuit of her career. *Walt Disney's Magazine* explained that "the life of a Mouseketeer is a busy one, as Annette Funicello can tell you. She goes to school—a full-time job for most 15 year-olds. She works five hours a day on the set. At night she studies both her homework and the next day's script . . . Annette works at a pace which would discourage most people—young and old" (Gray 5).

Annette's ethnic identity was presented by Disney through her family and its traditional familial structure, with an emphasis on her maternal qualities as the

central caregiver within a domestic environment. She considered herself a "second mother" to her baby brother, and her mother described her as comfortable in the kitchen, where "she can boil spaghetti, broil a steak, bake a potato, and prepare hotcakes" (Budge 64). Stardom was never seen to interfere with or supplant Annette's primary goal of marriage and children. Typical of many Italian Americans, the Funicello family's ultimate aim was "to see her *sistemata* [married off], settled and competent in her role as a woman" (Gambino 151). Though the Disney publications made frequent mention of Annette's dates with other teen stars, including Paul Anka, she was explicit that she never went steady, and she never went on blind dates without her parents' approval (Funicello, "Annette Answers").

Yet, by the age of nineteen, Annette revealed in *Seventeen*:

> I don't want to keep on with my career. I'd like to get married and have a lot of children. I don't know whom I want to marry, but I have a definite picture of him in my mind . . .I don't want a husband who's married to a studio; I'd rather be married to a businessman or a professional man. (Funicello, "I'm Just Myself" 65)

Annette appeared, while under contract at Disney, in five AIP clean teen beach party movies. The characters Annette portrayed in these films sustained Annette's image as chaste and driven by the desire to marry: "Miss Funicello is always cast as the guardian of Morality—the girl who can't say yes" (Bart X9). Annette's Italian American identity was so clearly linked in the popular discourse with the working-class values of restraint, hard work, family cohesion, and religiosity that she was soon chosen, after the birth of her first child, as a spokeswoman for Mennen Baby Magic products because of her "old-fashioned Italian" image (Klemesrud 36). In 1979, she would more famously become the "mother" in the television advertisements for Skippy peanut butter.

Though the Disney studio had exerted tremendous control over the entire production of *The Mickey Mouse Club*, the one decisive factor in its popularity that they were unable to control and had not even anticipated was the physical development of the Mouseketeers as they entered their teen years. Every day viewers were able to watch on their television screens the Mouseketeers' entrance into puberty and the emergence of their budding sexuality. Annette, in particular, became the focus of viewer's desires, and, by the second season, her physical development had become a national preoccupation for young boys (Watts 342). As former Mouseketeer Paul Petersen recalled, "Alert young men all over America had taken note of the distortions seen in the chest-mounted nameplates. The standard joke among adolescent boys was, 'Let's go home and watch Annette grow'" (98). With newspapers starting to describe her as "full-busted," the show's staff attempted to find ways to diminish her sexualization by requiring her to be

strapped down under her sweaters and pullovers. These efforts proved ineffectual, and much of the fan mail that she received was from young boys who openly expressed their desire for her. Typical letters included: "My son is six years old and has shown no noticeable desire for girls, but he insists on seeing you daily," "Annette, in my book, you are beautiful. I dream of you every night," and "There are a lot of girls in my class, but I don't think of them. I think of you" (qtd.in Santoli 152). In response to hundreds of requests for a pin-up photo of Annette, *Walt Disney's Mickey Mouse Club Magazine* provided a snapshot of Annette lying down fully clothed on her lawn, her entire body blocked from view with her dog at her side. The accompanying note explains, "The editors of the *Mickey Mouse Club Magazine* say that they have lots of letters asking for a snapshot of me. I gave them this snapshot to publish in the magazines because it's one of my favorites" (Funicello, "A Note" 4).

During the run of *The Mickey Mouse Club*, the entrance of the Mouseketeers and their audience members into puberty marked a period in their social development in which sexual desirability became linked with physical appearance. The show then became a national forum around which child viewers debated and discussed the desirability and developing sexuality of the cast members. If television had been successful by the 1950s in transforming children viewers into a homogenous white audience, the presumption of female desirability for this audience would be the blonde busty beauty standards, embodied in Marilyn Monroe, Jane Mansfield, and Sandra Dee, that proliferated at the time. And yet Annette's "classic Latin features—a creamy velvet complexion, lustrous eyes, naturally wavy hair" (St. Onge 8) became the fantasy image for "every American boy who rushed into adolescence watching *The Mickey Mouse Club*" (Petersen 201). Annette offered an alternative form of sexuality that was distinctive from her more WASPish co-stars and was defined by a sexualized image of ethnic identity that was proliferating at the time through the popularity of the Italian starlets Gina Lollobrigida and Sophia Loren. These stars offered an "alternative vision of passionate sexuality smoldering beneath their dark hair and heaving bosoms" (Yalom 192). Of all the Italian actresses of this period, the one that most typified female Italian identity for American audiences was Lollobrigida, the star who "fixed a look and a manner of being that was identified with the Italian woman. Within this way of being, sexuality was 'an inoffensive weapon' that was wrapped up in disarming innocence" (Gundle 156). Occupying a position of racial inbetweeness, these stars served to mediate between the alleged purity of white, Anglo femininity and popular conceptions of more erotic and hypersexualized women of color.

The desirability of Annette's dark and earthy Mediterranean appearance complete with her blossoming figure was significantly enhanced by the Disney studio's promotion of her traditional Italian American values. The studio publicists were able to construct for their audience a surprisingly sexualized image of femininity

that suggested an emerging passion simmering beneath Annette's girlish shyness and traditional ethnic values. As Marling recalled,

> I, for one, would have traded all my Tab Hunter pinups and charm bracelet to be Annette for a single hour; the canonical blonde hair of the 1950s looked ordinary and boring alongside her cap of brunette curls. In the world of pre-teendom, Annette was exotic, enchanting, and entrancing, especially to little boys . . . the boys swooned over her, even before she began to fill out that little sweater with noticeable curves. Maybe it was the dark doe eyes. Or the shyness, the sweetness—a femininity so complete as to make her peers in the audience gasp in wonderment and beg for training bras. (292)

The ability of the producers of *The Mickey Mouse Club* to simultaneously exploit and contain Annette's ethnic sexuality led to her unprecedented popularity with suburban audiences.

By 1954, Estes Kefauver's well-publicized Senate subcommittee's investigations into the impact of television on juvenile delinquency led to widespread concerns about the impact of television on children viewers and helped create an environment that tightly controlled and censored any sexual material, especially in children's television programming. The sexual innocence of Disney's child audience would seem to be a presumption that the studio's executives and staff members had brought to the creation and production of *The Mickey Mouse Club*. And yet once the studio became aware of Annette's sexual appeal, they continued to use it to promote the show. Former Mouseketeer, Eileen Diamond, recalled that "every note you sang you knew that the camera, somehow, would manage to land on Annette. . . . It got to the point where all of us, well the girls at least, began to wonder what we'd done wrong, where we'd missed the boat. It was ridiculous to think success was equated with a big chest" (Petersen 118). Contemporaneous newspapers even reported that, with Annette, "Disney does not overlook the fillip of the sexy nymphets" (Rosenfield n.p.). In turn, the director of show, Sidney Miller, described how Annette "sparks. She's magnetic. She's sexy, even at that age" (qtd. in Watts 342). Former Mouseketeer, Doreen Tracy, recalled the time when Annette and she were fourteen and were wearing tight T-shirts under their Mouse sweaters so that they could be flattened down because they were "very big-chested broads." They passed Walt Disney and a "couple of other guys' as they were walking down the lot, and one of them said, "Look, aren't the girls growing up?" and Disney said, "Girls? They're more for the fathers than the kids in the audience" (Bowles 88). Yet when Annette begged Walt Disney to send her to a psychologist to work on her self-confidence because of her embarrassment over the attention her blossoming figure was receiving in the media, he refused. "I think your being a little bit shy is part of your appeal," he advised her (qtd. in Funicello, *A Dream* 114). Disney would continue to promote this contained,

sexualized image of Annette in her later appearances in the beach party movies when he famously required that she should never expose her belly button while gyrating on the beach.

The libidinal charge that Funicello's star image provided her fans was not simply a product of her "getting them." As she herself pointed out, "Even today when people, men especially, attribute my popularity as a Mouseketeer to my developing bustline, I often feel as if I should point out that I was still fairly flat-chested then, and there were often girl Mouseketeers as 'curvaceous,' and I use that term loosely, as I was" (qtd. in Funicello, *A Dream* 114–15). Annette became the object of desire for many of her fans because of the way in which her sexual desirability was framed within a discourse that foregrounded her traditional, working-class, Italian American identity. The television stardom of Annette problematizes Lipsitz's claims that "commercial television emerged as the primary discursive medium in American society at the precise historical moment that the isolated nuclear family and its concerns eclipsed previous ethnic, class, and political forces as the crucible of personal identity" (85). The Disney studio in their promotion of Annette drew upon her Italian American ethnicity as the core of her identity in their construction of her star image. And her immense popularity with young fans signaled the continued significance of ethnicity in suburban lives during the postwar era. Annette was indeed Disney's All-American girl in the 1950s precisely because of her Italian American identity.

Notes

1. Annette continued to be cast according to her ethnicity after *The Mickey Mouse Club* ceased production. She appeared on September 30, 1962 in the *Disneyland* TV series in a two-part mystery set in Italy, *Escapade in Florence*, and had a recurring role as an Italian exchange student on Danny Thomas' sitcom, *Make Room for Daddy* (ABC 1953–1957, CBS 1957–1964).

Works Cited

Anderson, Nancy. "What Is an Annette?" *Photoplay* Sept. 1959: 55+.

Bart, Peter. "Hollywood Beach Bonanza." *New York Times* 12 Dec. 1964: X9.

Bowles, Jerry. *Forever Hold Your Banner High!: The Story of* The Mickey Mouse Club *and What Happened to the Mouseketeers*. Garden City: Doubleday, 1976.

Breines, Wini. *Young, White, and Miserable: Growing Up Female in the Fifties*. Boston: Beacon Press, 1992.

Brenner, Ralph. "We're Grown Up Now!" *'Teen* Dec. 1962: 21–23.

Budge, Gordon. "The Dolly Princess." *TV Radio Mirror* July 1958: 30+.

"Business in 1955." *Time* 9 Jan. 1956: 78–84.

Donaldson, Ann. "College, Non-Acting Husband Goals of Former Mouseketeer." *Dallas Morning News* 21 Nov. 1961: n.p.

Funicello, Annette. "Annette Answers Your Questions." *Walt Disney's Magazine* June 1959: 12–13.

———. *A Dream Is a Wish Your Heart Makes: My Story with Patricia Romanowski*. New York: Hyperion, 1994.

———. "I'm Just Myself." *Seventeen* Jan. 1962: 65+.

———. "A Note from Annette." *Walt Disney's Mickey Mouse Club Magazine* Spring 1956: 4.

Gambino, Richard. *Blood of My Blood: The Dilemma of the Italian-Americans*. New York: Doubleday, 1974.

Gans, Herbert. *The Levittowners: Ways of Life and Politics in a New Suburban Community*. New York: Pantheon Books, 1967.

Goldberger, Paul. "Design Notebook." *New York Times* 2 Apr. 1981: C10.

Gray, Anthony. "Young Star: The Story of Annette Funicello." *Walt Disney's Magazine* June 1958: 4–9.

Gruenberg, Sidonie. "Homogenized Children of New Suburbia." *New York Times* 19 Sept. 1954: SM14.

Gundle, Stephen. *Bellisima: Feminine Beauty and the Idea of Italy*. New Haven: Yale University Press, 2007.

Henderson, Harry. "The Mass-Produced Suburbs: 1. How People Live in America's Newest Towns." *Harper's Magazine* Nov. 1953: 25–32.

———. "Rugged American Collectivism: The Mass-Produced Suburbs, Part II." *Harpers Magazine* Dec. 1953: 80–86.

Jacobson, Matthew Frye. *Roots Too: White Ethnic Revival in Post-Civil Rights America*. Cambridge, MA: Harvard University Press, 2006.

Jones, Landon Y. *Great Expectations: America and the Baby Boom Generation*. New York: Coward, McCann & Geogegan, 1980.

———. "Swinging 60s?" *Smithsonian* Jan. 2006: 102–7.

Keller, Keith. *The Mickey Mouse Club Scrapbook*. New York: Grosset & Dunlap, 1975.

Klemesrud, Judy. "Mouseketeer of Yesteryear." *New York Times* 29 Apr. 1969: 36.

Kruse, Kevin and Thomas Sugrue. *The New Suburban History*. Chicago: University of Chicago Press, 2006.

Lipsitz, George. "The Meaning of Memory: Family, Class, and Ethnicity in Early Network Television Programs." *Camera Obscura* 6 (1988): 78–116.

Marling, Karal Ann. "The Girl in the Mouse Ears." *New York Times* 5 June 1994: 292.

Mumford, Lewis. *The City in History: Its Origins, Its Transformation, and Its Prospects*. New York: Harcourt, Brace & World, 1961.

Nichols, Mark. "Stardom Bound." *Coronet* Jan. 1960: 61–73.

Nicolaides, Becky. *My Blue Heaven: Life and Politics in the Working-Class Suburbs of Los Angeles, 1920–1965*. Chicago: University of Chicago Press, 2002.

Petersen, Paul. *Walt, Mickey and Me*. New York: Dell, 1977.

Putnam, Robert D. *Bowling Alone: The Collapse and Revival of American Community*. New York: Simon & Schuster, 2000.

Roediger, David. *Working Toward Whiteness: How America's Immigrants Became White: The Strange Journey from Ellis Island to the Suburbs*. New York: Basic Books, 2005.

Rosenfield, John. "'Shaggy Dog' Into Gold Mine." *Dallas Morning News* 7 May 1959: n.p.

Santoli, Lorraine. *The Official Mickey Mouse Club Book*. New York: Hyperion, 1995.

Spigel, Lynn. *Welcome to the Dreamhouse: Popular Media and Postwar Suburbs*. Durham: Duke University Press, 2001.

St. Onge, Gaspard. "Stars of the Mouseketeers." *Young Catholic Messenger* 28 Feb. 1958: 8–9.

Walt Disney Annette's Life Story. No. 1100. Dell Publishing Co., May–July 1960.

Watts, Steven. *The Magic Kingdom: Walt Disney and the American Way of Life*. New York: Houghton Mifflin, 1997.

Wyden, Peter. *Suburbia's Coddled Kids*. New York: Doubleday & Company, 1962.

Yalom, Marilyn. *A History of the Breast*. London: Pandora, 1998.

"The New Activists": Girls and Discourses of Citizenship, Liberation, and Femininity in *Seventeen*, 1968–1977[1]

Kirsten Pike

As the U.S. feminist movement gained exposure in the late 1960s and early 1970s, women's magazines attempted to capitalize on women's liberation while making it palatable to advertisers and mainstream tastes. In recent years feminist scholars, such as Susan Douglas and Naomi Wolf, have critiqued these attempts, providing valuable insight into how glossies like *Cosmopolitan* and *Vogue* addressed changing ideas about gender roles for an audience of "new" women. Though vital scholarship on teen magazines by Angela McRobbie, Mary Celeste Kearney, and Kelly Schrum has done much to help us understand how post-World War II and contemporary girls' magazines have produced and navigated shifting constructions of youthful femininity, teen magazines from the 1960s and 1970s have received less critical attention. How did liberation-era magazines aimed at girls engage with feminism? And to what extent did they assist girls in discerning what it meant to be "liberated"? To help answer these questions and shed light on girls' important yet oft-overlooked place in the history of feminism and popular culture, this chapter explores the ways *Seventeen* magazine negotiated ideas about citizenship, women's liberation, and femininity during the height of second-wave feminist activism.

Since its beginning in 1944, *Seventeen* has been recognized primarily as a beauty and fashion magazine, but it has also regularly paid attention to current events and social issues. Although *Seventeen* was not the only teen magazine marketed to U.S. girls during the liberation era, it was by far the most popular. Be-

tween 1968 and 1977 *Seventeen*'s average monthly circulation ranged between 1.4 and 1.6 million copies—double the reach of its closest competitor, *'Teen* (*Magazine* 83; *Ulrich's* 1631, 410). Taking pass-along readership into account, *Seventeen* estimated that it drew 6.4 to 7 million readers per issue, or roughly half of the more than 13 million teen girls in the U.S. in the late 1960s and early 1970s.[2] These figures, combined with my investigation of every issue of the magazine printed between 1968 and 1977 (120 issues total) as well as numerous issues of *Advertising Age*, suggest that *Seventeen* was one of the primary publications to which liberation-era girls turned for information and advice on everything from colleges, careers, dating, and fashion to gender politics and women's lib.[3]

Overview: Women's Liberation, Citizenship, and *Seventeen*

The ten-year period between 1968 and 1977 is commonly considered to be one of the most significant in U.S. history for its spotlight on, and advancement of, women's social and political rights. From the feminist protest of the Miss America pageant in 1968 to the "Strike for Equality" rallies of 1970, from Billie Jean King's triumph over Bobby Riggs in the "The Battle of the Sexes" tennis match in 1973 to the National Women's Conference in 1977, it was an era, as Winifred Wandersee has aptly described it, when women were "on the move" (202). Though the feminist battle for the Equal Rights Amendment (ERA) continued into the 1980s, 1977 marked a turning point in that it was the last year that a state—Indiana—voted in favor of ratification. Focusing on the years that witnessed some of the greatest transformations for women, then, it is worth asking: how did cultural changes ushered in by second-wave feminism shape the discourses consumed by the era's female youth?

A close analysis of *Seventeen* indicates that one of the magazine's primary aims was to promote good citizenship practices among girls. Throughout the period of study, but especially between 1968 and 1973, *Seventeen* printed numerous articles that reminded girls about the wealth of problems facing the country, including racial injustice, student unrest, Vietnam, pollution, and poverty. Alongside the stories of a troubled America, *Seventeen* regularly discussed ways that girls could (and should) get involved in causes designed to improve society. Sometimes *Seventeen* ran "how to" articles that offered girls guidelines for working toward social reform in their communities, such as how to close the generation gap or how to ease racial tensions. At other times, the magazine celebrated girls' personal stories of volunteering. *Seventeen* even promoted its success in bringing up good girl citizens to potential advertisers. For instance, in a 1969 ad published in *Advertising Age*, *Seventeen*'s editor in chief, Enid A. Haupt, touted the results of "a new *Seventeen* survey" that asserted, "presently five million [girls] use many many hours for

humanitarian needs in their local areas. . . . How fortunate we are that they are searching for a better life in a better world" ("That's the," May 81).

Of course, promoting good citizenship to girls was nothing new in the 1970s. Ideas about citizenship and femininity have circulated in American popular culture since at least the mid-nineteenth century when girls' novels, such as Louisa May Alcott's *Little Women*, began exploring girls' struggles to reconcile their yearnings for public activity and independence with the demands to be good model citizens in restrictive Victorian society. With regard to *Seventeen*, Kelly Schrum has demonstrated how the magazine, from its inception, "offered articles on politics and world affairs" and encouraged readers to "become active, questioning citizens" in addition to cultivating beauty and fashion (149). Stories about civically responsible girls also emerged in a variety of other twentieth-century media, including: girls' book series, such as the Nancy Drew Mystery Stories (Keene); radio shows, such as *Meet Corliss Archer*; films, such as *The Littlest Rebel*; and television series, such as *Gidget*.

What is unique about *Seventeen*'s model of good citizenship at the height of second-wave feminist activism, however, has to do with what it leaves out or relegates to the margins. In spite of all of its calls to active citizenship, the kinds of causes in which girls were encouraged to participate between 1968 and 1973 rarely pertained to the women's movement. For instance, an April 1971 article titled "Maybe This Is the Summer to Volunteer" suggested over one hundred examples of social activities and/or organizations that girls could get involved with, but none of them related directly to feminism, such as the National Organization for Women (NOW) or the Women's Equity Action League.[4] Perhaps this is not surprising considering that between 1968 and 1977, *Seventeen* ran only *one* feature-length article that took the women's movement as its sole focus. This article, "How Is Women's Liberation Doing in the High Schools?" appeared in the same issue as the volunteer essay mentioned above. The fact that these two articles were published together is intriguing because it suggests that *Seventeen*'s editors wanted to be a part of the conversation about women's liberation but were reluctant to recommend it as a viable model of citizenship for girls. Indeed, the article on volunteerism offered numerous organization addresses to which interested girls could write, whereas the article on "women's lib" provided none. Furthermore, the editors advertised the volunteerism piece on the cover but did not promote the liberation article. In quietly commenting on the state of women's liberation in high schools, then, *Seventeen* represented itself as being "current" while carefully avoiding making recommendations to girls about feminist volunteer work or activism. Ultimately, when compared to the vast number of articles on other social issues that asked for girls' participation during the era, the difference in the way that liberation was handled is striking.

Certainly, this is not to say that women's liberation, or themes related to it, weren't mentioned in other places in the magazine. They were, and with increasing frequency as the years went on. Between 1968 and 1973, beauty editorials, fashion layouts, and advertisements often adopted liberation themes to sell products to girls. Beginning in 1973, a column called Hot Lines offered snippets of information about feminist activities and products. In 1975, the magazine introduced Mini Mag—a newspaper-like insert—and several articles in the mid- to late 1970s made reference to women's liberation. Girl readers and role models offered thoughts on women's lib in letters, opinion pieces, and interviews. And throughout the decade, themes of women's progress appeared in articles on colleges, careers, sports, sexuality, and self-defense. It is also worth noting that Gloria Steinem, perhaps the most well-known feminist of the era, worked as an editorial consultant for the magazine from April 1970 to January 1971.

Though it is important to applaud the ways that ideas about feminism percolated through *Seventeen*'s beauty-centric veneer, it is equally vital to investigate the problematic patterns that emerged in this process. For one, the magazine often appeared more interested in selling "liberation" to girls as a commodity than as a right—a phenomenon that connects to Robert Goldman, Deborah Heath, and Sharon Smith's concept of "commodity feminism." According to this idea, when feminism is appropriated by advertisers, it is relocated within the field of commodity choices and "cooked to distill out a residue—an object: a look, a style" (Goldman et al. 336). In other words, advertisers "re-encode" feminism "as a sequence of visual clichés and reified signifiers" so that it can be "worn as a stylish sign" (336). The commercial attempts of advertisers "to choreograph a non-contradictory unification of feminism and femininity" have thus led contemporary women's magazines to construct "an aesthetically depoliticized feminism" (334). The concept of commodity feminism is well suited to an analysis of *Seventeen* in the 1970s, for while the magazine packaged (and privileged) feminism as an attractive consumer product, it simultaneously consigned second-wave feminist politics to the peripheries of its overall content. In the process, *Seventeen* diminished the political potential of women's liberation to be seen as a viable model of citizenship for girls.

Liberation Advertising and Consumer Citizenship

Although drawing on liberation motifs to sell products to girls wasn't a new idea in the 1970s, a new *fervor* toward using them developed with the rise of second-wave feminism. As Thomas Frank has noted,

> The advertising of the sixties was, by and large, astonishingly sexist stuff. . . . But then everything changed, and quite suddenly, in 1969 and 1970. Faced with an

articulate popular uprising that looked to be as widespread and as powerful as the revulsion against the mass society, industry leaders quickly changed course. Liberation was their stock-in-trade, and they scrambled to align the Creative Revolution with this latest wave of cultural dissidence. (152)

Frank goes on to reveal how advertising professionals in the 1960s connected "the age of options" with increased consumption for women; within commercial culture, "the liberated woman was to be welcomed because she was a 'heavy user'" (153). In her research on 1960s' ads for portable television sets, Lynn Spigel also notes this association, demonstrating how products like the "TV purse" came to be the "handmaiden for women's 'right' to overconsume" (99, n41). Teen magazines were not immune to the rush among advertisers to link the freedom associated with women's liberation to the "freedom" associated with individual purchasing choice and product consumption. In fact, with teen spending on the rise—$20 billion spent by teens in 1967 grew to $22.3 billion in 1969, with girls outspending boys 52 to 48 percent—advertisers were eager to exploit feminism's commercial potential in order to tap into the lucrative teen girl market.[5]

In *Seventeen,* beauty columns, fashion spreads, and advertisements all utilized liberation themes to sell products and ideologies to girls. For instance, in October 1968, one month after the feminist protest of the Miss America pageant, *Seventeen* adopted a protest theme to dish beauty advice. Without any mention of the pageant or politics that led to its protest, readers learn that girls must protest their own bodily imperfections. As the introductory copy alongside one girl's photograph explains, "*Seventeen* salutes the beauty protesters! Change is what we're after this bright October. Join the march! Enhance the color of your hair, erase the imperfections of your complexion and your figure flaws" ("The Beauty" 98). Of course, waging a beauty war on one's body requires purchasing an assortment of goods. According to the experts, items for the arsenal include some combination of the following: a hair highlighting kit, medicated soap, hypoallergenic cleanser, electric sauna, bath oil, medicated "towelette," emollient cream, electric complexion-care appliance (complete with a cold-hot pack for moisturizing and a massager for whittling away chin-line baby fat), clay-based mask, loose powder, matte foundation, "swansdown" puff, surf board, Danskin leotard, and/or a trip to the dermatologist.

Obviously, this editorial is problematic on numerous levels. Whereas the Miss America protest was a demonstration against the objectification of women, *Seventeen*'s version of the "beauty protester" encouraged girls to scrutinize their bodies and shop in a manner that would surely rival the rituals of beauty pageant preparation. In acknowledging a key moment in the women's movement, sapping it of all its original political meaning, and bringing it back in line with the beauty and

consumerist ideologies that govern the magazine, *Seventeen* suggested that liberation could be attained through product consumption. Systemic reform is substituted for one that is much more easily managed and exploited: bodily reform. If, with a little effort and money, "The Beauty Protesters Win" (or so say the editors on the cover), who needs a liberation movement?

Seventeen also had no qualms about employing activist images or appropriating the term "activist" to encourage consumerism. For instance, the January 1972 issue features a lengthy fashion spread with "The New Activists," a group of fifteen "accomplished" girls from around the country who excelled in everything from scholastics and athletics to pageants and volunteer work. As was typical of *Seventeen* during this era, the majority of girls featured in the layout were white (among them, rising tennis star Chris Evert). Still, the fashion spread's inclusion of four minority teens—one Asian American and three African Americans—hints at the editors' interest in acknowledging (and selling to) a more diverse population of girls. In fact, one of the "new activists," Pamela Jones, an African American dancer from the Dance Theatre of Harlem, was also depicted on the issue's cover.[6] Although the achievements of these do-gooder teens were highlighted as qualities of good citizenship to which girls should aspire, the layout's primary function was, of course, to sell products to girls. In small but noticeable text underneath each girl's fashion photo appears a list of prices and stores for every clothing item and accessory pictured. In using the term "activist" to describe some of America's "loveliest" National Merit Scholars, tennis champs, and beauty queens, *Seventeen* tapped into the political climate of the time while neutralizing any threatening associations with its meaning; in the process, the ideal teen "activist" appeared as a cute and capable girl who was *active*—not activist—and who made bold political statements through consumption—not protest.

Oodles of advertisements published in *Seventeen* also adopted liberation themes in their attempts to court girl shoppers. In 1968, Revlon heralded its Moon Drops collection as "the great new freedom movement in makeup happening now!" (Revlon 21). In 1969, Loveable promoted its new "Hose-Up" briefs with the slogan "Let Freedom Cling" (Loveable 169), and Talon Zephyr claimed that its nylon zipper wouldn't slip open in men's or women's slacks because "all our zippers are created equal" (Talon 430). In February 1970, Singer announced the arrival of its "Independence" sewing machine, complete with tips on making "freedom fashions" (Singer 76). The same month Peter Pan, a bra manufacturer, took out a full-page ad that pondered, "In San Francisco on August 1, 500 women took off their bras in protest. Should you have been among them?" Though the ad admits that Peter Pan's solution, the "Soft N' Low" bra, will "never satisfy the new feminists," it is the logical choice that the reader is encouraged to make (Peter 207). Massengill declared in 1970 that its feminine hygiene deodorant spray, "the freedom spray," would offer girls "freedom now" (Massengill 52), and Yardley

promoted its new eye shadow with the slogan, "You're too lib to live in anybody's shadow" (Yardley 14). Joyce shoes ran a series of ads in 1971 that toyed with the concept of "walking all over" someone. The first (February) includes a close-up of a white woman's foot stepping on a young white man who is lying down. The heel of her shiny red shoe digs into his bare chest while the toe presses on his chin. Across his neck and shoulder the text reads: "The Joyce strap shoe. For the liberated woman" (Joyce 57).

As recent research on girls' media by scholars such as Kelly Schrum, Anita Harris, and Sarah Banet-Weiser demonstrates, *Seventeen* was not unique in asking girls to attend equally to citizenship and consumerist responsibilities. Rather, what makes *Seventeen*'s liberation-era calls to citizenship intriguing is the way that beauty editorials, fashion spreads, and advertisements operated as more acceptable forums than feature articles for the celebration of liberation ideals. What are we to make of this? On the one hand, it is undeniable that some of the magazine's advertising images and slogans offered highly rousing appeals to liberation—delivering attractive messages about confidence, independence, assertiveness, and control. On the other hand, it appears that the easier and safer way for *Seventeen* to deal with liberation was to sell it as a commodity/lifestyle that girls could buy rather than discuss it as a basic human right to which they were entitled. To this end, *Seventeen*'s promotion of products promising "liberation" might be seen as a "stand in" for actual, achieved social rights and equality for girls—or, as Goldman et al. put it, "feminist goals of independence and professional success" (336). As Kate Kane has argued with regard to feminine hygiene advertisements, claims to women's freedom in marketing discourse are "pseudo-feminist" because they assert "a false independence, the freedom to choose fetishized femininity over politics" (297). In applying this logic to *Seventeen*, liberation advertisements suggested to girls that gender equality could be attained through goods and purchasing power; put another way, freedom was for the taking if one simply had enough money to buy it.

Of course, as a commodity, "liberation" would not have been equally available to all *Seventeen* readers. Girls from lower socio-economic groups would not have been able to buy the "looks" and products that promised liberation as easily as girls from the middle or upper classes. As Anita Harris points out:

> This blending of the political aspects of citizenship with one's ability to consume has particular effects for those young women who are shut out of the consumption process due to lack of money. Being unable to participate in the right kinds of consumption processes means one is "at-risk" of engaging in disordered patterns of consumption, thereby being excluded from occupying powerful social positions. . . . Therefore, those who cannot consume are doubly disengaged from citizenship. (90–1)

Far from delivering freedom, then, consumption—especially the sort of excessive consumption promoted in *Seventeen*—likely delivered to many girls a blow to the pocketbook and a sense of self-worth problematically tied to their acquisition of "stuff." Other girls (i.e., those without disposable income and the cultural capital to successfully engage in consumer practices) were left out of the model of consumer citizenship altogether. In either case, spending was heralded as the better (if not only) means to liberation and power than actual political reform.

Advertisements that *Seventeen*'s editors regularly placed in *Advertising Age* provide additional evidence of the magazine's interest in selling girls to advertisers. For instance, several ads from the late 1960s promoted the fact that *Seventeen* offered "more advertising pages than any women's monthly magazine" ("That's What" 19; "That's the," May 81). One 1969 ad claimed that *Seventeen* had carried more advertising than its rivals "for 16 consecutive years" and announced that the August 1969 issue marked "a new high" in sponsorship with 357 advertising pages ("That's the," June 88). Later ads celebrate girls' spending habits. For instance, one 1973 ad asserted that *Seventeen*'s readers "love to shop and they have the money to buy what they want. Over $8.7 billion of their own—plus the uninhibited use of family bank accounts and charge cards" ("This Girl" 13). Another ad from 1975 cheerily proclaimed that "Teenage Girls Spend More on Cosmetics Than England Spends on Tea" ("Teenage" 29). Ultimately, in hawking its reputation as the most abundant publisher of monthly advertising pages and repeatedly reminding sponsors that "this is where the girls are" (as one 1970 ad put it), *Seventeen* displayed its tendency to view girls as consumers, first and foremost, and as citizens second ("This Is" 31).

Girls and Consumer Citizenship

Still, it is important to point out that girls did not universally accept *Seventeen*'s model of consumer citizenship. Many girls wrote letters to the editor challenging the narratives of consumerism and beauty that permeated the publication, and these can be seen as important moments of negotiation with the magazine's dominant structure. In their work on teen magazines, Elizabeth Frazer and Angela McRobbie have demonstrated that some girls take "a critical stand vis à vis texts" (Frazer 182), participating in a "more fluid, more active and ultimately more engaged process of reading" which typically includes "the creation of textual meaning" (McRobbie 142). In line with this scholarship, letters published in *Seventeen* in the 1970s suggest that girls didn't adopt unwittingly the magazine's model of consumer citizenship, yet they didn't completely dismiss it either. More precisely, girls questioned specific details about, but not necessarily the overall structure of, consumer citizenship. For instance, in April 1971, the magazine published the following letter by Debi Schneider of Alexandria, Minnesota:

Please understand that I don't mean to sound like a fiendish enemy when I roar out: *What is happening to this magazine?* I like to find out what's new on the makeup, clothes and food scene just as much as any girl, but don't you people realize that there are more important things going on in the world than how to become a gourmet cook? And please, could you devote at least half an issue to more important things than pantyhose ads? When I was little, I used to like the ads because they made great paper dolls. But when you are seventeen, what do you do with them? If only a magazine with such great youth influence as yours would take a stand on some things that are really important! Peace (?). (4)

Schneider's letter is significant because it indicates that girls were active, critical readers—not just passive consumers—of the magazine's content. It also highlights *Seventeen*'s willingness to print critiques of its consumerist bent. While Schneider's complaint that *Seventeen* dedicates too much space to ads and, presumably, not enough space to "more important things" is a valid point, her concession that she likes to find out "what's new on the makeup, clothes and food scene just as much as any girl" suggests that her issue has more to do with the ad-to-article ratio than with the ways the ads might attempt to exploit her (4). Although *Seventeen* only occasionally published a response to a girl's letter, Schneider's memo apparently warranted one. It read: "See pages 48 ["How's Women's Liberation Doing in the High Schools"], 72 ["Maybe This Is the Summer to Volunteer"] and 128 ["Five Who Fight Pollution"] of this issue—for starters. (And remember that it's the 'paper dolls' that make pages on 'more important things' possible.) Peace. —Ed" (4). Ultimately, in implying that the only way they were able to write about "more important things" was via the capitalist market, the editors further revealed their firm commitment to and endorsement of the consumer citizenship ethos.

While, in reality, girls of the early 1970s still had many battles to fight before gaining any semblance of liberation on par with boys, the majority of ads in *Seventeen* after 1973 operate under the auspices of gender equality no longer being a major concern. Aside from the occasional reemergence of liberation themes, such as the Air Force "equal pay" ads in 1974, more traditional images of romance predominated *Seventeen*'s advertising pages for the remainder of the decade, including numerous ads for engagement rings, hope chests, and wedding china. Although 1973 marked a decline in liberation-themed ads, the magazine opened up new spaces for circulating ideas about feminism, including Hot Lines and Mini Mag. Furthermore, girls themselves picked up the slack and continued the conversation about women's lib when the magazine's editors didn't see fit to provide more in-depth discussion of the movement.

Recognizing and Restricting Feminism: Hot Lines and Mini Mag

Introduced to *Seventeen* in May 1973, the Hot Lines column (described as "the latest word on what's going on . . . and who's making it happen") offered blurbs about popular issues, people, and trends. Although discussing feminism in this space seemed to flag it as a "hot" topic, it also problematically positioned the women's movement as a temporary or passing fad (i.e., a "flash in the pan"). In its debut feature, a blurb titled "Lib and Let Lib" announced that women were taking on jobs once reserved for men, citing Michigan's first female exterminator and Iowa's first female member of the National Guard as examples ("Lib" 34). One of *Seventeen*'s boldest, lib-related Hot Lines appeared in June 1973. Though only two sentences in length, the blurb, "Rights On!," was the first instance in which the magazine revealed support for the ERA. Appearing in the top, right-hand corner of the page along with twelve other newsy items, the announcement stated: "With women still earning, on the average, 3/5 of what men with similar qualifications make, the Equal Rights Amendment can use all the help it can get" ("Rights" 64). An address for "Common Cause, Box ERA" in Washington, D.C. followed the announcement.

Many other Hot Lines peddled feminist products. While some endorsements seem to have been motivated by a genuine interest in supporting a "good cause," other plugs appear as more clear-cut attempts to capitalize on feminism. For instance, a 1973 Hot Line relayed that the women's movement was promoting its cause on a long-playing record, *Virgo Rising*; the blurb offered ordering information and indicated that proceeds would go to the Women's Action Alliance ("Women's" 38). More typical, however, were Hot Lines that exploited feminism's commercial potential, such as one from 1973 that applauded the big-glasses-look worn by Gloria Steinem and Billie Jean King in order to encourage girls to shop at "Lugene stores" for stylish frames ("Public" 64). In 1974, Hot Lines promoted ERA bracelets as a hip accessory and suggested feminist-approved toys and dolls as gift ideas for younger siblings ("Chain" 46; "Hello" 60). Similarly, a 1975 Hot Line asked, "What do young feminists want in their stockings?" Biographies of notable women from the Dell/Laurel Leaf Books Collection were offered as the answer (43).

In April 1975, *Seventeen* unveiled a new feature called Mini Mag. Defined as "a zippy magazine-within-a-magazine," Mini Mag was a newspaper-like insert inside the magazine proper. Peppered with a variety of "mini" articles and quizzes (as well as Hot Lines, which were moved to this section upon its debut), Mini Mag ran approximately eight pages in length. Between 1975 and 1977, themes relevant to women's progress often surfaced here. For example, in June 1976, a four-question quiz titled "Test Your ERA IQ" attempted to assuage fears and correct misconceptions about the ERA. One question asked, "If I support the ERA,

will I be a women's libber?" The answer: "No, unless you want to be. Supporting the ERA says you're in favor of 'equality of rights under the law'" ("Test" 47). The article offered a short list of organizations endorsing the ERA and ended by asking readers, "And you?" (47). In November 1977, Mini Mag's "Seventeen-Second Interview" with NOW president Ellie Smeal revealed what NOW could do for girls. Explaining that women earn a little more than half of what their male counterparts earn, Smeal emphasized the importance of passing the ERA. The brief article, written in Q&A form, provided a mailing address for NOW and ended with Smeal stating, "We need inspiration from the young" ("Seventeen-Second" 56).

Overall, the Hot Lines and Mini Mag blurbs are significant because they reveal an increased willingness by *Seventeen*'s staff to give girls meaningful information about women's liberation. In so doing, the magazine suggested that the ideal girl citizen no longer had to focus primarily on making the world, or herself, better for everyone else. In a society beleaguered by gender inequalities, she could also do something to improve her own life and experience as a young woman in America . . . within reason, of course. She could read a liberal feminist book but couldn't embrace the tenets of Valerie Solanas's *S.C.U.M. Manifesto*. She could write a letter to NOW but couldn't march with the Red Stockings. But to learn which book to buy and where to send her letter, *Seventeen*'s girl reader needed to be attentive to small details and fine print. Without a keen sense of gleaning, she might miss important references to feminism altogether.

And herein lies the primary problem with Hot Lines and Mini Mag; though increased attention was paid to feminism in these columns, the structure of each diminished feminism's significance, thereby severely undercutting its power. Moreover, in taking political issues and recasting them with a commercial twist, *Seventeen* positioned commodities as the true "agent[s] of progressive social transformation" (Goldman et al. 347). Even in opening new spaces for discussion of women's liberation, then, the magazine contained and commodified it—a conundrum that, according to Susan Douglas, prompted feminists in the 1970s to ask, "Why . . . must the media always take away with one hand what they had just given us with the other?" (205). As to *Seventeen*'s role in this puzzle, Hot Lines typically restricted feminist updates to two or three sentences. Mini Mag often did the same. When more information was allowed, it was conveyed in a brief, Q&A style spanning no more than one quarter to one third of a page. In comparison to feature articles, both formats significantly curtailed (and, hence, tightly controlled) the overall space allotted for feminist issues. Feminist-themed blurbs also competed for attention with numerous others on the same page—making it easy, it would seem, to miss a feminist "newsflash." There's also something a little juvenile about Mini Mag. Unlike the rest of the magazine, it was printed on beige, non-glossy paper with occasional color splashes and cartoon drawings reminiscent of children's activity books. Why did feminism have to go in the "special" maga-

zine rather than the "regular" magazine where, presumably, *real* issues got more attention? The answer, it seems, was that feminism was a special kind of issue that needed to be handled delicately, discreetly, and in very basic, non-threatening terms. *Seventeen's* editors couldn't avoid women's liberation any longer but still weren't sure how to handle it with much depth or seriousness, either. Consequently, where *better* to contain feminist politics than in Mini Mag's grab bag of puzzles, pictures, and pop-newsy snippets?

Whereas *Seventeen* in the 1970s didn't see fit to provide extensive discussion of the women's movement in feature-length articles, the magazine *did* rely heavily on girl writing for commentary about feminism. Teen girls regularly wrote about women's liberation in opinion pieces and letters to the editor and talked about it in interviews. Undoubtedly, girls' thoughts about feminism were the most spirited of all those printed in the magazine, and a range—from supportive to unsupportive and everything in between—could be seen throughout the period.

Girls and Do-It-Yourself Citizenship

As early as 1968, girls were commenting on gender equality in the monthly column, In My Opinion, which featured a one-page opinion statement written by a teen girl (or, occasionally, a teen boy) and recognized the author by name, hometown, and a photograph. The first In My Opinion essay to focus specifically on women's liberation was published in June 1970. In "Women's Liberation Is Long Overdue," 17-year-old Rona Wilensky poignantly discusses how women are not regarded as men's intellectual equals and how many women feel compelled to embrace "the old 'feminine' ways" (i.e., downplaying intelligence and cultivating beauty) in order to land a man. Wilensky acknowledges that a girl "who wants more out of life than a wedding gown" will be discriminated against but recommends that she "fight it"; as she explains, "She'll take her cue from the women's liberation groups and join with other girls to analyze the problem and find workable solutions" (198). In September 1970, Eloise Crabtree decried beauty pageants, describing them as "pathetic auctions" that should be put to rest (230). In a similar spirit, Maureen Connell asserted in 1972, "Let's Get Rid of Sexist Textbooks!" (354). In 1975, Donna Binsted argued for equal pay and nonsexist language (66), while later that year, Phillipa Benson proclaimed, "The Women's Conference Was a Breakthrough!" (46). In 1976, Tina Facos suggested that "the double standard" denied girls equal freedom with boys (76), and in 1977, Lucette Lagnado denounced troubling images of women on television (48).

Taken together, these examples indicate that some girls were keenly aware of, and affected by, gender inequalities and stereotypical media representations. Their irritation and anger led them to devise and dispense creative recommendations for social change, and in at least a couple of instances, it prompted them to look

to feminist organizations for help. Although feminists today might admire In My Opinion essays for their feistiness, many girl writers place the responsibility for change on the shoulders of girls rather than social and/or political institutions. The message conveyed more often than not is that reform is up to each individual; equality can be attained if each girl simply works hard enough at it. Perhaps the popularity of such assertions is not surprising considering how narratives of individualism and self-improvement govern teen magazines like *Seventeen*. The problem, however, is that when seeking solutions to their own gender subordination, girls often looked for change within themselves first, thereby ignoring structural problems and minimizing any need to consider the women's liberation movement as a model of citizenship that could empower them politically.

In My Opinion essays that supported themes of women's liberation were always met with mixed review from girls in *Seventeen*'s letters to the editor column, Your Letters. For instance, in August 1970, *Seventeen* published four responses (two for, two against) to Rona Wilensky's essay, "Women's Liberation Is Long Overdue." Andrea Avrutis writes:

> I completely agree with Rona Wilensky; it is time that women were regarded as complete human beings and that efforts to improve their position were not looked at with amused disdain. . . . As Rona says, girls should realize their worth in terms of their own standards and work so that everybody can realize their worth also. (6)

J.R. of Flushing, New York, muses: "Isn't it ironic that such a well thought out, *true* article as Rona Wilensky's should appear in the very magazine most responsible for mesmerizing teen-age girls into the 'femininity-syndrome'?" (6). In contrast, Bonni Levy objects to Wilensky "calling me (and thousands of others) wishy-washy, propagandized, subordinate girls with absolutely no integrity" (6). As she explains, "I do not consider that I have failed to 'maintain' my 'integrity' since I do not throw my superior abilities (some masculine, I'll admit) up to my beau. I consider that maintaining the use of tact" (Levy 6). Lorabeth Staley also perceives Wilensky's essay as an insult: "All right, Rona, so you want total liberation for women. Fine! You can just march right off to Southeast Asia to fight and die with the best of them. You may also find marvelous, fun-filled jobs in sawmills, salt mines, oil wells and fishing boats in Alaska. If you want to be termed man's equal, you must live up to his standards" (6).

Clearly, readers disagreed on what it meant to be liberated. Some, like Avrutis, envisioned liberation as looking past gender differences to focus on each person's value as an individual. Others, like Levy and Staley, feared that liberation required the loss of certain privileges associated with women's conventional roles. And J.R. viewed liberation as an entity at odds with much of the discourse in *Seventeen*. In

some form or another, all of these letters grapple with how to reconcile liberation with notions of traditional femininity. What is interesting about this and other debates in Your Letters is that the editors rarely entered the conversation, leaving girls to synthesize meanings of liberation on their own. While this might be seen as empowering in some ways, it also likely promoted confusion among readers. Indeed, many girls' comments indicated as much—prompting the editors to list the "Fem Lib movement" in the category of "things you couldn't make up your mind about" in a 1972 article reflecting on the past ("Your" 53).

What are we to make of *Seventeen*'s reliance on girl writing for the preponderance of commentary about women's lib? In her dissertation, *Writing Trouble:* Seventeen *Magazine and the Girl Writer*, Carley Moore reveals that *Seventeen* printed more girl writing during the late 1960s and 1970s than in the 1980s and early 1990s (27). And, as we have seen, much of this writing tapped into themes of gender equality (as Moore shows also). Unlikely to be just a coincidence, it appears that *Seventeen*'s staff didn't quite know what to do with women's liberation—especially considering the magazine's reliance on discourses of beauty and consumerism to deliver readers to advertisers. So, to play it safe, they stayed out of the conversation. Not content to remain quiet, however, girls vigorously debated and (at times) took an aggressive stand on feminist issues. In detailing *Sassy* magazine's transformation in the late 1980s and 1990s from innovative and alternative to status quo, Mary Celeste Kearney has highlighted "the mainstream media's continued uneasiness with any troubling of traditional gender roles and modes of representation" (297). With this in mind, *Seventeen*'s reliance on girl writing makes sense; for, in making girls the primary purveyors of opinion on women's lib, the magazine would have been safeguarding itself against critique on at least two fronts. First, it wouldn't come off as neglecting the women's movement, in spite of not focusing on it in feature-length articles. Second, with regard to almost anything that was printed, the editors could use girls as scapegoats if need be (i.e., "It's one girl's opinion, not ours"). Rather than delve into messy debates about "any troubling of traditional gender roles" (297), then, girls writing in *Seventeen* in the late 1960s and 1970s were the ones who made "trouble."[7]

Certainly, *Seventeen* shaped the parameters of girls' debates about women's liberation. Nevertheless, it seems that by commenting on liberation in ways that the magazine's staff could not (or would not), girls enacted their own form of do-it-yourself (DIY) citizenship with regard to issues of feminism and femininity. Although DIY is a term more often associated with punk culture and post-1990s' politics, I use it here to describe how girls engaged in a kind of civic action and dialogue by circulating their *own* ideas, stories, and opinions to a broader network of readers. Considering that girls have little to no access to traditional forms of citizenship, DIY practices have been (and continue to be) a crucial means through which girls exercise cultural agency. In *Uses of Television,* John Hartley attributes

DIY citizenship practices to young female TV characters, like Clarissa (Melissa Joan Hart) in *Clarissa Explains It All* and Moesha (Brandy) in *Moesha*, arguing that they teach "semiotic citizenship to their child-constituency" (184). As he explains, these shows depict "a world governed by a child, and they present that world, that government, to young viewers not only for their entertainment but also . . . their edification" (185). Although Sarah Banet-Weiser reminds us that Nickelodeon's "gender neutral" stance (i.e., creating characters whose issues are not gender-specific) helped series such as *Clarissa* promote "a profoundly ambivalent form of girl power" (128), the concept of DIY citizenship is still useful in understanding how *Seventeen*'s girl writers negotiated tensions within and between cultural politics and the magazine's practices. In actively debating the meanings of liberation and making persuasive appeals, girl writers became DIY citizens who offered visions of feminine guidance and/or feminist empowerment to their peers. Though, as Hartley and Banet-Weiser both note, DIY culture can be contradictory and limited, it still offers an "empowering version of what the 'selves' of do-it-yourself might actually *do* with their citizenship" (Hartley 188).

Conclusion

Between 1968 and 1977, girls actively debated the terms and boundaries of citizenship, liberation, and femininity in the pages of *Seventeen*. The myriad ways in which the magazine packaged liberation as a commodity and relegated it to the margins of its overall content point to a strategy of compromise and containment. Yet, in opening up new spaces for dialogue about feminism and offering girls a certain amount of freedom to ask questions and wage critiques, *Seventeen* addressed changing ideas about gender roles and politics, even as it tried to contain them. Ultimately, *Seventeen*'s 1970s version of the "new activist" girl appeared to be a bright, active, and dedicated young woman who could don the "look" of liberation as part of responsible citizenship yet who understood that cultivating femininity was an equally valuable form of power—bestowing upon those who did it well such benefits as beauty, boys, and a bevy of consumer goods. Good girl citizens emerged as those who consumed the activist spirit of the liberation era while carefully distancing themselves from the more threatening outcomes and connotations of feminist activism.

For girls who embraced *Seventeen*'s model of the "new activist" (either wholly or partially), feminism was likely something they felt conflicted about as they entered young adulthood in the 1980s. As cultural scholars, we can only hope that girls' negotiations with liberation-era messages about strength, confidence, and independence helped prepare them for the considerable political and cultural backlash against feminism that lurked around the corner. Yet, for some girls, this backlash may have exacerbated ambivalence towards feminism. Certainly,

for readers who "upgraded" to commercial women's magazines like *Vogue* and *Glamour*, antagonistic responses to feminism would have been immediately apparent. As Susan Douglas has cleverly demonstrated, the "narcissism as liberation" campaign utilized by advertisers in the 1980s "pretended to advance feminism by harboring antifeminist weaponry" (266). Although the specific advertising slogans may have changed, commercial co-optations and containments of feminism continue to this day in girls' and women's magazines (and, arguably, all commercial mass media). Ultimately, then, *Seventeen*'s 1970s' celebration of consumerism over politics reminds us that "commodity feminism" in girls' popular culture has historical roots that run especially deep. It also suggests just how far our culture still has to go to make shopping for feminist politics as valuable an activity as shopping for feminine products.

Notes

1. I would like to thank Lynn Spigel, Mary Celeste Kearney, Mimi White, and Chuck Kleinhans for their helpful comments on drafts of this chapter. This essay is based upon one chapter of my dissertation. For additional details, see Pike 27–75 and 260–75.
2. For statistics, see "'Seventeen' Marks" 45, "This Girl" 13, and "Teenage Girls" 29.
3. As part of my broader research, I also examined all of the issues of *Seventeen* from 1978 and 1979 as well as numerous issues of *'Teen* from the late 1960s and 1970s.
4. It is worth noting, however, that Planned Parenthood is mentioned in the article as a place where one girl volunteered.
5. For statistics, see "'68 Teen" 39 and "Teen Spending" 67.
6. For a fuller discussion of race in this issue, see Pike 66–73.
7. See, also, Moore on "making trouble," especially 1–41.

Works Cited

"'68 Teen Spending Hit $20 Billion, Rand Bureau Says." *Advertising Age* 10 Mar. 1968: 39.
Air Force. Advertisement. *Seventeen* Apr. 1974: 85.
Air Force. Advertisement. *Seventeen* June 1974: 79.
Alcott, Louisa May. *Little Women*. 1868. New York: Grosset & Dunlap, 1947.
Avrutis, Andrea. Letter. *Seventeen* Aug. 1970: 6.
Banet-Weiser, Sarah. *Kids Rule! Nickelodeon and Consumer Citizenship*. Durham: Duke University Press, 2007.
"The Beauty Protestors Win." *Seventeen* Oct. 1968: 98–103.
Benson, Phillipa. "The Women's Conference was a Breakthrough!" *Seventeen* Nov. 1975: 46.

Binsted, Donna. "Let's Have Equal Pay and Nonsexist Language." *Seventeen* May 1975: 66.

"Chain Reaction." *Seventeen* Jan. 1974: 46.

Connell, Maureen. "Let's Get Rid of Sexist Textbooks!" *Seventeen* Aug. 1972: 354.

Crabtree, Eloise. "Beauty Pageants are Pathetic Auctions!" *Seventeen* Sept. 1970: 230.

Douglas, Susan J. *Where the Girls Are: Growing Up Female with the Mass Media.* New York: Random House, 1995.

Editor. Response to Debi Schneider. *Seventeen* Apr. 1971: 4.

Edmiston, Susan. "How is Women's Liberation Doing in the High Schools?" *Seventeen* Apr. 1971: 48+.

Facos, Tina. "The Double Standard Denies Girls Equal Freedom With Boys." *Seventeen* Dec. 1976: 76.

Frank, Thomas. *The Conquest of Cool: Business Culture, Counterculture, and the Rise of Hip Consumerism.* Chicago: University of Chicago Press, 1997.

Frazer, Elizabeth. "Teenage Girls Reading *Jackie*." *Culture and Power: A Media, Culture and Society Reader.* Eds. Paddy Scannell, Philip Schlesinger, and Colin Sparks. London: Sage, 1992. 182–200.

Goldman, Robert, Deborah Heath, and Sharon L. Smith. "Commodity Feminism." *Critical Studies in Mass Communication* 8 (1991): 333–51.

Harris, Anita. *Future Girl: Young Women in the Twenty-First Century.* New York: Routledge, 2004.

Hartley, John. *Uses of Television.* New York: Routledge, 1999.

"Hello, Doll-Lib." *Seventeen* Dec. 1974: 60.

Joyce. Advertisement. *Seventeen* Feb. 1971: 57.

J.R. Letter. *Seventeen* Aug. 1970: 6.

Kane, Kate. "The Ideology of Freshness in Feminine Hygiene Commercials." *Feminist Television Criticism: A Reader.* Eds. Charlotte Brunsdon, Julie D'Acci, and Lynn Spigel. Oxford: Clarendon Press, 1997. 290–99.

Kearney, Mary Celeste. "Producing Girls: Rethinking the Study of Female Youth Culture." *Delinquents and Debutantes: Twentieth-Century American Girls' Cultures.* Ed. Sherrie A. Inness. New York: New York University Press, 1998. 285–310.

Keene, Carolyn. Nancy Drew Mystery Stories. New York: Grosset & Dunlap, 1930–1979; Simon & Schuster, 1979–2003.

Lagnado, Lucette. "TV is Unfair to Women!" *Seventeen* Dec. 1977: 48.

Levy, Bonni. Letter. *Seventeen* Aug. 1970: 6.

"Lib and Let Lib." *Seventeen* May 1973: 34.

Loveable. Advertisement. *Seventeen* Oct. 1969: 169.

Magazine Circulation and Rate Trends: 1940–1971. New York: Association of National Advertisers, Inc., 1972.

Massengill. Advertisement. *Seventeen* June 1970: 174.

"Maybe This is the Summer to Volunteer." *Seventeen* Apr. 1971: 72+.

McRobbie, Angela. *Feminism and Youth Culture: From* Jackie *to* Just Seventeen. Boston: Unwin Hyman, 1991.

Moore, Carley. *Writing Trouble:* Seventeen *Magazine and the Girl Writer.* Diss. New York University, 2004.

"The New Activists." *Seventeen* Jan. 1972: 54–67.

Peter Pan. Advertisement. *Seventeen* Feb. 1970: 207.

Pike, Kirsten M. *Girls Gone Liberated? Feminism and Femininity in Preteen Girls' Media, 1968–1980.* Diss. Northwestern University, 2009.

"Public Eye." *Seventeen* Sept. 1973: 64.

Revlon. Advertisement. *Seventeen* Jan. 1968: 21.

"Rights On!" *Seventeen* June 1973: 64.

Schneider, Debi. Letter. *Seventeen* Apr. 1971: 4.

Schrum, Kelly. "'Teena Means Business': Teenage Girls' Culture and *Seventeen* Magazine, 1944–1950." *Delinquents and Debutantes: Twentieth-Century American Girls' Cultures.* Ed. Sherrie A. Inness. New York: New York University Press, 1998. 134–63.

"'Seventeen' Marks Birthday (Its 25th) with Info on Gains." *Advertising Age* 1 Sept. 1969: 45.

"Seventeen-Second Interview: A Feminist with an Eye Out for the Future." *Seventeen* Nov. 1977: 56.

Singer. Advertisement. *Seventeen* Feb. 1970: 76.

Solanas, Valerie. *S.C.U.M. Manifesto.* London: Olympia, 1971.

Spigel, Lynn. *Welcome to the Dreamhouse: Popular Media and Postwar Suburbs.* Durham: Duke University Press, 2001.

Staley, Lorabeth. Letter. *Seventeen* Aug. 1970: 6.

Talon Zephyr. Advertisement. *Seventeen* Aug. 1969: 430.

"Teenage Girls Spend More on Cosmetics Than England Spends on Tea." Advertisement. *Advertising Age* 31 Mar. 1975: 29.

"Teen Spending Still Soaring, Rand Says." *Advertising Age* 13 Apr. 1970: 67.

"Test Your ERA IQ." *Seventeen* June 1976: 47.

"That's the Strength of 'Seventeen.'" Advertisement. *Advertising Age* 19 May 1969: 81.

"That's the Strength of 'Seventeen.'" Advertisement. *Advertising Age* 23 June 1969: 88.

"That's What 'Seventeen' Is All About." Advertisement. *Advertising Age* 24 Mar. 1969: 19.

"This Girl Means Business." Advertisement. *Advertising Age* 5 Feb. 1973: 13.

"This Is Where the Girls Are." Advertisement. *Advertising Age* 18 May 1970: 31.

Ulrich's International Periodicals Directory. 17th ed. New York: R. R. Bowker, 1977.

Wandersee, Winifred D. *On the Move: American Women in the 1970s.* Boston: Twayne, 1988.

"What Do Young Feminists Want in Their Stockings?" *Seventeen* Dec. 1975: 43.

Wilensky, Rona W. "Women's Liberation Is Long Overdue." *Seventeen* Apr. 1970: 198.

Wolf, Naomi. *The Beauty Myth: How Images of Beauty Are Used Against Women.* London: Vintage, 1991.
"Women's Lib Retto." *Seventeen* July 1973: 38.
Yardley. Advertisement. *Seventeen* Oct. 1970: 14.
"Your Whole Life Catalog." *Seventeen* Jan. 1972: 53.

Little Butches:
Tomboys in Hollywood Film

Kristen Hatch

In the 1976 comedy, *The Bad News Bears*, 11-year-old Amanda Whurlitzer (Tatum O'Neal) undergoes a remarkable transformation. When we are introduced to her, Amanda wears a long skirt, peasant blouse, and floppy, oversized hat. She is the epitome of precocious femininity. By the end of the film, she has transformed into a baseball-playing tomboy whose powerhouse pitch helps save a team of underachieving boys from ignominious defeat. Such a transformation, from feminine girl to tomboy, is virtually unheard of in the annals of tomboy narrative.

Even more surprising than Amanda's metamorphosis into a tomboy is 15-year-old Angel's (Kristy McNichol) rejection of heterosexuality in favor of same-sex bonds in *Little Darlings* (1980). In the film's opening sequence, tomboy Angel responds to the crude come-on of a neighborhood boy by kicking him hard between the legs. Over the course of the film, Angel is taunted as a lesbian, and in an effort to fit in with the other girls at summer camp she seduces Randy (Matt Dillon). However, by film's end, Angel has rejected Randy and forged a bond with another girl, Ferris (Tatum O'Neal). The film ends on a close-up of the two girls, smiling arm in arm.

Writing a decade before the release of these films, Leslie Fiedler confidently identified the transformation of the tomboy into a feminine woman as the defining element of the tomboy narrative (333). Likewise, Barbara Creed has argued that the cinematic tomboy functions to regulate lesbian representation even as she offers a means of exploring the pleasures of female masculinity and same-sex

bonding. According to Creed, the tomboy film ultimately works to reinforce heterosexuality (86). While tomboy narratives have long offered a thrilling glimpse of female masculinity and the possibility of same-sex desire, they have also demanded the tomboy's capitulation to heteronormativity. Indeed, in the case of the most famous of fictional tomboys, *Little Women*'s Jo March, readers' expectation of and desire for such an end were so strong that Louisa May Alcott was pressured to marry off her heroine against her own better judgment (Quimby). Given this history, Amanda and Angel are remarkable tomboys indeed.

Not surprisingly, the tomboy stars of the 1970s—Kristy McNichol, Tatum O'Neal, and Jodie Foster—have functioned as icons of identification and desire for lesbians of a certain age, and 1970s' films like *Little Darlings*, *Foxes* (1980), and *Times Square* (1980) are often identified as lesbian films.[1] Before we imagine that the 1970s marked a new acceptance of female masculinity and lesbian desire on the part of Hollywood, though, it is worth considering why this change in the tomboy narrative occurred and under what conditions that tomboy was able to escape the constraints that had bound Jo March and countless other tomboys after her. In fact, in the 1970s no less than in earlier decades, the tomboy was synonymous with childhood and sexual immaturity. And a closer examination of the tomboy films released between 1950 and 1980 suggests that these films were never as concerned with enforcing femininity and heterosexuality as one might expect. The tomboy functions as a means of regulating aberrant sexuality precisely because her transformation is taken to be guaranteed. Because the tomboy so successfully represents the disciplining of female gender and sexuality, because her eventual embrace of femininity and heteronormativity is so assured, she is emblematic of the disciplining of gender and desire more generally. Nonetheless, the 1970s' tomboy films suggest one means by which lesbian desire could be made visible within mainstream Hollywood film. Ultimately, the tomboy's efficacy as a disciplinary figure was undone when her status as a pre-sexual girl came into question.

The Tomboy's Cinematic Metamorphosis

Prior to Amanda's transformation from feminine girl to tomboy in *The Bad News Bears*, Hollywood's tomboy narratives conformed to the generic conventions established by *Little Women* and other nineteenth-century literature. Cinematic tomboys peaked in popularity during the silent era, in the 1910s and '20s, with such films as *The Tomboy* (1924), *The Boy Girl* (1917), and *The Amazons* (1917), as well as a multitude of films starring Mary Pickford and Mabel Normand. The tomboy film enjoyed a resurgence of popularity in the postwar era. Carson McCullers' novel, *The Member of the Wedding* was adapted into a Broadway play and a Hollywood film in the early 1950s. In the film, Frankie (Julie Harris) is em-

blematic of all who are banished to the periphery of society, a lonely tomboy who longs for the pleasures of belonging. More common in the early 1950s, were the historical films that featured tomboys—*Annie Get Your Gun* (1950), *On Moonlight Bay* (1951), *Calamity Jane* (1953), and *Rose Marie* (1954). These films nostalgically created an imagined national past in which unruly tomboys were tamed by rugged men.[2] *Gidget* (1959) helped to establish the tomboy within the teen film genre, followed by *The Truth About Spring* (1965) and *Billie* (1965). These films combined the thrill of young women's acting against gender norms—reveling in physical pursuits like shooting, surfing, and baseball—followed by their transformation into properly submissive and demure women.[3] This metamorphosis of the spunky tomboy into a feminine woman is a key element to these tomboy films—as important as her defiance of gender norms—because it provides assurance that regardless of any instability in gender roles, women will gladly accept their position within the gender hierarchy once they are awakened to heterosexual desire. However, postwar tomboy narratives are less concerned with policing female behavior than they are with enforcing male heteronormativity.

Rather than suggesting that the tomboy poses a threat to gender norms, the tomboy films from the first half of the twentieth century suggest that her transformation into a feminine woman is inevitable. For one thing, the tomboy's gender identity is never really in question. In this regard, the tomboy film is akin to the "temporary transvestite" film, one of the defining features of which, according to Chris Straayer, is that the audience is never in any doubt as to the gender of the disguised character. In *Sylvia Scarlett* (1936), for example, characters within the film may read Sylvia Scarlett (Katharine Hepburn) to be a boy, but audiences easily recognize the woman beneath her disguise. Likewise, in early tomboy films, characters may occasionally mistake the tomboy for a boy, but the audience is never in any doubt of her gender. In part this is due to the audience's familiarity with the stars who enact these tomboy roles. In *On Moonlight Bay*, Bill (Gordon MacRae) mistakes Margie (Doris Day) for a boy when he bends her over his knee to administer a spanking, but the audience can clearly perceive Doris Day beneath her knickerbockers. Further, costuming serves to emphasize the tomboy's femininity rather than signaling her masculinity. Margie's knickerbockers and sweatshirts emphasize her breasts and hips rather than downplaying her womanly figure. In *The Truth About Spring* (1964), Spring (Hayley Mills) is introduced wearing an oversized pea coat and sailor's cap, while Rose Marie (Ann Blyth) in *Rose Marie* (1954) wears buckskins and a coonskin cap for most of the film. However, rather than disguising their gender, these costumes highlight the actresses' diminutive stature and feminine delicacy.

If the stars' bodies aren't enough to cue us that their tomboy characters will ultimately metamorphose into feminine young women, the films offer other cues as well. In *The Truth About Spring*, for instance, Spring's appearance on screen is

generally accompanied by the romantic sound of strings on the soundtrack, alerting us to the fact that, despite her tough exterior, Spring will ultimately succumb to the call of heteronormativity. In *Gidget* (1959) the transformation is promised in the film's theme song,

> A regular tomboy
> But dressed for the prom—Boy!
> How cute can one girl be?

This transformation is also suggested in the film's opening shot of a bathing suit hanging on a clothesline as Gidget (Sandra Dee) explains in voiceover, "This summer was the turning point in my life." The tomboy's body is already absent from the opening frames of the film, its absence signaled by the bathing suit that initially represented her difference from the other, sexier girls. Her transformation has taken place before the film begins.

Ultimately, the tomboy's inevitable transformation is fueled by heterosexual desire. For instance, Gidget's tomboyishness is bound to her revulsion for boys' sexual desire. She finds heterosexual romance "icky" and the idea of going on a date with a boy makes her shudder. By contrast, her first ride on a surfboard elicits squeals of excitement, as she gushes to her parents, "You can't imagine the thrill of shooting the curl. It positively surpasses every emotion I've had." However, the film suggests that in the natural progress toward maturity, the thrill of surfing will be supplanted by the thrill of sexual desire, and Gidget will become more interested in Moondoggie (James Darren) than in shooting the curl. And once she has been awakened to heterosexual desire, Gidget embraces the feminine behaviors she had once rejected.

Surprisingly, while we may imagine the tomboy's newfound femininity to be accompanied by her sartorial shift from overalls to party dresses, as both Fiedler and *Gidget*'s theme song suggest, in fact the tomboy's transformation is not a matter of appearances alone. Gidget, for instance, undergoes no discernable change in appearance. She may have worn a baggy bathing suit, flippers, and a snorkeling mask on her first visit to the beach, but after that she appears in form-fitting suits that reveal her hourglass figure even before she transfers her affections from surfing to a surfer. Thus, while appearance is no guarantee of femininity, what does signal the tomboy's successful transformation into a feminine woman is her willingness to submit to male authority. Moondoggie's suitability as a partner for Gidget is demonstrated by his repeatedly rescuing her. First, he frees her from a bed of kelp in which she has become entangled and takes her to shore on his surfboard, introducing her to the thrill of surfing. The second time he rescues her from drowning, she discovers the thrill of attraction as he carries her to shore and tucks a blanket around her. However, it is not until his third attempted rescue, when Moondog-

gie imagines that she is being seduced by Kahuna (Cliff Robertson), that Moon-doggie begins to reciprocate her feelings, and the two are "pinned." In *Rose Marie*, the title character falls for an outlaw trapper when he rescues her from a runaway horse, and her transformation is signaled not by her donning a dress but by her asserting to the man whom she used to rebelliously bite and scratch, "Whatever you tell me, I will do." *Annie Get Your Gun* makes the terms of love explicit. Frank (Howard Keel) rejects Annie (Betty Hutton) until she allows him to win a shoot-ing match against her and thereby demonstrate his physical superiority. It would appear that the tomboy's submission to a man is a more important condition for love than is putting on a dress.

In this manner, the postwar tomboy film demonstrates that gender is not a product of clothing and hair style alone but is predicated on a set of behaviors that bolsters a system of male dominance and female submission, and within this gender system, femininity is required less for its own sake than it is in the service of reinforcing masculinity in men.[4] During the 1950s, it seems, men's refusal of middle-class heteronormativity seemed a greater threat than did female masculin-ity. During this period, white masculinity seemed to be threatened by the rise of corporate capitalism and suburban domesticity. Within corporate culture, traits historically associated with masculinity—aggressiveness, competitiveness, domi-nance—were a detriment to white-collar workers, while those associated with femininity—a willingness to submit to authority, responsiveness to the needs and opinions of others—were highly valued. As a result, white-collar work was felt to be antithetical to masculinity, and professional men turned increasingly to leisure activities to nurture a masculine identity. However, leisure time during the baby boom era was defined in terms of domesticity and consumerism, both of which were associated with femininity, thus further compromising 1950s' masculinity. Further, as Americans spent more money on consumer items, more and more married women entered the work force to help pay for the luxuries associated with middle-class suburbia, undermining the economic foundation of masculine dominance and feminine submission.[5]

In 1950s' tomboy films, such as *Gidget*, masculine girls are dangerous insofar as they fail to domesticate their male counterparts, who also rebel against the ideal of suburban domesticity. While the girls' transformations appear inevitable, the men's transformations remain uncertain until the final frames of the film, sug-gesting that it is far more difficult to coerce men than women into domesticity. In *On Moonlight Bay*, Bill avows that he does not believe in marriage until he goes overseas to fight in the war and realizes the value of what he had rejected. In marrying Spring, in *The Truth About Spring*, Archer chooses a life of monogamy and work as a lawyer in Philadelphia over a life of polygamous luxury, sailing the world on his uncle's yacht.

In his analysis of popular 1950s' literary and cinematic images of teenagers, Leerom Medovoi argues that these narratives of adolescence articulated dissatisfaction with domesticity and heteronormativity, creating a framework for the rebellions that would erupt into the identity politics of ensuing decades. In his analysis of *Gidget*, Medovoi points out that the film offers its characters several alternatives before Gidget and Moondoggie are coupled and acquiesce to heteronormativity at film's end. Gidget and Moondoggie are both attached to an older man, Kahuna, who has rejected domesticity and corporate culture, choosing instead to live the peripatetic life of a surf bum and adopt a non-white, quasi-Hawaiian identity. Moondoggie plans to drop out of college and accompany Kahuna on his travels along the coast of South America. Gidget, meanwhile, attempts to attract Moondoggie by seducing Kahuna. And all three characters have developed an intense passion for surfing, which, the film suggests, offers an autoerotic thrill akin to sexual passion. Like Gidget, the boys in Kahuna's band of surfers prioritize surfing over dating, and the film is replete with scenes in which Gidget, Moondoggie, and Kahuna smile ecstatically in close-up as they surf. Moondoggie's and Kahuna's acquiescence to the demands of middle-class masculinity is predicated on Gidget's embracing femininity; it is her transformation that makes them recognize the necessity of their assuming a domestic role.

These films suggest that social stability is reliant on girls' giving up the pleasures of childhood masculinity and assuming a feminine role. However, they also affirm that the tomboy's transformation into a feminine woman is as certain as the physical changes that accompany adolescence, while male domesticity must be actively enforced. Ultimately, the tomboy films of the 1950s are more concerned with the possibility that men might rebel against heteronormativity than they are with policing lesbian desire.

Forever Young

Why did the tomboy narrative change so profoundly in the 1970s? It is tempting to attribute this shift to the influence of second-wave feminism, as Judith Halberstam has done (*Female Masculinity* 188). After all, in many ways the tomboy seems to have been the poster child of the feminist movement. In 1972, through the efforts of feminist lobbyists, Title IX was passed, prohibiting sex-discrimination in schools that received federal funding. One result of this prohibition was that girls' sports began to receive more funding, and in some cases this even translated into allowing girls to play on otherwise all-male sports teams. That year, the founders of *Ms.* magazine collaborated with Marlo Thomas to produce *Free to Be You and Me*, which celebrated gender diversity in children, and each issue of *Ms.* magazine included "Stories for Free Children," excerpts from stories and poems that did not reproduce the gender stereotypes found in much mainstream fiction

for children. In 1974, the National Organization of Women (NOW) helped to win one of several lawsuits against the Little League, requiring the league to allow qualified girls to play on their teams. Imagining an androgynous future for their sons and daughters, second-wave feminists hoped to dismantle a gender system that celebrated male accomplishment and female passivity, to create ambitious daughters and nurturing sons.[6]

However, this feminist investment in tomboys does not adequately explain the radical readjustment of the tomboy genre during the 1970s. After all, this was not the first time that tomboyishness was encouraged in girls for the benefit of their adult selves. Sharon O'Brien has demonstrated that antebellum child-rearing advice literature of the previous century had also recommended "free, active untrammeled childhoods for little girls and even advocated tomboyism" since "an active tomboy would surely develop the resourcefulness, self confidence, and most important, the physical health required for motherhood" (352). And yet, during the antebellum period the tomboy's transformation was as central an element of her narrative as it was in the postwar tomboy films.

On the surface, the 1970s' tomboy films may have appeared to support feminist calls for gender equality. However, their underlying function was not to celebrate the new gender and sexual freedoms of the decade but to signal girls' status as innocent and pre-sexual in a culture where the rules about gender and sexuality were rapidly changing. The sexual revolution ushered in an era of unprecedented sexual freedom. However, anxiety about these new freedoms was often expressed in terms of concern over girlhood innocence. In *Paper Moon* (1973) young Addie (Tatum O'Neal) is a precocious, foul-mouthed child who smokes cigarettes and knows how to use childish charm to bilk widows out of their savings. She is knowledgeable about sex, though she herself remains innocently pre-sexual. Off-screen, ten-year-old Tatum O'Neal was equally precocious, attending nightclubs on the Sunset Strip and parties at the Playboy mansion before she was old enough to drive. Indeed, O'Neal was one of several children whose appearance on and off screen was at once troubling and titillating. Jodie Foster and Brooke Shields were 13 years old when they played prostitutes in *Taxi Driver* (1976) and *Pretty Baby* (1978) respectively. And Shields scandalized audiences when she appeared in a Calvin Klein commercial at the age of 15, asking provocatively, "Want to know what comes between me and my Calvins? Nothing." In the 1970s, such exhibitions of sexual knowledge suggested that childhood innocence was under threat.

This anxiety about the sexualization of children should offer a clue to the motivation of Amanda's reverse transformation in *The Bad News Bears*. The film is less a narrative of feminist empowerment than it is an expression of concern that children are growing up too fast. *The Bad News Bears* sidesteps any direct reference to the women's movement.[7] Ultimately, this is a film about protecting childhood from competitive adults and sexualized culture rather than a valoriza-

tion of masculinity in girls. As in the majority of Hollywood's tomboy narratives, Amanda's adoption of the accoutrements of femininity marks her passage into womanhood. However, she is only 11 years old. With Amanda's transformation back into a tomboy, *The Bad News Bears* does not so much suggest that tomboys should hold on to their masculinity forever as it does that they should hold on to their childhood for as long as possible. Similarly, *Freaky Friday* (1976) offers the promise of the tomboy's transformation while at the same time suggesting that it should happen later rather than sooner. In the film, tomboy Annabel (Jodie Foster) wakes up one morning to find herself occupying her mother's body, while her mother (Barbara Harris) is trapped in Annabel's body. Annabel revels in her new curves, trying on her mother's clothes and makeup, and flirting with the boy next door. The film hints at the transformation that was so central to postwar tomboy films only to delay Annabel's maturity, returning her to her own body at the end of the day.

The tomboy plays a similar role in *Little Darlings*. Like *The Bad News Bears*, *Little Darlings* addresses anxieties about the perceived foreshortening of childhood. However, in this case the girls are 15 years old and preoccupied by sex. Ferris and Angel, a tomboy, meet in summer camp and instantly dislike one another. Their animosity leads them into a competition to see which of them can lose her virginity first, which the campers euphemistically refer to as "becoming a woman." The film suggests that, in pursuing sexual experience, the two girls are wishing away their childhoods, wanting to "become women" too soon. Ferris's quest for the prize defloration leads her to one of the camp counselors, Gary (Armand Assante). He gently turns her down, cautioning her that she is over-romanticizing sex. As though to prove the point, Angel manages to seduce Randy and finds sex with him to be an unpleasant experience. The moral of the story is that both girls are too young to experience sexual pleasure, and they should stave off sex until they are older when, presumably, it will be more pleasurable. Thus the tomboy's transformation is not eliminated altogether; it is merely imagined to be postponed past the closing credits of the film.

In "Femininity and Adolescence," Barbara Hudson delineates the ways in which girls are caught between two competing discourses, the discourses of femininity and of adolescence, each of which contradicts the other (31), in part because adolescence has been largely imagined in terms of masculinity (35). This association of adolescence with masculinity would suggest that tomboyishness is interpreted as a marker of immaturity as much as it is one of gender rebellion, and girls' overtly feminine behavior is often interpreted as a sign of precocity.[8] Indeed, in *The Bad News Bears* Amanda's femininity is figured as dangerously precocious. When we see her initially, dressed in flowing skirts and an off-the-shoulder blouse, Amanda appears far older than her eleven years. Likewise, in *Little Darlings* it is the hyper-feminine girl, Cinder (Krista Errickson) who is perceived to be a prob-

lem, not the tomboy. Cinder's precocity is attributed to her career as a model, and it is signaled by her femininity. She is more concerned about her appearance than the other girls are and less interested in playing sports. It is Cinder who pushes Ferris and Angel into the competition to lose their virginity, dismissively observing that "some of us are women, and some are little girls" when she discovers that neither of them has had sex. By the film's end, however, all of the campers have rejected Cinder and her valorization of sex in favor of extending their childhood for another summer.

As in *Gidget* and *The Truth About Spring*, Angel's masculinity seems to be bound to her disinterest in boys; when a neighborhood boy suggests, "Why don't you slip me something nice?" Angel kicks him hard between the legs. However, unlike the postwar tomboy films, *Little Darlings* does not insist that the tomboy will discover heterosexual desire and transform herself into a feminine woman. To the contrary, when Angel does pursue a boy, it is because she is engaged in a competition, not because she is attracted to him. And her sexual experience prompts her to reject heterosexual love rather than embrace femininity. This might appear to suggest that the film offers a progressive examination of lesbian girlhood. However, within the framework of this film, Angel's masculinity and her rejection of heterosexuality do not signal an emerging lesbian identity. Rather, they point to her status as a child.

Second-wave feminists may have embraced the tomboy as a symbol of a future unbound by restrictive gender roles, and Hollywood may have tapped into the affirmation of tomboyhood that was taking place in the culture at large. Nonetheless, tomboy narratives of the 1970s no less than those of the postwar era define female masculinity as coterminous with childhood. In these tomboy films, the tomboy is celebrated not for her refusal to conform to gender expectations but because her masculinity seemed to signal her status as a pre-sexual girl. Ironically, it is precisely because these tomboy narratives are less concerned with regulating lesbian desire than they are with policing other aspects of sexuality—enforcing male heteronormativity and childhood innocence—that they speak so successfully to lesbian desire. Ultimately, however, the tomboy character could not function as a sign of childhood once the tomboy star became sexualized.

Little Darlings

In the 1950s, the tomboy's salient feature was her capacity to transform into a heteronormative young woman. In the 1970s, it was her status as a pre-sexual child that best spoke to adult concerns about children's place in an increasingly sexualized American culture, and the tomboy's transformation was no longer a necessary component of her narrative. However, in the case of *Little Darlings*, the tomboy was not up to the task of supporting the myth of childhood asexuality,

and today the film is better remembered as a tale of budding lesbian romance than as a call for teen abstinence.

In *Uninvited*, Patricia White examines the terms by which lesbian sexuality can be made visible in films made to conform to Hollywood's Production Code, which forbade representations of homosexuality.[9] In films that ask us to imagine that a female protagonist is without sexual desire—films about mothers and daughters, for example, or spinsters—audiences might read these women as merely lacking desire for men, in which case their bonds with other women invite a lesbian reading. Likewise, when we interpret the tomboy not to be lacking sexual desire but merely to be uninterested in boys, Code-era films become narratives of lesbian desire. *Calamity Jane*, for instance, has been widely read as a lesbian text (Merck; Savoy). Calamity's relationship with Katie (Allyn McLerie) suggests the possibility of lesbian domesticity, as the two women redecorate their shared cabin while singing of the transformative power of "a woman's touch." Calamity's age reinforces this reading. The film asks us to understand Calamity's masculinity as a product of her immaturity, sexual and otherwise, which she will outgrow once she is awakened to heterosexual desire. (Indeed, the film's reviewers regularly referred to her as a tomboy.) However, Doris Day brings a maturity to the role that belies the film's attribution of her character's masculinity to childishness and invites us to read Calamity as a butch woman. *Gidget*, too, has been subject to queer readings (Medovoi; Whitney). Gidget's boyish friend, BL (Sue George) suggests an alternative to heterosexual romance. Instead of joining the other girls on their "manhunt," Gidget and BL spend their summer days in Gidget's bedroom, where BL helps her friend practice surfing by vigorously shaking the bed as Gidget tries to keep her balance. Given the film's equation of surfing with sexual excitement, it is not a big leap to imagine them practicing other things as well.

In the case of the 1950s' tomboy film, as Creed has argued, the tomboy's transformation into a feminine woman ultimately works to reinforce heteronormativity; after exploring the pleasures associated with girlhood masculinity, the tomboy willingly trades in her freedom for heterosexual love. Thus, if audiences are to take the "Woman's Touch" sequence in *Calamity Jane* as an ode to lesbian cohabitation, they must ignore the film's ending in which Calamity discovers that she has been harboring a love for Bill Hickock all along. Likewise, Day's recording of "Secret Love" may have been appropriated by gay and lesbian audiences as a song about coming out of the closet, but within the context of the film Calamity is expressing her love for a man. Similarly, in *Gidget*, BL's visits to Gidget's bedroom are in the service of helping her friend land a date with Moondoggie. A queer reading of these films is necessarily a negotiated reading that requires audiences to ignore or overlook prominent narrative elements of the films (Doty; Ellsworth; Hall).

In the case of *Little Darlings*, however, a queer reading does not require the selective amnesia necessary for reading lesbian desire into earlier tomboy narratives. In fact, generic expectations and marketing work to encourage such a reading. Rather than signifying pre-sexual childhood, the tomboy had come to signal lesbian desire. Released over a decade after the Production Code had been replaced by the ratings system, *Little Darlings* takes every opportunity to titillate while remaining within the bounds necessary to earn an R rating. Nonetheless, meaning in this film is often as ambiguous as it is in the films of the Production Code era. The film explicitly introduces the possibility that Angel is a lesbian but leaves the answer to the question—is she or isn't she?—to the viewer's imagination. In the bathroom at a rest stop on the way to camp, Cinder declares that Ferris and Angel are "probably lezzies." Ferris responds by objecting, "Maybe she is, but I'm straight," but Angel, who thinks "guys are a pain in the ass," never does deny the charge. Instead, when Cinder repeats, "I think you're into girls," Angel angrily makes a grab for her breast. And Angel's actions throughout the film only confirm Cinder's suspicions. Once caught in the competition to lose their virginity (and, presumably, demonstrate their heterosexuality), Angel sets her eyes on Randy. Yet their pairing hardly signifies heterosexual desire. For one thing, they look remarkably alike. True to the androgynous style of the time, they wear their straight brown hair in similar styles, and both are introduced wearing black tank tops and blue jeans, though Randy sports a bandana in his right pocket. When they meet, Angel assumes the masculine position of "bearer of the look," while Randy is the feminine object of her erotic gaze (Mulvey). Indeed, in her review of the film, Maslin notes that "Mr. Dillon spends much of his time [in the film] bare-chested, and is presented as much more of a sex object than Miss McNichol. That's another of the movie's curiosities" (C15). Angel accordingly takes on the role of aggressor in seducing Randy, solidifying her masculinity and undermining his.

The narrative conventions of a teen romantic comedy dictate that Angel and Ferris will discover something about themselves that helps them to mature into adults. As we have seen, in tomboy films this self-discovery often involves heterosexual romance. In this case, the girls learn complementary lessons about sex. After sleeping with Randy, Angel learns that sex is more intimate than her mother had lead her to believe, while Gary teaches Ferris that she has too romantic a view of love. The conventions of a romantic comedy would lead us to expect that the two campers will apply this newfound knowledge to a mutually satisfying romance (Schatz).

Little Darling's structure reinforces this expectation. Cross-cutting during the opening sequence invites us to anticipate that the relationship between Ferris and Angel will be important to the film. When the girls finally do meet, true to the conventions of romantic comedy, they fight. Due to their animosity towards one another, the girls engage in a sexual competition that resolves in their forming a

bond. In the film's final sequence, Angel introduces Ferris to her mother ("This is my friend. My *best* friend."), and the film ends on a tight two-shot of the girls arm in arm. As one of the film's reviewers noted, "Essentially *Little Darlings* plays like an old Spencer Tracy/Katharine Hepburn story, except both roles are updated sexually and played by fifteen-year-old girls" (Cohen 22).

Further, despite the casting of teen heartthrob Matt Dillon as a romantic lead, *Little Darlings* rejects the possibility of heterosexual pleasure for girls. Angel finds sex with Randy to be unsatisfying, though it is never entirely clear why. At fifteen, he may not be the most skilled of lovers, but he does genuinely care for Angel. And she doesn't appear to have encountered any physical pain during sex, a fear that preoccupies many teenage girls before they have intercourse. The only explanation seems to be that Angel is not aroused, despite Matt Dillon's manifest sex appeal. Within the terms of the film, we're meant to understand that fifteen-year-old girls are incapable of enjoying sex. However, marketing for this raunchy sex comedy encouraged a different reading.

Publicity for *Little Darlings* reinforces a lesbian reading by highlighting the relationship between Angel and Ferris, downplaying their pursuit of Gary and Randy. One-sheets and print advertisements feature O'Neal and McNichol sitting back-to-back and smiling above a tag line that reads, "Don't let the title fool you." One promotional lobby card features photos of O'Neal and McNichol broadly smiling, O'Neal's arms around McNichol's shoulders, McNichol's arms around O'Neal's waist. Another pictures the bikini-clad girls arm in arm, smiling directly into the camera. By contrast, in publicity photos featuring Dillon and McNichol, the two glumly eye one another, a significant distance between them. In this way, the film's advertising invites audiences to consider the possibility that this R-rated sex comedy would offer a titillating glimpse of lesbian sex rather than a lesson in abstinence.

Further, McNichol's off-screen identity in the early 1980s was as tomboyish as her on-screen one, if not more so, which worked to reinforce the film's lesbian reading. McNichol rose to stardom through her role as the tomboy, Buddy, on ABC's *Family* (1976–1980), and her publicity tended to play up her status as a tomboy off-screen as well as on. She often appeared in the pages of *Tiger Beat* and *Teen Beat* magazines on a skateboard, dirt bike, or even a speed buggy. While Doris Day's and Sandra Dee's glamorous and feminine star images worked to assure audiences that Calamity Jane and Gidget would eventually succumb to heteronormative femininity, McNichol's masculinity off-screen suggested the possibility of an adult, butch identity for Angel.

In *Little Darlings*, unlike the Code-era films, the tomboy does not capitulate to heteronormative adulthood, and a lesbian reading is as viable as one that asks us to imagine that girls are incapable of experiencing sexual pleasure before they've turned twenty-one. And rather than enforce a heterosexual reading, the film's

publicity worked to encourage the expectation that this "leering and exploitative" (Faber) sex comedy would celebrate sexuality rather than abstinence. And for some, the film delivered on this promise. Writing for the *Village Voice*, sex columnist Tristan Taormino recalls that the film led her to associate summer camp with sexual experimentation: "After I saw teenagers Tatum O'Neal and Kristy McNichol in *Little Darlings* (the perfect butch–femme dyke couple), I couldn't wait to go [to camp]—not to lose my virginity to Matt Dillon, but to have a sexy slumber party with those two cuties" (Taormino 156). Nonetheless, the tomboy's masculinity was understood to be temporary, a sign of her immaturity.

Conclusion

Clearly, the tomboy film changed significantly in the 1970s via films like *Paper Moon, The Bad News Bears,* and *Freaky Friday.* Whereas the tomboy's transformation into a feminine woman had once been a defining feature of the genre, the tomboy is no longer expected to relinquish the freedom associated with her masculine childhood. However, within the terms of the narratives themselves, the unreformed tomboy does not represent a threat to the dominant gender system. Rather, her masculine traits signal her immaturity. It is precisely because the association between the tomboy's masculinity and her immaturity is so strong that tomboy narratives so effectively assure that femininity is natural and inevitable for women and that gender fluidity is coterminous with childhood; the tomboy's gender rebellion is understood to be a natural part of growing up, and her metamorphosis into a feminine woman is imagined to be as inevitable as the physical changes that attend puberty. In the 1950s, when fears about men's unwillingness to assume the role of breadwinner played a prominent role in public discourse, these narratives of the tomboy's transformation helped to provide reassurance that young men would eventually settle on domesticity, just as the tomboy would inevitably renounce the pleasures of girlhood masculinity in favor of marriage and domesticity. In the 1970s, the tomboy's transformation was not a necessary element of the narrative because concerns about teenagers' sexual precocity seemed far more pressing than fears about gender conformity. By delaying the tomboy's transformation past film's end, 1970s' movies signaled that childhood could be prolonged, innocence maintained. However, while the films may have encouraged an understanding of girlhood masculinity as asexual, audiences have not read the tomboy's lack of heterosexual desire as a sign that she is pre-sexual. Instead, in the case of *Little Darlings*, the tomboy narrative speaks to lesbian desire in a manner that mainstream Hollywood had previously failed to offer.

The 1970s' tomboy vogue did not survive into the 1980s. The year of the release of *Little Darlings*, 1980, marked the dawn of the Reagan era, when the backlash against sexual and gender radicalism of the 1970s began to be felt. That same

year, the American Psychiatric Association added Gender Identity Disorder to the *Diagnostic and Statistical Manual of Mental Disorders*, instructing psychiatrists to interpret children's transgendered behavior in terms of psychopathology.[10] And in 1981, the popular "tomboy" tennis star, Billie Jean King, came out as a lesbian when her lover sued her for alimony. Perhaps a bigger contributor to the decline of tomboy stars and films, though, is the fact that *Little Darlings* did not do very well at the box office. *Foxes* (1980), which also featured tomboys, also did poorly that year. It is likely that film producers and distributors of this period determined that there was no market for films that explored relationships between girls.[11] Four years later, the release of *Sixteen Candles* (1984) launched a new cycle of teen films that downplayed girls' friendships in favor of stories about burgeoning heterosexual desire. Yet the tomboy was not altogether absent from this cycle. In *Some Kind of Wonderful* (1987), Watts (Mary Stuart Masterson) is a punk tomboy who watches from the sidelines as her male best friend falls for one of the popular girls, all the while wishing he would choose her instead.[12]

For the most part, tomboy narrative and tomboy stars no longer hold as central a place in the contemporary popular imagination as they once did. The rise of independent films in the 1990s introduced more nuanced representations of tomboys in films like *The Incredibly True Adventure of Two Girls in Love* (1995) and *Girlfight* (2000), and lesbian sexuality is no longer hidden behind innuendo in such films as *The Incredibly True Adventure . . .* , *All Over Me* (1997), and *The Runaways* (2010). Mainstream Hollywood, however, continues to imagine the tomboy as caught in an eternal childhood in films like *Blue Crush* (2002).

With or without the once requisite transformation of the tomboy, these contemporary films imagine adolescence to be a period of impermanence, a time of experimentation before girls assume adult gender and sexual roles. This permits a certain freedom in terms of what can be represented in mainstream Hollywood film, but it does so at the expense of reinforcing the association between queer identities and immaturity in a society that has not traditionally conferred the full rights of citizenship or sexual freedom on adolescents or homosexuals.

Notes

1. See, for example Murray; Olson; and Tracey and Pokorny.
2. While contemporary viewers might identify figures like Annie Oakley and Calamity Jane as butch women, within 1950s' discourse they were described as tomboys. This terminology worked to desexualize these masculine women while also marking their difference from their more traditionally feminine counterparts. This technique of marking masculine women as asexual, and thus unthreatening, continued as late as the 1980s, when tennis star Billie Jean King was popularly described as a tomboy before she came out as a lesbian.

3. This analysis does not address films about pre-adolescent tomboys, such as those starring Shirley Temple or Jane Withers in the 1930s.

4. This analysis is indebted to Bailey's examination of the "etiquette" of masculinity and femininity in postwar culture.

5. Gender and sexuality in post-war America have been the subject of a great deal of scholarship. For accounts that relate these changes specifically to adolescence, see Bailey and Medovoi.

6. Interestingly, despite this emphasis on raising daughters who would not be bound by the same gender expectations that had constrained their mothers, feminist activists of this period did not perceive girls to be active participants in the feminist movement (Kearney).

7. The Bears have been admitted into the league only because a judge determined that every child has the right to play baseball, regardless of his or her level of ability. In this way, the film alludes to the court decision that forced the Little League to accept girls while reframing the controversial ruling as a victory for incompetent players rather than one for girls.

8. In "Oh! Bondage Up Yours" and *Female Masculinity*, Judith Halberstam argues against this normalizing view of female masculinity. Rather than understanding female masculinity as a transitory stage in female development or as a mere shadow of male masculinity, she demonstrates that female masculinity can signify a radical refusal of heteronormativity that is as significant a permutation of masculinity as any other (working-class masculinity, black masculinity, white, middle-class masculinity).

9. The Production Code, which was enforced between 1934 and the mid-1960s, outlined a philosophy and a set of practices designed to forestall boycotts and government censorship. As Richard Maltby argues, the Code's restrictions necessitated that audiences engage in actively seeking out the meanings that remained hidden in the films' ellipses. Under the Production Code, "if plots had to be morally unambiguous in their development, dialogue, and conclusion, the site of textual ambiguity shifted from narrative to the representation of incident, in a manner that required the audience to construct an event that may or may not have taken place. . . . Textual indeterminacy became a feature of Hollywood's representation of sexuality, emerging in complex and oblique codes that resembled neurotic symptoms or fetishes" (Maltby 65–66).

10. See Sedgwick and Halberstam, "Oh! Bondage Up Yours," for extended discussions of the emergence of this psychiatric discourse

11. The same was not true of television. *The Facts of Life* (1979–1988), a half-hour sit-com that focused on a group of boarding-school girls and featured a tomboy character (Nancy McKeon) and her femme nemesis (Lisa Whelchel), ran for nearly a decade on NBC.

12. While the film offers a vision of unreformed, tough girlhood, it forestalls the lesbian subtext that propelled earlier tomboy narratives. Like Angel in *Little Darlings*, Watts is accused of being a lesbian, but in this case, the audience already knows that she is in love with Keith (Eric Stoltz). And, unlike An-

gel, she never establishes a relationship with her femme rival, Amanda (Lea Thompson). The film does include a sequence in which Watts, clad in boxer shorts and an undershirt, looks across a steamy locker room and watches Amanda undress. The camera glides in slow motion towards Amanda's body as Watts looks longingly at the woman her best friend desires, until her reverie is interrupted by the taunting of the other girls when they notice that she's wearing men's underwear. Watts' desiring look, her masculinity, and the teasing of the girls in the fraught space of the girls' locker room evoke experiences of lesbian teens, but the sequence remains untethered to the narrative, which is otherwise preoccupied with unrequited heterosexual love.

Works Cited

All Over Me. Dir. Alex Sichel. Perf. Alison Folland, Tara Subkoff. Fine Line Features, 1997.

Bailey, Beth. *From Front Porch to Back Seat: Courtship in Twentieth-Century America.* Baltimore: Johns Hopkins University Press, 1989.

The Amazons. Dir. Joseph Kaufman. Perf. Marguerite Clark. Famous Players, 1917.

Annie Get Your Gun. Dir. George Sidney. Perf. Betty Hutton, Howard Keel. MGM, 1950.

Billie. Dir. Don Weis. Perf. Patty Duke, Jim Backus. United Artists, 1965.

Blue Crush. Dir. John Stockwell. Perf. Kate Bosworth, Michelle Rodriguez. Universal Pictures, 2002.

The Boy Girl. Dir. Edwin Stevens. Perf. Violet Mersereau. Universal Film Manufacturing Company (as Bluebird Photoplays), 1917.

Brickman, Barbara. "The Queer Kid and Women's Lib." Society for Cinema and Media Studies annual conference. Los Angeles, CA. 18 Mar. 2010. Unpublished paper.

Calamity Jane. Dir. David Butler. Perf. Doris Day, Howard Keel. Warner Bros., 1953.

Cohen, Dean. "Hot Movies." *Playgirl* July 1980. 23–24, 89.

Creed, Barbara. "Lesbian Bodies: Tribades, Tomboys, and Tarts." *Sexy Bodies: The Strange Carnalities of Feminism.* Eds. Elizabeth Grosz and Elspeth Probyn. New York: Routledge, 1995. 86–103.

Doty, Alexander. *Making Things Perfectly Queer: Interpreting Mass Culture.* Minneapolis: University of Minnesota Press, 1993.

Ellsworth, Elizabeth. "Illicit Pleasures: Feminist Spectators and *Personal Best.*" *Issues in Feminist Film Criticism.* Ed. Patricia Erens. Bloomington: Indiana University Press, 1990. 183–96.

Faber, Stephen. "Untitled." *New West* April 7 1980.

The Facts of Life. Perf. Nancy McKeon, Lisa Whelchel, Kim Fields, Mindy Cohn. NBC 1979–1988.

Family. Perf. Sada Thompson, James Broderick, Kristy McNichol. ABC 1976–1980.

Fiedler, Leslie A. *Love and Death in the American Novel.* New York: Anchor Books, 1992.

Freaky Friday. Dir. Gary Nelson. Perf. Jodie Foster, Barbara Harris. Walt Disney Productions, 1976.

Gidget. Dir. Paul Wendkos. Perf. Sandra Dee, James Darren, Cliff Robertson. Columbia Pictures, 1959.

Girlfight. Dir. Karyn Kusama. Perf. Michelle Rodriguez. Independent Film Channel, 2000.

Halberstam, Judith. *Female Masculinity.* Durham: Duke University Press, 1998.

———. "Oh Bondage, Up Yours!" *Sissies and Tomboys: Gender and Nonconformity and Homosexual Childhood.* Ed. Matt Rottneck. New York: New York University Press, 1999. 153–79.

Hall, Stuart. "Encoding/Decoding." *Culture, Media, Language: Working Papers in Cultural Studies, 1972–79.* Eds. Stuart Hall, Dorothy Hobson, Andrew Lowe, and Paul Willis. New York: Routledge, 1991. 107–16.

Hudson, Barbara. "Femininity and Adolescence." *Gender and Generation.* Eds. Angela McRobbie and Mica Nava. New York: Macmillan, 1984. 31–53.

The Incredibly True Adventure of Two Girls in Love. Dir. Maria Maggenti. Perf. Laurel Hollomon. Fine Line Features, 1995.

Kearney, Mary Celeste. "Coalescing: The Development of Girls' Studies." *NWSA Journal* 21.1 (2009): 1–28.

Little Darlings. Dir. Robert Maxwell. Perf. Kristy McNichol, Tatum O'Neal. Paramount, 1980.

Maltby, Richard. "The Production Code and the Hays Office." *Grand Design: Hollywood as a Modern Business Enterprise, 1930–1939.* Tino Balio. Berkeley: University of California Press, 1993. 37–72.

Maslin, Janet. "Screen: Little Darlings a Rite-of-Passage Comedy." *New York Times* 19 Mar. 1980, sec. C: 15.

Medovoi, Leerom. *Rebels: Youth and the Cold War Origins of Identity.* Durham: Duke University Press, 2005.

The Member of the Wedding. Dir. Fred Zinnemann. Perf. Julie Harris, Ethel Waters. Columbia Pictures, 1952.

Merck, Mandy. "Travesty on the Old Frontier." *Move over Misconceptions: Doris Day Reappraised.* Eds. Jane Clark and Diana Simmons. London: BFI, 1980. 21–28.

Mulvey, Laura. "Visual Pleasure and Narrative Cinema." *Visual and Other Pleasures: Theories of Representation and Difference.* Bloomington: Indiana University Press, 1989. 14–28.

Murray, Raymond. *Images in the Dark: An Encyclopedia of Gay and Lesbian Film and Video.* New York: Plume, 1996.

O'Brien, Sharon. "Tomboyism and Adolescent Conflict: Three Nineteenth-Century Case Studies." *Woman's Being, Woman's Place: Female Identity and Vocation in American History*. Ed. Mary Kelley. Boston: G. K. Hall, 1979. 351–72.

Olson, Jenni. *The Ultimate Guide to Lesbian and Gay Film and Video*. New York: Serpent's Trail, 1996.

Paper Moon. Dir. Peter Bogdanovich. Perf. Tatum O'Neal, Ryan O'Neal. Paramount Pictures, 1973.

Pretty Baby. Dir. Louis Malle. Perf. Brooke Shields, Susan Sarandon, Keith Carradine. Paramount Pictures, 1978.

Quimby, Karin. "The Story of Jo: Literary Tomboys, Little Women, and the Sexual-Textual Politics of Narrative Desire." *GLQ: A Journal of Lesbian and Gay Studies*, 10.1 (2003): 1–22.

Rose Marie. Dir. Mervyn LeRoy. Perf. Ann Blyth, Howard Keel. MGM, 1954.

The Runaways. Dir. Floria Sigismondi. Perf. Kristen Stewart, Dakota Fanning. Apparition, 2010.

Savoy, Eric. "'That Ain't *All* She Ain't': Doris Day and Queer Performativity." *Out Takes: Essays on Queer Theory and Film*. Ed. Ellis Hanson. Durham: Duke University Press, 1999. 151–82.

Schatz, Thomas. *Hollywood Genres: Formulas, Filmmaking, and the Studio System*. New York: McGraw-Hill, 1981.

Sedgwick, Eve Kosofsky. *Tendencies*. Durham: Duke University Press, 1993.

Straayer, Chris. *Deviant Eyes, Deviant Bodies: Sexual Re-Orientations in Film and Video*. New York: Columbia University Press, 1996.

Sylvia Scarlett. Dir. George Cukor. Perf. Katharine Hepburn, Cary Grant. RKO, 1935.

Taormino, Tristan. "Kinky Summer Camp." *Village Voice* 18 June 2002. Web. 18 Oct. 2010.

Taxi Driver. Dir. Martin Scorsese. Perf. Jodie Foster, Robert DeNiro. Columbia Pictures, 1976.

Thomas, Marlo. *Free to Be You and Me*. New York: Running Press Books, 1974.

Times Square. Dir. Allan Moyle. Perf. Trini Alvarado, Robin Johnson, Tim Curry. Robert Stigwood Organization, 1980.

The Tomboy. Dir. David Kirkland. Perf. Herbert Rawlinson, Dorothy Devore. Chadwick Pictures, 1924.

Tracey, Liz and Sydney Pokorny. *So You Want to Be a Lesbian? A Guide for Amateurs and Professionals*. New York: St. Martin's Griffin, 1996.

The Truth About Spring. Dir. Richard Thorpe. Perf. Hayley Mills, John Mills, James MacArthur. Universal Pictures, 1965.

White, Patricia. *Uninvited: Classical Hollywood Cinema and Lesbian Representability*. Bloomington: Indiana University Press, 1999.

Whitney, Allison. "Gidget Goes Hysterical." *Sugar, Spice, and Everything Nice: Cinemas of Girlhood*. Eds. Frances Gateward and Murray Pomerance. Detroit: Wayne State University Press, 2002. 55–71.

This Tween Bridge over My Latina Girl Back: The U.S. Mainstream Negotiates Ethnicity

Angharad N. Valdivia

How can we—this time—not use our bodies to be thrown over a river of tormented history to bridge the gap? . . . I cannot continue to use my body to be walked over to make a connection,
— Cherríe Moraga, *This Bridge Called My Back* (xv)

In 1981 Gloria Anzaldúa and Cherríe Moraga co-edited the now classic and canonical *This Bridge Called My Back: Writings by Radical Women of Color*. Seen now as an opening salvo for cross-ethnic alliances among feminists, the book included essays by and about Chicanas, African American, Asian American, and Native American women.[1] Its cover included the outline of a nude woman on all fours, whose head is cut off by the left-hand side of the book but whose back visually anchors the metaphor of the bridge at the level of the body or "theory in the flesh," the concept deployed by Moraga within the book. Twenty-eight years later, collections about women of color and lesbian women are much less unusual than Anzaldúa and Moraga's collection was at the time of its publication.[2] As a relative newcomer to the fields of Gender, Feminist, and Women's Studies, Girls' Studies inherits this complex and intersectional history. Girls, like women, come in a range of ethnicities. It behooves Girls' Studies scholars to remember the clarion call issued by Anzaldúa and Moraga in 1981. Whose back carries the burden of symbolic and material connections between women, and now, between girls? Who performs a bridge function between whom? What are we bridging over? What are the ramifications of being the bridge? Where does the bridge go?

Moraga and Anzaldúa directed our attention to the experience and writings by and about Chicanas. In the contemporary situation, I want to take up the bridge metaphor as it applies to Latina girls and Latinidad in popular culture to explore the ongoing categorization of young women and girls as ethnicized and differentially valued subjects. In 2010 we are facing a dynamic and changing national situation. The last fifteen years have proven to be decisive in foregrounding the changing composition of ethnicity in the United States. Three elements—census data, a Latina/o cultural boom, and the gendered tweening of U.S. popular culture—coalesce to redirect our attention to the location of Latina girls in popular culture. Since the 2000 Census, Latina/os are acknowledged to be the largest racial minority group in the country, surpassing African Americans, who had historically held that position. Preceding that demographic discovery, a Latina/o cultural boom, partly generated by Selena's posthumous cross-over in 1996 as well as Ricky Martin's and Jennifer Lopez's rises to fame in the last few years of the previous millennium, had already begun to bring to the fore celebrity Latina/os and the presence of Latinidad within the U.S. nation-space. Indeed Deborah Paredez astutely claims that the Latina/o boom exploded over Selena's dead body. *Selena* (1996) the movie begins with the girl-child Selena as she becomes a major musical act in Tejano culture and is poised to cross over into the white mainstream. Alas, Selena did not live to experience her posthumous cross-over as a result of the hit movie. The bridge and Latina body that carried this boom over turbulent waters to the mainstream were Jennifer Lopez and her bootie in a move that revises Anzaldúa and Moraga's metaphor to "this bridge called my bootie."[3]

A third element of the contemporary moment that is relevant to the themes of this collection, perhaps more evidently than the other two, is the "tweening" of mainstream U.S. popular culture. Media programming and product merchandising address the pre-teen girl consumer in both gendered and ethnicized ways. Indeed, much of the Disney television channel's success can be linked to its pursuit of the tween audience and its multiracial components (Valdivia, "Mixed Race"). In fact, the newest Disney star, Selena Gomez, a sixteen-year-old Mexican American named one of the fifty most beautiful Hispanic celebrities by *People en Español* in April 2009, was named after that other Selena, the cross-over star that ushered in the latest wave of the Latina/o boom.

U.S. popular culture has begun to include a variety of (potentially) Latina girls in its branded approach to synergistic distribution. Drawing on a perspective of hybridity and relationality, this chapter explores a range of locations in popular culture, such as girl movies, girl television, and mediated doll lines—that is, dolls based on successful media properties or vice versa—where the mainstream marketing of and to the Latina and other tweens constructs a subtle and ambiguous ethnicity that is palatable to the dominant culture while also appealing to ethnic audiences. The study of Latina girls in popular culture has to be carried

out, within a Media Studies framework, in concert with the ongoing research about narratives of Latinidad, the process of being, becoming, and performing a Latina/o identity. The location of Latinidad as an in-between category that mediates the white normativity of the mainstream against the still-threatening (to the mainstream) demands for inclusion from the historically longstanding black populations places it as a strategic bridge in continuity with Anzaldúa and Moraga's now classic anthology: Latina girls are the bridge over whose backs and booties ethnicity is currently negotiated in this U.S. mainstream.

Ethnicity, Bridges, and Hybridity in Popular Culture

Ethnic bridges are not a new thing in mainstream U.S. popular culture. One of the predominant ways in which African Americans are represented is in "comic relief" roles. Since African Americans have been more likely to appear in sports and comedic genres within television, they also often played the role of bridge between two white characters who might have been discussing a serious issue (MacDonald). As such the African American character not only provided comedy but also served a diffusion function in terms of tension and possible disagreement among white folk. A classic example of this character was Anthony Bouvier, played by Meshach Taylor, in the long running hit series *Designing Women* (CBS 1986-1993). Anthony often mediated between Julia, the older and wiser matriarch, and Mary Jo and Suzanne, both younger and less diplomatic. In film and television shows African American characters have often played the buddy role and provided a comic bridge between the protagonist and whatever situation there is to be resolved.

In the new millennium movies and television shows are increasingly populated by tween girls, some of whom perform the ethnic bridge role. What *Seventeen* magazine has known since 1944 has been transported into the rest of mainstream popular culture—it pays to target tween girls through media, with whatever gender-specific messages, such as consumption and shame, generate profits (Merskin). As Sarah Projansky notes, "The fact that U.S. popular culture pays attention to girls is certainly not a new phenomenon. . . . [R]epresentations of girls have significantly intensified since the mid-1980s" (189). While the tween target audience has existed since at least the sixties, its prominence and multicultural component are more recent (Valdivia, "Mixed Race"). The so-called post-feminist moment targets girls through messages of empowerment, solidarity, consumerism, and individualism—an internally contradictory set of messages that have been a mainstay of mainstream media representations of women (Banet-Weiser).

The new ethnic sensibility permeating contemporary U.S. popular culture also includes ethnic diversity in girl media vehicles. Whereas mainstream representations of girls used to be mostly white, a revised dominant whiteness with

small black elements in the 1990s has morphed again to a palette including a range of ethnicities, culminating with the contemporary white-to-ambiguous ethnic palette. The latter representation of ethnicity displaces or erases skin darkness from popular culture. Instead, a light brown Latinidad, often subtle enough to be ambiguous, can appeal to a broad range of global ethnicities from white to black with all in-betweens—Latina/o, Native, Asian, Middle Eastern—included. This ethnic ambiguity is nonetheless unambiguously ethnic—that is, we might not know exactly the ethnicity of the character, but we do know that the character is ethnic (Valdivia, "Geographies").

Communication scholars such as Marwan Kraidy urge us to consider hybridity as an additional element of contemporary U.S. identities ("Hybridity"; *Hybridity*). Isabel Molina Guzmán and Angharad Valdivia have examined the use of the Latina body as a malleable hybrid that can appeal to a broad range of audiences. Jennifer Lopez, for instance, can play a range of ethnicities including Latina, as she is light enough to be white but dark enough, with a bootie to match, to be ethnic. Her roles position her as a bridge between cultures and ethnicities. Helene Shugart warns that hybridity in contemporary popular culture, especially in relation to Latinidad,[4] is ultimately deployed so as to shore up whiteness as hegemony. This argument could be recast in a bridge perspective as light Latinidad serves as the bridge back to hegemonic whiteness as the norm.

Contemporary Girl Popular Culture

While there is a huge range of mediated product lines targeted at girls in the contemporary marketplace, I have chosen a few items as representative of the above mentioned tendency: mediated doll lines, including American Girl, Dora the Explorer, and Bratz; contemporary girl films, such as *Blue Crush* (2002) and *Sisterhood of the Travelling Pants* (2005); and Disney girl television, especially *The Cheetah Girls* (2003, 2006, 2008) and *The Wizards of Waverly Place* (2007–). All of these media vehicles foreground girls, are easily available in the mainstream, and serve to synergistically circulate other products aimed at the tween market, ranging from traditional media, such as books, television shows, movies, popular music, and digital games, to a broader range of products, such as clothing, makeup, food, and furniture. Beyond particular products, these media vehicles circulate narratives of girlhood that include normative visions of femininity, class, nation, and sexuality as well as the possible spectrum of difference allowable within the mainstream. All of these media either include a subplot of difference or make it a central element of the narrative. Difference is negotiated through an explicit range of ethnicities within the universe of the particular media product or in relation to other products available and known to be in the marketplace. Latinidad is the difference, the bridge that serves to link whiteness to color, and "normal" to

"other." Given the synergistic tendencies within contemporary media, all of the girl products analyzed in this essay appear in the three locations of marketing: doll lines, television, and movies. Nonetheless they are discussed within the category in which they were introduced into the marketplace.

Mediated Doll Lines

Highly profitable mediated doll lines, such as American Girl, Dora the Explorer, and Bratz, incorporate hybridity and Latinidad. Their circulation through television, film, books, and online chat rooms informs a discursive formation of gender and ethnic identity. Unsettling Barbie's five-decade reign, these three mediated doll lines challenge the narrative and the profit line of the previously dominant doll whose suburban whiteness and femininity reigned supreme in the U.S. marketplace, despite the occasional Barbie of color. Barbie's signature whiteness and hyper-feminine sexuality stand in stark contrast to these three doll lines. American Girl began as a media and doll line simultaneously. Dora the Explorer began as a television show by the same name (Nickelodeon 2000–)[5] and branched out into other media and a huge range of products. Currently Dora has grown into a cute tween with much more hair and clothing style than her younger counterpart. Given the profitability of the brand, she seems poised to grow up with her audience much like the Olsen twins of an earlier decade.[6] (Because Dora the Explorer began as a television series, I will explore that property when addressing other TV shows below.) Bratz began as a doll line and has branched out into media through television, movies, and books, as well as a generalized range of products.

The American Girl dolls were created in 1986 as an explicit alternative to Barbie, which Pleasant T. Rowland, the company's founder, thought too sexualized, and Cabbage Patch dolls, which she found too simplistic. The original American Girl dolls were white and firmly ensconced within Eurocentric histories, the marketing approach being one of releasing a doll with an accompanying book set in a historical time. The mediated doll line thus combined a pedagogically grounded history with a gender sensitive agency—girls as the agents of history. In 1992 Addy, an African American doll, was introduced, and later in 1997, Josefina, a Mexican doll, joined the other American Girls. Of note is that unlike the other American Girl dolls, Josefina was the only one whose history located her outside the U.S. national space, thus reiterating the characterization of U.S. Latinas/os as eternal outsiders.[7]

One of American Girl's other doll lines is "Girl of the Year," whose accessories are retired after twelve months and thus become more valuable on alternative marketing sites, such as eBay. In 2005 American Girl angered the Latina/o community following the introduction of Girl of the Year Marisol "Born to Dance" Luna whose narrative had her moving out of her Pilsen neighborhood in Chicago

and into a "better" situation.[8] American Girl did not directly answer the resulting outcry from a number of Latina/o organizations, though subsequent Girls of the Year have become progressively whiter. Jessie, 2006 Girl of the Year, is of Japanese and Irish American background and seems to have been a transition girl from the more ethnically coded and potentially problematic Marisol on the way to the safe whiteness of most of the other American Girls. American Girl has steered away from ethnicity by placing its subsequent Girls of the Year, Nicki (2007), Mia (2008), and Chrissa (2009), firmly and unambiguously within whiteness. Although these girls have ethnic friends—one of Chrissa's friends is Sonali, an Indian American girl—the protagonist girls are white.

Marisol and Josefina, the two Latin/a American Girls provided a bridge role within the doll series. To be sure, Josefina followed the introduction of African American Addy and ushered the introduction of Native American Kaya. Those three historical characters have remained the enduring ethnics within this doll line. Marisol Luna brought ethnicity into the Girl of the Year universe only to exit into hybrid Jessie and the return to whiteness with the rest of the dolls in that series. While these girls may have ethnic buddies, since Marisol, American Girl has not produced an ethnic main character. The troubled waters under that bridge were too turbulent for the company's mainstream marketing approach. Hybridity was attempted on the transition back to a safe whiteness only after Marisol ushered in a wave of Latina/o outcry. The company's only remaining Latina doll, Josefina, remains safely encoded in the historical past and outside the nation space. American Girl's history impels us to engage with the conditions under which ethnicity is made safe by being firmly located in the past.

Bratz, the second mediated doll line, is intrinsically hybrid, containing ambiguous Latinidad so subtle that it can be harnessed to represent any, all, or no difference. Introduced in 2001 by MGA Entertainment, Bratz dolls were meant to compete with Barbie via an updated aesthetic. Bratz have huge heads, large lips, lots of hair, small torsos, curvy full hips, and (slightly unnerving) snap-on feet with painted on shoes or boots. The Bratz dolls include Jade, an ambiguously named hybrid Latina; Cloe, the most white of the four; Sasha, nearly African American; and Yasmin, somewhat Asian. Bratz are a reaction to and rejection of Barbie. Their hip-hop clothing style and implicit location are decidedly contemporary urban. One of their original accessories was a chunk of a brick graffiti wall. Much like Disney's princesses of color, their hair is huge and takes a life of its own (Lacroix). Bratz dolls look more like Beyoncé and Jennifer Lopez than the Grace Kelly look of Barbie. Their staging forms a bridge between the main character in *Ugly Betty* (2006–2010)[9] and the ambiguously ethnic representations of Jennifer Lopez. Bratz and Lopez muddle ethnicity but remain inescapably different and brown.

MGA Entertainment's marketing logo for the Bratz dolls is "girls with a passion for fashion," thus co-opting hip-hop's social justice impetus towards a consumerist goal ensconced in the language of girls and consumerism. They are the poster girls of post-feminism, highly independent with attitude or rather "brattitude," with subtle racial hybridity thrown in for good measure. The radical hybridity of these dolls is nonetheless articulated via familiar ethnic categories. The ethnic brownness of most Bratz dolls renders them potentially Latina. Yet the dolls' website and their transition into feature-length movie stardom have morphed their look into straight hair and almond shaped eyes, making them very similar to each other, all of them possibly and ambiguously Latina. Those subtle signifiers of difference may not resonate with their target audience (Acosta-Alzuru and Kreshel). Nevertheless, Jade performs her Latinidad in *Bratz: The Movie* (2007) through her proclivity for dance and the fact that she appears to have a mariachi band living in her kitchen (Puig 2007).

Bratz, like the other two mediated doll lines, exposes the internal contradictions of marketing to a tween girl audience through representations of active and assertive girls while simultaneously commodifying and sexualizing them at an increasingly younger age. Much of the reaction to Bratz dolls focuses on their sexuality and generates a moral panic. Still their "brattitude" coincides with the representation of ethnic girls, including Latinas, as physical and pushy in other mainstream media (Valdivia, "Living"). Whereas assertiveness can be coded as positive, its slippage into "brattitude" places it within the racialized realm of behavioral problems. These hybrid girls are tamed when they cross into Hollywood film; they are made more assimilable and therefore commodifiable for a mainstream audience.

Television Girls

Television tween girls hail from a diverse set of origins. Dora the Explorer originated as a children's television series, which became a mediated doll line with all the synergistic options explored, including the protagonist growing up to tween age with her audience via a feature-length film. Some tween-oriented made-for-TV or Hollywood movies build on a pre-existing line of novels.[10] These novels are mentioned only to the extent that the difference between the written and the audiovisual serves to illustrate the mainstreaming tendencies within televised girl culture. Some Disney television girls ride the line of ethnic ambiguity as they are launched into an expanding terrain of performance.[11] Nevertheless, television tweens now include ethnicity in general and Latina specificity and ambiguity in particular.

Dora the Explorer, which began as a television show in 2000 on the Nickelodeon cable television network, was also broadcast by CBS television (2003–2006)

and quickly expanded to other media as well as a huge collection of products ranging from clothing to furniture, food, toys, linen, and draperies (Guidotti-Hernández; Harewood and Valdivia). The basic premise of this show foregrounds Dora as an explorer of an island. Whereas American Girl dolls are encoded into traditional paradigms of ethnicity, Dora is ambiguously encoded within Latinidad but is unambiguously Latina. Dora resides on a deterritorialized island with elements from the Mexican American and tropical narratives of Latinidad. The latter paradigm features island elements, such as palm trees and often includes nearly combustible colors in neon and bright hues as well as dynamic movement. In concert with upward mobility narratives that represent assimilating smaller families and single people, the tropical is the ascending discourse within Latinidad. Dora's island contains both a Mayan-looking pyramid and tropical palm trees. Background music tends to be tropical salsa, yet Boots the monkey reminds us of Frida Kahlo's pet, a Mexican reference. Dora plays with a squirrel and walks by an oak tree, which alludes to the Midwest. Within Latinidad, these mixed-up cultural signifiers have generated heated discussion about the show on web chatrooms (Harewood and Valdivia), but it is doubtful whether many non-Latina/os notice the incongruousness of Dora's setting. Since Dora is one of the few young Latinas widely visible in contemporary commodity culture, her construction bears the burden of representing the heterogeneity within Latinidad. Her mix of Latina/o signifiers provides a mainstream bridge into Latina/o ethnicity although her show and character are constructed with educating mainstream (read white, monolingual) children.

The Cheetah Girls made-for-TV movies, which had a following among the tween crowd prior to their Disney cross-over, are based on a book series about a five-girl musical group, in turn based on the real performing juggernaut Destiny's Child. One can now find dolls, movies, books, popular music, and games with these characters. Once on television the Cheetahs were reduced to four members and, by the third movie, to three. Moreover, their characters and stories were slightly altered for the television movies. Chanel "Chuchie" Simmons, who is Dominican, Puerto Rican, and Cuban, becomes just Chanel, an ambiguously Latina rich girl who tells Dorinda, one of the other girls, that she "is a little of this and a little of that," thus keeping her mixed Latina heritage but erasing any ethnic specificity. While in the books Dorinda is a mixed Korean and African American child, in the movies she looks very white yet lives with a working-class African American foster family. Thus, by comparison, she becomes ambiguously white. The bridge moment occurs when Chanel finds out Dorinda's secret: She lives with a foster family headed by the superintendent of an upscale building, whereas all of the other Cheetahs are rich. Dorinda confesses she does not know who her parents are, that she is unsure of her heritage, and that she was ashamed to share her working-class status with others in the group. Chanel not only shares her mixed

background but also gifts Dorinda a very expensive fur vest. Thus, Dorinda's class and racial marginality are reconciled through consumerism. Chanel's mixed Latinidad assuages Dorinda's uncertain whiteness and bridges the divide between Dorinda and the other two Cheetah girls, Italian/African American Galleria and African American Aqua. In *The Cheetah Girls 2* (2006) Chanel translates Spanish for the other Cheetahs during their stay in Barcelona. In *The Cheetah Girls: One World* (2008), three of the girls travel to India to make a Bollywood film. Chanel is selected as the main role yet gives it up in order to keep unity within the group. In all three of the movies ambiguous Latina Chanel plays the role of bridge, either in terms of class, language and nation, or girlfriend solidarity.

The Wizards of Waverly Place on Disney Channel focuses on the Russos, a family that harbors a secret. While the mom is Mexican American, the Italian American father is actually a wizard who is schooling his three children in wizardly ways. Alex, played by Selena Gomez, is the main character in the show with her parents, two brothers, and a best friend playing supporting roles. Selena Gomez, of Mexican American parents and named after Selena the Tejana star, is currently one of the hot stars in the Disney universe, often pictured with Miley Cyrus and Demi Lovato, other tween pop stars. Theresa, Alex's mother, is played by María Canals Barrera, a Cuban actress. Most of the time the family's Latinidad is so subtle as to be literally invisible. However, one episode in the first season entitled "Quinceañera" provided the audience with a glimpse into Theresa's background and into Alex's bridge role as a wizard Latina tween. In this episode, Theresa prepares Alex for her quinceañera party, which she describes as a celebration of a girl's coming-of-age according to Latin American traditions.[12] In particular, she tells Alex, there are rituals to be performed with one's father that symbolize becoming a woman. Alex replies: "I love being half Mexican and half whatever he is. . . . It is just not me. I really don't want one." Alex objects to the femininity of the ritual—the pink dress, the high heels, the crown—rather than its Mexicanness. Her best friend, Harper, who is unambiguously white, tells Alex she ordered the dress from Oaxaca, Mexico, to which Alex replies that Harper sounds like she is expectorating when she pronounces "Oaxaca." This turn of events hurts Theresa, whom, we are told by Magdalena, her mother (and Alex's grandmother), was not able to have her own quinceañera because her parents could not afford it. Alex, whose full name—Alexandra Margarita Russo—is invoked in this episode as if to exemplify Alex's otherwise subtle Latinidad, is caught in the middle, trying to fulfills her mother's wish while being a tomboy in the contemporary world.

To secure Theresa's Latinidad, Magdalena shows up for the quinceañera. Played by Belita Moreno, who also plays Benny Lopez in *The George Lopez Show* (ABC 2002–2007; syndicated 2007–) and thus might be familiar to Latina/o audiences and any others who watched that popular show, Magdalena is as outrageous as she was in that other series.[13] She rides into town—literally on a bi-

cycle—and constantly challenges the Russo brothers to wrestling fights. She also makes them drop a salsa class in which Theresa had enrolled them. Max, the little brother, does not even know that salsa is a dance: "Oh salsa, we should have brought chips! . . . It's not just a zesty dip." The salsa music played at the party does not really sound like salsa. Moreover, salsa is not a Mexican dance, so its presence in this show works to flatten difference within Latinidad on U.S. television. Additional subtle signifiers of Latinidad include party goers positioned basically as background props. They nearly blend in as wallpaper composed of a broad range of multicultural looking people, and the main characters do not socialize with them.

Eventually all tension is resolved through magic, as we would expect from a Disney show about wizards. Alex changes bodies with her mom, and the boys change bodies with their dance teachers. After the party all returns to wizardly normal. Alex's shortened name and her characterization as a rebellious yet "normal" teen who likes video games and dresses as a rocker do not include any elements of Latinidad. Her mother's infrequent comments referring to Latina/o heritage and this one quinceañera episode are the only hints at her ambiguous ethnicity. Alex, being the protagonist of this show, functions as the bridge between three cultures in one attractive tween body.

Movie Girls

Girl-themed movies targeted to the tween audience have nearly become a mainstay of Hollywood film and of other global distributors (Projansky). The particular type of tween girl movie I explore here is composed of a group of girlfriends and heavily influenced by feminist and post-feminist themes. That is, the independence and resourcefulness are coupled with femininity, beauty, and consumer elements that form a major part of the narrative. The girls are strong and assertive and exhibit great female solidarity while engaged in atypical activities without necessarily losing their feminine characteristics. In sum these movies exhibit the classic elements of a post-feminist approach, foregrounding girls in consumer and ideal of beauty themes without losing all their agency, individuality, and female solidarity. Moving beyond the previously typical search for heterosexual love that often dissolved any female friendship, these movies conclude with the enduring friendship of the girls even as they pursue somewhat masculine careers and romantic heterosexual love. Moreover, the movies include a range of ethnicities among the protagonists and thus the possibility of Latina/o bridge analysis.

Contemporary girl culture, including recent movies, foregrounds themes of girl power. While many of these movies are composed mostly of white girls, including *Mean Girls* (2004), *Aquamarine* (2006), and *Sleepover* (2004), others contain a palette of either identifiable or ambiguously ethnic girls. *Josie and the*

Pussycats (2001)[14], *Bratz: The Movie* (2007), *Blue Crush* (2002), and *The Sisterhood of the Traveling Pants* (2005) fall under the latter category. In *Josie,* the musical group is composed of three girls, one of whom, Valerie Brown (played by Rosario Dawson), is an ambiguously ethnic character. *Bratz* includes a Latina (Jade), an Asian American (Yasmin), an African American (Sasha), and a white girl (Cloe)—all of them ambiguously and slightly ethnic.[15] I focus on *Blue Crush* because of its representativeness of the ambiguous ethnic approach and *The Sisterhood of the Traveling Pants* for its inclusion of an identifiable Latina.

Blue Crush was advertised as the surfer version of *Bring It On!* (2000), the hit movie about cheerleaders which opposed a white and Asian American upper-middle-class squad and an African American and Latina working-class squad. In truth, *Blue Crush* was different from *Bring It On!* given that the former film includes real female surf champions who appear as minor characters. *Blue Crush's* plot revolves around the main character Anne Marie, played by Kate Bosworth, an unambiguously white working-class girl parenting her younger high-school-age sister in Hawai'i. Her quest to return to competitive surfing circles, at least enough to secure sponsors and therefore a living, drives the plot of the movie. Her two friends include ambiguously ethnic Eden, played by Michelle Rodriguez, and Lena, played by Sanoe Lake, the latter being the only Hawai'ian surfer in the cast. The girls live from hand to mouth working at a luxury hotel during the day so they can help Anne Marie train in the afternoons. The plot thickens when Anne Marie slacks off on her training as a result of dating a football player who is staying at the hotel. Eden tries to get her to focus: "Some guy thinks you look good in a bikini and you forget all about the contest?" Anne Marie later replies, "Get your own life and stop living through me!" Later we are told that both girls were champion surfers in their childhood, but Eden realized at 10 years old that Anne Marie was the better athlete.

As the story continues, the girls begin teaching some of the other football players to surf. Two of them, a pair of large and dark African Americans, play the role of buffoons wearing Speedos despite their large frame, volunteering for the luau, and acting ridiculously. In turn their room displays their lack of hygiene (complete with vomit, fecal matter, and used condoms), which, like their behavior, generally underscores their unambiguous African American presence. The girls, however, are not as clearly typed, although their difference from each other is also foregrounded. While their focus is on getting Anne Marie to the surfing championship in spite of her romance with the football player, Eden and Lena play the roles of the streetwise task master and consoling friend, respectively. Rodriguez, the most recognizable actor in the film, having already appeared in *Girlfight* (2000), *Resident Evil* (2002), and *The Fast and the Furious* (2001), plays her usual macha character (Beltrán 2004). Thus, Anne Marie's white femininity, and her eventual success at the surfer championship, are secured thanks to Eden's labor

and Lena's emotional support. The three girls are further differentiated from the African American buffoons. While the girls are working-class and barely able to pay their bills, they are "rescued" by the football players who pay them handsomely for surfing lessons. Anne Marie also gets to live a Cinderella dream when she is courted by the rich football player who hosts her in his luxury suite, buys her fancy clothes, takes her to banquets, and generally allows her to engage in high-end consumption practices. Anne Marie may not win the surfing contest, but she performs brilliantly enough to achieve popularity and recognition while reuniting with her friends and continuing her romantic relationship. Thus at film's end the protagonist's quest, facilitated by her loyal and multi-racial friends, is secured as is her upward mobility in the worlds of sport and love.

The Sisterhood of the Traveling Pants, like *The Cheetah Girls*, is based on a series of four books. The movies are narrated by Carmen, a half Puerto Rican writer played by America Ferrera of *Ugly Betty* fame. The four girls—Carmen, Tibby, Lena, and Bridget—find a pair of pants that fits them all, despite their different height, build, and weight. Carmen's relatively larger frame stands in contrast to the other three girls. Tibby and Bridget come from comfortable white middle-class families; the former is a bit punk and the latter is a combination beauty and tomboy. Lena is part Greek, and her sojourns back to that country form a large part of the narrative. While the pants erase the embodied differences among these otherwise somewhat similar girls, their career paths are strikingly similar. All four girls, despite their subtle ethnic differences, live in a comfortable upper middle class normatively white world where it is assumed they will go to college. While all four girls embark on journeys of self-discovery, Carmen has to negotiate difference more than the rest. To begin with, in the scene when they each try on the magical pants, Carmen is the most doubtful about their fit. After all, she is the only one of the four who is visibly curvy and noticeably shorter. When the pants fit her, we *know* they are magical.

While Tibby simultaneously works in a local Walmans[16] and produces a documentary, the other girls take their summer trips: Bridget goes to a football (soccer) camp in Mexico, Lena visits relatives in Santorini, Greece, and Carmen travels to South Carolina to visit her father. Carmen's father does not tell her that not only has he moved in with a woman with two children of her own but also he is going to marry during Carmen's stay. Moreover, the new family he has joined appears to be a classic WASPish family: utterly white, thin, and emotionally silent. Two significant moments include a breakfast where she speaks to the family in Spanish, after experiencing frustration about the lack of communication in the family coupled with resistance to their Anglo habits. Another moment of conflict comes when she is woken up so that a Latina maid can wash her sheets. Carmen reacts to being awakened and to having another Latina clean up. She offers to do the sheets herself. These are but two of many instances wherein Carmen is made

to feel as an outsider and less important than the wedding plans, and she finally breaks down when her bridesmaid dress does not fit her. Whereas the pants fit her perfectly, the dress is so tight that another one will have to be ordered. As she is trying to get out of the tight dress, she overhears her soon-to-be stepmother and the saleswoman discussing her size without even using her name. They refer to her as "the other." Carmen walks out and eventually returns home. Her difference with her father's new family is irreconcilable, and she returns as the rest of her girlfriends are also coming home from their summer trips. At the movie's end, her three friends decide to drive her to the wedding, where her father, spotting her in the last row, insists she take her place in the wedding party, and she serves as a bridesmaid wearing the magic jeans. Carmen brings together the group of friends, and they, in turn, facilitate her bridge back to her new Anglo stepfamily. She has to bear the burden of accepting her father's new family through her acceptance of his location within white middle-class normativity.

Conclusion

As we know from Media Studies, representation is more about power than absolute numbers. Contemporary mainstream girl culture's acknowledgment of diversity within the U.S. population dovetails with themes found in representation of race and ethnicity. At issue is how that diversity is represented and what is left out. In a sense we have begun to see the realization of a demographic shift seep into girl culture. We can use the introduction of *Dora the Explorer* in 1999 and the introduction of Bratz in 2001 as representing a trend in ethnicity and girl culture. The first property foregrounds the identifiable Latina within a muddled Latinidad. The second property muddles ethnic signifiers into an ambiguous light ethnicity. Other doll properties and televised tween movies and shows flesh out this component of contemporary tween culture. The introduction of both identifiable Latinidad and ambiguous ethnicity ushers in a new era of representation with two important sets of ramifications. First, the inclusion of the bridge category of Latinidad and Latina/os expands the ethnic register. It brings that brown element to the previous black and white binary mode of representation. Whereas the two poles of racial purity, black and white, previously stood for ethnic difference, the inclusion of an in-between third category allows for a lighter blackness and a darker whiteness to be part of the representational terrain. Second, difference gets transported to the Latina body, often in nearly imperceptible ways, such as in the *Wizards of Waverly Place*, *Bratz*, *The Cheetah Girls*, and *Blue Crush*. Nonetheless, the Latina girl becomes the signifier of difference and ethnicity; her character and body enable the narrative structure to resolve conflict and contradiction. Moreover, that in-between space often has the effect of displacing African American girl representation. Furthermore, the malleability of the light brown

body is much more serviceable for a range of possible audience identifications than an Asian American body as light brown opens up the possibility to many more ethnic interpellations.

The bridge metaphor remains useful in this cultural moment. In all of these sites of contemporary mainstream tween girl culture the identifiable and the ambiguous Latina serves as a bridge between whiteness and difference. While sometimes the Latina, such as the Carmen character in *The Sisterhood of the Traveling Pants*, literally bears the burden of under-representation on her back and bootie, which physically do not fit into the bridesmaid dress, at other times the Latina body demonstrates the extent that the mainstream is willing to include difference at this point in time. Additionally, the Latina also serves as the bridge between difference and blackness. African American or any darker difference disappears in favor of the light brown and slightly curvy Latina, the girl culture equivalent to the success of Jennifer Lopez in the mainstream. Thus, while gaining representational space, Latina girls also replace or displace blackness from the mainstream. One such instance is *Blue Crush* wherein blackness is represented in a buffoonish manner dating back to early representations within Hollywood film. In that same movie Michelle Rodriguez, a light Afro-Latina actress plays a much more complex character than the African American football players whose darkness codes them as unidimensional buffoons. The hybrid Latina serves a very useful function. We cannot discount the fact that a form of diversity is being represented that enriches the ethnic landscape within mainstream girl culture. However, as critical media scholars we must also pay close attention to the uses and abuses that this hybrid representation serves. The hybrid and ambiguous Latina girls simultaneously expand the ethnic register and introduce Latinidad while potentially replacing other less malleable ethnicities. Inter-ethnic competition for a limited portion of the representational pie substitutes a more democratic alternative of changing the way that we continue to privilege whiteness. In fact, the light Latina, as malleable as she is, can be harnessed to once more marginalize blackness from the national imaginary.

Notes

1. The book also foregrounded both lesbian and working-class subjectivities thus becoming and remaining a cutting-edge project.
2. The working class, however, remains an understudied area within U.S. feminism and Girls' Studies.
3. There is a substantial amount of literature on the Latina bootie. For some of the best material, see Barrera; Beltran, "The Hollywood Latina" and "Más Macha"; Durham and Báez; Fiol-Matta; Negron-Muntaner; and Molina Guzmán and Valdivia.

4. Although firmly grounded in Latina/o Media Studies, Shugart does not explicitly credit this scholarly formation nor does she name Latinidad as the location she is analyzing.
5. *Dora the Explorer* appeared in 1999 as a pilot. The series did not begin until 2000.
6. Mary Kate and Ashley Olsen entered the national imaginary playing the 9-month-old baby in *Full House* (ABC 1987–1995) and morphed into branded moguls who continue to appear in celebrity culture and to create media and fashion lines.
7. On this topic see the work by Acosta-Alzuru and Kreshel as well as Acosta-Alzuru and Lester Roushanzamir.
8. This issue received a fair amount of local press coverage characterized by the work of Swanson and Herrmann referenced in this chapter.
9. In the U.S. version of *Ugly Betty*, the main character is an inescapably Latina woman whose address, dress, style, and food are heavily coded as Mexican American and working-class.
10. *The Cheetah Girls* and *Nancy Drew* are two recent tween vehicles that began as popular novel series.
11. Selena Gomez, Vanessa Hudgens, and Demi Lovato are either Latina and/or play Latina characters.
12. This is not quite accurate. A quinceañera is more of a Central American celebration. It is not a Southern Cone tradition.
13. As "Benny," Moreno played the neglecting mother who raised George. We learn that she was an alcoholic with many boyfriends who rarely paid any attention to George, who was left to fend for himself. She remains a selfish person throughout the show.
14. There was an animated television show with the same name in the seventies.
15. Elsewhere (Valdivia 2009) I have written about this movie and how each of the Bratz characters became lighter and less ethnically identifiable as they morph from their original doll property into their major Hollywood film.
16. This is an obvious and none too subtle version of Walmart.

Works Cited

Acosta-Alzuru, Carolina and Peggy J. Kreshel. "'I'm an American Girl . . . Whatever *That* Means': Girls Consuming Pleasant Company's American Girl Identity." *Journal of Communication* 52.1 (2002): 139–61.

Acosta-Alzuru, Carolina and Elli P. Lester Roushanzamir. "Everything We Do Is a Celebration of You!: Pleasant Company Constructs American Girlhood." *Communication Review* 66.1 (2003): 45–69.

Anzaldúa, Gloria and Cherríe Moraga, eds. *This Bridge Called My Back: Writings by Radical Women of Color.* New York: Kitchen Table, Women of Color Press, 1981.

Banet-Weiser, Sarah. "Girls Rule! Gender, Feminism, and Nickelodeon." *Critical Studies in Media Communication* 21.2 (2004): 119–39.

Barrera, Magdalena. "Hottentot 2000: Jennifer Lopez and Her Butt." *Sexualities in History: A Reader*. Eds. Kim M. Phillips and Barry Reay. New York: Routledge, 2002. 407–17.

Beltrán, Mary. "The Hollywood Latina Body as Site of Social Struggle: Media Constructions of Stardom and Jennifer Lopez's 'Cross-over Butt.'" *Quarterly Review of Film and Video* 19.1 (2002): 71–86.

———. "Más Macha: The New Latina Action Hero." *Action and Adventure Cinema*. Ed. Yvonne Tasker. London: Routledge. 2004. 186–200.

Durham, Aisha and Jillian M. Báez. "A Tail of Two Women: Exploring the Contours of Difference in Popular Culture." *Curriculum and the Cultural Body*. Eds. Stephanie Springgay and Debra Freedman. New York: Peter Lang, 2007. 131–45.

Fiol-Matta, Licia. "Pop Latinidad: Puerto Ricans in the Latin Explosion, 1999." *Centro Journal* 14.1 (2002): 27–51.

Guidotti-Hernández, Nicole M. "*Dora the Explorer*, Constructing 'LATINIDADES' and the Politics of Global Citizenship." *Latino Studies* 5.2 (2007): 209–32.

Harewood, Susan J. and Angharad N. Valdivia. "Exploring Dora: Re-embodied Latinidad on the Web." *Girl Wide Web: Girls, the Internet, and the Negotiation of Identity*. Ed. Sharon R. Mazzarella. New York: Peter Lang, 2005. 85–103.

Herrmann, Andrew. "Pilsen's Not Good Enough for New American Girl?; In Book, Doll Moves to Suburbs—Now Real Neighbors Feel Snubbed." *Chicago Sun-Times*, 1 Feb. 2005.

Kraidy, Marwan M. "Hybridity and Cultural Globalization." *Communication Theory* 12.3 (2006): 316–39.

———. *Hybridity or the Cultural Logic of Globalization*. Philadelphia: Temple University Press, 2005.

Lacroix, Celeste. "Images of Animated Others: The Orientalization of Disney's Cartoon Heroines from the *Little Mermaid* to *The Hunchback of Notre Dame*." *Popular Communication* 2.4 (2004): 213–29.

MacDonald, Fred J. *Blacks and White TV: African Americans in Television Since 1948*. Chicago: Nelson-Hall Publishers, 1992.

Merskin, Debra. "What Every Girl Should Know: An Analysis of Feminine Hygiene Advertising." *Growing up Girls: Popular Culture and the Construction of Identity*. Eds. Sharon R. Mazzarella and Norma O. Pecora. New York: Peter Lang, 1999. 113–32.

Molina Guzmán, Isabel and Angharad N. Valdivia. "Brain, Brow or Bootie: Iconic Latinas in Contemporary Popular Culture." *Communication Review* 7.2 (2004): 205–21.

Negrón-Muntaner, Frances. "Jennifer's Butt." *Aztlán* 22.2 (2002): 182–95.

Paredez, Deborah. *Selenidad*. Chapel Hill: Duke University Press, 2009.

Projansky, Sarah. "Gender, Race, Feminism, and the International Girl Hero: The Unremarkable U.S. Popular Press Reception of *Bend It Like Beckham* and *Whale Rider.*" *Youth Culture in Global Cinema.* Eds. Timothy Shary and Alexandra Seibel. Austin: University of Texas Press, 2007. 188–206.

Puig, Claudia. "'Bratz' Movie Totally Cliché." *USAToday.com.* USA Today, 2 Aug. 2007. Web. 5 Sept 2007.

Shugart, Helene A. "Crossing Over: Hybridity and Hegemony in Popular Media." *Communication and Critical/Cultural Studies* 4.2 (2007): 115–41.

Swanson, Al. "Analysis: Doll's Story Offends Hispanics." UPI, 3 Feb. 2005. Web. 13 Oct. 2009.

Valdivia, Angharad N. "Geographies of Latinidad: Constructing Identity in the Face of Radical Hybridity." *Race, Identity, and Representation.* Eds. Warren Critchlow, Gregory Dimitriadis, Nadine Dolby, and Cameron McCarthy. New York: Routledge, 2005. 307–20.

———. "Living in a Hybrid Material World: Girls, Ethnicity, and Mediated Doll Products." *Girlhood Studies* 1.3 (2009): 73–93.

———. "Mixed Race on Disney Channel: From *Johnnie Tsunami* to *The Cheetah Girls.*" *Mixed Race Hollywood: Multiraciality in Film and Media Culture.* Eds. Mary Beltrán and Camila Fojas. New York: New York University Press, 2008. 269–89.

Reception and Use

"We Didn't Have Any Hannah Montanas": Girlhood, Popular Culture, and Mass Media in the 1940s and 1950s

Rebecca C. Hains, Shayla Thiel-Stern, and Sharon R. Mazzarella

Millennial popular culture in the United States teems with images of teenage girls. From Disney's *Hannah Montana* to the *Twilight* saga; from *High School Musical* to *Gossip Girl*; from the *Sisterhood of the Traveling Pants* to journalistic headlines promising to reveal "The Truth about Teen Girls" (Luscombe 66), popular images of teen girls are everywhere. One might ask how teen girls became such a sudden focus of popular culture, but the truth is that girl culture developed in the early twentieth century and has only been *rediscovered* in recent years (Schrum). Through oral histories of American adult women who grew up during the 1940s and 1950s—and, specifically, who were teenagers during the 1950s, when teen culture was considered to be at its post-war height—we seek to understand how girls came of age in the United States at a time characterized by a proliferation of mediated images of and for teenage girls. Modern collective memory offers a vivid image of rock and roll-loving, *Seventeen*-reading, poodle-skirt-wearing teenagers who grooved to *American Bandstand* (WFIL/ABC/syndicated 1952–1989) and *The Ed Sullivan Show* (originally *Toast of the Town*; CBS 1948–1971). Popular cultural artifacts perpetuating such images of 1950s' teenage girls decades later include *Happy Days* (ABC 1974–1984) and *Grease* (1978). This nostalgic vision, though an evocative cultural construct, fails to reflect the range of girls' lived experiences during that era.

We begin this chapter by examining the historical literature on the evolution of western constructs of the child, the teenager, and the teen girl. We then

discuss our oral history methodology. Finally, we present findings based on interviews with fifteen women born between 1935 and 1944, who grew up in varying geographic regions in the United States and who were raised in a range of socioeconomic backgrounds. (These informants are a subset of a larger sample of more than thirty women born between the early 1920s through the mid-1940s whose interviews will inform a broader comparative study of U.S. teenage girlhood in the 1930s, 1940s, and 1950s.) The similarities and differences in their personal histories provide a useful understanding of post-war teens as a multifaceted, complex generation, offering better insight into what it means to be a girl—then and now.

Coming of Age in the Twentieth Century

The Cultural Construction of the Child

> The child is a cultural construct, a pleasing image that adults need in order to sustain their own identities. Childhood is the difference against which adults define themselves.
> — Lynn Spigel (259)

In order to understand what it was like to come of age in the mid-twentieth-century United States, one must first understand that how Americans think about young people is a construction of a particular set of social, political, economic, and cultural changes that occurred during the late nineteenth and early twentieth centuries in the U.S. Previously, children had been considered and treated as miniature adults who, in all but upper-class families, attended school for a mere handful of years (Aries). In the early years of urbanization and industrialization, for example, city children labored long hours in factories, often fending for themselves in "the urban stews" (Savage 36).

Ellen Wartella and Sharon Mazzarella identify several changes taking place in the United States between 1900–1930 that contributed to the changing cultural definition of childhood (and eventually the creation of the teenager) (174). First, public education was institutionalized, and during the early twentieth century, an increased percentage of youth stayed in schools longer. Second, children became the focus of scientific study and inquiry, as seen, for example, in the work of G. Stanley Hall, who coined the term "adolescence" in his 1904 book of the same name (Savage). Third, local, state, and federal legislations were enacted to "protect" children (e.g., child labor laws, mandatory schooling laws) (Savage). Finally, paralleling the newfound definition of children as innocent, it was seen as incumbent on adults (notably mothers) to properly mold children; hence, childcare experts and advice manuals proliferated (Wartella and Mazzarella).

Simultaneous to the social/cultural construction of adolescence as distinct from adulthood, young people had more free time and began to create a leisure-based

youth culture distinct from their parents' generation, largely revolving around new media and popular culture. In the midst of this leisure revolution and its attendant public outcry, a new youth culture was born (Wartella and Mazzarella).

Constructing the "Teenager"

Naming something helps to bring it into being: assumed both by youth market- ers and youth itself, the Teenage was clear and said what it meant. This was the Age—the distinct social, cultural, and economic period—of the Teen.
— Jon Savage (453)

If, as Spigel reminds us in the epigraph opening the previous section, the child is a "cultural construct," the same can be said for the "teenager." While some trace the U.S. teenager's evolution back only as far as the post-war 1950s (Doherty 35), recent scholars have shown that characteristics defining the teenager in western cultures go back further. Specifically, Kelly Schrum describes the decades *pre-ceding* the 1950s as "the formative years" of teenagers "as high school students, consumers, and trendsetters" (2). She identifies three factors that contributed to the entrenchment and definition of the teenager conceptualized in the decades preceding the 1950s. The first was high school attendance, which increased from 10 to 50 percent of eligible youth (aged 14–17) between 1900 and 1930, reach- ing 85 percent by 1960. Mary Celeste Kearney attributes this increase to pre- and post-war baby booms and the "transformation of adolescents' public roles," precipitated in part by returning vets displacing young people from the work- force and pushing them back into schools ("Recycling" 269). The second factor Schrum identifies is the increased production and availability of varied consumer goods, and the third was increased advertising spending (14), factors Kearney ar- gues paralleled the perception of early teenagers as "one of the most lucrative and influential consumer markets" ("Recycling" 269).

While a 1941 issue of *Popular Science* magazine is often credited with first using the label "teenager," according to Schrum, "teener," "teen," "teen-age," and "teen-ager" were used during the late nineteenth and early twentieth centuries (Schrum 18). According to Savage, by 1944 teenager became "the accepted way to describe this new definition of youth as a discrete, mass market" (453). Indeed, during the 1940s and 1950s, teenagers—particularly teenage girls—were primar- ily considered consumers.

Constructing the Teenage Girl

From fashion and beauty to music and movies, girls were active in the develop- ment of teenage girls' culture, but they were also greatly influenced by the com- mercial, media, and an academic interest in their lives and consumer choices.
— Kelly Schrum (171)

Historians and girls' studies scholars including Schrum, Kearney, Ilana Nash and Georganne Scheiner have documented the teenage girl's distinct historical evolution in the United States—a history they argue predates the 1950s by twenty or thirty years. Grounded in her studies of girls' diaries and letters as well as high school yearbooks, short stories and other such writings, Schrum's research exposes us to the "voices" of high school girls from the 1920s through 1940s. She argues that "the period from 1920 to 1945 proved crucial in the formation of teenage girls' culture in the United States" (1) and that this culture was "identifiable" as early as 1938 (4). Scheiner begins her research on American motion picture representations of teenage girls and on teen girls as fans in 1920 because "that is when a clear teen culture came into being" (3). Similarly, Nash begins her study in 1930 "because that is roughly the moment at which mass culture began to take systematic notice of teenagers as a distinct social category; general consciousness of teen identity manifested very sparsely before the 1930s" (17). Kearney points out that 1940s' journalistic accounts of teen girls far outnumbered similar accounts of teen boys, evidencing a public fascination with the teen girl. Moreover, such accounts typically homogenized "all teenager girls under the label of 'sub-debs' or 'bobby soxers'" ("Birds" 572).

Through her historical research, Schrum shows how marketers began targeting high school-aged girls in the 1920s, increasing the practice in the 1930s and 1940s (98). For example, *Seventeen* magazine, founded in 1944, sold out its first issue of 400,000 within 6 days (Schrum 2). Its print run increased to 530,000 within 6 months (Savage 450); its circulation exceeded 1 million by early 1947 and 2.5 million by mid-1949 (Schrum 2). According to Kearney, from the early 1940s through the mid-1950s, "girl-centered entertainment properties," such as novels, comic books, films, radio programs, live theater, and television programs, "saturated American popular culture" ("Recycling" 270).

While the period immediately preceding the mid-1950s featured a wealth of teen girl popular culture artifacts, by the mid-1950s, such portrayals dramatically declined. Nash attributes this to an overall postwar "crisis in masculinity" as returning servicemen sought to regain their literal and symbolic place in American culture (174). Kearney also notes that major entertainment industries changed ("Recycling" 286). Radio competed with television; suburban migration resulted in a decline in movie attendance, prompting Hollywood to focus on gimmicks, like 3-D; and comic books came under attack. As a result, Kearney and Nash argue, teen girls' popular culture portrayals changed and lessened. Girls were more likely to be portrayed in domestic situations only, while the sheer presence of teen girl characters declined, replaced by teen males "more often angry than playful or charming" (Nash 174–75). By the mid-1950s, media had "masculinized the teenager" (Kearney, "Recycling" 287).

Methodology

We undertake this project within the context of mid-twentieth-century teen girl culture, interviewing adult women who grew up in the United States during the 1940s and 1950s. To better understand the role of media in post-war girls' and adolescents' lives, we interviewed fifteen adult women born between 1935 and 1944, from diverse regions and socioeconomic statuses.

The oldest informant in the subset examined for this essay was 15 years old in 1950; the youngest, 15 at the end of that decade. Roughly half of our informants grew up in rural areas, and roughly half grew up in urban areas. They describe their families' socioeconomic statuses as having ranged from very poor to quite privileged. Their parents were sheet metal mechanics, sheep ranchers, laundrymen, mill workers, small business owners, farmers, and more; they grew up in such geographic locations as urban areas in Massachusetts, North Carolina, and Tennessee, and rural parts of Kentucky, Ohio, and Utah. Despite this regional and socioeconomic diversity, they lack racial diversity. Only one is African American; the rest are Caucasian and of European descent. (Many have British, German, Scandinavian, and/or Dutch roots, while a few are of French, Italian, or Polish descent.) We acknowledge this as a shortcoming of our research. Although our informants' experiences cannot be generalized to reflect those of all girls who came of age during that era, their recollections provide snapshots revealing a diversity of girlhood experiences. (Refer to Appendix A for demographic descriptions of each participant.)

To learn more about our informants' girlhoods and media use during that time, the authors employed the method of oral history—appropriate because it allows women from different walks of life to share their lived stories. We find this method preferable to the frequent use of official historical records to explore bygone times because such records, constructed by people in positions of authority, can reflect only the worldview of people with power and agency (Thompson 7), for example, by excluding the lived experiences and contributions of girls and women. We seek to present a multiplicity of experiences.

In asking informants to share recollections, we are cognizant of memory work's limitations. Memory reconstructs past experiences filtered through the lenses of more recent events and newer knowledge. Therefore, we recognize our informants might have originally interpreted their experiences differently than they do now, and that these interpretations may have likewise varied at other points in the fifty years since. We also recognize that, as with any research methodology, our informants' participation in the research process may color their responses.

Women were recruited using snowball sampling. The authors first talked to women whom they knew, then asked for referrals to other women to secure a larger group of research participants. Each woman was asked a predetermined set

of questions in a semi-standardized interview structure. Fourteen interviews were conducted by phone or in person and one by email. All the oral interviews were audio recorded and transcribed. Conversations meandered, questions were asked in differing orders depending on the conversations' flow, and the participants generally directed the course of the conversation. The researchers asked follow-up questions freely. Two of our informants—a set of sisters—requested a simultaneous interview. The rest were interviewed individually, which Bruce Berg (83) finds especially useful "when investigators are interested in understanding the perceptions of participants or learning how participants come to attach certain meanings to phenomena or events." When we asked informants to address the different forms of mass media in both their girlhood and teen years, they elaborated on more specific memories of the role this media played in their daily lives (or in some cases, on how the media was *not* necessarily a large part of their daily lives).

In keeping with the oral history tradition, the interviews—which ranged from twenty minutes to over two hours in length—should be considered the creation of an original document or artifact in which the pieces should not be removed (Howarth). We have read through the entire transcripts of all of these interviews in order to glean women's narratives, and then we conducted our analysis to focus on their experiences with media and popular culture. Although we cannot include entire interviews here, we chose the passages we feel best represent the dominant narratives. We view this work as feminist and wish to draw from the feminist ethnography tradition, in which a narrative ethnography allows the women to speak for themselves, in their own voices, rather than through the carefully chosen lexicon of the academic researcher (Abu-Lughod). Although feminist ethnographers sometimes choose to avoid analysis and concluding commentary to steer clear of the "interpretive/analytical mode being questioned by the very construction of narratives" (Abu-Lughod xvii–xviii), we have provided an analysis of our participants' stories to better illuminate the role of mass media in a historical time period when girls and media were simply not investigated. We feel it important to add cultural and historical contexts to their stories. Still, we feel our study allowed the women to speak at will, letting patterns manifest themselves without glossing over the complexity of gender, media, and identity.

Girls' Lives in the 1940s and 1950s

We began our study by asking: "What did you do for fun when you were a child? How would you describe your leisure time?" We then asked about teenage years specifically. The majority of our fifteen informants focused on outdoor play. Only four mentioned media use without prompting (Maggie, Ramona, Rose, and Tori), and they grew up in urban and suburban areas where they may have had greater access to media in the postwar era than did their rurally situated peers. Either way,

however, media options were limited during this time. As Maggie (b. 1940), who grew up in urban North Carolina, noted:

> Maggie: We didn't have the choices that you have now. The books were there, but they weren't always accessible. It was very limited as to what you could watch on TV . . . like there was only one channel. And it was very limited as to the program because they only broadcast maybe, like, six hours a day. And . . . the radio stations were only AMs at that time, and when they had to cut off—at sundown, I think it was—there was, you know, only a few stations that you could pick up at night, and all of the static was very, very bad on them. And we didn't have the choices in books. We just didn't have the choices. And then, see, part of that was caused by the war. The war had just ended in 1946 [sic], and by the time you got into the early 50s and all of that, the country was really just—it took a long time to get back from the war.

Contrary to what one would assume about the differences between rural and urban childhood experiences, regardless of where they grew up, our informants typically recalled their girlhood as being centered on pursuits other than the media and popular culture.

Overall, informants believed the media offered limited contributions to their girlhood identities. Some stated this belief directly. Edwina (b. 1935) concluded the media's role in her life "wasn't that important." Elizabeth (b. 1944), hard-pressed to recall specifics about the media she enjoyed as a girl, commented, "I'd say it was *not* a big part of my childhood." The fact that our informants perceive media to have been of relative unimportance during their girlhoods is significant, offering context for the following sections.

Postwar Girls and Popular Culture

When asked about their media and popular culture consumption, our informants recollected having enjoyed a range of artifacts including radio programs, television programs, books, films, recorded music, and comic books. Interestingly, much media use was family centered—in particular listening to radio programs, watching early television programs, and movie-going (for those who grew up in towns or cities with a movie theater).

Although most had to be prompted about each specific medium, and many stressed that media and popular culture did not play a big role in their youth, respondents typically recalled such classic radio programs as *The Shadow* (MBS 1937–1954), *Fibber McGee and Molly* (NBC 1935–1959), *The George Burns and Gracie Allen Show* (NBC/CBS 1936–1950), and *The Lone Ranger* (WXYZ/MBS/NBC Blue/ABC 1933–1954); television variety programs, like *The Ed Sullivan Show*, Sid Caesar's *Your Show of Shows* (NBC 1950–1954), *The Lawrence Welk Show* (ABC/syndicated 1955–1982), and *The Mickey Mouse Club* (ABC 1955–

1959); as well as movies featuring such actors as Gene Kelly, Kirk Douglas, Anthony Quinn, Alan Ladd, Roy Rogers, Gene Autry, and Bob Hope. Many shared similar memories of their families' first televisions. They spoke not of specific programs but rather of the sets' size (large pieces of furniture with tiny screens) and of the ubiquitous presence of a test pattern during the early years.

Few spontaneously identified female-centered media content and/or actresses/performers, and fewer still spontaneously recalled *young* female-centered media content, characters, performers, or cycles typically mentioned in the academic literature, such as Deanna Durbin, Shirley Temple, *Little Orphan Annie* (WGN/NBC Blue/MBS radio 1930–1942), *A Date with Judy* (NBC/ABC radio 1941–1950; film 1948; ABC television 1951–1953), *Meet Corliss Archer* (WGN/NBC Blue/MBS radio 1943–1956; *Kiss and Tell* film 1945; CBS television 1951–1952; syndicated television 1954–1955), or even *Seventeen* magazine (1944–present). In fact, when Tori (b. 1935) was asked if she read *Seventeen,* she replied that she didn't know if it was even out when she was a teen. Only a handful of respondents talked about the magazine, and only briefly, although sisters Lacey (b. 1938) and Honey (b. 1942) fondly recalled waiting each year for the special fall fashion issue's release.

As discussed in our literature review, many Girls' Studies scholars regard the mid-twentieth century as a time when media depictions of girls increased (Kearney; Nash; Scheiner; Schrum). However, the majority of women interviewed could not think of any media content that spoke to them as girls.

> Leslie (b. 1941): Really not.
> Tori: Not off the top of my head, no. I don't, I don't recall growing up as *a girl,* having a lot made of that.
> Winifred (b. 1936): I don't recall [media] being an influence on . . . who and what I became. Everything was media aimed at males or boys.
> Maggie: Most of the things that were on the radio or anything like that seemed to be geared toward boys.
> Stella (b. 1944): I remember a program called *The Shadow,* and another called *The Green Hornet,* and different radio soap operas . . . I don't recall any of the characters speaking to me specifically as a girl.
> Rose: [On the] radio, everything was really oriented toward, it was always men.
> Ramona (b. 1944): There weren't very many [girls]. Mostly they were guy things, cowboy and Indian things, and every once in a while there was a girl.

Lacey and Honey, raised on a successful sheep ranch in Utah, noted no main women characters on television and in radio programs with whom they identified. Instead, Lacey remembers being "just more or less forced" to attend to stories featuring male characters. Similarly, Leslie and Stella spontaneously recalled that news programs such as *The Today Show* (NBC 1952–present) featured mostly men: "I don't remember seeing any women in any of that media at that time—news

media," Leslie said. While recent historical accounts of girls during this time period document a wealth of young female characters and girl-targeted media, our informants were not familiar with, did not have access to, or did not recall such characters as Corliss Archer or Judy from the *A Date with Judy* series. In fact, few interviewees mentioned female characters. When they did, it was often Nancy Drew (1930–present). According to Nash, "Nancy Drew had an unprecedented impact; she was the most popular and the most influential literary heroine for girls at the historical moment when adolescence came to public consciousness" (19).

Maggie, Lacey, Honey, Leslie, and Melissa (b. 1935) all recalled reading Nancy Drew books (although some also read The Hardy Boys books [1927–present]). In fact, Honey felt she and her sister were "probably less gender focused" than boys at that time because they didn't just read books targeted to and/or about girls, while they felt boys would never have read Nancy Drew or Bobbsey Twin (1904–1979) books. When asked if any characters spoke to her as a girl, Honey said she "lived through" the "excitement" of Nancy Drew, "because we didn't have adventures like that. They were different." In response to the same question, Leslie also mentioned reading Nancy Drew books, but she felt this was less because Drew was a girl than because of her own interest in solving puzzles and mysteries.

Some informants identified real life women as having been the subjects of much of their reading.

> Honey: I remember one of the series that was in our library at school, was a series of biographies, I can just see it now. It had orange bindings. But I always read the women like, uh, Louisa May Alcott and uh,
> Lacey: Clara Barton—
> Honey: Clara Barton. I remember Florence Nightingale—, you know, historical figures . . . I still enjoy history more than fiction.

Two of our informants who eventually became nurses also recalled reading books about nurses, including Clara Barton. While both women had successful nursing careers, each noted that media portrayals of nurses were misleading.

> Winifred: I read all the Clara Bartons. They're nursing books, and I'm sure that influenced me to go into nursing. . . . I read everything there was about all these little nurses that did good things all over the world, and it was nothing like that when I got to be a nurse. [Laughs.]

Also referring to nursing books, though with less specificity, Leslie recalled a standard plot.

> Leslie: There was always this poor nurse, and then she met this rich man, and he saved her from all her trials and tribulations.

Romance narratives such as this have served a socializing function, suggesting to girls and women that romantic relationships and being saved by the right man are more important than other pursuits, including career (Christian-Smith), so it's no surprise that some respondents recalled such narratives from their youth. Amanda (b. 1943) recalled similarly "soupy-soppy" stories in what she called "the love magazines" (e.g., *Modern Romance*, although she could not recall specific titles).

> Amanda: My mother loved them, and, of course, I read them too. But you know these are these gorgeous love stories, that this woman fell in love with this handsome man who fell for her. They were really pretty soupy-soppy, but I remember those magazines.

While some identified specific female characters/media personalities, others remembered having identified with the men featured in their favorite stories. As Schrum observes, "female fan culture can demonstrate acceptance of traditional gender norms. It can also signify resistance against gender norms and prescribed identities" (160). For example, Amanda wanted nothing more than to be a dancer, citing Gene Kelly and Fred Astaire as "idols." When prompted to recall female dancers, she identified Leslie Caron and Ginger Rogers—but mentioned they were primarily noteworthy for having danced with Fred Astaire and were not her role models in their own right. Melissa said she looked up to Roy Rogers "and the good, white-hatted cowboys." Rose (b. 1936) offered a similar sentiment and an explanation for the appeal of heroic cowboys:

> Rose: Well, see, I used to like cowboys. [Laughs] So I used to identify with Roy Rogers, the Lone Ranger, any old comics, movies; all the movies and comic strips where the cowboys were good guys, and they always won in the end.
> Interviewer: Why do you think that you found that so enjoyable?
> Rose: I think maybe because we were struggling so much as a family—all our families were—most of our families were—that it was nice to see somebody win when we were working so hard to just make it day-to-day at times.

Stories in which good won in the end were important to other informants, as well. Growing up poor in Appalachia, Harriet's (b. 1940) access to media was limited, but she did recall that she "loved reading stories in *The Progressive Farmer*" (1886–present), a magazine passed around her father's general store. Of particular interest to her were the histories.

> Harriet: My high school friends thought I was nuts! In *The Progressive Farmer*, it was the descriptions in the stories. The good always won out in them. They were very closely identified with the hardships and challenges in my own life. Knowing that other people lived the same way—that meant so much to me. I

met them through reading even if I never met them in real life, and I was connected to them.

Several participants related a desire for strong female characters that went generally unfulfilled in their media environment. Ramona liked the idea of "stronger women characters" and disliked depictions of weak girls:

> Ramona: I think mostly I would imagine being a hero! I was, you know, like Robin Hood; or Maid Marion in Robin Hood; but I didn't like the helpless girl characters.

Because of this interest, Wonder Woman enthralled her. Her father considered *Wonder Woman* comics (1941–present) a waste of money, however—so she read her cousin's copies. Harriet also recalled inspiring stories of brave girls with strong values, such as a story of girls who had been kidnapped by "Indians" and tales about Pocahontas. Rose found great appeal in feature film stories about nuns, partly because the nuns had a powerful "mysticism" and authority.

> Rose: Because I wanted to be a nun, the only [women] that I really would have seen as a role model would have been those who played nuns in the movies. And there were quite a few of them back then, you know?

Rose also recalled identifying with Judy Garland and admiring Shirley Temple, but her comments on these stars were less specific than those about heroic cowboys and powerful nuns. For example, she enjoyed Judy Garland's films "because [Garland] always had a major role in the movie." Conversely, Edwina recalled an active dislike of Shirley Temple, noting that her friends looked up to and imitated the curly-haired idol—whereas Edwina's role models were historical figures.

Leslie critiqued what she saw as one-dimensional, stereotypical portrayals of those women and girls she observed in the various media of her youth. Specifically, she recalled that "the women always were in dresses, most of the time with aprons on and hair done, probably make-up, some jewelry. And girls were very obedient." She remembered advertisements featuring women/girls were for washers and stoves, "things that women would be involved in. What women and girls are supposed to be doing." She was cognizant of stereotypical portrayals because they opposed her own upbringing:

> Leslie: I think the reason those things didn't have a noticeable effect on me is because my dad was way ahead of his time. Poor fellow had four daughters and no sons. But he felt there wasn't really anything a girl couldn't do. . . . He was ahead of his time. He wanted his four daughters to be able to take care of themselves and not have to be dependent on a man. And I thank him for that.

Interviewer: Basically, what you're saying is the images of women and girls that you saw in the various media at that time *didn't* match the reality that you were living?
Leslie: That's true.

Leslie added that her mother was a nurse, providing a female role model rarely seen in media of that era. Indeed, most participants rejected the idea that media characters or personalities were role models, instead identifying real people as having influenced them.

Teenagers and Music in the Post-War Era

Scholarly literature and historic records demonstrate that in the 1950s, when rock and roll arose, the teen girl audience drove its success. Collective memory about shows like *American Bandstand* and *The Ed Sullivan Show* and singers like Elvis Presley are peppered with images of teenage bobby-soxers wearing poodle skirts and ponytails, dancing and screaming. However, music and/or dancing came up in only about half of our interviews. Although the majority discussed listening to radio as children and pre-teens, they often referred to dramatic or comedic radio programming, such as those mentioned earlier. Musical interest seemed to have had socioeconomic limitations for the women in our sample. However, those mentioning music were passionate about its place in their lives, and popular music became increasingly important to them in their teen years.

Tori: It's very much a part of my life. I loved music.

Some recalled songs and artists from film and television, including songs performed by film actress Debbie Reynolds and by many television stars. Women remembered seeing bands and singers on *The Lawrence Welk Show*, *The Ed Sullivan Show*, *American Bandstand*, and *Your Hit Parade* (NBC/CBS radio 1935–1955; NBC/CBS television 1950–1959). Many specifically mentioned Elvis Presley's famous appearance on *The Ed Sullivan Show* in 1956, while others identified *American Bandstand* as providing a window into the latest fashions and dances.

Robin (b. 1944): I think the thing that stood out, that stands out in my mind today was that, um, *American Bandstand* for sure, because you had to know what the latest fashion was, what they were wearing, what, how they were dancing . . . I think [my girlfriends and I] may have talked about it. I mean my friends at the time . . . we probably talked about *American Bandstand* the most!

Similarly, Edwina of Utah acknowledged the influence of *Your Hit Parade* on the recorded music she chose to buy.

Edwina: Whatever was the hit was what everyone would buy.

The advent of transistor radios, smaller in size and more portable than tube radios, impacted the lives of some participants and their ability to socialize and share media with friends outside the home. Tori mentioned her portable radio as a part of memories of hanging out with friends at the beach:

> Tori: I remember getting for one of my birthdays a portable radio to take to the beach. Because now living in Oceantown [pseudonym] and being you know, a teenager, we spent all of our summers down at the beach. Every day was spent down at the beach. And at night we could walk from our house down to the beach, and come home by another way. And it was very safe. It was no problem. But Oceantown Beach was most of the entertainment.

Dancing also seemed directly connected to the women's memories of music in their lives, crossing socio-economic classes and geographic placement in their teen years. While Melissa recalled street dances, sisters Lacey and Honey remembered twirling their skirts to waltzes and the various records their families owned; Amanda said the radio was "always on" in her home and music had been a huge part of her life. Stella said her parents would reluctantly allow her to attend house parties—called "jumps"—where both slow dancing and more upbeat dancing to rhythm and blues and rock and roll would be played. Tori recalled dancing to big band music at various commercial dance halls and sock hops at her high school. Winifred and Amanda also recalled sock-hops, where they would dance to the relatively new sounds of rock and roll music. Each said the dances were probably tame compared with their understanding of today's dances.

> Winifred: No drugs or alcohol, or for that matter no smoking allowed. My circle of friends were very straight. In fact at my fiftieth high school reunion we were all laughing at how boring we must have been.

Tori recalled how everyone appeared dressed up at the commercial dance venues as well as the style of dances they did:

> Tori: But it was all music. And everybody dressed. It wasn't this dungaree business and t-shirts, and shirts advertising for companies. We dressed, and we dressed in our heels and, you know, the full skirts and all that stuff. And jitterbugging. I loved to jitterbug. I just loved to jitterbug. And even school, the schools had dances, would have dances like on Friday nights.

Amanda remembered dancing at concerts with some of the more well-known pop music acts of the time.

Amanda: That was in my hometown when sock hops became popular. And it used to cost a dollar to go to the sock hop. . . . We were allowed to go there, and the place was filled with teenagers, and I remember going to one of these sock hops when Frankie Avalon, Annette Funicello, Fabian, um, who else was in those days? There was a set of twins. I can't come up with it . . . The Everly Brothers! All of these people used to come through our town. They would do these shows and it was fantastic!

Many of the women credited their parents with introducing them to music, specifically through formal lessons taken in childhood. For example, some took dancing lessons, including Amanda, who loved to emulate Gene Kelly's routines. Many took piano lessons, including Winifred who remembered sharing sheet music with girlfriends.

Winifred: Sheet music and records played a big roll. I played the piano and my friends would sing. I have a huge amount of sheet music from the '30s, '40s, and '50s. Some I inherited, but most of it I bought. By this time I had a job and could buy it with my own money.

In addition to participating in music through dancing or playing an instrument, many of the women's families encouraged playing recorded music in their homes. In Stella's case, her family actually worked within the live music industry. Until age 12 (when she moved to Minnesota), Stella lived above her grandfather's jazz club outside Spokane, Washington, where she heard and met such jazz greats as Cab Calloway, Lionel Hampton, and Hazel Scott. Sisters Lacey and Honey noted their parents' record collection and trips into a nearby city in Utah where they would purchase 78s (an early form of phonograph record) from a furniture store that sold music. Elizabeth mentioned that stores allowed customers to listen to music in private listening booths before purchase. Robin said that being able to purchase her own records (45s, a later version of records that contained one song on each side of the record) was a huge turning point in her life, even though she had to play those records on the family's shared record player.

Robin: Oh, buying a record! I can remember my first two records that I saved for, and I was so excited to be able to go out and buy them. They were the little 45s.

She said she was primarily into the "teen crazes" of the time, including Bobby Vinton, Frankie Avalon, and Elvis Presley.

Robin: My uncle gave me one of the first Elvis albums that came out, and I can remember everybody saying, thinking, that was a big deal [because of Elvis' fame].

Tori, who had moved from the city of Boston to the suburbs in her teen years, spoke of records almost as a salvation during an otherwise difficult time of adjustment. Her interview suggests music served as a more personal, private means of identity articulation for her as a teen.

> Tori: There wasn't anything [in the suburbs]. There wasn't as much to do to begin with. But by that time I was into music. And in those days, where we bought the records, you could go into a room, and play the records, play the music, listen to what you wanted, and it was on 78s, and they did have the single records too, whatever that was.

In keeping with Angela McRobbie and Jenny Garber's discussion of a girls' bedroom culture (6), Tori also noted music was a major connection point among her girlfriends and was a part of their socialization. They would play different records for one another and share favorites; of those, Tori mentioned Tony Bennett and Vic Damone, both of whom they idolized.

> Tori: And we would go to visit . . . different girls. We'd get together and we'd go down and listen to the records. We'd listen to the music and know what we were going to buy. I had quite a record collection of 45s.

As an African American, Stella said music was the one space within popular mediated culture where she noticed other African Americans. She said she adored popular music and buying records partly because of this fact. In the post-World War II era, popular music was still largely segregated, and African American forms, such as blues, bebop, and rhythm and blues, were somewhat marginalized. However, in the late 1950s, the popular music performed by African Americans was embraced by non-Black audiences as well (Ramsey). Stella's favorites included Marvin Gaye, The Supremes, Muddy Waters, Aretha Franklin, and Junior Wells and the All-Stars—artists unmentioned by the Caucasian research participants in our study. (Leslie did, however, mention she was a fan of Fats Domino and Chubby Checker, famous early rock and roll stars who were African Americans—performers of what she called "real rock 'n' roll.")

> Stella: When I was a teen, all my friends and I were heavily into 45 rpm records. During that timeframe, there were a lot of Black records produced and made—much more there in terms of media content than could even approach what was on TV or even the radio at that time. That [music] was the predominant media landscape for Black children and teenagers, I'd say.

Like many other women in the study, Stella said music became an important part of her life, and she did enjoy sharing her music with her friends, whom, she said, were primarily African Americans but included some Caucasians also. Since,

as Stella noted, media in the immediate post-war period were largely populated by White actors, the visibility of Black musicians and popularity of their music was particularly important to her.

Clearly, music appeared to be intrinsically woven into both the social and private lives of the women in our study, a number of whom mentioned it as an integral part of their teen identity and gender articulation. On the other hand, while recalling their teen experiences of music and dancing brought back fond memories, the majority of our informants did not discuss the kind of rabid fandom so often a part of the stereotypical bobby-soxer image. While Scheiner's research on mid-twentieth century Deanna Durbin devotees, for example, found that "girls used the discourse of fandom to make sense of the material conditions of the Depression and World War II" and that "fan generated texts also helped girls explore the dimensions of teen girl identity" (6), only two of our respondents, for example, mentioned fan-collecting behavior, such as autograph hunting. Interestingly, while fan collecting behavior was not mentioned often, for the two women who did mention it, it was an important part of their youth.

> Tori: And what the girls and I from school used to do. See the radio stations used to have the singers come to the radio station to push their new songs. And when they came to the radio stations, we used to travel by the trolley cars to Boston, mostly WHDH, and I don't remember what the call letters were, and I have many, many autographs from Frankie Laine and . . . Vic Damone. Vic Damone was one of my favorite singers.
> Interviewer: Autographed pictures or just autographs?
> Tori: Autographed pictures and I had signatures in an autograph book.
> Interviewer: Did you hang them up in your room?
> Tori: No, I wasn't allowed to do that. [Laughter] No, we didn't get into that that much. I don't recall that. We had them in, they call them memory books now. We sort of had our own photographs and scrapbooks, saving ticket stubs and things like that. But the live singers, we had, I had many, many autographs from them.

Similarly, Amanda recalled collecting autographed photos of famous actors and actresses.

> Amanda: I used to, from the time I was probably in third or fourth grade, whenever I went to movies and saw these beautiful movie stars, I would write a letter to the movie star and ask them, tell them, and, oh, I had a collection of movie stars, Peter Lorre, Betty Grable, Doris Day, all of these famous movie stars; would write letters to them and ask them to send me pictures. In those days, they *did* send pictures.

Like Tori, she did not hang such photos on her bedroom walls—not because she wasn't allowed to but rather because it was "private stuff."

Leslie, conversely, was openly disdainful of girls who fit the typical teenybopper fan stereotype. She recalled seeing Elvis Presley's first appearance on *The Ed Sullivan Show*.

> Leslie: I can remember them showing girls in the audience and thinking "what the heck?!" But he was good. There was no doubt about it.

While she enjoyed the music, she neither condoned nor engaged in outward fan behavior. Elizabeth of upstate New York also recalled Elvis Presley.

> Elizabeth: I think I saw him when he was first on *The Ed Sullivan Show* . . . Yeah, I liked him. I didn't go gaga over him.

In general, then, the popular image of post-war teen girls as "teenyboppers," smitten with the latest teen idol, did not resonate with our informants.

Conclusions: Post-War Girls, Popular Culture, and Identity

Kearney has described mid-twentieth century magazine exposés of teenage girls as creating a "homogenized" image of female adolescents as "strange and exotic creatures interested in particular modes of fashion, entertainment, behavior and language that set them apart from older women, traditional femininity, and the roles of wife and mother" ("Birds" 572). Indeed, our popular collective memory of post-war girls is of fashion-conscious teenyboppers swooning or screaming over the teen idol *du jour*. While *some* of those characteristics may describe *some* of our informants at *some* points during their youth, our findings reveal a much more complex and nuanced postwar teen girl experience. In fact, we are hesitant to even use the phrase "teen girl experience," because we've found a range of different experiences. As Schrum reminds us, there was no "single, unified teenage girls' culture," and there were "multiple teenage girls' cultures" at this time (4). In summarizing our findings, we therefore call on the title of Schrum's book "*some* wore bobby sox." Others wore poodle skirts, others Jantzen dresses and Joyce shoes. Some wore overalls as they did their chores on their family farms while others dressed conservatively for church. Some wore dance costumes while still others wore hand-me-downs. While some post-war girls may have fit the popular image, others did not.

We admit to being surprised that our informants did not mention many of the young female characters who have been the focus of much recent academic literature on post-war girl culture. In retrospect, this finding should not have been surprising, and it is most likely due to the reality that, by the mid-1950s, girl culture had been weakened and replaced by more of a teen boy culture. The majority of our informants were teens in the mid to late 1950s—a time when, according

to Nash (168), "images of teens, and girls in particular, dwindled significantly from their 1940s standard," a phenomenon previously reported by Kearney ("Recycling" 286). Nash (174–175) links this to a post-war "crisis of masculinity," resulting from returning servicemen attempting to reclaim their place in day-to-day American life.

Despite not fitting the image of the post-war teen girl of popular imagination and despite their diverse life experiences, many informants were united in describing their childhoods and teen years fondly. Moreover, some even took the time to compare their own childhoods with the media-saturated childhoods of young Americans today. For example, despite expressing her happiness for the new opportunities girls and women have now, Tori did see some things as better then:

> Tori: We didn't have any Hannah Montanas.[1] We weren't as clothes-conscious as they are today. Which in my mind is a good thing. We stayed young. We stayed teenagers instead of growing up before our years.

Appendix A: Interview Participants

All names are pseudonyms.

1935—Edwina: Caucasian (of Danish and British descent); grew up in a small town in Utah; describes family as having been relatively well-to-do.

1935—Melissa: Caucasian (of English, Scottish, and German descent); grew up in rural upstate New York; describes childhood SES as having been poor.

1935—Tori: Caucasian (of Italian descent); born in Boston, Massachusetts, but spent teen years in suburban Boston; describes family as having been middle-class.

1936—Rose: Caucasian (of French-Canadian descent); born and raised in urban Massachusetts (in a mill city); describes family as having been particularly poor during her junior high and high school years.

1936—Winifred: Caucasian (of Scandinavian descent); born in a small town in Illinois.

1938—Lacey: Caucasian (of Scandinavian descent); born in rural Utah (sheep ranch); sister of Honey; describes family as having been upper-middle-class and very fortunate.

1940s—Stella: African American; grew up in Spokane, Washington, and St. Paul, Minnesota; describes family as having been middle- to upper-middle-class.

1940—Harriet: Caucasian (of English, Dutch, and "possibly Irish" descent); born and raised in Southern Kentucky (Appalachia); describes family as having been poor.

1940—Maggie: Caucasian (of German and Dutch descent—"more German than Dutch"); grew up in urban North Carolina; responded to childhood SES question by saying "we didn't have a lot."

1941—Leslie: Caucasian (self-described WASP); born in rural Iowa and grew up on a farm in rural Illinois.

1942—Honey: Caucasian (of Scandinavian descent); born in rural Utah (sheep ranch); sister of Lacey; describes family as having been upper-middle-class and very fortunate.

1943—Amanda: Caucasian (of Polish descent); born and raised in a small city in upstate New York; parents owned a business.

1944—Elizabeth: Caucasian (of English, Dutch, and French descent); born in Flushing, New York, and grew up in a college town in upstate New York; describes childhood SES as middle-class.

1944—Ramona: Caucasian (of Pennsylvania Dutch or German descent); born in Ann Arbor, Michigan; spent early childhood in Pennsylvania, then grew up in Memphis, Tennessee; describes upbringing as middle-class.

1944—Robin: Caucasian (of Hungarian/German descent); born in Cleveland, Ohio, and raised in rural Ohio on a farm; describes family as working-class.

Notes

1. While teen and tween female celebrities such as Deanna Durbin, Judy Garland, Shirley Temple, Elizabeth Taylor, Annette Funicello, and Natalie Wood were extremely popular at various points from the late 1930s and into the 1950s, and might be considered comparable to today's Miley Cyrus (Hannah Montana) phenomenon, our informants rarely and only fleetingly mentioned such celebrities during their interviews. While it is possible our respondents would have been familiar with these celebrities at the time, the fact that they

did not specifically identify them in their recollections speaks to their lack of connection to them for whatever reason.

Works Cited

Abu-Lughod, Lila. *Writing Women's Worlds: Bedouin Stories*. Berkeley: University of California Press, 1993.

Ariès, Philippe. *Centuries of Childhood: A Social History of Family Life*. New York: Knopf, 1962.

Berg, Bruce L. *Qualitative Research Methods for the Social Sciences*. 5th ed. Boston: Allyn and Bacon, 2004.

Christian-Smith, Linda K. *Becoming a Woman through Romance*. New York: Routledge, 1990.

Doherty, Thomas. *Teenagers and Teenpics: The Juvenilization of American Movies in the 1950s*. Boston: Unwin Hyman, 1988.

Howarth, Ken. *Oral History: A Handbook*. Gloucestershire, UK: Sutton Publishing, 1999.

Kearney, Mary Celeste. "Birds on the Wire: Troping Teenage Girlhood through Telephony in Mid-Twentieth-Century U.S. Media Culture." *Cultural Studies* 19.5 (2005): 568–601.

———. "Recycling Judy and Corliss: Transmedia Exploitation and the First Teen-Girl Production Trend." *Feminist Media Studies* 4.3 (2004): 265–95.

Luscombe, Belinda. "The Truth about Teen Girls." *Time* 22, Sept. 2008: 64–9.

McRobbie, Angela and Jenny Garber. "Girls and Subcultures." *Feminism and Youth Culture: From* Jackie *to* Just Seventeen. Angela McRobbie. Boston: Unwin Hyman, 1991. 1–15.

Nash, Ilana. *American Sweethearts: Teenage Girls in Twentieth-Century Popular Culture*. Bloomington: Indiana University Press, 2006.

Ramsey, Guthrie P., Jr. *Race Music: Black Cultures from Bebop to Hip-Hop*. Berkeley: University of California Press, 2003.

Savage, Jon. *Teenage: The Creation of Youth Culture*. New York: Viking, 2007.

Scheiner, Georganne. *Signifying Female Adolescence: Film Representations and Fans, 1920–1950*. New York: Praeger, 2000.

Schrum, Kelly. *Some Wore Bobby Sox: The Emergence of Teenage Girls' Culture, 1920–1945*. New York: Palgrave Macmillan, 2004.

Spigel, Lynn. "Seducing the Innocent: Childhood and Television in Postwar America." *Ruthless Criticism: New Perspectives in U.S. Communication History*. Eds. William L. Solomon and Robert McChesney. Minneapolis: University of Minnesota Press, 1993. 259–90.

Thompson, Paul. *The Voice of the Past*. Oxford, UK: Oxford University Press, 2000.

Wartella, Ellen and Mazzarella, Sharon. "A Historical Comparison of Children's Use of Leisure Time." *For Fun and Profit: The Transformation of Leisure into Consumption*. Ed. Richard Butsch. Philadelphia: Temple University Press, 1990. 173–94.

Becoming a Country Girl: Gough, Kate, the CWA, and Me

Catherine Driscoll

Despite the significance of the rural/urban distinction, contemporary cultural research and theory have focused little attention on it. One reason for this neglect is the lack of a conceptual vocabulary for articulating the blend of psychic, cultural, and "real" geography that concerns us here.
— Barbara Ching and Gerald Creed, *Knowing Your Place: Rural Identity and Cultural Hierarchy*

[A]necdotes for me are not expressions of personal experience but allegorical expositions of a model of the way the world can be said to be working.
— Meaghan Morris, "Banality in Cultural Studies"

I remember, as a young girl, standing at the window of a darkened bedroom looking out over the city of Armidale in rural New South Wales (NSW), Australia. I was on holidays there, from my small hometown, and for me that field of twinkling lights was a spectacle which I was not sure I understood but was sure I wanted. It was a constellation of mysterious life outshining the stars I was used to at home, a material sign that the world I read about in books or understood vaguely from the radio really did exist. This image of the attractions of "city lights" has been a powerful one in Australian scholarship on rural youth, but for me it remains a complicated and ambivalent object of desire, which is less about difference between the country and the city than about lines drawn between them. My city lights would also have thought of themselves as the country.

"Country" and "girl" are imprecise terms, defined more clearly by what they are not than by any positive quality, but nevertheless there are girlhood experiences dramatically shaped by location outside the urban. The differences between experiences of Australian country girlhood are undeniably important. A girl from a station in Queensland and one from a small NSW river-town do not have the same country girlhood, and I did not have the same country girlhood as the aboriginal girl who sat in the next classroom and lived on another side of town. But every encounter with country girls, or ex-country girls, reminds me that an elusive thing we share matters in a way that is both slippery and vital. Confronted by this complexity in the course of researching Australian country girlhood, I finally decided on trying to find the specificity of my own country girlhood as a way of being better equipped to encounter that experienced by others. In fact, I had to be trained in the significance of being a country girl, and in some ways I learned to see it from the outside as well as in conversation with imperatives to define "the country" and "girls" that surrounded me every day.

This is an essay about Australia in the 1970s, a period of spectacular cultural change that is also when I become a country girl. I did so in relation to the production of an at least rhetorically cosmopolitan and multicultural Australia, the reimagining of Australia's economic dependence on primary resources, and the emergence of a self-conscious feminist public sphere. But these changes reached me in translation, carried along two very different trajectories. The first is a long continuity in Australian country life—the imperative to name the local, brilliantly invoked by Meaghan Morris's account of the diverse strategies "used to engender effects of place" in a country town (*Too Soon Too Late* 32). Every local paper, radio station, and meeting of any kind is repeatedly impelled to name *what* it is as some version of *where* it is, and the other way around. Lists of names proliferate, connected to other names and reaching into the past and from the local to other familiarly placed localities. Images of a new Australia in the 1970s seemed to threaten such localization. And the second trajectory is a discontinuity—a wave of changes to communications industries and practices flowing from the expansion of television through "regional," meaning non-metropolitan, Australia. While local media seem to name a highly specific constituency to which girls are marginal—newspapers claiming to represent a town, radio stations belonging to a valley or shire—media that address girls specifically has a sharper impact. My fieldwork suggests that the media experience of Australian country girlhood is an experience of distance shaped by both these forces and shared not only across locations and styles of girlhood but across generations.

Any attempt to map the histories of country girlhood must deal with the ambivalence of girlhood in modernity.[1] Representations of modernity and the rural often seem to be at odds, and the rural is associated with traditions modernity is presumed to disrupt or displace. Well before Raymond Williams published *The*

Country and the City in 1973, "the nonmetropolitan had come to stand for the past . . . and in particular for the past persisting in the present" (Driscoll, *Modernist Cultural Studies* 154). But in just this way the rural is endlessly engaged in and by dialogues about modernization. Moreover, as I argue in *Girls: Feminine Adolescence in Popular Culture and Cultural Theory*, girls are a crucial image of modernity at the same time as they are never its subject-citizen. At a conjunction of these problematic terms, country girls both exemplify change for the world around them and are distanced from the contemporary in their own experience. As Williams suggests, the country in modernity is a sign of loss, something always most visible as a site of change in which some innate value has just been lost, "Just back, we can see, over the last hill." (1973/1975: 9) Talking about Australian country girls inevitably participates in ongoing narratives about the decline of the rural, including a story about the drift of young women away from country Australia that is older than Federation. It does matter that I, like most country girls, moved away from the country in adolescence or young adulthood. But considering how one becomes a country girl raises a set of complications that I think we need in order to analyze how and why that happens.

As Heather Goodall points out, "In areas like Australia where colonization began after the processes of European 'modernisation' had taken hold, the impact of modernity is as much rural as urban" (22). But the country's claims to cultural distinctiveness are articulated against this modernity, and the interplay between metropolitan and country Australia often emphasizes unequal access to the resources needed to be "modern." That is, while access to amenities presents a problem in many country areas, these same limitations heighten a shared sense of community and place. Access has long been a focal point of sociological studies of rural youth, but the idea that the rural is characterized by lack can be misleading. The difference of access to media is often not about the equal distribution of products, because the distance across which they are consumed can make the same products mean something new.

The problems the country girl poses for thinking about modernity, media, and identification are difficult to pin down. My approach to the mesh of experience and image that constitutes country girlhood has been an interdisciplinary one, intersecting analysis of a media archive with other methodologies. Policy documents, demographics, and twelve months of ethnographic fieldwork dispersed across six different Australian country towns, all aided by a range of critical tools learned from cultural studies, geography, and sociology, have hopefully made my understanding of country girlhood richer and more complex, but they have also made it difficult to represent. I have thus found specific case studies helpful as points of access to this broad array of materials. And one of the most useful tools in checking myself against simplification has been an auto-ethnographic voice. Reflection on my own process of developing an identity as a country girl has been

indispensible in keeping the complex experience of country girlhood in view. Perhaps most importantly, focusing on a particular time and place, and indeed a particular feeling for place and identity, enables a many-layered cultural history that offers something new to discussions of both rurality and girlhood.

1973: Elizabeth Reid, *Bellbird*, and *Number 96*

As markers for my country girl's experience of 1973, Elizabeth Reid, *Bellbird*, and *Number 96* are relatively obscure. Outside Australia, they are generally unknown. Even within Australia *Number 96*, a successful television soap opera set in a city apartment building and centered on sensational stories about new Australian identities and new gender norms, and *Bellbird*, another soap opera, this time set in a quiet country town, will be more widely known than a briefly significant political figure like Elizabeth Reid. These are markers that speak to the historical specificity of cultural location, but they also point to two crucial influences on my learning I was a country girl: feminism and television. Both seemed to emerge in the city as specifically opposed to the lives of country girls, and they came into my life together.

"Country girl" is partly a political identity, and at least a semi-conscious one. By the middle of 1973, feminism was a word given extra currency where I lived by the appointment of Reid, a girl from the next valley, as the first Women's Adviser to the Prime Minister. It was a small moment of national relevance, certainly nothing to equal a hometown boy signing to a Sydney rugby league team. But Ms. Reid became part of a national political debate about Australian women and feminism evident in the one-page press statement about her appointment: "Ms. Reid's salary," it still tells me, "will be in excess of $10,000 a year" ("Press Release").

It seems that counter-cultural discourses are less visible in non-urban communities, which studies often suggest are dominated by conservative narratives about proper social roles. Johanna Wyn, John Stafford and Helen Stokes, in their 1998 summary of research on rural Australia, argue that gender relations in rural communities are based on narrower ideas of what constitutes masculine and feminine behavior (14–19). So if I had a political consciousness before I went to high school, and if I understood that to be "counter-cultural," and if I additionally thought that to be something of an achievement in my town, how did all of that happen? The obvious answer seems to be that the media told me about politics and showed me other choices than those most common around me. But if television had a particular impact it was most importantly via what I want to call, after Pierre Bourdieu, "girl cultural capital."

Girl culture is a system of exchange within which styles of girlhood are distinguished and evaluated, and girl culture capital names the ways in which girls artic-

ulate access to and facility with those resources. Such a network of evaluations is often discussed in terms of "peer pressure," but a concept like "girl culture capital" both stresses the particularity of girlhood in its local contexts and acknowledges the institutions and forces that provide material contents and contexts for such negotiation. As a refinement of Pierre Bourdieu's notion of cultural capital, girl culture capital is crucially not subcultural, although subcultures may interact with and even within it. Instead it is bound into and also deployed by "mainstream" culture (also sometimes referred to in youth studies as "parent culture") and often seems both less troubling and more irrelevant to public life than many other forms of youth culture.[2]

By the middle of 1973, most of the children at my school lived with televisions. The rise to cultural superiority of every child in a television-equipped house was rapid, and television brought with it new modes of knowledge, including new ways of knowing about the difference between the country and the city. The first television program I recall was one I never saw and would not have been allowed to watch. Like the city lights cast in studies of rural youth as the beguiling promise of a fulfilling life, *Number 96* (Channel 10, 1972–1977) was a glimpse of another world.

Television commenced for metropolitan Australia in 1956, with a national public broadcaster, the Australian Broadcasting Corporation or "ABC," and two commercial stations launching in time to cover Australia's first Olympic Games that year. Television thus connoted not only the national and urban but the transnational, tying Australia to global cultural flows. The demand for regional television networks was thus simultaneously about access, modernization, and representation. ABC television was committed to gradually covering rural areas, as ABC radio had done since 1923, but it was widely received as national rather than local. At home my family had listened to the local commercial radio station, 2KM, since it was available in the 1930s. This identification survived the station's relocation to a rival coastal town in 1980, changing the region it claimed to name (now 2MC for "Mid Coast"). But if we did not listen to ABC radio, the national identity of ABC television had different connotations.

ABC television entered Australian schools with a pedagogical purpose. The current affairs for children series *Behind the News* (1969–2003, 2005–) was a feature of my primary school education. It came, along with a television, to our assembly hall in 1973 in the wake of the new Whitlam government's commitment to equitable access to education. This suite of reforms singled out country girls as a special case. The 1975 *Report to the Schools Commission* notes:

> Improved educational levels among country girls may often result in a situation where the alternatives are to leave the area (a decision not open to married women as independent agents), or to remain and cope with the frustrations

associated with the absence of employment appropriate to the educational level reached and those of concealed unemployment among women. . . . These are important questions requiring investigation along with the educational needs of country girls and women. (McKinnon 7)

Policy developments regarding education, "women's affairs," and the extension of dense media networks into country Australia were thus directly entwined. Yet *Number 96*, rather than *Behind the News*, represented urban Australia to me. Via *Number 96*, feminism was not a news headline but a story about desire, relayed by girls with more access to television's currency of cool alongside strategies for getting to watch television.

From 1970, ABC television was distributed by microwave link and accessible to most of Australia, reinforcing a sense that what the country had less access to was commercial programming as the epitome of consumer culture. The ABC was what everyone had, was used by schools, widely permitted by families, and relatively "good for you." Commercial programs, especially those not concurrently screened for us, thus represented city television as more for pleasure than was ours, and the image of being up-to-date with what screened in the city was an important marketing tactic for regional television. The regional station GLV10, "Gippsland's own Independent Television Station," typically advertised itself as offering "the latest programs running ahead of other Australian stations," a slogan attached in 1966 to a weekly prime-time line-up that included *Peyton Place, Lost in Space, I Dream of Jeannie* and *Gidget* (GLV10 Advertisement 1966). Much of this content foregrounded as new and current was produced overseas, and especially in the United States, but in 1973 *Number 96* was the most popular program on Australian TV, and I not only knew that but understood it to represent a sophisticated Australian-ness opposed to the everyday lives around me.

Color television was available by the time there was finally a television in my home in 1975. Ours was not color, but like the early family cars my grandmother recollected in detail, I can remember it very distinctly—a curvaceous chunk of faux tweed and cream plastic. Like the car before it, television shifted what seemed to be exotic for country girls and presented a distinctive change in the media flows shaping their experience. There's a photograph of my grandmother at twelve years old, half-smiling behind an enormous oriental fan, wrapped in someone's dressing gown recast as a kimono for a concert where she fondly remembered having been complimented for her performance of foreign feminine charm. There is a photograph of my aunt in her twenties, curled up smiling on a beach towel with her bakelite radio, perm, and sexy swimsuit, straight out of *Gidget* (1959).

Like the arrival of cars and television as ordinary components of girls' lives, and like the newspaper ads for a once central picture theater which attest that in the 1930s and '40s it screened predominantly generic overseas films,[3] these

photographs date and map particular interactions between girls in my town and circulating media images of what girlhood meant for the world that was not our town. My point is not to claim the 1970s as a greater transformation than the 1910s, when the railway came to town, or the 1920s, when the movies first appeared in a paddock that became a theater in time. Instead I want to insist that a communications history of country girlhood offers a fresh perspective on its diverse cultural attachments and productions of identity. Crucial similarities can be found between the impact of the movies or radio and the impact of television on country towns, but there are differences as well due to television's combination of banality and spectacle.[4] In comparison to the Japanese girl and the beach girl, the girls of *Number 96* offered no definitive costume to dress up in. No matter what any girl wore, or how she did her hair, the new girlhood imagined by *Number 96* was neither an impossibly distant fantastic object nor available to us. It was an index of a lifestyle which was more glamorous and more real than our own and which was defined against us.

Australian television in the 1970s did attempt to represent country life. The soap opera *Bellbird* (1967–1977) was a central component of our early "family viewing" and consumed as a representation of Australia that included our lives. *Bellbird* commenced amid the mid-sixties' expansion of regional stations, staking a claim for the ABC's representation of country Australia. *Bellbird* represented country towns to the broadcaster's predominantly urban audience and was packed with encounters between the urban and the rural, for which a central difference of the country was to be comically small-minded. Nevertheless, *Bellbird* was popular with country viewers and only a moderate success in the cities. The innate virtues of "countrymindedness" were also attested to by *Bellbird*, as by many later TV soaps, including generous goodheartedness, despite some dramatic villainous exceptions, and a heroic struggle with the environment. These were virtues my town espoused about itself.[5] And there were country girls in *Bellbird*, girls whom I recognized because they were positioned somewhere between the local and a place of opportunities.

1975: *Countdown* and "the Dismissal"

From 1975 I have selected two moments that are rather better known on a national and even international scale than those from 1973, but which seem incongruous in combination. One is the ABC music television series *Countdown* (1974–1987), which appeared at the end of 1974, and the other is "the Dismissal" of the Whitlam government. While *Countdown* does not require much glossing for non-Australian readers beyond saying that it was a musical hits program, "the Dismissal" might. This names a constitutional crisis in which the reformist Labor government was removed from power by the Queen's representative (the Gover-

nor-General) after a Senate block on funding bills had halted government business and replaced by a conservative coalition of the Liberal and Country parties. However different the appearance of *Countdown* and the dismissal of Whitlam seem in terms of scale and significance, both were televisual events which cast into sharp relief changing relations between country and urban Australia, including dramatic conflicts between key claims to political constituency.

Like most country girls in the 1970s, I did not grow up surrounded by praise for Whitlam's reforms. The region in which I grew up had returned Country Party candidates at the Federal level since the electorate's formation in 1949, and almost without exception at the state level.[6] My central memory of "the Dismissal" is my grandmother throwing a rolled-up magazine at the television on which Malcolm Fraser was speaking following his appointment as caretaker Prime Minister. This incident is not only my first explicitly political memory but an index of how television had changed the world in which I lived. The television that had recently come to occupy the focal point of our loungeroom made me intensely aware of my family's responses to the dramatic Australian political situation. Scholarly approaches to television, such as Roger Silverstone's, have stressed its transformation of domestic space, and it evidently combines the conversational banality of radio and the special immersive event of cinema. This immediacy mattered to the impact of "the Dismissal" and allowed me, although it seems a strange proposition now, to understand this crisis as especially about the proper roles of women and youth, and thus about girls.

The 1972 federal election campaign, in which the Australian Labor Party (ALP) had declared it was "time" for a change—complete with catchy jingle sung by a chorus of film, television, and pop stars—underpinned more subtle generational narratives in the 1975 campaign. "Girls" and "the country" were signs of what had to either change or be preserved in Australia. An image of the country as repository of authentic Australian identity was ranged against images of Australian culture for which new styles of both youth and womanhood were representative. For both sides of the Australian political divide, the country figured on the side of stability, tradition, and age, inflected by the conservatives as maturity and the ALP as redundancy and stagnancy. Listening to National Country Party (NCP) leader Doug Anthony's 1975 policy launch now, its narrative about "young people" led astray by the false promises of an urbane new Australia still seems familiar. On the one hand, this danger is clearly identified as unemployment associated with decreased dependence on primary industries but, on the other hand, it is also "education" detached from "worthwhile and useful" lives and traditional/country values.

While in economic and cultural terms Whitlam approached the mythical place of the country in the Australian imagination with skepticism or outright hostility, he was committed to the significance of representing Australia. Among

the Whitlam government's many interventions in the field of culture, one of the most pervasively influential was the 1975 Australian Film Commission Act. The AFC, as Tom O'Regan has elaborated, was not just about film. It was also a repository for debates about local media content and incorporated guidelines still used for assessing television programming. As part of a drive to *have* and *be* culture evident in the establishment of the AFC, and of the Australia Council (for public funding of "the arts"), and indeed in the change of national anthems from "God Save the Queen" to "Advance Australia Fair," increased attention to local content resulted in expanding Australian television production in the 1970s. (The first of these series to make a profit had been *Number 96*.)

In thinking about the way political claims were laid for and against country and urban girlhood around me it seems no coincidence that the major redrawing of electoral boundaries around my hometown maps closely onto the key dates for the formation of the Country Women's Association (CWA). In the 1970s, the CWA was an iconic presence in my hometown. It had rooms off the council chambers, beneath the town clock, across from the town library, and next to the Baby Health Centre (which, like many similar centers, the CWA had established). Their functions were reported in the town newspaper, they ran the tearoom at the annual agricultural show,[7] and they provided one among several strongly factionalized social venues for local women. But despite an apparently logical interest in the country girl who would become country women, the CWA also defined itself against us.

Younger women and girls had been discussed as in need of both social outlets and new skills in the early 1920s' CWA publications. But only some types of change served the declared interests of the CWA, which soon came to represent itself as the bastion of conservative country womanhood. As the Association's own history *Serving the Country* admits, "it has been a challenge to accept that society has changed and to find a positive and constructive way of responding to that change while retaining the deeply entrenched values of the Association" (Townsend 200). The last "Younger Set" CWA conference was held in 1971 and after this the Association increasingly positioned itself as striving to understand or *with*stand the contemporary. By the mid-1970s, the CWA had been transformed into a largely nostalgic institution representing values perceived as lost or under threat. As Goodall argues with reference to Australian country life more generally,

> As social and cultural changes accelerate, the present generation's experiences begin to appear very different from those of parents and grandparents. Anxieties emerge as valued practices or knowledge are seen to be receding, a sense of loss develops and an array of tools and techniques are assembled, all aimed at preserving or recapturing a link to an "authentic" past. (20)

The CWA was undoubtedly one of these assembled tools and techniques. Something very like the CWA woman was the necessary complement to the Australian "bush" man, but it was a mystery to me how any girl came to want to be her.

Countdown offered a different kind of constituency. In the federal context of ABC television *Countdown* was committed to representing Australia, but for me it was a collage of musical acts which came from a foreign land. Its "local content" only stressed for me that in urban spaces there was an exchange with the rest of the world from which I was excluded. While it had a wider "youth" audience, like the pop music countdown genre more widely, *Countdown* especially appealed to girls, and girls dominated its on-screen audience. As such it seemed to enter my home addressed to me personally. Right from the early years of *Countdown* it included a mix of (generally mimed) live performance, interviews, commentary, and music videos, despite how few videos were available in the early years. The pioneering inclusion of music videos in *Countdown* and its competitor series in the mid-1970s may well attest to the sense of distance built into Australia's participation in the trans-national popular music culture of the time, but this was particularly resonant for country girls. The homogeneity of the music video clip explicitly reproduced the same musical image for viewers everywhere, and *Countdown* imagined for me a wide musical audience of young people. But this was a gendered and geographically located media experience.

It is widely reiterated that rural youth are socially isolated due to poor access to transport and appropriate spaces and activities. Such analyses, which find many negative consequences to boredom among rural youth, tend to sidestep as irrelevant, unhelpful, or even corrupting the circulation of mass culture within the country. Some even suggest, in a corollary to that education report cited above, that greater access to communication technologies can have the effect of merely highlighting for young people the types of entertainment they cannot access (Wyn, Stafford, and Stokes 15-19). But the way television works as "entertainment" is more complex than this. By 1977, *Countdown* was a routine part of my home and school life, and one of the ways in which I assessed my taste and identity relative to girls around me.

Restricted both by gender conventions that bind girls more closely to the home than boys—and while many normative dimensions of feminine adolescence have changed, this is still widely evident—and by more limited access to "youth culture" than even the most suburban version of the urban, television was highly significant for country girls. Several dimensions of non-urban life need to be taken into account here, rather than merely subsuming country girls into the accounts of "bedroom culture" that emerged from discussions of girl culture in the 1970s. Country girls are still more likely to be directed outside for unorganized leisure time, although it is often closely observed by adults, and Angela McRobbie and Jenny Garber's famous opposition between girl culture and a boy-

centered youth culture that "happened on the streets" means something different in this context (McRobbie 19).[8] Studies of rural youth routinely stress an opposition between idyllic and boring, wherein "parent culture" is presumed to adhere to the former interpretation of country life and "youth" to the latter (see, for a range of examples and references, Cloke and Little). In practice, both images of the country are widely circulated among girls and both exceed an opposition between private and public space.

1978: *The Kick Inside*

As James Carey notes in *Communication as Culture*, the telegraph separated communication from transportation and radically changed what distance meant to media. But the new transmission model of communication, which became more dominant with radio and television, did not end the constitution of regional identities around media. Radio and television furthered the division of nations into transmission points and time zones, and at the same time enabled the articulation of new regions, which were no less arbitrary than those constituting an array of other claims to produce regional communities: electorates, parishes, CWA "meetings," the zones organized by sporting leagues, and so on. The regional television stations surrounding and defining my hometown constituted regional systems of knowledge. Some parts of our town belonged to a network centered on the drier interior of NSW (Tamworth) and others to a coastal network (Coffs Harbor), which presented two quite different images of country Australia set against the urban-country divide articulated by the ABC. In some ways television's capacity to name regional identities was eroded by deregulation of the television industry across the 1980s and '90s. Video, satellite, cable, and then digital technologies have further changed what television means and whether it can claim to represent anywhere particular. In this sense my girlhood is in some ways the girlhood of regional Australian television.

Watching television is very often a mode of consumption shared, and thus negotiated, with others. In my home, as in many others, claiming the television demanded a degree of diplomacy. But I generally consumed music on albums or the radio alone and with a sense of more directly expressing personal taste. Kate Bush's 1978 album, *The Kick Inside* is one of the first albums I remember choosing with a self-conscious sense of my own girl culture style. As the urban and the rural are mutually produced by the progress of modernity, adolescence and the subject-citizen of modernity are mutually produced around a modern idea of training not only in citizenship but in taste. Coming to have a personal *style* is a crucial element of the way adolescence was recast in modernity more broadly (Driscoll, *Modernist Cultural Studies* 77–117), and girls have been especially associated in this process with the mass consumption of both commodities and

identities (Driscoll, *Girls* 203–34). Choosing what type of girl you are involves selecting from a set of available options with different relations to the "mainstream." As Holly Kruse suggests, in 1978 Kate Bush could be consumed as a #1 pop smash hit or as something much more alternative (389). But *country* girls make such stylistic choices with direct reference to locality. For example, a pony club girl might understand herself as in some senses "fitting in" through her club activities and in others as highly singular.[9] I wasn't a pony club girl. Instead I was a ballet girl, and that says something about what Kate meant to me, but she had other connotations as well.

Countdown and *Bellbird* co-existed for some time, telling stories about belonging that were starkly generationalized by their programming juxtaposition. The end of *Bellbird* in 1977 reflects further changes to the Australian mediascape, but it does not mark the triumph of Australian urbanity. *Number 96* ran out of controversial steam at the same time, and television images of the rural were proliferating in the new local content environment. Australian-ness was under negotiation in the 1970s, and stories about country girlhood had a representative role, exemplarily in a range of successful colonial period dramas on television and film. In the wake of examples like the ABC dramas *Seven Little Australians* (1973) and *Rush* (1974; 1976), the last of which was required viewing in my home, the Australian TV mini-series was born with 1978's *Against the Wind*. Screened on Channel 7 in the cities but disseminated through most regional networks, which could independently buy programming from any urban network, *Against the Wind* was an apotheosis of the wild Australian girl which brought home to every girl in my class the pastness of country girlhood as a valued object. I did not see the film *My Brilliant Career* (1979) until I'd been living in the city for years, but this acclaimed film's story about divided attachments and conflicting futures represents, despite its different audience, a similar fantasy of feisty romantic girlhood as *Against the Wind*.

These girl-centered versions of countrymindedness focused on strong-willed and relatively independent girls, who were clearly contemporary girls in their interrogation of gender norms even while they reinforced older popular Australian fictions about the girl in the bush. They differed starkly from the girls screened as my contemporaries on *Countdown*. While the countryminded girl was still an ideal available through the agricultural show girls or pony club girls, she could only be a slice of any country girls' contradictory present-tense life. Changed patterns of internal migration in the 1970s had significant impact on my town, with counter-urbanization movements as much as centralization of government resources feeding an emphasis on the past in local public culture. A colonial-themed tourist attraction opened on the edge of town in 1976, taking up these motifs from popular culture as much as the claims laid by the CWA and the NCP. But while movies and television produced in the city found in the country girl a

telling image of both change and of essentially Australian identity formation, the theme park contained little that helped one imagine girls then or now.

Girl culture capital for country girls is always inflected by a sense of distance. *The Kick Inside* represents my own experience of this distance, and its title also provides me with a promising metaphor for country girlhood's mesh of difference and attachment. The video for the album's first single, "Wuthering Heights," was frequently screened on *Countdown*. It shows the 19-year-old Kate dancing in a field. Her alien but familiarly rural world was entangled for me with the fraught oppositional narratives of puberty. Kate's lyrics and her image spoke to my experience of girlhood as neither the CWA nor the Office for Women's Affairs ever could. I consumed her *as* a country girl in a double sense, searching the radio frequencies nightly for stations that would play the music I preferred. Like television, radio in the 1970s began to cross broader distances and thus both close and represent the gap between the city and the country. Brisbane radio stations, when I could get them, seemed especially exotic, and the search itself was important—part of my attempts to be somewhere else and feel at home there. Kate was a personal relocation, an internal distancing from what had previously seemed to be my possibilities, and this distance became part of what Bourdieu would call my "habitus," a personal orientation in the world carried through later experiences.

In adapting Bourdieu's ideas about habitus to talk about girl culture we need to take account of the stratified intimacy with influence which characterizes girls' relationships to a diverse and changing mediasphere. Habitus is a way of accounting for "dispositions *acquired through experience*"—a "feel for the game" that does not assume conscious direction towards particular ends (Bourdieu, *In Other Words* 9–10). It is produced by experience of particular conditions by which people "anticipate the necessity immanent in the way of the world" (11). Bourdieu's concept is useful for thinking about country girls because it focuses on who we are relative to where we come from. But I find it useful also because of where it seems to fail; where it misses something important in the experience of country girlhood. Bourdieu uses habitus to explain how "dominant agents" succeed by "unselfconsciousness," by merely needing "to be what they are" (11), while I am arguing that country girlhood is intensely marked by consciousness of where one comes from. Rather than seeing the habitus of country girls as any kind of order into which girls are born, I want to see it as an assemblage of belonging and style. The process of forming "habitus" is described in Bourdieu's work as a social product, neither nature nor destiny, but however much it tends "to perpetuate" it can be changed by intention and education ("Habitus" 45). This recognition is an important one but needs to be combined with attention to the country girl's self-consciousness of her location, and attention to the importance of girl culture in forming, articulating, and evaluating an alternative cultural location.

I am not only arguing, as many have before me, that the contrast between country and city tells country people who they are by opposition. The sense of being a *country* girl intersects the ambivalences of feminine adolescence and of rurality and only arrives as an opposition to both the urban *and* the country within an experience of girlhood.[10] Bourdieu argues that "in all the cases where dispositions encounter conditions (including fields) different from those in which they were constructed and assembled, there is a *dialectical confrontation* between habitus, as structured structure, and objective structures" ("Habitus" 46). This is not only an insightful way to think about how it feels to find yourself somehow still a country girl when you have long been somewhere, and someone, else. It speaks also to the ways in which country girls seem to encounter such difference within themselves. Given that so much of rural culture is bound up in representing a definitively non-urban constituency, the paradoxical fact that these representations so often originate from the city—like *Bellbird*, like the CWA itself, like rural electorates and television licenses—needs to be understood as something more than a problem with access to resources for media production. The distance built into the idea of the country meets the stylistic assemblage of girl culture in a clash that leaves the country girl understanding herself as a subject of distance.

Notes

This project draws on an Australian Research Council grant to study country girlhood (2004–2008) and is indebted to many girls and women I encountered in that research. I want to thank Mary Celeste Kearney for her support and her astute criticism.

1. I have discussed the periodization of modernity at length elsewhere (see Driscoll, *Modernist Cultural Studies*). Here, I will make do with Anthony Giddens' definition of modernity as an "idea of the world" centered on "human intervention" and giving rise to "a complex of economic institutions, especially industrial production and a market economy" and "a certain range of political institutions, including the nation-state and mass democracy" (Giddens and Pierson 94). By this definition the 1970s cannot in any respect be "post" modernity.

2. Bourdieu distinguishes cultural from economic or social capital, and "cultural capital" seems especially useful for thinking about girl culture as a product of training, education, and experience. I am also replying here to another refinement of Bourdieu's model: Sarah Thornton's "subcultural capital." Thornton understands subcultural capital as "a sub-species of capital operating within . . . less privileged domains. . . . Subcultural capital confers status on its owner in the eyes of the relevant beholder" (186). This is a useful provocation for thinking about girl culture, precisely because it cannot describe girl

culture's complex imbrication with the mainstream. In Thornton's argument, girls are most often opposed to subcultural capital, as in the unhip figures of "Sharon and Tracy" (87–115).

3. This theater closed only in part because it was displaced by television. The changing local economy and demographics, coupled with broader changes to infrastructure and technology, meant more movement between towns in a region, and thus new limitations on the one-screen small-town independent picture theatre. In this case the theatre's competition, at least for the young, was less television than the nearby coastal town's acquisition of a multi-screened cinema and a drive-in theatre.

4. See Morris's account of television's complex conjunction of banality and spectacle in "Banality in Cultural Studies," which opens with a story about the gendered impact of television in country NSW.

5. "Countrymindedness" refers to a generalized attitude presumed to characterize both non-metropolitan life and ideology. For an overview of the significance of this concept in Australian public life, see Wear.

6. This party, which had formed in 1920 in protest against urban-centered Australian politics, also dramatically reconfigured its boundaries during my childhood and adolescence. In May 1975, the Australian Country Party tried to dispel an image that now seemed parochial by renaming itself the National Country Party of Australia. It changed its name again in 1982 to The National Party.

7. The Royal Australian Agricultural Society organizes agricultural shows by local districts feeding into larger shows in state capitals, the latter resembling a combination of U.S. 4H clubs and State Fairs. The election of a "show girl" has played an iconic part in the shows' representation of districts to themselves and, in regional cities and state capitals, of the rural to the city (see Darian-Smith and Wills).

8. See Tucker and Matthews on gender and the disciplinary observation of rural youth. In many rural locations this extension into the outdoors seems no longer as significant, a shift often related to the impact of domestic entertainment media like television, but also home video/DVD systems and computers (see Valentine). But neither the pleasure produced from identification with a geographically dispersed youth culture, nor the special importance attached to identifying with the local in the country, should be forgotten. If kids watching television are more easily watched, that does not erase the identificatory motivations and consequences of their consuming media that prioritizes belonging somewhere else.

9. "Pony clubs" are leisure groups for young horse enthusiasts. They are dominated by girls living on farms and are particularly active in country towns which host agricultural shows, where they can compete before the broader community.

10. A range of critics note that Bourdieu and Williams are contemporaries, as are their ideas of "habitus" and "structure of feeling" as ways of grasping

how social meanings are lived. Both concepts seem to me to offer useful, and underutilized, tools for thinking about country girlhood. While it is crucial that Williams first elaborates this concept in the book *The Country and the City*, within the scope of this essay I have focused instead on Bourdieu.

Works Cited

Against the Wind. Australia: 7 Network, 1978.

Anthony, Doug. "Country Party Policy Launch," 1975. *Whitlam Dismissal*. Malcolm Farnsworth, n.d. Web. 17 Apr. 2007. <http://www.whitlamdismissal.com/sounds/>

Behind the News. Australia: ABC Television, 1969–2003, 2005–present.

Bellbird. Australia: ABC Television, 1967–1977.

Bourdieu, Pierre. *Distinction: A Social Critique of the Judgement of Taste*. 1984. Trans. Richard Nice. Cambridge, MA: Harvard University Press, 1986.

———. "Habitus." *Habitus: A Sense of Place*. 2000. Ed. Jean Hillier and Emma Rooksby. Aldershot: Ashgate, 2005.

———. *In Other Words: Essays Towards a Reflexive Sociology*. 1987. Trans. Matthew Adamson. Stanford: Stanford University Press, 1990.

Bush, Kate. *The Kick Inside*. London: EMI, 1978.

Carey, James. *Communication as Culture: Essays on Media and Society*. 1989. New York: Unwin Hyman, 1992.

Ching, Barbara, and Gerald Creed, eds. *Knowing Your Place: Rural Identity and Cultural Hierarchy*. London: Routledge, 1997.

Cloke, Paul and Jo Little, eds. *Contested Countryside Cultures: Otherness, Marginalisation and Rurality*. 1997. London: Routledge, 2005.

Countdown. Australia: ABC Television, 1974–1987.

Darian-Smith, Kate and Sara Wills. "From Queen of Agriculture to Miss Showgirl: Embodying Rurality in Twentieth-Century Australia." *Journal of Australian Studies* 71 (2001): 17–32.

Driscoll, Catherine. *Girls: Feminine Adolescence in Popular Culture and Cultural Theory*. New York: Columbia University Press, 2002.

———. *Modernist Cultural Studies*. Miami: University Press of Florida, 2009.

Giddens, Anthony and Christopher Pierson. *Conversations with Anthony Giddens: Making Sense of Modernity*. Stanford: Stanford University Press, 1998.

Gidget. Dir. Paul Wendkos. Perf. Sandra Dee. U.S.A.: Columbia, 1959.

Goodall, Heather. "Fixing the Past: Modernity, Tradition and Memory in Rural Australia." *UTS Review* 6 (2000): 20–40.

Kruse, Holly. "In Praise of Kate Bush." *On Record: Rock, Pop and the Written Word*. 1988. Eds. Simon Frith and Andrew Goodwin. London: Pantheon, 1990. 385–97.

McKinnon, K. R. *Girls, School and Society: Report by a Study Group to the Schools Commission*. Woden, ACT: Schools Commission, 1975.

McRobbie, Angela. *Feminism and Youth Culture: From* Jackie *to* Just Seventeen. 1991. London: Unwin Hyman, 2000.

Morris, Meaghan. "Banality in Cultural Studies." *The Logics of Television.* Ed. Patricia Mellencamp. Bloomington: Indiana University Press, 1990. 14–43.

———. *Too Soon Too Late: History in Popular Culture.* Bloomington: Indiana University Press, 1998.

My Brilliant Career. Dir. Gillian Armstrong. Perf. Judy Davis and Sam Neill. Australia: GUO/NSW Film Corp., 1979.

Number 96. Australia: Channel 10, 1972–1977.

O'Regan, Tom. "Film and Its Nearest Neighbour: The Australian Film and Television Interface." *Culture and Communication Reading Room.* Tom O'Regan, n.d. Web. 19 Mar. 2007. <http://wwwmcc.murdoch.edu.au/ReadingRoom/film/AFTV.html>

Press Release No. 73. Office of the Prime Minister. Canberra: National Archives of Australia, 1973.

Rush. Australia: ABC Television, 1974; 1976.

Seven Little Australians. Australia: ABC Television, 1973.

Silverstone, Roger. "Television and a Place Called Home." *Television and Everyday Life.* New York: Routledge, 1994. 24–51.

Thornton, Sarah. *Club Cultures: Music, Media and Subcultural Capital.* Oxford: Polity Press, 1995.

Townsend, Helen. *Serving the Country: The History of the Country Women's Association of New South Wales.* Sydney: Doubleday, 1988.

Tucker, Faith and Hugh Matthews. "'They Don't Like Girls Hanging around There': Conflicts over Recreational Space in Rural Northamptonshire." *Area* 33.2 (2001): 161–68.

Valentine, Gill. "A Safe Place to Grow Up? Parenting, Perceptions of Children's Safety and the Rural Idyll." *Journal of Rural Studies* 13.2 (1997):137–48.

Wear, Rae. "Countrymindedness Revisited." APSA Conference. The Australian National University, 2000. Web. 10 Apr. 2007. <http://apsa2000.anu.edu.au/confpapers/wear.rtf>

Williams, Raymond. 1973. *The Country and the City.* London: Chatto and Windus, 1975.

Wyn, Johanna, John Stafford, and Helen Stokes. "Young People Living in Rural Australia in the 1990s." Youth Research Centre. Melbourne: University of Melbourne, 1998.

Falling in Love with *High School Musical*: Girls' Talk about Romantic Perceptions

Shiri Reznik and Dafna Lemish

On inauguration night, January 20, 2009, U.S. President Barack Obama and First Lady Michele Obama greeted supporters and danced at various balls in their honor throughout Washington, D.C. At the same time, according to a live report on CNN, their two young daughters, Malia (then 10 years old) and Sasha (7), celebrated this historic event with a group of close friends in their new home, the White House, with a private screening of *High School Musical 3* (2008). Given the wide popularity of the *High School Musical* franchise among tween girls around the world and the ubiquity of Disney products in commercial tween culture, this was a likely choice of entertainment in the celebration enjoyed by the girls and their friends.

As a modern version of Shakespeare's *Romeo and Juliet*, the first *High School Musical* movie is a love story between two high-school teens belonging to rival social groups: Troy Bolton (Zac Efron), the popular, handsome, white captain of the basketball team, and Gabriella Montez (Vanessa Hudgens), the shy, beautiful, and newly arrived Latina student in school who excels in math and science. Together they try out for leading roles in their high school's musical, despite peer pressure to avoid doing so. Both win their desired roles and they begin to develop a romantic relationship. Their relationship intensifies during the second movie in the series, which portrays the experiences of Troy, Gabriella, and their friends during a summer vacation when they all work together in a luxurious resort.

Since its first television screening on the Disney Channel on January 20, 2006, this Emmy-winning TV movie set a Disney Channel record with 7.73 million viewers its first night and 11 million the following two nights. By August 17, 2007, when the televised sequel, *High School Musical 2*, premiered, more than 160 million viewers worldwide had viewed the original movie. The sequel's premiere shattered the record for basic cable television when 17.24 million viewers tuned in (Hyman). The tremendous success of the two televised movies was followed by a third, theatrically-released feature film, *High School Musical 3— Senior Year*, in October 24, 2008. At the time this article is being written, *High School Musical 4* is in production in advance of its premiere in 2010. The original soundtrack of the first movie sold 7 million copies, making it the top-selling CD in the United States in 2006. It also set a Guinness record for having nine of its tracks make the best-selling singles chart (Hyman). The unprecedented success of this cultural phenomenon is not restricted to the U.S., as the three films and their associated merchandise (e.g., books, diaries, CDs, DVDs, shirts, jewelry) have become global hits in over 100 countries (Holloway).

For example, *High School Musical* has had enormous popularity in Israel, despite its focus on characters and narratives contextualized in American high school culture, including: prom night; pupils' participation in school athletic programs and the activities of various student clubs, such as drama and math; and deliberations regarding application to colleges or universities during senior year. These aspects of American high school students' lives are foreign to most Israeli Jewish youth, many of whom are preoccupied with looming post-high school induction into mandatory military service. Broadcast for the first time in Israel in August 2007 on the international JETIX channel, the original *High School Musical* movie achieved the highest rating of a movie ever offered on Viewing on Demand of the Israeli cable system HOT. Following the sequel's broadcast in 2008 (a collaboration between JETIX and HOT), a local musical theatre production in Hebrew, which retained the names and places used in the original, began performance in the summer of 2008 in Israel's major cities. In doing so, Israel became the third country in the world to produce a local theatrical version of this show (following U.S. and U.K.) (Burstein).

Given the unprecedented, global popularity of the *High School Musical* films in general and in Israel more specifically, it is intriguing to explore the meanings and interpretations that girl audiences construct of these texts and to speculate about the psychological and social needs they might be fulfilling for them. In this study, we chose to focus specifically on the ways in which Israeli girls negotiate and interpret the concept of romantic love presented in *High School Musical* as a central theme woven throughout the fabric of the movies. The intense appeal of this theme to pre-adolescent girls may well be due to their age, a time in their

lives when they are exploring their first romantic fantasies and feelings and, for most tweens, a time well before their experiences of such relationships in real life.

The Construction of Romantic Love

Historical analyses trace how the diverse meanings of romantic love have changed according to shifting social, religious, and philosophical worldviews in different cultural contexts (Beall and Sternberg). Apparently, contemporary culture provides us with many differing symbols, narratives, and representations through which we can express love. Indeed, content analyses of representations of romantic love have found them to be prevalent in a variety of genres and texts, including fairy tales (e.g., Rowe); Disney films (e.g., Henke and Zimmerman); romance novels (e.g., Pecora); magazines (e.g., Alexander; Illouz, "Reason") soap operas (e.g., Harrington and Bielby), and pop music (e.g., Scheff). All of these discursive spaces provide romantic models for personal lives (Illouz, *Consuming*) and may contribute to the formation and retention of romantic beliefs and attitudes about love and the appropriate ways to express it emotionally as well as behaviorally (Signorielli).

Two main themes stand out in extant scholarship: First, myths of romantic love as employed in pop culture glorify it as an intensely emotional, all-encompassing, and—in extreme cases—even fatal experience. Central among these myths are notions of "love at first sight"; "[we are] destined to be together and nothing can separate us"; "frequent and intense fights are a sign of true and very passionate love"; "love is all you need even if the two partners hold completely different values"; "the right partner completes you and make all your dreams and desires come true" (Galician). The prevalent use of such myths in popular culture may be responsible for romantic illusions that lead to deep frustrations and disappointments when real relationships fail to match them.

The second theme of these analyses is the oppressive gender roles portrayed in many romantic relationships: Here women's subordination is presented as desirable for romantic reasons, and love is a mythical force without which there is no purpose in life. Males, by contrast, are portrayed as the leaders of their communities, heroic warriors, and brave rescuers of the female character from her miserable fate. Thus, yearning for the "missing (male) piece" that will make a girl's life complete and therefore is the key to happiness and fulfillment perpetuates female dependency on men and serves as the rationale for over-investment of resources in search of the "one and only" rather than in herself as an independent individual with agency and self-worth.

Overall, though functioning in a Sisyphean manner, this theme has achieved strong appeal among young girls because the aspiration for romantic love has become so much a part of the construction of femininity and is promoted so in-

tensely in the majority of commercial texts geared at girls from a very young age. Many tween girls invest a great deal of their emotions and energies talking about romantic issues with their friends, thinking and day-dreaming about potential boyfriends, and in imaging as well as eventually developing intimate relationships (Florsheim; Furman, Brown, and Feiring). In this process, such girls develop a significant media preference for romantic genres (Lemish, Liebes, and Seidmann).

Furthermore, while many studies have considered the active meaning-making processes in which children are engaged while they interact with media texts (e.g., Buckingham; Lemish, *Children*), only a few have focused on how children make meaning of representations of romantic love. Christine Bachen and Eva Illouz examined how 8- to 17-year-old children and youth in the U.S. interpreted such visual representations in magazine advertising. They found that romantic perceptions of most participants were dependent on visual codes of consumption associated with an atmosphere of wealth and leisure and in the location of the lovers in circumstances and places that deviate from their daily routine. And, similar to Illouz's study with adults (*Consuming*), Bachen and Illouz found that the romantic perceptions of children were influenced by the predominant model of love in the media that associates romance with the capitalist market. However, in contrast to Illouz's adult population, Bachen and Illouz did not find socio-economic differences between the children, an issue to which we wish to return in our own study.

Lori Baker-Sperry examined the different ways in which six- to seven-year-olds interpreted the romantic messages conveyed in Disney's version of *Cinderella* (1950). Her findings indicate that girls embraced the story, identified with the leading female character, and especially enjoyed the transformation of Cinderella from a lady in distress to a high-status princess. Although the girls wished they would have a similar romantic fate as that of Cinderella, they still had the ability to negotiate and add to the original story based on their own experiences, hopes, and desires, for example, by declaring that Cinderella should have kids although the story does not end up this way.

Other studies have focused more specifically on girls and their negotiations with romantic texts. Linda Christian-Smith found that American middle- and working-class, 9- to 15-year-old girls from diverse racial backgrounds enjoyed romance novels since they fulfill such central functions as escapism, interest and pleasure, feelings of identification and belonging, and a sphere for learning about romance and heterosexual relationships. They recognized the gap between the books' romantic representations and their own concrete reality, yet they still were not willing to let go of the mediated fantasy and yearned for its fulfillment. Amy Aidman's study focused on the ways 9- to 13-year-old U.S. girls of diverse geographical, socio-economical, and ethnic backgrounds interpreted Disney's animated movie *Pocahontas* (1995) featuring a romance between a Native American heroine and British hero John Smith. Contrary to many other romantic fantasies,

this narrative did not end with "they lived happily after," as Smith had to return to England while Pocahontas chose to stay with her own people on their land. The girls argued that parallel to the sadness involved in the separation from the lover, they experienced a sense of pride and strength from Pocahontas's choice to stand by her people and not desert them for the sake of love. This finding demonstrates that, like other texts, the romantic text has the potential to serve as a site of multiple interpretations, including those that are sometimes contradictory to and not necessarily in accordance with the hegemonic reading.

Aidman also found that white, middle-class, urban girls demonstrated a more cynical, negotiated reading of the text, ridiculing and doubting the motivations of the producers as well as of Pocahontas. In contrast, lower-class girls of Native American or mixed origins embraced the character of Pocahontas wholeheartedly and uncritically perhaps due to the absence of other positive media images of Native Americans with whom these girls can identify.

These few studies suggest that representations of romantic love in texts consumed by girls are meaningful sources of identification, learning, and internalization of romantic narratives and behaviors. At the same time, researchers found that young girls are capable of interpreting romantic texts in a variety of ways, engage actively in negotiations with them, and discover messages that correspond to their individual subjective attitudes as well as interpretative communities. Based on these analyses of extant research and their findings, this study aims to examine the various ways in which girls understand romantic love and apply it to their own life, relying on their interpretation of *High School Musical.*

The Study's Methodology

This study of the *High School Musical* franchise is part of a larger research project about Israeli girls' interpretations of romantic love in popular culture.[1] The data gathering for this study included 76 tween girls ages 11 to 13. Among them, 45 came from well-to-do, non-religious, European backgrounds and lived in the center of Israel; the remaining 31 tweens had lower-class, religiously traditional, and Middle Eastern backgrounds and lived in the northern periphery of Israel. The research subjects were recruited through their schools, and participation followed parents' completion of consent forms as well as detailed questionnaires describing their family's background. The analyses revealed that these two groups, who differed by socioeconomic status (SES) and geographical location, held distinctly different views about romantic love and the way it is portrayed in the *High School Musical* franchise, and hence are referred to as high and low SES groups (HSES and LSES) in the presentation of findings below.

Interviews were conducted in 19 focus groups composed of close friends, 11 in the center of the country and 8 in the periphery. Focus group meetings were

conducted in one of the girl's homes. This context eased facilitation of an informal, open discussion of the impacted issues in the context of their private "bedroom culture," as this has been found to be most conducive for such "girl-talk" (Bovill and Livingstone). All interviews were conducted by the first author, lasted between 90–120 minutes, and were recorded and transcribed verbatim.

Specific discussion of *High School Musical* included viewing the following three segments from the first two movies, each of which was selected because of the portrayal of central romantic myths and gender roles, the subjects that were the focus of our investigation. We alternated the order of presentation of the three segments to avoid bias:

1. Meeting (first movie, beginning at 00:01:45): A segment from the opening episode when Troy and Gabriella meet for the first time on stage during a karaoke performance at a New Year's Eve party. As the two overcome their initial embarrassment, they engage in joint singing of the song "Start of Something New." Later they exchange telephone numbers and go their separate ways, not knowing if they will meet again.

2. Gabriella's departure (second movie, 01:16:50): An episode when Gabriella decides to leave Troy and the luxurious resort where they are employed during the summer. She does so due to her disappointment with Troy's behavior, as he chooses to neglect her in favor of Sharpay Evans (Ashley Tisdale), the rich daughter of the resort's owner. The episode includes with Gabriella's singing her explanation to Troy in the song "I Got to Go My Own Way."

3. The first kiss (second movie, 01:39:10): The concluding episode when Troy and Gabriella exchange their first kiss, and sing "You Are the Music in Me" surrounded by floating balloons, fireworks, and sprinklers that suddenly drench them, demonstrating that nothing can distract them from expressing their love to each other.

The lively, detailed discussion that followed viewing each segment was guided by questions that enabled us to understand the following research foci: the ways in which the girls interpreted the text and the feelings it aroused in them; their evaluation of the characters, their relationships, and the romantic myths that appear within it; and the degree to which the text seemed realistic to them. Multi-stage grounded analyses of the transcripts followed common qualitative procedures.[2]

Quotes incorporated in the following pages were translated into English by the authors with great sensitivity and care to maintain the personal flavor of each individual speaker while facilitating accessibility for the English reader. We cau-

tion the reader that due to space and style constraints of a book chapter of this sort, the quotes can present only very partial and decontextualized exemplars of lengthy transcripts. All names were changed to protect the privacy of participants.

Negotiating Romantic Love: Results

As interviews unfolded, it became very clear that *High School Musical* was particularly popular among our participants who claimed they have seen the movies several times (even eight viewings of the same movie!). Many purchased the soundtrack and books published about *High School Musical* in Hebrew. Most reacted with overt enthusiasm in discussing the plot lines as well as the main characters. They sang as well as danced while viewing the segments and clearly knew the words by heart. The popularity of this cultural phenomenon was also obvious from the posters and photos hanging on the walls of some of the girls' bedrooms, where most of the interviews took place.

So what sense do tween girls in Israel make of *High School Musical*'s messages about relationships, romance, and intimacy? How do they use this cultural site to negotiate meanings relevant to their own life experiences, dreams, and aspirations? Our grounded analysis of their discussions during the focus groups identified three central themes that permeated their concerns: the myth of "love at first sight," the idealized "first kiss," and notions of "girl power." We will consider each of these themes in turn as we highlight the similarities and differences between the two populations of girls from two very different social classes. Finally, in the section entitled "Lost in Translation," we will refer to the girls' reactions to the Israeli theatrical production of *High School Musical* in comparison to the original American movie.

Love at First Sight

Discussion of "love at first sight" was stimulated by the viewing of the segment from *High School Musical* when Troy and Gabriella meet for the first time and find themselves on stage singing a love song, "Start of Something New." Girls in both groups interpreted the symbolism of this scene as conveying "love at first sight." For example:

> T: The words fit, as he sings to her that he doesn't believe it is happening to him, that she is making him start feeling something new . . . something new is beginning. It's the love story that starts between them.
> IN: What kind of love is this?
> L: Love at first sight!

Yet, contrary to expectations, the girls struggled with this portrayal and demonstrated a high level of ambiguity in negotiating its realism. Such, for example, was the discussion among 11-year-olds from the LSES group:

> IN: So, would you have like to experience love at first sight?
> S: Yes, because love at first sight is much more fun than waiting a long time until someone proposes friendship to you.
> R: You can see it in the eyes.
> A: I think that love at first sight is not good because first you need to check out how we are getting along together, and only then to find out if yes or no; because you need to know each other in order to propose friendship.
> N: What A is saying is that it is worthwhile to get to know each other . . . but how are you going to know him if you don't love . . . ?

Vacillating between accepting the myth and fantasizing about it and/or hesitating whether it is a reliable predictor of a good relationship was typical of discussions among the HSES groups as well, but this was expressed in a much more cynical and even resistant manner. Notice the self-mockery and knowingness surfacing in some of the following exchanges from the HSES group of 11-year-olds, which allow "love at first sight" to be ridiculed and enjoyed at the same time:

> IN: So tell me, what kind of love is this?
> M: Love at first sight.
> IN: Do you agree?
> All: Yes.
> IN: And is there something like this in reality? Have you felt it before?
> A: My mom and dad. My mom said that my dad's brother introduced them . . . and my mother said that she fell in love with him at first sight but was a bit shy. He kind of did not get it that he loved her, only after some time. That's what she told me.
> N: There is something like that. It's nice. You don't need twenty dates in order to know each other. It didn't happen to me yet.
> A: There is another movie where it happens—*Enchanted*. The princess falls into his arms, and two minutes later they get married.
> M: Let's say a woman falls out of a window and a firefighter catches her, so if she is a 20-year-old and he is 60, kind of old, would they suddenly get married??!
> IN: Do you think that if you ever fall in love at first sight? What kind of characteristics would he have?
> L: I have no idea.
> N: Like it happened to Gabriella and Troy that somehow got connected. That he will have traits that are similar to you, perhaps.
> IN: And what would he look like, that fellow?
> N: Externally? Long hair perhaps or just like Troy, why not? He doesn't look bad . . . [laughter]
> A: He needs to be very handsome to have girls fall in love with him!
> IN: Who is handsome in your opinion?

A: I don't know . . . Troy is a hunk.

M: Yes, there is a chance that I will fall in love with someone at first sight if he is a total hunk.

IN: Like who, for example?

N: Ran Danker [a handsome Israeli model and actor-celebrity].

M: For example, if I see him helping someone cross the road it will be nice.

L: If he is a total hunk, if he is popular and likes sports.

IN: Why is that attractive? Why would you fall in love with him at first sight?

L: Because he has "six pack abs" [shaped abdomen muscles] . . . Not because of that . . . I want him to have traits similar to mine. I like sports, too.

A: I have some criticism . . . You said you want him to have your characteristics, but how would you know what his characteristics are if you don't know him, and it is "love at first sight"?

In many such instances the HSES girls expressed a cynical, critical, even put-down approach to *High School Musical*'s representation of falling in love. Several argued that "love at first sight" is only a first, unsubstantiated impression, as suggested by S and Y (13):

S: I don't believe in love at first sight, because I think you need to build up relationships. So OK, maybe you can meet each other for the first time and say—OK, he looks very appropriate. But you don't immediately hug and become friends. You need to meet again, to get to know each other, to build this up. Here [in *High School Musical*] they don't even know each other's name.

IN: And how do you define love at first sight?

Y: Love at first sight is: "Wow! He's a hunk, he's got it! Let's see where it can evolve," but it's not "come live with me" . . .

We can see that the girls enlist their life experiences (e.g., "my mother told me"), other media texts (e.g., *Enchanted*), as well as other adored media personae (e.g., Ran Danker) in negotiating the meaning of the concept of "love at first sight". They are very much aware of the characteristics that make a boy popular among girls—being a "hunk," liking sports, being popular (all fitting the character of Troy as well), but they also expect him to be a good person (e.g., help someone cross the street). They somewhat mock their own popular criteria of "hunkiness" (e.g., having "six pack abs"), as well as the myth of the hero (e.g., the older fireman). Above all, they think of the candidate for their love as someone similar to themselves, rather than someone that complements them or someone who is very different or foreign to them. While the girls, for the most part, recognized the unrealistic nature of the "love at first sight" myth, most nevertheless fantasized about it and derived great pleasure while watching it take place on the screen.

LSES girls also gave voice to their own cultural world by introducing into the discussion "God" and "fate," notions completely absent from the HSES girls' repertoire of concerns. For example, expressions like "My mom says that everything

is 'written,' it means that everything is determined and God sends you the one that is for you" (S) and "why would God decide on someone who is not appropriate for you?" (M) suggest that the girls recruited their religious family upbringing in an attempt to explain romantic myths such as "love at first sight" and the choice of the destined "one."

The differences between the two groups can also be explained by Pierre Bourdieu's argument that the characteristics of lower-class people include less cultural capital and a tendency to identify more with popular cultural products, while higher-class persons tend to cultivate a somewhat emotional distance that is expressed via cynicism and disrespect or to concentrate more on their formal and aesthetic styles. This argument is also in line with the findings of studies referred to earlier (Aidman; Illouz *Consuming*).

The First Kiss

How did girls in our study imagine their first kiss in comparison to the representation of Troy and Gabriella's kiss, following a build-up conducted over two full *High School Musical* movies that culminated in balloons, fireworks, and sprinklers? Girls in both groups recognized these symbols of romance and expressed pleasure viewing this scene. At the same time, they were critical of the very images they enjoyed. However, here, too, we found interesting differences between the two populations. Higher-class girls expressed their objections of these representations based mainly on critiques of the production's formal features: the exaggerated use of "kitsch" as well as the scene's highly constructed, non-original and unreliable nature. Such, for example, was the following exchange among 11-year-olds from the HSES group:

> T: I want an original love story.
> IN: And what will make it original?
> T: That it will be different from all those love stories I hear all the time.
> IN: In what way?
> T: For example, all the love stories end with a total kiss, so it won't be such a total kiss but a little kiss, realistic.

Yet, discussion among 12-year-olds in a HSES group critiqued the scene as being "over-romantic":

> G: Wow! It was too much, it was not believable anymore. It would have been enough to have the fireworks or only to release the balloons from above on the hill, but everything together was just too much.
> S: What chance is there that this would happen? . . . but it was so romantic . . .
> G: Romantic but kitsch.
> IN: Could it be "over- romantic"?

All: Yes.

N: And then it's not romantic anymore.

. . .

G: At the beginning there were balloons and then the fireworks started. But when the sprinklers started, I said to myself "well, really . . ." [in cynical intonation].

As the discussion unfolded, it became clear that the girls were expressing their awareness of the constructed nature of the mediated reality in the film. For example, one girl in a different 12-year-old HSES group stated:

M: It is only a movie; a movie needs to be a bit exaggerated. The fireworks seem exaggerated? It is in order to show that nothing will pull them apart, not the fireworks, not the noise in the background, not the sprinklers.

The girls also seemed to be very much aware and able to articulate an understanding that many of these symbols have become accepted as icons of romantic love, describing them as "classic." At the same time however, we found in a manner similar to previous research that when asked whether they would have liked to experience a similar kiss, the same girls responded unequivocally, "But of course!" suggesting that fantasy yearnings and rational criticism do not necessarily rule out each other but somehow co-exist in a lively manner.

Among lower-class participants, objections to the kiss took a very different nature, as their comments focused for the most part on it being performed in public. Modesty is a central value in these girls' traditional backgrounds, particularly with regard to the taboo in many religiously conservative societies forbidding public expressions of young sexuality, and especially young female sexuality. Thus, talking about sex or openly exhibiting sexual behavior is perceived, culturally, to be inappropriate and transgresses deeply engrained values and traditions. However, talking openly about romantic love breaks from earthly sexuality, physical desires, and needs, focusing instead on the spiritual side of love as a meaningful connection between souls (Lemish, *Screening*). The following excerpt from an LSES group of 11-year-olds is exemplary of this concern:

M: First kiss like this—never, it is too exaggerated; I prefer kissing in a modest place and without all the fireworks and the sprinklers; it is not a wedding! It has to be viewed as a kiss, not as a major event.

S: I wish to have a bit more privacy for my first kiss, and here they didn't have it.

IN: And what about the fireworks, do you want them?

S: No, it is not as if I am getting married, it is only a first kiss!

R: For the first kiss one needs privacy, because it is embarrasing to have all your friends around.

T: I also would have wished for privacy, but I love the fireworks if it would have happened unexpectedly and was not planned. It is beautiful and moving. And if your first kiss was by the sunset, it would have been also pretty.

The wish for privacy and modesty associated with the first, naïve intimate experience is juxtaposed with the many extravagant effects that are perceived as being much more appropriate for a formal wedding celebration, the highlight of a traditional girl's aspirations.

Both groups of girls, then, thought that the "first kiss" scene was a bit too much, but they offered different reasoning for their evaluation. It is possible to view the cynical approach of the higher SES girls as their desire to break away from clichéd, excessive representation styles to an original expression of love, much in line with Illouz's findings regarding upper-class adults' desire to feel original and unique (*Consuming*). An oppositional reading by the higher-class girls challenges media representations of romance by exposing the lack of authenticity. This interpretation resonates with Roland Barthes's postmodern critique of popular love discourse. According to Barthes, the amorous subject's search for signs by which to show and receive love exposes illusory myths involved in such a pursuit. Hence, when we realize that the ways we express our most intimate feelings are just a duplication of a general lexicon of overused constructed symbols, we cannot help but see our romantic reality as merely clichéd gestures void of genuine meaning. However, in comparison to the HSES girls' disapproval of the exaggerated romantic representations, LSES girls in this study were not critical of the representations and their relationship to reality per se but rather of the ideology embedded in the scene and its "loose" approach to intimacy.

"Girl Power"

Both groups of girls in our study perceived Troy as a perfect yet unattainable romantic object of yearning: the most popular boy in school, with the perfect looks and character, who can thus be located only in the realm of fantasy. In contrast, Gabriella was perceived as a more realistic character, not perfect, but a role model for girls for being brave, retaining her dignity and yet characterized by wisdom, beauty, and singing talent. She is introduced in the first movie as strongly disadvantaged: the new Latina girl in class who is shy and an unpopular "geek." However, such positioning makes her more human, allowing girls to identify with her and to connect to the romantic fantasy that one day, perhaps, the most popular boy in school will fall in love with them and transform them into popular, self-confident, desired girls as well. Gabriella's narrative of transformation from a shy, insecure girl to one that discovers her talent and also wins love and social popularity is, according to the girls in our study, one of the most attractive plot lines of the movies. This is, of course, no surprise, as this plot builds strongly on traditional tales following

the "Cinderella myth"—the discovery and rescue of the poor, disadvantaged, marginalized girl by "Prince Charming" (Baker-Sperry; Shumway).

In response to the segment in which Gabriella decides to part with Troy (as she is neither willing to forsake her own agency and self-pride nor to comply with the needs and desires of her misbehaving "Prince Charming"), a group of HSES 12-year-olds said:

> Y: I think she is both strong and weak. She is weak because she can't handle the fact that he is with other people and not with her all the time, and she is strong because she showed him "who is the boss," and that she will not stay with him always regardless of his behavior, and that caused him to beg her to stay with him.
> H: She is strong because she dared to leave. I wouldn't have dared because I also have friends there, not only him.
> M: She wanted to show him that she is not a puppet and that she can stand on her own and he can't insult her.

This sense of agency and demonstration of "girl power" was also articulated by other groups, such as the discussion in this HSES group of 13-year-olds:

> R: She says she wants to leave.
> S: She prefers to go her own way and not to change for the sake of other people.
> Y: She has a backbone. I would have adopted this quality of being who you are and not being other people's Play-Doh, because there are people who change for other people, and I decided that I will never do this again. It is difficult; it has good and bad. When you change you can be part of many groups of people, but people take advantage of it.
> . . .
> IN: Would you have liked to see more characters like Gabriella in other movies?
> All: Yes.
> Y: Sure!
> IN: Why?
> Y: Because she is real.
> A: But in my opinion she doesn't think about what's going to happen and that, perhaps, because of this she is not going to have a boyfriend.
> R: I think that she does not share her opinions when it is not so pleasant for her, but she does what she feels.
> Y: Exactly!
> IN: And you appreciate this?
> R: Yes.
> B: One can learn how to react, how to behave, from other movies like this.

The realistic portrayal of Gabriella's character is perceived by the girls as "normal." Furthermore, she is both "strong and weak," offering realistic and relevant lessons to be learned and applied to the girls' everyday experiences. She is perceived as a positive role model with whom they can identify because of her realistic portrayal

of imperfection: She is the new girl at school who is shy, insecure, and from a single-parent family background. Thus, she stands in contrast to the rich, beautiful blond character, Sharpay, who was constructed in the film, and interpreted by the girls, as her anti-thesis. Indeed, at the same time, Gabriella is talented, pretty, smart, and brave, with a clear sense of self-respect; she is no soft "Play-Doh"-like character as one of the girls suggested colorfully. In this sense Gabriella joins other depictions of strong feminine girl heroes in children's television who seem to have inspired emergence of the concept of "girl power," as introduced by *The Spice Girls* into popular culture consumed by girls (Lemish, "Spice Girls").

While such strong girl characters are represented as brave, smart, and independent, many also embrace the centrality of physical attractiveness (presumably for their own pleasure). Thus, they are liberated and empowered girls who are not passive objects posing in order to please the male gaze. Analysis of this evolving strategy combining feminism with femininity demonstrates that it weaves together many seemingly contradictory messages about the co-existence of strength and femininity while nourishing themes of "girl power" and power feminism (Banet-Weiser; Hains; Lemish, "Spice Girls"). Accordingly, being strong, brave, successful, and independent does not necessarily negate the pleasure of embracing "girlishness."

Gabriella's attractiveness for many of the girls also relates to another emerging issue related to images of girls and women discussed in recent scholarly literature: the presentation of more "brainy" characters who break away from negative depictions as unattractive and unpopular (Inness). Previous portrayals presented clever women in a subordinate position to men, whose cleverness and intelligence are sexy assets and not obstacles. In contrast, Gabriella's intellectual qualities contribute to the notion that one can be a smart, attractive, and "cool" teen (similar, for example, to the character of Rory in *The Gilmore Girls*, 2000–2007, WB and CW). This is much in line with the notion advanced in postfeminism that feminist and feminine are not necessarily binary oppositions, and that one can be an independent, smart girl and still enjoy displaying girlish sensibilities and feminine performances.

Lost in Translation

An unexpected, fascinating theme that emerged spontaneously during the focus groups expressed a form of disengagement from the Hebrew theatrical production of *High School Musical*. It seemed that the unapproachable and unattainable romantic fantasy lost its appeal once it became too close to the Israeli reality, perhaps due to the fact that local actors and actresses speaking in their native Hebrew language were performing the narrative.[3]

The girls' rejection of the Israeli version took several forms. For example, a group of LSES 11-year-olds said:

Y: I saw both movies. Now it is also going to be in Israel, in Hebrew.
A: Yuck! Disgusting!
IN: Why is it disgusting in Hebrew?
Y: They are not going to sing the same way.
S: And the original is much nicer. But they will sing partly in English. I saw a report on it on television.
IN: And you are not going to want to see the Hebrew show?
A: Maybe, not sure.
IN: And now when it is going to be done in Israel in Hebrew, will it be romantic in your view?
A: Perhaps not.
Y: I don't think so, because they are not going to sing like them.
S: But have you heard them singing at all? Why are you saying this?
Y: Because the Gabriella they chose is ugly; she doesn't look like her at all, but Troy is similar.

It seems that in the comparison between the original American version and the local Israeli one, the local is bound to lose, as it is always perceived as lacking: The characters are not as pretty, the singing is not as good, and the production values are not as high. For example, a group of 11-year-olds from a LSES said:

T: In Israel it is all so predictable, that the two meet, and all of this. But in the American movie they know how to make it exciting and all of that.
R: It depends on the actors.
M: So perhaps it is better to see it, but preferable to depend on the original.
S: I think in Hebrew it is different, because in English there isn't always a happy ending, and in Israel there is always the same one; and it is irritating, that's how it is in all the series and books in Israel. You already can anticipate what they will do.
IN: But in *High School Musical* in English there is a good ending, too, no?
T: No. Because there is suspense, for example, in the first movie.
M: In Israel you know that there will be only one show; and in America there are sequels, like 1, 2, and in Israel they will only make one.

Similar to findings from previous cross-cultural studies (e.g., Lemish et al., "Global"; Lemish, "America"), our study found that American media are perceived as the "real thing" while "glocalized" versions, where global and local elements are combined, seem to pale in comparison. Furthermore, the girls' perception of the American version as the original, in which romance is "real," versus their perception of the Israeli version as a dull imitation expresses how the girls' familiarity with the version closer to their own reality makes it less appealing and less romantic. This preference can be interpreted in light of Jean Baudrillard's definition of postmodern society as a society that has replaced reality and meaning with cultural and media symbols that are perceived as reality itself, symbols which he refers to as "simulacra." Thus, the representation supercedes reality

creating a feeling of detachment from our own existence that can be seen in the girls' aversive reaction to the local version of *High School Musical*. This can also be interpreted in light of discussions of Americanization of local cultures, which is strongly entangled here with admiration of things American.

Conclusion

Our study examined the different ways in which Israeli girls negotiated and interpreted the concept of romantic love as presented in the *High School Musical* franchise. We found that these highly popular Disney movies served for the girls as sites of struggle between, on the one hand, traditional romantic messages that reinforce conservative gender roles while portraying love as a mythical glamorous phenomenon and, on the other hand, more down-to-earth, realistic messages about love that expand female romantic behavior repertoire to include a stronger and more independent agency. While our case study reinforces cultural studies' findings of children's active meaning-making, it also serves to caution us against adopting a celebratory pose, as our subjects' freedom of interpretation of romantic love was restricted by very narrow cultural frames of reference. "Real life" experiences, such as love stories related by their parents, also seem to play an important role in reinforcing or challenging media portrayals and may expand children's vision regarding their own possibilities for experiencing loving relationships.

Our hypothesis that experiences in the real world make a significant difference in the reception of popular messages about romantic love was also demonstrated by the comparison between our two populations. While girls from both lower and higher SESs identified with the character of Gabriella and expressed yearning as well as doubt towards the romantic representations portrayed in *High School Musical*, we also found some differences in the ways each group interpreted these romantic representations. Relying on their different cultural backgrounds, religious beliefs, life experiences, and social norms, each group of girls offered a unique critical reading of the concept of love at first sight and the main characters' flamboyant first kiss. While higher-class girls expressed a more cynical perspective and were well aware of the gap between realty and stereotypical romantic representations, lower-class girls were more concerned with moral values, such as modesty, privacy, and religious fate. Accordingly, we propose that romance is constructed and interpreted in multiple ways among girls: The two groups of girls in our study, for example, seem to be located in somewhat two different interpretive communities in their readings of these popular romantic texts.

Yet, in contrast to the mixture of both pleasure and critique the girls applied towards the romantic fantasy depicted in the movies, they seemed collectively reluctant about the Israeli stage version of *High School Musical* featuring local Hebrew-speaking actors. One possible interpretation of this finding is that an

essential part of enjoying romance may depend on longing for an unattainable relationship that exists in the realm of fantasy outside of the girls' everyday lives. Furthermore, it seems that the original version of *High School Musical* allows the girls to employ a "melodramatic imagination." Such a type of imagination can be regarded as a psychological strategy used in order to overcome the material meaninglessness of everyday existence, when human romantic relationships, too, subsume to routine and habit (Ang). Watching Troy and Gabriella's passionate and exciting connection may inspire female viewers to dream about experiencing a similar kind of romance in their own lives. In contrast, in the Israeli version, *High School Musical*'s romance loses some of its appeal. This may be due to the over-familiarity of the melodramatic love story, as it lacks the unique "larger than life" quality imparted by the foreign romantic fantasy.

As a result, mixing the original American fantasy with the local culture that is the girls' reality made the new glocalized version less appealing and even "disgusting" to some of the girls in our study. This interesting finding contradicts the original marketing assumption that the globalization of a product is more likely to succeed when the product or service is adapted specifically to each locality or culture it is marketed in (Robertson) and suggests, in this case, that romantic fantasies may lose their appeal in such an attempt at cultural translation. Consequently, future studies may examine the ways in which the *High School Musical* franchise and other popular romantic texts can be interpreted by tween girls contextualized in different cultures and backgrounds as they negotiate with the hegemonic reading according to their own personal needs and dreams, as well as the values and discourses available to their own interpretive communities.

Notes

1. This article is based on the first author's forthcoming dissertation, entitled *What's Love Got to Do with It? The Role Media Play in the Construction of the Romantic Love Concept among Girls from the Periphery and Center of Israel*, written at Tel Aviv University under the supervision of the second author.
2. See, for example, Lindlof and Taylor.
3. Please note that this theme was only discussed in the lower-class groups, due to the coincidence of the timing of the interviews; thus, we are in no position to suggest any class differences.

Works Cited

Aidman, Amy. "Disney's Pocahontas: Conversations with Native American and Euro-American Girls." *Growing Up Girls: Popular Culture and the Construction of Identity*. Eds. Sharon R. Mazzarella and Norma O. Pecora. New York: Peter Lang, 1999. 133–59.

Alexander, Susan H. "Messages to Women on Love and Marriage from Women's Magazines." *Mediated Women: Representations in Popular Culture.* Ed. Marian Meyers. Cresskill: Hampton Press, 1999. 25–37.

Ang, Ien. *Watching Dallas: Soap Opera and the Melodramatic Imagination.* London: Routledge, 1989.

Bachen, Christine M. and Eva Illouz. "Imagining Romance: Young People's Cultural Models of Romance and Love." *Critical Studies in Mass Communication* 13.4 (1996): 279–308.

Baker-Sperry, Lori. "The Production of Meaning through Peer Interaction: Children and Walt Disney's *Cinderella*." *Sex Roles* 56 (2007): 717–27.

Banet-Weiser, Sarah. "Girls Rule!: Gender, Feminism, and Nickelodeon." *Critical Studies in Mass Communication* 21.2 (2004): 119–39.

Barthes, Roland. *A Lover's Discourse.* New York: Hill and Wang, 1979.

Baudrillard, Jean. *Simulacres et Simulation.* Paris: Galilee, 1981.

Beall, Anne E. and Roger J. Sternberg. "The Social Construction of Love." *Journal of Social and Personal Relationships* 12.3 (1995): 417–38.

Bourdieu, Pierre. *Distinction: A Social Critique of the Judgment of Taste.* Cambridge, MA: Harvard University Press, 1984.

Bovill, Moira, and Sonia Livingstone. "Bedroom Culture and the Privatization of Media Use." *Children and Their Changing Media Environment—A European Comparative Study.* Eds. Sonia Livingstone and Moira Bovill. London: Lawrence Erlbaum Associates, 2001. 179–201.

Buckingham, David. "Children and Media: A Cultural Studies Approach." *International Handbook of Children, Media and Culture.* Eds. Kirsten Drotner and Sonia Livingstone. London: Sage, 2008. 219–36.

Burstein, Nathan. "'High School Musical' Heads to Holy Land." *The Jewish Daily Forward.* 27 Mar. 2008. Web. 15 May 2009.

Christian-Smith, Linda K. *Becoming a Woman through Romance.* New York: Routledge, 1990.

Florsheim, Paul. *Adolescent Romantic Relations and Sexual Behavior.* London: Lawrence Erlbaum Associates, 2003.

Furman, Wyndol, Bradford B. Brown, and Candice Feiring. eds. *The Development of Romantic Relationships in Adolescence.* Cambridge: Cambridge University Press, 1999.

Galician, Mary-Lou. *Sex, Love, and Romance in the Mass Media.* London: Lawrence Erlbaum Associates, 2004.

Hains, Rebecca C. "Power(Puff) Feminism: *The Powerpuff Girls* as a Site of Strength and Collective Action in the Third Wave." *Women in Popular Culture: Representation and Meaning.* Ed. Marian Meyers. Cresskill: Hampton Press, 2008. 211–35.

Harrington, Lee C. and Denise D. Bielby. "The Mythology of Modern Love: Representations of Romance in the 1980s." *Journal of Popular Culture* 24.4 (1991): 129–43.

Hendrick, Susan S. and Clyde Hendrick. *Romantic Love*. Newbury Park: Sage, 1992.

Henke, Jill B. and Diane Zimmerman Umble. "And She Lived Happily Every After: The Disney Myth in the Video Age." *Mediated Women: Representations in Popular Culture*. Ed. Marian Meyers. Cresskill: Hampton Press, 1999. 321–37.

Holloway, Diane. "'High School Musical 2' Debuts Friday as Disney's Pop-culture Phenomenon Fuels a Cottage Industry." *Austin 360.com*. Cox Media Group. 14 Aug. 2007. Web. 15 May 2009.

Hyman, Mark. "High School Musical: Confounding the Media and Cultural Elite." HumanEvents.com. Eagle Publishing, Inc. 7 Sept. 2007. Web. 7 Sept. 2009.

Illouz, Eva. *Consuming the Romantic Utopia: Love and the Cultural Contradictions of Capitalism*. Berkeley: University of California Press, 1997.

———. "Reason within Passion: Love in Women's Magazines." *Critical Studies in Mass Communication* 8.3 (1991): 231–48.

Inness, Sherrie A., ed. *Geek Chic: Smart Women in Popular Culture*. New York: Palgrave Macmillan, 2007.

Lemish, Dafna. "'America, the Beautiful': Israeli Children's Perceptions of the U.S. through a Wrestling Television Series." *Images of the U.S. around the World: A Multicultural Perspective*. Ed. Yahya R. Kamalipour. New York: SUNY Press, 1999. 295–308.

———. *Children and Television: A Global Perspective*. Oxford: Blackwell, 2007.

———. *Screening Gender on Children's TV: The Views of Producers around the World*. New York: Routledge, 2010.

———. "Spice Girls' Talk: A Case Study in the Development of Gendered Identity." *Millennium Girls: Today's Girls around the World*. Ed. Sherrie A. Inness. New York: Rowman & Littlefield, 1998. 145–67.

Lemish, Dafna, Kirsten Drotner, Tamar Liebes, Eric Maigret, and Gitte Stald. "Global Culture in Practice: A Look at Children and Adolescents in Denmark, France and Israel." *European Journal of Communication* 13 (1998): 539–56.

Lemish, Dafna, Tamar Liebes, and Vered Seidmann. "Gendered Media Meanings and Uses." *Children and Their Changing Media Environment—A European Comparative Study*. Eds. Sonia Livingstone and Moira Bovill. London: Lawrence Erlbaum Associates, 2001. 263–83.

Lindlof, Thomas R. and Bryan C. Taylor. *Qualitative Communication Research Methods*. London: Sage, 2002.

Pecora, Norma. "Identity by Design: The Corporate Construction of Teen Romance Novels." *Growing Up Girls: Popular Culture and the Construction of Identity*. Eds. Sharon R. Mazzarella and Norma O. Pecora. New York: Peter Lang, 1999. 49–87.

Robertson, Roland. "Glocalization: Time-Space and Homogeneity-Heterogeneity." *Global Modernities*. Eds. Mike Featherstone, Scott Lash and Roland Robertson. London: Sage, 1995. 25–44.

Rowe, Karen. "Feminism and Fairy Tales." *Women's Studies* 6 (1979): 237–57.

Scheff, Thomas J. "Words of Love and Isolation." *Soundscapes—Journal on Media Culture* 4 (2001). Web. 15 May 2009.

Shumway, David R. *Modern Love*. New York: New York University Press, 2003.

Signorielli, Nancy. "Adolescents and Ambivalence towards Marriage: A Cultivation Analysis." *Youth and Society* 23 (1991): 121–49.

Playing Online: Pre-teen Girls' Negotiations of Pop and Porn in Cyberspace

Sarah Baker

E mergent studies of Internet culture suggested the utopian possibilities of on-line worlds (Robins; Wellman). Some researchers exploring young people's engagement with the Internet came to imagine cyberspace as offering a "virtual bedroom," especially for girls, often emphasising the private or personal nature of online engagement. Joy Chen, for example, examined young girls' online Britney Spears fan culture, arguing that girls' online fan activities confirm and extend Angela McRobbie and Jenny Garber's original analysis of bedroom culture—the bedroom being the prime physical site of girls' consumption of cultural artefacts. For Chen, cyberspace becomes a "virtual bedroom," enabling greater engagement with teenybopper culture through the use of chatrooms, artist websites and other ever-expanding web applications. The online environment enables bedroom culture to be "reproduced" and, while enabling social interaction with other Britney Spears fans, the Internet still, according to Chen, "retains the privacy of the bedroom environment."

Paul Hodkinson and Sian Lincoln also draw on the idea of a virtual bedroom in explaining young people's negotiations of space, technology and identity via the Internet. They contend that "core elements of the symbolic and practical use of both spaces [the bedroom and the Internet] by young people render their comparison instructive and help to illustrate the role of individual space in young people's identities and social lives" (42). This conclusion comes after a comparison of original studies looking at teenage bedroom culture and young people's

engagement with online journal software (LiveJournal), with a suggestion that this might also extend to social network sites, like Facebook. While providing a more complex analysis than Chen, Hodkinson and Lincoln's article also rests on an understanding of bedroom and online spaces as primarily personal or private.

Although I would agree with these authors that the bedroom provides a useful metaphor for examining young people's online cultural practices, it is also necessary for research to analyze those times when Internet activity, or indeed that of bedroom culture, is unable to be considered private, such as in those contexts where Internet access can be subject to both adult and peer surveillance (Baker "Pop in(to) the Bedroom"). This chapter provides such an intervention through a consideration of girls' collective use of the Internet at school but outside of school hours.

Drawing on an ethnographic study of seven pre-teen girls aged 8–11 years old in Adelaide, Australia, this chapter provides a snapshot of girls' online activities at the beginning of the millennium. For eight months during 2000, I spent three to four afternoons every week with a fluctuating group of approximately thirty pre-teen girls in an outside school hours care (OSHC) facility located in a Catholic girl's school in the South Australian capital. From this group seven girls attended OSHC regularly and thus became the project's key participants. In addition to participant observation at OSHC, I visited the girls' homes, talked with them on the phone and by email, and went shopping with them and to the movies. A deliberate aspect of the research involved giving each of the key girls a camera and tape recorder for six months during the course of the fieldwork (see Baker "Auto-audio Ethnography"; Bloustien and Baker). With these audio-visual tools under the girls' complete control, the resulting materials provided a record of the girls' cultural practices within OSHC and also beyond its confines. Incorporating the voices of the research participants, this chapter provides a description of the girls' Internet use in OSHC and illustrates the ways in which their online explorations of identity and sexuality mirror other elements of their play with media and each other offline.

I argue here that the girls' exploration of identity using computers is necessarily structured by their habitus, what Pierre Bourdieu describes as the embodied dispositions of biographical experience. As this chapter demonstrates, this is particularly evident in the girls' negotiation of the images they viewed on the official Britney Spears website and what they described as "porn" sites, websites which were initially stumbled upon and then sought out. These websites became a space of "play," with play understood here as a (unconscious) strategy enabling the girls to deal with the duality and uncertainty of the social world (the new and the familiar) (Handelman; Schechner). The "doing" of gender is enabled by this play, with the images of the sexual female body contained on the websites becoming part of the girls' accumulated kinetic knowledge. In this sense, play is both

serious and hard work (Willis). The chapter concludes with an offline incident demonstrating the danger of sexual play as it threatens a habitus underpinned by notions of the innocent, good, moral girl.

Background to the Study

The girls who participated in this research were Felicity, Rosa, Kate, Amelia, Emlyn, Kylie, and Clare (all pseudonyms), and they were aged between eight and eleven years old when the fieldwork began, Felicity being the youngest at eight and Clare the oldest at eleven. They lived in different inner suburbs of Adelaide, and their familial, societal and cultural backgrounds were varied, despite all attending the same Catholic school in the city. Three of the girls—Felicity, Amelia, and Clare—were from Anglo-Celtic backgrounds. Of the others, Rosa identified as Italian, Kate's background was Western European, Emlyn's background was strongly influenced by her father's French-Canadian connections, while Kylie had been born in Korea and adopted by an Anglo-Australian couple. All the girls had at least one working parent. However, the class positions of these girls were not easily attributed. Clare, Kylie, Kate, Rosa, and Emlyn appeared to come from what would conventionally be called "middle-class" families. Yet amongst the girls, it was clear that how such a class position was lived, interpreted, and understood, its situations and expectations, were highly nuanced.

Differences of background were further evident in the family situations of each girl. Four of the girls had no siblings. But whereas Felicity and Amelia lived in single-parent households with their mothers, Kylie and Kate were living with their non-biological and biological parents, respectively. The other three girls all lived with their biological parents and male sibling(s). Rosa had a twin brother, Emlyn's two brothers were both in their mid-teens, and Clare had a younger brother. For some girls, however, household situations changed over the course of the fieldwork. At different times, both Kate and Emlyn shared their homes with teenage exchange students (male and female) from Europe and Asia. Mid-way through the research Felicity and her mother moved into a house with friends, and prior to the fieldwork Amelia was also living with her mother's female partner. Most girls' domestic situations were therefore never fixed in a way typical of middle-class families.

Familial, cultural, and societal contexts were pivotal to the ways in which the seven girls represented and constituted their identities. The ethnographic methodology deployed in this research enabled a consideration of how the background of each girl influenced her cultural practices. But alongside the finely nuanced differences in the girls' backgrounds there were a number of common links. The most obvious is their age and gender. However, homogeneity cannot be simply assumed in such a grouping. For example, how age was experienced for each

of the participants differed. Some identified themselves as "teenagers" but faced constant reminders they had not yet attained that position. As Amelia says of her mother, "She treats me like a little kid; 'you're only nine Amelia!'" Other girls saw themselves to be less "aged" than "gendered" with Kylie and Emlyn unhappy at being called kids or children, "Not children. Girls," said Kylie. Emlyn nodded in agreement, "Yeah, just girls." The other commonality is the girls' attendance at St. Cecilia's Girls School and the OSHC run by the school. As this chapter focuses on computer use in the school's OSHC facility, it is important to contextualize these sites before turning to a discussion of the ethnographic findings.

St. Cecilia's Girls School is a non-government, Reception–Grade 12 Catholic school in central Adelaide. Underpinned by feminist principles, and part of an institution dedicated to the care and education of disadvantaged girls, the school prides itself on the number of graduates who go on to tertiary education. Although St. Cecilia's is a fee-paying school, the school encourages families who may be eligible for government assistance to apply for the "School Card," which automatically entitles a reduction in school fees. Moreover, a policy of the Catholic Education Office is that no child would be denied a Catholic education because of financial hardship. The student population of St. Cecilia's is therefore drawn from all socio-economic backgrounds. Furthermore, the students represent over sixty nationalities, and their religious backgrounds are also diverse with only 60 percent of students identifying as Catholic. The central location of St. Cecilia's also makes the school easy to access from across the metropolitan area. The diversity of the student population is regarded highly by the school.

My research took place in the OSHC facility that is managed by the school. Located in the school grounds, the facility cares for girls under the age of 12 from 3–6 pm if the parent/guardian is unable to collect them at the end of the school day. The OSHC is situated in the old caretaker's room and comprises a large playroom with a television, video player, books and board games, and a small kitchen used for the preparation of snacks. The playroom is the domain of the girls under the age of 8. The OSHC also has access to a classroom adjacent to the playroom where the girls aged 9–12 are able to do their homework, as well as the netball courts and playground for outside activities, and the school's computer lab—the setting for the material in this chapter.

Computers in OSHC

In her book *Children and the Media Outside the Home*, Karen Orr Vered provides a detailed analysis of after-school care in South Australia. Through observations and interviews with 119 children aged 5–12 in six OSHC services, Vered explores the availability and use of different media in after-school care settings. As such, Vered's study provides us with a broad picture of the place of computers in OSHC

services in metropolitan Adelaide; settings which "are increasingly an important site for public access" to the Internet for Australian children under the age of 12 (9). Access to computers in OSHC facilities vary and are often dependent on the service having access to the school computer labs. However, as Vered points out, those that do have access to such labs are limited in their use by supervision arrangements. As computer labs are often physically distant from the main OSHC area, and with a required supervision ratio of one adult for every fifteen children, it is sometimes difficult "to assign a staff member to the computer lab while maintaining sufficient supervision over the other areas of indoor and outdoor space" (Vered 56).

Supervision is an important issue in computer rooms where access to the Internet is available, as there is a general fear among adults that unsupervised children "may cross boundaries and venture into spaces of adult content" (Vered 7). The ideal design for school computer space is to have, as Vered observed in one OSHC service, "monitors around the perimeter of the room but facing inwards . . . because it offers the greatest screen visibility for teachers and peers" (135). This arrangement is not always possible and, for another service in Vered's study, which had four computers situated in a very small room, "one of the concerns that staff had was the children's unmonitored access to the Internet. While staff could see the children in the room, they could not see the computer screens" (139). The staff members were concerned about children viewing adult content, but Vered's observations in this service did not find cause for concern. The girls, for example, used the Internet for "looking at 'gossip' sites, finding information about pop stars, and details on dolls, animals, and other collectibles that were popular at the time" (Vered 140). In situations where it was difficult to monitor computer screens, Vered found some reliance by staff on "children's ability to self-regulate and for peer-monitoring to have some regulatory effect either in the form of surveillance or by children 'dobbing in their mates'" (141). For those staff in the well-designed computer room who could monitor screens with ease, they were, according to Vered, "secure in their belief that most children would not break the rules and that if rules were broken, another child would report it" (141).

The computer lab available to the girls in St. Cecilia's OSHC was designed so that there were monitors around the perimeter of the room (as in Vered's well-designed lab), but there were also two rows of computers in the middle of the room. This meant the OSHC staff could not see all monitors all of the time. The girls principally used the computers to access the Internet, with only a small amount of their computer time devoted to homework. As Vered (137) had also observed in her research at OSHC sites, the girls at St. Cecilia's would often be at their own computer station but would "share their discoveries" with others in the room, and especially with those sitting at adjacent computers. The girls were rarely denied access to this room as most days there were two staff members to

supervise the thirty girls in the facility. However, with the OSHC co-ordinator principally supervising the playroom, the second staff member was left to supervise a much larger and physically distant space, taking in two netball courts, a playground and the computer lab. Monitoring of computer screens by staff did occur but was not constant.

As I will demonstrate in the next section, the girls in my research took advantage of the gaps in supervision, but, I argue, their Internet activity was bounded by their habitus. This brings us back to Vered's comment about children's self-regulation when using computers. By habitus I mean that the girls' exploration of the Internet and their simultaneous negotiation of gendered identity, were structured by an "individual and collective history" that keeps their behavior in check (Bourdieu and Wacquant 123). Habitus provides a tacit form of self-regulation in that it structures what is possible. To demonstrate this I will provide a snapshot from my fieldwork of one particular incident in OSHC involving Emlyn and Kylie, both aged 10. For comparison, I then detail an offline incident involving Amelia, aged 9.

Two Windows: Britney Spears and Ten.com

I arrived at OSHC and found Emlyn and Kylie sharing a computer in the lab, looking at the official website for the pop singer Britney Spears (www.britney-spears.com). When I pulled up a chair to sit with them, the girls proceeded to tell me what had happened earlier in the afternoon when they had attempted to look up the website for the television channel Network Ten. What they found was not the website of an Australian television channel but rather a website which they described as having "pornographic" content; meaning it contained images of semi-naked women engaged in stripping or exotic dancing rather than forms of sexual intercourse. By this stage in the research I had developed a relationship with the girls that was friendly and trusting and which, especially with Emlyn, could be described as almost sisterly. From the outset my role in the OSHC facility was not to be in any way authoritative, and it had been made clear to all involved that I was not there in a supervisory role—that was the domain of the OSHC staff—but rather I was just "hanging out," wanting to learn about the place of popular culture in girls' lives. As such I was privy to details of the girls' everyday experiences that they would not normally share with other adults in their lives. Emlyn and Kylie were therefore very excited and giggled as they told me about the "naked" girls on the site and the way the word "sex" appeared in big letters. Unsatisfied with simply describing the site to me the girls' decided they should show me exactly what they meant. While keeping the Britney Spears website on-screen, Emlyn opened up an additional browser window and typed in the URL, ten.com.

These windows enabled the girls to place themselves in two different contexts simultaneously (Turkle 13). In one window the girls were looking at the Britney Spears website and in the other window the girls were on the portal of a porn site—the adult content so feared by parents and the OSHC staff in Vered's research. Having these two windows available to them was important for the girls' play in terms of staff monitoring of the computer lab. If the staff member who was supervising the computer lab was deemed as coming too close, Emlyn would attempt to shield the screen with her hands while Kylie minimized the ten.com window. This left only Britney Spears visible to the staff member and by all appearances it would look like the girls were viewing a music website rather than a pornographic one. In this chapter I want to consider the possibilities opened up by both windows. Firstly, I will discuss the girls' play with Britney Spears' website before turning my attention to the other window containing ten.com.

Window 1: Britney Spears

During their time in OSHC the girls often explored official and unofficial popular music websites such as those of the bands Bardot and 5ive. On these websites the images of the artists were often privileged by the girls over and above such things as lyrics and biographical information. The girls would carefully scrutinize each image. "Oh, she looks so pretty there," said Emlyn as she viewed a photograph of Britney Spears on the official website. As can be expected, the website's picture gallery contained photographs of the singer taken in different locations, on different days, and wearing different outfits. Emlyn had a headshot of Spears displayed on the screen which she liked because, "It looks more natural." Then she clicked to enlarge another photo in the gallery, commenting, "See, I think that she looks so ugly here with all this make-up and the scraggy hair." Of the next photo Emlyn said, "She just looks dirty in this one."

McRobbie asserts that "pop is about images and about looking" (169), and images of female pop stars become an important mode of bodily discourse for young girls, transmitting "the rules of femininity" (Bordo 17). Britney Spears' image enabled particular representations of femininity to be questioned (too much make-up/unkempt hair) or confirmed (natural look) by Emlyn. Emlyn's criteria of what comprises authentic femininity are linked to her historically constituted habitus as it has been structured by familial, cultural, and societal discourses. For Emlyn, a display of "correct" femininity involved being well-groomed with minimal make-up: St. Cecilia's disallowed students wearing make-up at school, Emlyn's mother wore very little make-up, and in the girls' magazines read by Emlyn it was often the "natural" look, with make-up kept to a minimum, that was depicted. This was a disciplined femininity Emlyn frequently articulated through-

out the research, perhaps a subconscious attempt to confirm her own narrative of "growing up girl."

Emlyn's critique of Britney Spears' hair and make-up in the images on the official website is part of her understanding of "doing woman." As Liz Frost points out, popular discourses of "doing woman" emphasize "doing make-up and choosing styles, manicures, and hair-dos, deportment and increasingly, sometimes quite savagely, the alteration of actual body shape and size" (76). Looking at a photo of Britney Spears wearing a bikini, Emlyn remarked:

> Urgh! She looks disgusting there. She is so big. She looks like she's had those breast implants there. There was all this stuff about whether she had breast implants, but in some pictures it looks like there's nothing, but in others, like this one.

In negotiating such images, Emlyn can be understood as in the process of learning "the art of being feminine" (Brownmiller 14), but the different aspects of femininity found on pop star websites means the "feminine" is struggled over. Negotiating these images is no easy task, as Melanie Lowe's research on teenage girls' reception of Britney Spears confirms, and can be compounded by the contradictory nature of images in the photo gallery: Images of the singer as "sex siren" (scantily clad and writhing with a python) sit uncomfortably beside images of the singer as "virgin" (with her declarations "just because I look sexy on the cover of *Rolling Stone* doesn't mean I'm a naughty girl" ["Saint Britney"]). Emlyn's understanding of "doing woman" was further complicated by her embodied play, with Emlyn "becoming" Britney Spears in the St. Cecilia's Book Week parade and in a game called "Shooting Britney" during which Emlyn's peers played the role of paparazzi chasing her (in the role of Britney) around the playground with imaginary cameras. By way of mimesis (a way to cope with that which is not yet understood [Taussig]), Emlyn embodied in these moments the complexities of the singer's female sexuality—a sexuality which is said to emphasize a "knowing" innocence, a deliberately contradictory notion of young femininity where the good girl and bad girl stereotypes are combined in one package (Lowe; Whiteley).

In this sense, the mimetic faculty produced "an otherwise unattainable proximity" (Gebauer and Wulf 2-3) to the images provided on the official Britney Spears website. By slipping into the "otherness" offered by Britney Spears, Emlyn attempted to tame the images, to reduce them to a discourse she could master (Schechner 4). The girls' engagement with the images found in Spears' online photo gallery, and their associated embodied play as the pop star, both tested and confirmed (tacit) familial, cultural and societal boundaries understood by the girls as constituting "growing up girl." This play intensified in the other window for ten.com.

Window Two: Ten.com

As used by Emlyn and Kylie, the Britney Spears website provided a safety net because the photo gallery appeared on-screen while they navigated another website, ten.com. The home page of this website contained warnings about over-18 content. The girls laughed at this and the other warnings concerning the website's "explicit heterosexual, bisexual and transsexual images." Both Kylie and Emlyn would glance around the computer room to see if the OSHC worker was within viewing distance of their screen. Looking at the images the girls would giggle loudly and at times they laughed with uncontained excitement. This was a different response to that which the girls exhibited when navigating the Britney Spears website, but it was still a response firmly located at the site of the body, an idea I explore further below.

The girls' laughter suggested something other than frivolity. Although the girls were having "fun," their play was also serious. In Handelman's account of the seriousness of play, he notes "the affinity of the idea of 'play' with that of 'uncertainty'" (63). Play is uncertain because it is unpredictable, dynamic, processual (Handelman), and "can contain within itself not only the clear apollonian moment of free self-determination, but also the dark dionysian moment of panic self-abandon" (Fink 25). What Richard Schechner calls dark play "occurs when contradictory realities exist, each seemingly capable of cancelling the other out," and so is about disruption rather than integration (36). Giggling and laughing, the girls' reactions to their play with porn betrayed their uncertainty. Such play is risky in that although it is necessary in order to "make sense" it also destabilizes what we think we know (Schechner). Emlyn and Kylie's laughter as they navigated ten.com registered "a tremor in cultural identity, and not only in identity but in the security of Being itself" (Taussig 226). The girls managed such a tremor by exaggeration and mimetic excess. Their giggling claimed that this was "just play," enabling them to explore the pornographic images on the website while simultaneously denying the possibilities of these images. This would suggest that giggling is an important strategy adopted by girls in exploring sexuality despite previous research finding that it is pre-teen boys, not girls, who deploy laughter as a means to navigate sexual matters in same-sex groups (Halstead and Waite). I would argue that in the case of Emlyn and Kylie, only through giggles could these images be tamed, mastered and remain safely within the bounds of the girls' habitus.

The pornographic images on the home page of ten.com were only a taste of what the website had to offer. In order to see more images an online registration form needed to be submitted, prompting Emlyn to click the registration button. At the prospect of seeing more explicit photographs, the laughter increased, especially Kylie's. A number of times Emlyn, wary they were drawing too much attention to themselves, told Kylie to "Come back to reality." Without a credit card

their registration was not accepted, but this was only a minor setback as the next thing Emlyn did was enter a different URL, nine.com, in the hope it would contain similar content. This URL redirected the girls to a different website, pussy. com. At the sight of the word "pussy," the girls literally fell about laughing again. Emlyn, legs slightly parted and pointing to her crotch said, "It's weird how they call pussy cat the same as there." "Because they're both furry," giggled Kylie. At that moment Emlyn noticed how close the OSHC worker was and frantically told Kylie to, "Get it down, get it down. Put the Britney page back on."

In this way the girls' used Britney Spears, a legitimate interest for pre-teen girls, to cover up their exploration of porn sites. The irony here is not lost. Britney Spears' music video for the song "From the Bottom of My Heart" was directed by a former porn director, Gregory Dark. Britney Spears also came under attack around the time of my fieldwork for her overtly sexual image. Controversy surrounded her *Rolling Stone* magazine cover, for example, which depicted her lying on pink satin sheets, dressed in a bra and knickers, phone in one hand, child's toy in the other, with the cover announcing, "Barely legal: Britney Spears–inside the bedroom of a teen dream" (Koha 47). With eighteen-year-old Spears proclaiming to be a virginal good girl, the *Rolling Stone* cover and the images Emlyn and Kylie found in the official photo gallery are suggestive of the singer's Lolita-like qualities. Indeed, one commentator describes a carefully orchestrated record company campaign for Spears which alternates "apple pie wholesomeness with brazen acts of sexual provocation. . . . One minute she's the bashful girl next door who swears allegiance to her Mum, God and the flag, the next she is writhing on stage in a bikini with a python between her legs" (McCormack). In a playful sense Britney Spears becomes pop star and pornstar, engaged in her own mimesis. Emlyn recognized this fine line in the increasing sexiness of Britney Spears' music videos. She emailed me wanting to know, "is the brits video [for 'Don't Let Me Be the Last to Know'] sexier than the [video for] 'Stronger'? If it is I don't know how she could get even more clothes off without being a porn*[star]." A few days later, Emlyn, having now seen the video, emailed me with her response, "brits does look a bit like porno when she's at the beach but if she did she would already be in the papers on the cover BRITNEY SPEARS REALLY DOES DO PORNO-GRAPHIC WORK CONFIRMED [AUSTRALIA'S PRIME MINISTER] MR JOHN HOWARD."

Sex in the Virtual Bedroom

The girls' play with these websites in OSHC points us to an absence in discussions of bedroom culture, virtual or otherwise. In its traditional formulations, girls' bedroom culture has been largely devoid of the sexual. While there has been discussion of young girls' explorations of romance in the bedroom, and suggestions

that gazing at pop pin-ups or fantasizing about male pop stars in this space could "carry a strong sexual element" (McRobbie and Garber 13), these behaviours were also interpreted as girls "buying time . . . from the real world of sexual encounters" (McRobbie and Garber 14). Though it could be argued that romance and sex are connected for youth (Shulman and Kipnis 348), it remains that girls' bedroom culture is rarely linked to the explicitly sexual. The bedroom, both physical and virtual, has been principally described as a place of consumption rather than a site of sexual activity or a space to explore sexiness. It is where girls' gossiped, tried on clothes, listened to music, and experimented with make-up (Chen; McRobbie and Garber). Yet bedrooms are also "where the most private sexual functions are performed" (Billington, Hockey, and Strawbridge 39) and so provide a legitimate space for the exploration of sexual identity. In terms of young lesbians, for example, research has found that although "being in the bedroom often had nothing to do with sexual activities, it was here that girls learned about lesbians and sometimes about sex" (Petrovic and Ballard 201). Although the girls in my research may not have been "having sex," they were certainly negotiating sex, sexiness, and sexuality while playing with pop stars and porn in the "virtual bedroom."

The absence of sex in the traditional construction of young girls' bedroom culture is perhaps due to the notion of little girls' sexuality being somewhat taboo, with adults struggling to maintain a sense of childhood innocence (Walkerdine "Daddy's Girl"). However, as Lockard points out, "neither Britney Spears nor her fans are innocent":

> They may be virgins in a strict sense, but this is a mere technicality that relies on a limited physical definition of virginity. . . . Together with her smile and thrust-out breasts, Britney Spears' midriff is a calculated sex substitute: sexual purity meets pure sex. This is chastity that is not chastity, a performative pretense.

In their online play, we glimpse Emlyn and Kylie's negotiation of this pretense, in their giggling for example, and this is a negotiation that is necessarily located at the site of the body.

The websites for ten.com and pussy.com incorporated moving images as well as still images, and these were primarily of women in the process of stripping, teasingly moving their bodies for the enjoyment of the viewer. All forms of media show girls "what their bodies could be and should be," but websites like these are particularly illustrative that for women "being 'grown-up' necessitates being massively identified with the body" (Frost 30, 71). As Kerry Carrington and Anna Bennett have also observed of the pedagogic function of girls' magazines, the images of women stripping that the girls found online provided them with new knowledge about the female body—not only its appearance but also what the body could do.

In a different moment of my fieldwork, where again Emlyn and Kylie were together at a computer in OSHC, Emlyn said to Kylie, "Let's look up more of that rude stuff." Once the computer had booted up, Emlyn said, "I'm going to look up Pornstars." As she typed in pornstars.com she added, "You know Sophie [from the all-girl pop group Bardot, which formed on the Australian version of the television series *Popstars*], that's what she wanted to call the Popstars." I pointed out they were being redirected to a different website, orgy.com. Emlyn then said, "What's orgy? Is that when you do this?" and proceeded to demonstrate seductive, stripper-like dancing. These moves were similar to those she had seen on ten.com, pussy.com, and the Spears website. Emlyn had not only been reading the bodies of the porn stars as "texts of culture" but rather "ma[d]e them body" (Benson 143). The images from the porn websites were incorporated into her play, becoming kinetic knowledge. On another occasion Emlyn was dancing, out of my view, behind a row of chairs the janitor had perched on a table in the OSHC classroom. I knew that she was dancing because I heard a girl tell Emlyn to "Stop doing sexy moves." Curious, I poked my head from around a chair and glimpsed Emlyn giggling, swaying her hips and posing provocatively. It was a very sexual display of slow dancing which seemed to be over almost as soon as it began. It was an ephemeral assumption of the female body as seen on the "porn" websites.

Emlyn's sexy moves were, however, accompanied by a giggle similar to that described in her play with Kylie on ten.com. Again, this was a giggle of uncertainty in a moment of mimesis where there was an attempt to grasp, however momentarily, the slipperiness of sex, sexiness, and sexuality. Part of the girls' understanding of the images seen on the porn websites and also the Britney Spears website comes by way of their bodies. In the case of pop and porn (and the blurred line which separates them), for the girls in my research "comprehension is (essentially) corporeal" (Bourdieu 160). This corporeality offers a challenge to conventional understandings of the asexual girl-child (Evans). But such a challenge must be contained by what Bourdieu calls "practical sense," must follow the "tacit rules of the game" (as provided by habitus) if boundaries are not to be breached (Bourdieu and Wacquant 99). The (unconscious) strategies, such as giggling and hiding, used by Kylie and Emlyn to deal with the contentious material on the websites enabled their play to remain in check, within the bounds of what was considered acceptable behaviour, exploration and representation by their peers—the other pre-teen girls in OSHC using the computer lab. As such, none of the other girls present reported Emlyn and Kylie to the staff. However, in OSHC not all explorations of pornographic images were considered legitimate, and so in this final section I turn to an offline incident.

Amelia's Diary

One day during the fieldwork Amelia brought a "secret" diary to OSHC in which she had stuck pictures of naked women. These had been cut from pornographic magazines and were accompanied by hand-written captions, like "Big Breasts." While Amelia was showing the diary to myself and Kate (who had seen the diary once before), Clare and Kylie joined us in the corner of the classroom asking to see the diary. Without too much protest, Amelia let them see its contents. Then Emlyn was allowed to join the group, but when eight-year-old Felicity approached, she was told, "Go away, you're too young." Clare, Kylie, and Emlyn were not impressed by Amelia's diary and visibly displayed their disgust. They also commented on the scent of the diary: "It smells like someone's humped it," observed Clare. The three girls then took me aside, and Clare said, "It's sick. I'm going to tell my teacher tomorrow because Amelia shouldn't have stuff like that." The next day Clare and Kylie both told their teachers about Amelia's diary. The teachers spoke to Amelia about it. She admitted the diary was hers and that she had found a magazine "lying around," cut out the pictures, and stuck them in her diary. Kylie told me, "Amelia cried and isn't speaking to us now." "Not that we care," said Clare. "I called her a pervert today," added Kylie.

Unlike the online exploration of porn by Kylie and Emlyn where they distanced themselves from the content with exaggerated behaviour and laughter, Amelia demonstrated an ownership of the material, and in taking the sexual material seriously by collecting the images in the form of a diary she therefore became, in the eyes of her peers, a "pervert." Amelia had unwittingly breached an invisible boundary and in doing so demonstrated her inability to "read" the situation, her "out of sync[ness]" with her peers (Bourdieu and Wacquant 130). What Emlyn and Kylie had been allowed to explore by their peers (in that their online explorations were not reported to teachers or OSHC staff) was not extended to Amelia. She had inadvertently over-stepped what was acceptable in her OSHC peer group. Part of the problem was that amongst the girls in OSHC Amelia was credited with little status. The girls had, on previous occasions, labelled Amelia "vicious," "feral," and "lacking manners." Moreover, they questioned the sexual orientation of Amelia's mother, and often their behavior towards Amelia suggested they considered Amelia sexually deviant. For example, Rosa and Kate would not play with a ball after Amelia had used it because they believed she would "sit on it and rub herself." The incident with the diary further highlighted that Amelia did not know her place, and as a result her actions were censored by the peer group. The other girls' refusal of Amelia's images of naked women, which were less explicit than those on the websites Emlyn and Kylie explored, was an assertion of their position in social space, and in their reaction to Amelia's diary, the girls, in distinguishing themselves from her, betray these positions.

Good girls are "guardians of the moral order" but, as Valerie Walkerdine states, "'good girls' are not always good" (*Schoolgirl* 77, 103). When their "badness" is lived, it is as a "sexualized child" whose eroticism threatens the notion of childhood innocence. Walkerdine discusses this in terms of a narrowly defined "little working-class girl" who "is too precocious, too sexual": "While she gyrates to the music of sexually explicit popular songs, she is deeply threatening to a civilizing process understood in terms of the production and achievement of natural rationality and nurturant femininity" (*Daddy's Girl* 4). For the girls in my research, Amelia was equally threatening. She was censored by her peers because her engagement with porn threatened their historically constituted habitus that was underpinned by particular notions of the innocent, the good, the moral girl. The girls' own challenges to adult discourses of the girl-child's asexuality remained contained within accepted familial, cultural, and societal discourses. But there was always the danger, the uncertainty that comes with play, that these discourses might be challenged too much. As Amelia's situation demonstrates, there was a fine line between being within and without the groove of social reproduction in the space of OSHC.

Conclusion

This chapter began with a consideration of cyberspace as a virtual bedroom—a concept that allows researchers to connect girls' identity-work online with traditional understandings of their cultural practices, including negotiations of girlhood, in the physical bedroom. Notions of bedroom culture, virtual or otherwise, too often emphasize the personal or private nature of this space, which led me to explore girls' use of the Internet in OSHC where online exploration was a shared practice open to surveillance by peers and OSHC staff. The focus on Emlyn and Kylie shows how the girls overcame Internet regulation by using a website of legitimate interest to pre-teen girls to mask their navigation of websites they knew would be of concern to OSHC staff. The representation of the female body on both kinds of websites had to be negotiated by the girls, and this was done on multiple levels: through discussions with each other and myself where they offered interpretations of what they were seeing; through mimesis, where they embodied the images and incorporated the new kinetic knowledge into their dancing; and linked to both of these, the giggle of uncertainty that kept their play in check and registered that "this is just play" rather than "this is real."

Such play demands that the sexual be inserted into understandings of bedroom culture, and the virtual bedroom, even though acknowledging the sexuality of pre-teen girls continues to be fraught terrain. Young girls' sexuality remains taboo as evidenced by submissions to the Parliament of Australia's 2008 Senate Inquiry into the sexualization of children in the contemporary media environ-

ment or in the 2007 report prepared by the American Psychological Association Task Force on the sexualization of girls. What this chapter demonstrates is that pre-teen girls' sexuality is contested among pre-teen girls themselves, and Bourdieu's concepts of habitus and practical sense provide us with a way of understanding this. Kylie and Emlyn's online explorations of the sexualized woman were contained by their tacit understanding of what was acceptable, so that they could challenge asexuality yet could always, as Emlyn said to Kylie, "come back to reality." Though the images they looked at online were more explicit than those in Amelia's diary, the girls recognized Amelia as having crossed a line in what is acceptable exploration of sexuality by pre-teen girls. Her ownership of the material announced "this is real" rather than "this is just play." As a result, Amelia experienced a level of surveillance and regulation that Emlyn and Kylie never experienced in the computer lab.

With such a small group of pre-teen girls involved in this research it is clear that generalizations cannot be made here to encompass any universal pre-teen girl and her engagement with sexuality on- or off-line. The aim of this chapter is not to draw large conclusions or definitive statements. Rather it is intended to provide a nuanced and textured snapshot of some girls' cultural practices at the start of the new millennium. What I hope is that the story I have told here will open up and raise new questions about the virtual bedroom which might lead to further interrogations of girls' negotiations of sexuality and cyberspace.

Works Cited

American Psychological Association. *Report of the APA Task Force on the Sexualization of Girls*. Washington, DC: American Psychological Association, 2007. Web. 6 Oct. 2009.

Baker, Sarah. "Auto-audio Ethnography: Or, Pre-Teen Girls' Capturing Their Popular Music Practices on Tape." *Context: Journal of Music Research* 26 (2003): 57–65.

———. "Pop in(to) the Bedroom: Popular Music in Pre-Teen Girls' Bedroom Culture." *European Journal of Cultural Studies* 7.1 (2004): 75–93.

Benson, Susan. "The Body, Health and Eating Disorders." *Identity and Difference*. Ed. Kathryn Woodward. London: Sage, 1999. 121–82.

Billington, Rosamund, Jenny Hockey, and Sheelagh Strawbridge. *Exploring Self and Society*. Basingstoke: Macmillan, 1998.

Bloustien, Geraldine and Sarah Baker. "On Not Talking to Strangers: Researching the Micro Worlds of Girls through Visual Auto-Ethnographic Practices." *Social Analysis* 47.3 (2003): 64–79.

Bordo, Susan. "The Body and the Reproduction of Femininity: A Feminist Appropriation of Foucault." *Gender/Body/Knowledge: Feminist Reconstructions of*

Being and Knowing. Eds. Alison M. Jaggar and Susan Bordo. New Brunswick: Rutgers University Press, 1992. 13–33.

Bourdieu, Pierre. "Program for a Sociology of Sport." *Sociology of Sport Journal* 15 (1998): 153–161.

Bourdieu, Pierre and Loïc J. D. Wacquant. *An Invitation to Reflexive Sociology.* Cambridge: Polity Press, 1992.

Brownmiller, Susan. *Femininity.* New York: Linden Press, 1984.

Carrington, Kerry and Anna Bennett. "'Girls' Mags' and the Pedagogical Formation of the Girl." *Feminisms and Pedagogies of Everyday Life.* Ed. Carmen Luke. Albany: State University of New York Press, 1996. 147–66.

Chen, Joy. "Click Me Baby One More Time: Britney Spears, Popular Music, and Teenyboppers Online." 8th Australia-New Zealand Branch Conference of the International Association for the Study of Popular Music. University of Technology Sydney, Sydney. 28 Sept. 2001.

Evans, David T. "Falling Angels?—The Material Construction of Children as Sexual Citizens." *International Journal of Children's Rights* 2 (1994): 1–33.

Fink, Eugen. "The Oasis of Happiness: Toward an Ontology of Play." *Yale French Studies* 41 (1968): 19–30.

Frost, Liz. *Young Women and the Body: A Feminist Sociology.* Houndmills: Palgrave, 2001.

Gebauer, Gunter and Christoph Wulf. *Mimesis: Culture-Art-Society.* Berkeley: University of California Press, 1995.

Halstead, J. Mark and Susan Waite. "'Living in Different Worlds': Gender Differences in the Developing Sexual Values and Attitudes of Primary School Children." *Sex Education* 1.1 (2001): 59–76.

Handelman, Don. *Models and Mirrors: Towards an Anthropology of Public Events.* New York: Berghahn Books, 1998.

Hodkinson, Paul and Sian Lincoln. "Online Journals as Virtual Bedrooms?: Young People, Identity and Personal Space." *Young* 16.1 (2008): 27–46.

Koha, Nui Te. "All a Whirl for Britney." *Adelaide Advertiser* 27 May 1999: 46, 51.

Lockard, Joe. "Britney Spears, Victorian Chastity and Brand-Name Virginity." *Bad Subjects* 57 (2001). Bad Subjects. Web. 23 Apr. 2002.

Lowe, Melanie. "Colliding Feminisms: Britney Spears, 'Tweens,' and the Politics of Reception." *Popular Music and Society* 26.2 (2003): 123–40.

McCormack, Neil. "Britney, Goddess of Virginity." *The Age,* 25 Feb. 2002. Fairfax Media. Web. 23 Apr. 2002.

McRobbie, Angela. *Feminism and Youth Culture: From* Jackie *to* Just Seventeen. Basingstoke: Macmillan, 1991.

McRobbie, Angela and Jenny Garber. "Girls and Subcultures." *Feminism and Youth Culture: From* Jackie *to* Just Seventeen. Angela McRobbie. Basingstoke: Macmillan, 1991. 1–15.

Parliament of Australia Senate. *Inquiry into the Sexualisation of Children in the Contemporary Media Environment.* Commonwealth of Australia, June 2008. Web. 24 Mar. 2009.

Petrovic, John E. and Rebecca M. Ballard. "Unstraightening the Ideal Girl: Lesbians, High School, and Spaces to Be." *Geographies of Girlhood: Identities In-Between*. Eds. Pamela J. Bettis and Natalie G. Adams. London: Lawrence Erlbaum Associates, 2005: 195–209.

Robins, Kevin. "Cyberspace and the World We Live In." *Cyberspace/Cyberbodies/Cyberpunk: Cultures of Technological Embodiment*. Eds. Mike Featherstone and Roger Burrows. London: Sage, 1995. 135–55.

"Saint Britney." *Dotmusic.com*. Miller Freeman Inc. 12 Dec. 2000. Web. 23 Apr. 2002. <http://www.dotmusic.com/news/December2000/news16894.asp>.

Schechner, Richard. *The Future of Ritual: Writings on Culture and Performance*. London: Routledge, 1995.

Shulman, Shmuel and Offer Kipnis. "Adolescent Romantic Relationships: A Look from the Future." *Journal of Adolescence* 24 (2001): 337–51.

Taussig, Michael. *Mimesis and Alterity: A Particular History of the Senses*. New York: Routledge, 1993.

Turkle, Sherry. *Life on the Screen: Identity in the Age of the Internet*. New York: Touchstone, 1997.

Vered, Karen Orr. *Children and Media Outside the Home: Playing and Learning in After School Care*. Houndmills: Palgrave Macmillan, 2008.

Walkerdine, Valerie. *Daddy's Girl: Young Girls and Popular Culture*. Basingstoke: Macmillan, 1997.

———. *Schoolgirl Fictions*. London: Verso, 1990.

Wellman, Barry. "The Three Ages of Internet Studies: Ten, Five and Zero Years Ago." *New Media and Society* 6.1 (2004): 123–29.

Whiteley, Sheila. *Too Much Too Young: Popular Music, Age and Gender*. Abingdon: Routledge, 2005.

Willis, Paul. *Common Culture*. Buckingham: Open University Press, 1990.

Role Models and Drama Queens: African Films and the Formation of Good Women

Sandra Grady

In the living rooms of most Somali Bantu apartments in the United States, the television demands primary attention. Sitting as it generally does in an entertainment center cluttered with stereo consoles and speakers, a DVD player, videocassette recorder, an assortment of videotapes, DVDs, music CDs, and often other televisions, it serves to focus the attention of most individuals who enter the room. The rest of the living space is highly decorated with vibrant African textiles, creating a profound sense of withdrawal from the surrounding American environment. The overcrowded entertainment center, however, provides a stunning contrast to the predominant African décor, a contrast made even more dramatic when the television (or multiple televisions) remain switched on continuously, broadcasting the sounds of U.S. programs over those of family gatherings in the otherwise African space. For Somali Bantu refugees, the entertainment center provides an important new element of family life in resettlement, opportunities for family recreation and self-presentation.

The increased consumption of media by Somali Bantu refugees is an element of wider forces affecting most culture groups across the globe at the turn of this century. According to Arjun Appadurai, two defining characteristics of the postmodern world are the vastly increased scale of human migration across the globe and the abundance of electronic media options for consumption. These two forces are particularly important, he argues, because they influence the social imagination and, consequently, shape personal and cultural identity (Appadurai

3–4). According to Lila Abu-Lughod, a hallmark of contemporary culture is that it is co-produced by both local forces and the mass media forces that cross national boundaries. Despite its role as a global force, local identity and its meaning systems are still intrinsic to media production and consumption (Abu-Lughod 121–3). The influence of mass media on young refugees is particularly significant to Appadurai because diverse media choices offer young people a number of alternatives to the models of adulthood offered by parents or elders in more traditional practices of cultural reproduction (Appadurai 43–5). This chapter explores the media practices of a group of East African refugees who have recently been resettled in the United States in order to explore this larger question of how media consumption affects practices of cultural reproduction in a transnational context. In this community, communal television viewing has become an important avenue for reinforcing traditionally held values about gender roles and the centrality of domestic life.

The Somali Bantu Community

The designation "Somali Bantu" refers to members of an ethnic minority population from southern Somalia who are united by a common history, and whose ethnic identity is emerging in the midst of diaspora. This name was adopted by the international refugee administrative systems to identify members of this community following their displacement from rural villages during the collapse of the Somali state in the early 1990s. In the nineteenth century, most of the Somali Bantu arrived in Somalia from a variety of locations in present-day Tanzania and Mozambique as part of the Indian Ocean slave trade. Prior to slavery, they belonged to disparate culture groups. After they were forcibly settled in Somalia, they adopted agricultural work, integrated into the Somali clan system, accepted Islam, and adopted a local dialect of Somali language. At the same time, they continued various cultural practices from their pre-slavery past. In the nineteenth and twentieth centuries, the ethnic Somali treated them as social inferiors, and the Somali Bantu operated on the margins of colonial and post-colonial Somali society. As a result, there is little scholarly literature on them, and when they do appear, a very limited picture emerges from broader studies about Somali pastoralists (Besteman, "The Invention of Gosha"; Besteman, *Unraveling Somalia*; Cassanelli; Menkhaus). With the chaos of the early 1990s, many Somali Bantu fled to refugee camps in northern Kenya, where they continued to live until 2003, when the U.S. State Department began resettling approximately 15,000 members of the community to 52 locations in the United States (Van Lehman). The ethnographic material in this essay is part of a larger study of one Somali Bantu community of approximately 1,000 people who have resettled to a large midwestern city.[1]

For the Somali Bantu, the experiences of exile and resettlement have provided a paradox. Dislocation and recognition by aid agencies have offered the community many opportunities to document its history and language and have allowed local diasporic communities to form associations with other groups of Somali Bantu in resettlement. However, the experience of upheaval from long-established rural villages in southern Somalia has required them to accommodate American culture and has forced them to adapt their cultural practices significantly. Some of the greatest adaptations have disproportionately affected school-age refugees. In resettlement, their traditional practices of initiation into adulthood must operate alongside the experience of adolescence as commonly practiced within American culture, which is an approach reinforced by the U.S. educational system. As a result, the Somali Bantu life cycle is being altered by resettlement to the United States. Young people have new roles in school and at home, and the period of transition from childhood to adulthood has been radically extended. The educational aspects of the traditional life cycle event, which was characterized by ritualized genital cutting and an extensive period of seclusion and recovery that allowed for instruction into adulthood within the community, is being replaced by high school. In the practice of such initiation ritual, after the recovery period, the initiates would re-enter the community as adult members of it. This pattern of separation from childhood, a discreet period of transition (or liminality) guided by community elders, and subsequent incorporation into the community as adults has been well documented by scholars of initiation ritual (Turner; Van Gennep). In the case of the Somali Bantu, young refugees must find models of identity within their new environment because of the disruption of these traditional rites of passage.

One place where these models can be found is in the media, particularly the consumption of African video dramas, a genre of filmed entertainment that has become increasingly popular throughout the continent and among Africans in diaspora. It is in these media encounters where young girls are often explicitly exposed to a distinct gendered model of adulthood. The viewing of African-made drama, primarily involving family/communal crisis, makes up a significant proportion of their media engagement, and typically occurs within the extended family structure in the public social space of the living room, which allows adults to reinforce traditional female roles.

Video Watching as Cultural Process

Within the Somali Bantu home, the living room is a space dominated by women, the site of much of their labor and entertainment. Consequently, women have considerable authority about the media choices made in that space and are its primary consumers. While the television plays, women and teen girls move about the

room, often simultaneously preparing food and caring for the young children also gathered there. Meanwhile, Somali Bantu men and teen boys move in and out, engaging briefly in the ongoing television entertainment, then quickly moving on to other activities. For many of the boys, this activity often includes backstage media consumption with their male peers: watching and playing videogames in the bedrooms of their agemates, or in the living rooms of those houses where women and children are not present to dominate that space. For the girls, however, media engagement happens primarily in the public living room space, in the company of female elders, and is dominated by the viewing of African-made videos, primarily dramas involving family/communal crisis. Available on videocassette and DVD, the production of these video dramas has escalated in Africa over the last decade, beginning first in Nigeria and moving out into other African countries as the availability of video technology has made it easier for local filmmakers to create and distribute their own works. The cheap production and distribution of videos have also made it easy for increasingly larger numbers of Africans to view and circulate these movies, even in diaspora. John C. McCall notes that while celluloid films were not largely accessible to African audiences, video production has made locally produced videos into an astonishingly familiar form of entertainment because their content reflects contemporary African concerns, they contain familiar aesthetic markers, and they are easily shared in family groups. Not only are the videos popular, he notes, but they have established themselves as a forum for public discourse because they raise larger social issues often overlooked by the more highbrow film industry (McCall 80–82, 85).

This element of public discourse is central to the role of videos in transmitting traditional patterns of gender to young refugees resettling into a world both geographically and culturally distant from that of the African continent. Keyan Tomaselli, Arnold Shepperson, and Maureen Eke note that oral traditions, unlike textual ones, require the formation of identity within communal relations. They argue, "[O]ral traditions rely on the contact between generations for the elaboration of individual subjectivities" (Tomaselli et al. 57). In other words, storytelling events and video watching, particularly in a family context, invite multi-generational discussion on content, which in turn shapes the formation of cultural identity. In this instance, movies serve as an extension of local, oral traditions and provide a necessary tool for illiterate families to illustrate social roles for their dislocated children. Jonathan Haynes has noted that, even in Africa, video viewing has become an emergent part of African cultural processes, "producing specifically shaped public spheres as organs for the evolution of specifically African modernities" (28). Video movies allow African communities to represent modern social problems and provide a forum for discussing them. Among resettled Somali Bantu refugees, this pattern of media consumption is not only an evolving cultural process, it is emerging into a cultural routine, which David F. Lancy describes as

a socially created routine used for raising children and inculcating social values (24). In a more traditional context, games or riddling practices serve as cultural routines, allowing a child to develop cultural identity through play. Among refugees, the routine viewing of video dramas—particularly those set in an imagined traditional past—performs a similar function. Dislocated as they are, with formal structures of child development in disarray, the family viewing of African videos has become an important, easily repeated routine that allows senior women to reinforce cultural identity for younger ones.

Among the Somali Bantu, African films are a staple of entertainment within the home, garnering greater attention than their American counterparts and often played repeatedly within family gatherings. In most of my unscheduled visits to Wedgewood, the housing project where a number of Somali Bantu families live, the more senior women were typically tuned into an assortment of such movies set in a pre-modernist African past, where actors are costumed in traditional dress, sporting furs, beads, and brightly-covered African textiles. In most cases, the movie had been seen repeatedly by both the adults and children in the house, who could repeat dialogue from it verbatim and often talked with me over the noise of the television. As I gained greater familiarity with the community, it became increasingly clear that girls were more likely to participate in family viewing of these movies and could offer some synopses of their stories. By contrast, the teenage boys were rarely seen watching these historical dramas, and typically left the living room space to seek entertainment elsewhere while these films occupied the television and others' attention.

At the Movies

In order to describe the ethnographic experience of these videos within refugee life, I will offer one particular viewing of such a movie within a Somali Bantu family at Wedgewood. I have chosen this specific instance because, on this occasion, the videotape was put on while I was visiting with a wide range of family members, allowing me both to participate in the viewing for an extended period, and also to observe the practices of the family over the course of most of the film. This visit was scheduled during the summer break from school, and when I arrived, I encountered the middle-aged[2] matriarch, Batula, and members of her extensive family gathering to watch a DVD of a 2007 Nigerian movie, *Stronger than Pain*, which won best acting awards for both its male and female lead at the 2008 Africa Movie Academy Awards. In this instance, the family's lower television was turned off while a multi-generational collection of women gathered in the sitting room to watch the film, chat, and care for about a dozen children ranging in age from 1 to 10. For parts of the movie, we were joined by Batula's husband, Ahmed, but never by any boys over the age of 10. Also, Batula and two of her daughters were

engaged throughout the movie in a game of cards, which further caused them to divide their attention between the film and the children surrounding them.

Like many of the films I encountered during home visits, *Stronger than Pain* is set in a rural village sometime in an imagined African traditional past. The male characters wear two pieces of weaved cloth, one wrapped around the waist and another held in place at the shoulder, and the women wear ensembles of cloths dyed with traditional designs and tied onto their bodies to reveal bare midriffs and most of their legs and arms. Members of both genders sport a variety of beads, the men wearing theirs around their necks and the women in their hair and around necks and arms. Both males and females have painted decorations on their arms, and the women also have painted decorations on their faces. Frances Harding notes that characterization in Nigerian movies is often by stereotype, and clothing is typically important for indicating character (82). With its use of traditional cloths, beads, and body paint, the costuming and make-up in this case were designed to evoke a sense of the past. However, its strategic covering of breasts and groins while revealing midriffs and legs displayed the clothing and modesty standards of a more modernized Africa. For the Somali Bantu women viewers, who typically cover themselves from head to foot to conform with Islamic standards of modesty, the fictional village landscape and characters served as a realistic enough reflection of African life for them to connect with the film while, at the same time, it was clearly not representative of their own specific cultural history. Although this is not universally the case with Nigerian videos, this one was in English, a language that most Somali Bantu adult women who do not work outside the home generally struggle to understand. However, most of the women gathered in Batula's living room had seen the movie so many times that they had the dialogue memorized, and seemed to have no difficulty understanding the turns of the plot, despite the language difference and the ongoing card game. In fact, in an effort to verify that I could understand it, Batula's married daughter, Asnina, sat close by me and narrated the English dialogue to me throughout the movie.

The film begins with a married couple, Eringa and Ulonna, asleep in bed. The wife, Eringa, wakes up and eagerly drinks from a gourd only to spit out the contents upon tasting them. She confronts her sleeping husband and learns that he has replaced her palm wine with water because "a good woman" does not drink early in the morning. She responds by telling him he is "such a weakling." This opening pattern between the couple, of Ulonna attempting to train Eringa into socially acceptable womanhood, and her frustration with his lack of masculine strength in the face of the community, is the core issue of the movie, which essentially maps how this transgressive domestic situation, in which the gender roles are skewed, causes escalating problems in the wider social hierarchies of African life. The conflict between Ulonna and Eringa soon ripples outward. We learn from Ulonna's sister that the village does not approve of Eringa's treatment of

him. However, in response, Ulonna confesses that their sexual chemistry together is unlike what he has experienced with other women, and he believes that this is love. His sister, Ure, and her husband, Okolo, question if it is merely weakness. Back at his home, Ulonna and Eringa reconcile and are sexually intimate. In subsequent scenes, his agemates counsel him to find a new wife, reminding him that "warriors [Ulonna's current status in the life cycle] are never scared of their wives." Eringa finds him and scolds him publicly, and at home nothing he does satisfies her. She continues to scold and hit him, then demands that he make love to her. He refuses, asking for respect. She insists that all she is asking for is respect. When she tries to force him to function sexually, he insists that he is not a donkey, and again flees to his family. Later, other women of Eringa's age group come to confront her. They plan to chase her out of the village for being a bad wife, ending the marriage and ostracizing her. But Ulonna stops them, insisting that hurting him is a way of showing affection and that he has no complaint against his wife. His sister and her husband then enlist an unmarried village beauty to try and seduce him away, offering him to her in marriage. Soon, there is another domestic quarrel over the dinner that Ulonna has made, followed by another confrontation between Eringa and her agemates. When Ulonna takes Eringa's side against his sister, Ure tells him to stop coming to her home to cry and hide from his wife. The would-be seductress then makes her move, and Ulonna is caught embracing her. He runs and tries to hide at his sister's, who sends him home. Eringa appears to forgive him, and he tells her that "every man does one foolish thing every day of his life." Once he falls asleep, Eringa brings out a whip and beats him with it. After this altercation, the elders come and tell Ulonna that Eringa must leave the village, or they will drag her into the bush, rape her, and leave her there alone. Ulonna protests, telling them his love is stronger than pain, but Eringa flees to her parents' house outside Ulonna's village.

In the second part, Eringa returns to the village, and she is seen. So the warriors follow her back to her parents' home and beat her unconscious. Ulonna nurses her back to health, and while he is caring for her, the elders come and order Ulonna away from her. He gets a knife and begins a fight, so they leave. At this point, Eringa becomes a loving wife, apologizing to Ulonna and telling him how lucky she is to have him, and he promises to stay by her side. The elders return and threaten him with ostracism for his disobedience to them and for living at his wife's father's house when she has been ostracized by the village. He tells him they cannot disown him because they do not own him in the first place. The elders leave, and Eringa suggests that Ulonna leave her, but he stays. When he appeals to his sister for help caring for Eringa, he is rebuffed. When he returns to Eringa, she gets on her knees and apologizes and says she will stay by him and be a good wife. He sings and cries. When Ulonna appeals to a village elder to allow her to return because of her changed personality, the elder throws him out and Ulonna

insults him. Upon returning to Eringa, she suggests that they stay at her place, but Ulonna wants to be in his father's compound. Eringa then makes him a delicious soup, and they share this meal and are happy. Soon, the warriors from his village come to the compound with elders and knives to destroy the house of her father. Eringa runs away and tries to eat poisoned leaves, but Ulonna stops her. They return to Ulonna's house in the village, and the elders and warriors soon come to kill them. Ulonna confronts them, tying a noose around Eringa's neck and asking for permission to hang her along with himself. They plead with him to marry a good woman, and he reminds them that nobody is perfect, telling them if they can produce a perfect woman to marry, he will kill Eringa and do so. In the meantime, he insists that he loves her. The head warrior soon lays down his stick and leaves, and soon all of the men from the village go. Eringa and Ulonna return to the house, and she immediately begins bullying and insulting him. He laughs very hard and tells her he loves her, but that she has started her nagging too soon. As the film ends, he embraces her, laughing while she scowls.

Despite its melodrama and setting within a romanticized African past, *Stronger than Pain* highlights two important African themes that resonate deeply within the community of refugees living in their dislocated present: gender roles within domestic life, and the hierarchies of authority within the larger community and their control over the individual. This theme is not particular to this film, and according to most synopses offered to me of other African movies, the conflict between the demands of leaders and the problematic love of individuals often leads to violence and despair in these dramas as well.[3] While, on one level, this particular movie consistently demonstrates the importance of male authority over women, community authority over the individual, and elder authority over their juniors, these hierarchies are also continually subverted throughout the story: Eringa bosses Ulonna, their agemates are not able to force them into social conformity, and the elders do not ultimately get their way. In the end, the question of both village and domestic long-term harmony is left unresolved, as Eringa has clearly not changed her ways. The potential for conflict remains.

Themes and the Learning of Gender Roles

Because of its ambiguity, its interplay of traditional authority and the subversion of it, and the way it asserts good and bad gender roles, watching *Stronger than Pain* in this refugee context provides an interesting focus for examining the development of the social imagination within this particular family and its teens, and how the everyday cultural routine of sharing a video aids elders in shaping gender patterns among their young. Harding points out that the watching of videos in family groups allows for a more "African" viewing style, a participatory one in which the viewer argues with and reacts to what happens on screen (83). In short,

it allows for public discourse. As already noted, this film was well known within Batula's family on the day we viewed it. Consequently, family members could divide their attention and frequently listened for the parts of the movie that particularly resonated with them, thereby reinforcing the importance of those plot turns and lines of dialogue by directing my attention toward the television set, repeating the lines among themselves, laughing and nodding in agreement, and instructing the younger members of the audience. At other points in the movie, when attention was less intense, conversation went on over the video's sound, the family patriarch left and returned to the room, and the card game or children garnered greater interest than the drama on screen. Increasingly, what became clear was that the movie had something to teach the adolescent girls about domestic and societal relations, and those points were repeatedly emphasized by elder family members during the shared viewing of the movie.

For the assembled adults, there was no debate about the individual characters of *Stronger than Pain*'s central players. Ulonna was a fool, and Eringa needed correcting or removing from the community. In the early part of the story, family members often shook their heads at the inversion of authority within Ulonna's household, making brief sounds of disagreement when Eringa scolded and chased her husband, and shaking their heads in disagreement when Ulonna attempted to justify her behavior. At this stage in the movie, most of the attention of Batula's family members was on the variety of ongoing household activities. Where attention on the video first became highly concentrated was at the point when Eringa demanded that Ulonna make love to her. Ulonna's response, "I am not your donkey," garnered huge laughs from Ahmed and the women gathered in the living room. Although it was delivered on television as an earnest line of dialogue, within the family this dialogue served as a punchline, and was repeated over and over, earning great laughter both from the women and from Ahmed, the sole male in the room. Ulonna's later protestations of innocence when he was caught embracing the young beauty sent to seduce him also elicited comic laughter from all in the group, and most of the adults repeated his dialogue and jumping movement away from the young woman as if it were slapstick. For the assembled group, there was little acceptance of Ulonna's sincerity in either instance. The married women and adult male in the room expected the leading male to desire sex in every instance, whether with his abusive partner or with a beautiful young temptress. His protestations that he could not or would not perform sexually when invited to do so were simply absurd. The unmarried young women watching the film, while demonstrating considerably less confidence about the matter, looked to the expertise of the surrounding adults and laughed along with their comedic renderings of the dialogue and action.

As the theme of *Stronger than Pain* became clear, and Ulonna and Eringa continued in their transgressive patterns—she as dominant, he as submissive—the

assembled family made it clear that they had little sympathy for either of these characters. Likewise, as the domestic strife spilled outward into the community, moving from Ulonna's kin to the agemates of the married couple and, eventually, to include the elders, the viewers' lack of sympathy turned to contempt. Once the couple onscreen began refusing the authority of the village elders, and as Eringa insulted them, what had been comical became insufferable. The viewers gathered in the living room stopped in their various distractions to shake their heads in righteous anger and make disapproving noises. While initially the pair had been considered foolish, the assembled viewers eventually saw them as deviant and agreed that both Ulonna and Eringa needed to be ostracized. Meanwhile, in the midst of the collective adult reaction to this issue, the young adults in the room responded very little to the actions onscreen. At the point when Eringa and Ulonna have their first confrontation with the village elders, I asked aloud what I should be learning from the film. Asnina, a married daughter of the family in her twenties, answered simply, "Be nice." After a few moments of thought, she explained, "I try to be nice with my husband and everyone I meet." As evidence of Eringa's failings as a wife, Batula pointed out, "She treats him poorly and she cannot cook." Ahadho, another of her married daughters, explained to me, "The woman is not a good woman; they have no children, and she cannot cook," providing even further reasons why the marriage should end, particularly since its strife had now spilled over to the surrounding village. In contrast, 17-year-old Halimo offered only that Ulonna was foolish, an opinion clearly shared by those gathered around her. As an unmarried teenager, she could not judge Eringa as an experienced wife would, but she learned from the women around her that the standard for judging good women is that they observe existing social hierarchies of age and gender, produce children, and cook good food for their husbands.

In an attempt to gather more information, I asked if the kind of disruption caused by Ulonna and Eringa's marriage would happen within their community in Somalia. Asnina responded quickly that it was happening to the villagers on film because "these are not Muslims." Then, after another moment to gather her thoughts in English, she explained further, "I never argue with my husband. I walk away even when he wants to start a fight." What Islam offers that the fictional village did not, in Asnina's opinion, is a fixed hierarchy of men over women, a social organization which maintains peace within the household so that domestic conflict does not escalate and disrupt the larger society. Ironically, Asnina's personal experience is an inversion of the notion that a fixed domestic order maintains social order. The larger societal conflict which erupted in Somalia in the early 1990s has broken down households and separated families. Ladan Affi has noted the toll that the breakdown of the Somali state has had on marriage and family as institutions. Many women, like Asnina, are single-parent heads of household, and even when a marriage remains intact, there tends to be a higher incidence

of marital conflict over resources just as the social systems for mediating marital conflict—extended clan and family systems—have broken down (112–3). In this particular case, Asnina's husband remains in East Africa awaiting the appropriate paperwork to join her in the U.S. Their separation, which has lingered for some four years, has not only left Asnina as the successful head of her own household, but has also caused her to consider divorce so that she can remarry and have more children while she is still young. But within her mother's home, as we consider the imagined African village and the traditional social hierarchy we see on screen, a pattern of social cohesion remains workable in the social imagination, and it begins with the proper respect of a Muslim wife for her husband, it begins with the effort to be nice.

At the same time, raised exclusively in refugee camps and U.S. housing projects in a family splintered by war and dislocation, Halimo seemed considerably less certain of the importance of social hierarchies and the role of a good wife, offering no lessons to be learned from the video. In her work on a legend cycle[4] involving a transgressive woman in Indiana, Janet L. Langlois noted a similar difference in opinion between younger and older community members about the importance of rigid gender roles in the narration of the legend. By questioning the gender of the legend's protagonist (a woman accused of murdering her husbands and children), older members of the community highlighted the necessity for clear sexual distinctions in a well-ordered community. Younger narrators never discussed the gender issue, which Langlois attributed to the decline in symbolic power of men's and women's roles in twentieth century America (117). The rigid social hierarchies underscored by Asnina, were largely absent in the life experience of Halimo.

Once the first part of *Stronger than Pain* ended, and Eringa was run out of the village, gathered family members lost interest in the film, and the women began to prepare for the evening meal, at first talking over the movie, then switching it off before its conclusion. They had shown me the important part of the film, which they had been eager for me to view, this representation of African village life, its patterns, and a struggle to rid itself of an unruly woman. To complete my own picture, I asked Asnina how the film ends, and she reported that Eringa eventually mocks the village elders because they are old, so their sons come and beat her into a coma. In fact, this is not how the story concludes, but Asnina's ending restored order to the fictional village, and was a satisfying one for her. Community harmony is re-established with the destruction of the transgressive woman, and the gathered adult viewers considered that a good outcome. Ironically, the lone dissenting voice to this collective female opinion came from the teenage grandson, 16-year-old Abdikadir, who returned to the house for his dinner and talked with me about the movie, which he, too, had seen before. Abdikadir's opinion on the characters in the film differed significantly from those of his elder family

members. He demonstrated virtually no interest in Eringa, who had been the source of much scorn by the women family members. Instead, Abdikadir focused on Ulonna, whom he considered heroic because of his decision to stand by the woman he loves, regardless of who tempts him to leave her. To teenage Abdikadir, the larger society was in the wrong, and by sticking with his wife, Ulonna showed exceptional strength. For him, the film was a very satisfying romance, providing a modern model of domestic life rather than reinforcing traditional models of social control.

Videos as Cultural Routine

In his work on the proliferation of Bollywood videos in Nigeria prior to the explosion of the home-grown video industry, Brian Larkin points out that many of those films also focus on the problem of marriage, how its traditional role as the bedrock for stable social life often conflicts with its more modern purpose as the union of two individuals who love each other. He notes that the Indian videos are popular in this African context because they often illustrate "the tension of preserving traditional moral values in a time of profound change" (413), and therefore epitomize the conflict traditional cultures have with modernity. This instance of viewing *Stronger than Pain*, admittedly an ambiguous film, demonstrates adults' use of video watching in the home to illustrate traditional patterns of African life to young people who have not experienced those patterns. In the family viewing of this film, there was no ambiguity. The young women who remained in the living room were reminded repeatedly that women and men have distinct roles within family life. Men are authoritative figures who are expected to be routinely potent. Women are subordinate figures who are measured by their acceptance of social hierarchies as well as their ability to cook and reproduce. A disruption to this order results in disruption to the larger social order and should conclude with the removal of the transgressive woman from the local community.

In his discussion on cultural reproduction in an era of dislocation, Appadurai remarks that the "pains of cultural reproduction in a disjunctive global world are, of course, not eased by the effects of mechanical art (or mass media)" because the media provides to young people "counternodes of identity," contrary to parental desires in which new gender politics and violence are included. The difficult task of reproducing "the family-as-microcosm of culture" is often drowned out by the loud background soundtrack playing out the fantasies of the new ethnoscape (45). However, the media consumption of these Somali Bantu families indicates a far more complex and ambiguous relationship between the fantasies of the new ethnoscape and the reproduction of the family as a microcosm of culture. For the girls, the proliferation of African dramas allows them to explore social imaginaries that reinforce their connection to traditional gendered roles, and the viewing

experience is heavily influenced by other adult community members. For the immediate present, their choices are shaped by this social imaginary, and most make progress toward socially sanctioned goals of marriage and the acquisition of their own households and its traditional roles. It remains to be seen, however, how the work of cultural reproduction will continue as they begin to raise a new generation.

Notes

1. This chapter and a corresponding one in *Mediated Boyhoods*, the companion to this collection, were adapted from a chapter on the role of media in modeling gender for Somali Bantu refugees in my dissertation, *Improvised Adolescence*.
2. Age is difficult to verify among members of the Somali Bantu refugee community who were born in southern Somalia because no exact records were kept of time or place of birth. In addition, members of the Somali Bantu community determine age-related status based on life cycle landmarks rather than chronological age. Women who are married are considered adults, regardless of whether they are younger or older than 18. Likewise, grandmothers have status as female elders within the community.
3. In her essay on the "woman-on-top" phenomenon, Davis describes a similar reaction to domineering wives within early modern European communities, noting that the community often publicly and physically punished the transgressive couple in an effort to restore the traditional hierarchy within the home (140).
4. Folklorists distinguish legends from folktales based on the former's core claim that the story refers to something within the historical record, although it may have been embellished in circulation over time. A legend cycle, then, includes as many variants of information as can reasonably be obtained about a particular legendary occurrence or figure.

Works Cited

Abu-Lughod, Lila. "The Interpretation of Culture(s) after Television." *Representations* 59 (1997): 109–34.

Affi, Ladan. "Domestic Conflict in the Diaspora-Somali Women Asylum Seekers and Refugees in Canada." *Somalia—the Untold Story: The War through the Eyes of Somali Women*. Eds. Judith Gardner, Judy El-Bushra and Catholic Institute for International Relations. London: Ciir, 2004. 107–15.

Appadurai, Arjun. *Modernity at Large: Cultural Dimensions of Globalization*. Minneapolis: University of Minnesota Press, 1996.

Besteman, Catherine Lowe. "The Invention of Gosha: Slavery, Colonialism, and Stigma in Somali History." *The Invention of Somalia*. Ed. Ali Jimale Ahmed. Lawrenceville, NJ: Red Sea Press, 1995. 43–62.

————. *Unraveling Somalia: Race, Violence, and the Legacy of Slavery*. Philadelphia: University of Pennsylvania Press, 1999.

Cassanelli, Lee V. "The End of Slavery and The 'Problem' of Farm Labor in Colonial Somalia." *Proceedings of the Third International Congress of Somali Studies*. Ed. Annarita Puglielli. Roma: Pensiero scientifico editore, 1988. 269–82.

Davis, Natalie Zemon. "Women on Top." *Society and Culture in Early Modern France*. Stanford: Stanford University Press, 1975. 124–42.

Grady, Sandra. *Improvised Adolescence: A Study of Identity Formation among Somali Bantu Teenage Refugees*. Diss. University of Pennsylvania, 2010.

Harding, Frances. "Africa and the Moving Image: Television, Film and Video." *Journal of African Cultural Studies* 16.1 (2003): 69–84.

Haynes, Jonathan. "Introduction." *Nigerian Video Films*. Ed. Jonathan Haynes. Rev. and expanded ed. Research in International Studies. Africa Series No. 73. Athens: Ohio University Center for International Studies, 2000. 1–36.

Lancy, David F. *Playing on the Mother-Ground: Cultural Routines for Children's Development*. Culture and Human Development. New York: Guilford Press, 1996.

Langlois, Janet L. "Belle Gunness, the Lady Bluebeard: Narrative Use of a Deviant Woman." *Women's Folklore, Women's Culture*. Ed. R.A. and S.S. Kalcik Jordan. Philadelphia: University of Pennsylvania Press, 1985. 109–24.

Larkin, Brian. "Indian Films and Nigerian Lovers: Media and the Creation of Parallel Modernities." *Africa: Journal of the International African Institute* 67.3 (1997): 406–40.

McCall, John C. "Madness, Money, and Movies: Watching a Nigerian Popular Video with the Guidance of a Native Doctor." *Africa Today* 49.3 (2002): 79–94.

Menkhaus, Kenneth. *Rural Transformation and the Roots of Underdevelopment in Somalia's Lower Jubba Valley*. Diss. University of South Carolina, 1989.

Stronger than Pain. Dir. Tchidi Chikere. Exec. Prods. Gabriel Okey Okonkwo and Peter C. Okonkwo. O. Gabby Innovations, Ltd., 2007.

Tomaselli, Keyan, Arnold Shepperson, and Maureen Eke. "Towards a Theory of Orality in African Cinema." *African Cinema: Postcolonial and Feminist Readings*. Ed. Kenneth W. Harrow. Trenton: Africa World Press, 1999. 45–71.

Turner, Victor Witter. *The Ritual Process, Structure and Anti-Structure*. Lewis Henry Morgan Lectures, 1966. Chicago: Aldine, 1969.

Van Gennep, Arnold. *Rites of Passage*. Trans. Monika B. and Gabrielle L. Caffee Vizedom. 1909. Chicago: University of Chicago Press, 1960.

Van Lehman, Dan and Omar Eno. "Somali Bantu: Their History and Culture." 2002. *The Cultural Orientation Project*. Center for Applied Linguistics, The Cultural Orientation Resource Center. Web. 12 May 2009.

"She was like ___": Re-framing Hip-Hop Identity Politics through Dance and Gesture

Jennifer Woodruff

At the John Avery Boys and Girls Club in Northeast Central Durham, North Carolina, music surrounds the children in many of their activities and social exchanges. Kids participate in informal musical activities, such as listening to the radio and talking about music, and organized activities, like the John Avery Gospel Choir and Step Team. Music marketed as "urban contemporary," known as "hip-hop" more generally, flows through the club: on the speakers that are turned up to full volume once everyone's homework is finished, in the dances that girls and boys practice, and as a reference point for jokes at others' expense. Although girls and boys listen to the same music, know the same dances, and watch the same videos, girls' musical activities dominate the club space. Even though everyone wants to listen to the radio, it is always girls who control the dial. When girls decide that they want to dance in a room by themselves, they can usually kick the boys out without any staff members objecting. For girls at the club, musical activities, such as listening and dancing to music, provide opportunities to socialize with one another, to hone their musical skills, and to learn and share ideas about being female and black.

This chapter comes from a larger project on African American girls' musical practices at the John Avery Boys and Girls Club (commonly referred to as "John Avery" by club members and staff). For eighteen months (from January 2006 through June 2007), I spent every weekday afternoon at the club, and I was a part-time staff member for the club's 2006 summer camp. Any school-age child

can come to the club; all that is required is a $10 per year membership fee. This fee means that the child is a "member" and can come to John Avery every day after school until 6:30 pm, when the club closes. Membership at John Avery mirrors its surrounding area. Ninety-one percent of club members are African American, and seventy-three percent of members live at or below the federal poverty level (Fehskens).[1] The club is located in the city's historic Hayti neighborhood, which was once referred to as the "Capital of the Black Middle Class" by the American black press and was known as one of the most progressive black communities in the country (Franklin; Vann and Jones; Jones). Now the most impoverished area of the city, the local, state, and federal governments are pursuing strategies for economic redevelopment and ending the cycle of drug abuse and gang activity among minors in Northeast Central Durham (Durham Office of Economic and Workforce Development).[2] John Avery's mission to "inspire and enable all youth, particularly those from disadvantaged circumstances" is important to federal and local goals for the area. It is the only recreational facility available within a four-mile radius and serves as many as 150 members at one time. City, state, and federal funding provides programming designed to prevent drug and alcohol abuse, early sexual activity and gang behavior (Fehskens).

John Avery's membership was officially around 300 during my fieldwork, with around 100 kids present at the club on most days. I spent time with thirty to forty girls on a regular basis, all of whom were African American and between kindergarten and seventh grade, and twenty-five of whom had parental consent to be part of my research. My research participants were all from working-class families, and most qualified for free or reduced lunch. My role at John Avery fluctuated throughout my fieldwork. I began as a volunteer. The club's staff knew about my long-term project, but it was three and a half months before I started giving out consent forms and bringing my camera. During that time, I spent my time fluctuating between trying to be the most helpful to the staff and ingratiating myself with girls at the club. I listened to music with girls, helped them with their homework, and sang with them in the club's Gospel Choir. They, in turn, taught me how to dance and told me about the latest songs. My role transitioned to that of staff member in the summer of 2006, when the club needed to fill a sudden vacancy. I spent the rest of the summer as a staff member, and I went from "Jenny" to "Ms. Jenny." The "Ms." stayed after school started back, and I spent the remaining nine months of my fieldwork as somewhere in between staff member, mentor, and older kid. I had some authority, but kids looked to me for entertainment and talked to me about things they didn't discuss with staff members.

No matter what my role at the club was, I usually brought my personal iPod to John Avery to facilitate musical listening. With the exception of the first few days when I initially needed to show everyone how the iPod worked, girls had almost complete control of the iPod and decided which songs to play, how loud to

play them, and for how long. The vast majority of the songs they chose to listen to were from *Billboard*'s Hot R&B/Hip-hop chart. All of the versions were "clean," that is, the versions without profanity and "explicit" lyrics. Dancing was the most notable musical activity at John Avery. Kids danced when their homework was finished, and male and female staff members sometimes joined in when they had the time and the inclination. The repertoire of dances consisted of those popularized in music videos and in viral videos passed along YouTube and other on-line social networks, such as MySpace, Facebook, and Bebo. These dances were part of the fairly small repertoire of songs played on local radio stations and on cable television channels, such as BET and MTV. Even though boys and girls did the same dances, girls' musical performances, as opposed to boys', were closely monitored by staff members and peers for dancing that might be, in the girls' words, "unnecessary," "inappropriate," or "nasty." Girls' dancing was posited, explicitly and implicitly, as a site where adults and other girls make judgments about the kind of parenting a girl has had, her status within her peer group, and even her moral character.[3]

Girls often participated in dance battles, in which two girls would face off against one another in front of other kids, and dancing contests, in which a number of girls would take turns dancing in the center of a group of kids. In this essay, however, I focus on the spontaneous dance and dance-related gesture in conversations and informal listening sessions. On these occasions music launched the stories, jokes, and comments that bounced from person to person. Girls often integrated small fragments of dance into their social interactions, inspired by either the music that played, or by moments in the conversation where it made sense to use a dance move to illustrate a thought. Dance and gesture moved quickly from person to person, shortcuts to past events and shared understandings. The gestures followed such phrases as "s/he be ____," "s/he said ____," or "she was like ____."[4] Throughout this chapter I refer to these occasions as "____" moments, so as to focus on the many possible meanings in each gesture, and less on the gesture's referential quality. Embedded within any one particular "____" could be a number of different references, commentaries, and implications: the sounds, lyrics, and images that were associated with a particular dance, for instance, or a reference to a girl's "inappropriate" dancing or behavior. Girls' use of gestures not only had a referential quality but also had the potential to change the way girls thought of the dances, occasions, and people they referred to.

In this essay I examine "____" moments through multiple iterations of gestures related to one dance, the "walk it out." In particular, I analyze "____" moments in one conversation and one informal listening session. I investigate the way girls use "____" moments to try out unskilled and "inappropriate" dancing without fear of reprobation, while at the same time critiquing that kind of dancing. I will conclude the chapter with a discussion of the different kinds of mean-

ing that can be indexed within one "____" and consider how these moments have a liberating potential for girls. In some ways this essay is an attempt to address cumulative processes of listening, the way girls' listening experiences stay with them when talking and not talking about "music" per se. "____" moments are references to past events, other people, and musical experiences, but part of the "process" of these moments is the way girls incorporate critique and commentary in their references. The commentary and critique in "____" moments are directly related to the intersection of girls' musical experiences and the way they process these musical experiences in their bodies. This chapter argues that "____" moments are interpretations of musical skill, personal character, and social status, all of which are related to girls' musical activities.

"That was just unnecessary when they did that"

The "walk it out" was one of the most popular dances at John Avery during my fieldwork. It was a favorite of both girls and boys, and girls frequently used it in dance battles. The dance goes with the song of the same name by Atlanta-based rapper DJ Unk.[5] The song had continuous radio play almost the entire time of my fieldwork, with kids' interest in the song and dance peaking in late fall of 2006. The dance has a relatively simple movement that can be adapted to any number of other songs. The dancer stands with her feet shoulder-width apart, bends her knees, and turns her ankles in and out, similar to the popular 1960s' dance the "twist." Unlike the twist, the dancer travels forward instead of staying in one place. Although the song features a syncopated bass line, the "walk it out" follows a simple rhythm: The dancer steps on every beat. Like when I learned how to do the "motorcycle," where the dancer's arms imitate revving a motorcycle's engine, girls were very specific in telling me what to do and what *not* to do with the dancing: seventh-grader Shontreal gave micro-critiques on almost every part of my lower body, from the balls of my feet to the direction of my hips. She taught me to pick up my feet and "walk" instead of twisting my feet on the floor. She also taught me to bend my knees, stick my butt out just a little, and keep my hips still while moving forward.

Once I had mastered my lower body (at least to Shontreal's specifications) and felt comfortable walking it out with the kids, girls started telling me that I needed to do something with my arms. *What* exactly I should do with them they never said explicitly. However, the use of the upper body and arms was a big part of personalizing the "walk it out." Most girls used their upper bodies to put their own spin on the dance, and some would move their arms back and forth at their sides or sway their torsos back and forth. Girls often did the "motorcycle," while walking it out, coordinating their upper bodies with the syncopated bass line. Because it lent itself to a number of variations, there was always the potential for

a girl to take the dance "too far," leading to critiques by other girls and staff members. And when girls wanted to talk about others' "too far" dancing, "too far" was usually represented with exaggerated arm and torso movements.

In the video for "Walk It Out," large groups of men and women gather in different spaces and do the dance. In terms of profane lyrics and scantily clad women, the song and the video are relatively tame in comparison with other songs the girls listened to. However, my research participants considered a number of aspects of the women's performance objectionable. The women in the video, as well as those in televised live performances of the song, such as DJ Unk's performance at the 2006 BET Hip-Hop Awards, are dressed in short shorts and midriff-baring t-shirts or bikinis, which most girls considered "nasty." The women also give long, sultry looks to the camera and at times touch each other while dancing, both indicators of "inappropriate" sexuality and desire. However, in terms of their movement, the main thing that differentiates their dancing from that of the girls at John Avery is how the women dance from the waist up. They arch their backs, move their arms back and forth in front of them and over their heads, and swing their heads so their hair whips around their faces. These dancers, even though they have obviously mastered the essential movement of the "walk it out," are seen by most girls at John Avery as examples of how *not* to do the dance.

When I asked girls about the women in the video and the women dancers on live performances such as the Hip-Hop Awards, a few of them told me that the way the women danced was "just unnecessary." This observation came during a conversation about the dance itself, a conversation prompted by my asking when they first learned to walk it out.[6] Fourth-grader Tamika said she first became aware of the dance when she saw someone doing it at the Chris Brown/Ne-Yo concert, which many of the kids had attended a couple of months earlier.[7] Fifth-grader Ashondra agreed, and went on to talk about one girl in particular who walked it out at the concert. From there the conversation turned to the subject of girls and women walking it out in various "unnecessary" ways, and eventually, to the female dancers at the BET Awards. In this conversation, girls used flailing arms and exaggerated torso movements in their "____" moments to describe the kinds of dancing they saw.

Ashondra first answered my question by talking about a girl sitting close to her and her sister at the concert. "I hadn't really known how to walk it out," she said. "But this girl right there, me and my sister were sitting over there and this girl was ____." Ashondra stood up from her chair and quickly shook her arms over her head. "I was like, 'Yeah, you might want to move that way.' Cause she was about to punch me!" she said. "She started doing a split, and a pop at the same time, she was doing some kind of. . . . She was like ____." Ashondra exaggerated her facial expression and again shook her arms over her head.

Sisters Tamyra and Tamika jumped in with their own experience at the concert. "This girl at the concert was challenging us," fourth-grader Tamyra said. "They was challenging us!" Tamika agreed. "So you know my cousin. . . ." The other girls nodded as Tamika trailed off. "She like to dance, both of them!" Tamyra picked up where Tamika left off. "They started doing some _____." Tamyra jumped up out of her chair and did an exaggerated version of the "walk it out," jogging in place and waving her hands over her head. "I didn't want to get my hands dirty, so I didn't get down," Tamyra said, indicating that she didn't feel it was in her best interest to answer the girl's dancing challenge.

"She looked like she was doing Michael Jackson," Tamika said. "It looked like she was on crack, to be honest," she continued. "Like she had no bones!" Tamyra added. "Like the girl off of BET Awards!" Ashondra said. The other girls laughed and nodded. Now Ashondra imitated the dancers who walked it out at the 2006 BET Awards: "And she was like _____." Ashondra moved her torso in circles and arched her back, imitating the way the dancers walked it out in the aisles of the theatre. "Was that necessary?" she asked rhetorically. "For real!" Tamika answered. Ashondra continued. "Cause they just came out into the rows and they was like _____." Now Ashondra shook her arms rapidly over her head. "They didn't have to do that," Tamyra said. "That was just unnecessary when they did that!"

Girls use "_____" to playfully describe the dancing or the behavior (or sometimes both simultaneously) of those outside the circle of participation—girls and women they don't know but about whom judgments can be made. On the surface, "_____" moments in this conversation appear to be purely referential. It is easier for girls to use their bodies to imitate the dancing they saw than it would be for them to describe it with words, and so they use imitative movement in their communications with one another. Yet the similar gestures used by Ashondra, Tamyra and Tamika do more work than mere imitation—they suggest that the girls and women they are describing were, unlike the girls telling the story, completely out of control. Ashondra begins by describing a girl who invaded her personal space during the Ne-Yo concert, suggesting that the other girl's dancing was so wild that Ashondra was almost punched. Tamika and Tamyra describe their cousins' dancing as being unruly enough to cause themselves bodily harm ("I was like, 'don't break it!'"), while being careful to distance themselves from their cousins' dancing ("I didn't want to get my hands dirty, so I didn't get down"). Then Tamyra compares the other girls at the concert to Michael Jackson, referencing both a style of dancing that the girls consider hopelessly passé and a public figure that, for as long as the girls have been alive, was publicly configured as having a questionable sexuality and a freakish pattern of behavior.[8] Tamika elaborates and says, "It looked like she was on crack," implying that one of the girls' bodies appeared to be under the influence of a powerful drug, which also calls into question the girl's moral standards. The gesture Tamika used to refer to the crack-smoking, Michael

Jackson-like dancing makes Jada think of the BET Awards, which had aired a few days earlier. During this performance, a line of women in white t-shirts and short shorts paraded down the aisles of the theatre, walking it out in a similar style to the dancing in the video.

The similar gestures in the girls' uses of "_____" link the real girls they saw dancing at the concert to the televised women they saw on the BET Awards, who in turn resemble the dancers in the "Walk It Out" video. While it's unlikely that the girls at the concert were dancing in exactly the same way as the women at the BET Awards, especially since the BET Awards aired two months after the concert, it is apparent that Tamika, Ashondra, and the other girls in this conversation *thought* about them in the same way. In other words, when communicating to each other the full impact of other girls' dancing, the movements that they *actually* did at the concert aren't nearly as important as the ideas that are embedded in the movement, which Tamika, Tamyra, and Ashondra understand to be the same as or comparable to the ideas embedded in the movements of the BET Awards dancers. In both cases, the girls understand these ideas to be related to the dancers' care of their bodies.

As Kyra Gaunt points out, African American girls use their musical practices as a way of identifying themselves as black, which is a means of connecting with the social world beyond the club—with mothers, grandmothers, staff members, older sisters, the DJ on the radio. Through learning to hear the "beat" of a song, for instance, girls at John Avery trained themselves to recognize key aesthetic components of black music, learning what Gaunt has termed "musical blackness": "black musical identifications through an embodied practice" (3). However, learning to dance involved more than coordinating one's body to the beat. Dancing at John Avery is a local site where lessons about bodily responsibility are concretized through critique from peers and adults. In the eyes of individuals at the club (both adult and child), girls' embodied dance practices tell stories about whether a girl understands what it means to be "appropriate" for her age, race, and gender. Girls were always mindful of the ways in which they might cross the boundaries of propriety through their dancing. Part of learning to dance is learning how *not* to dance.

The "like _____" gestures signal a chain of signifiers related to the girls' and women's dancing. In this case, the girls use arm and torso gestures to demonstrate the women's "unnecessary" dancing, which is not actually limited to the upper body but is directly related to other behavior that the girls would consider to be excessive and "inappropriate": a lack of bodily control; the use of drugs; showing too much skin; and deriving pleasure from dancing with other women. Through the chain of signifiers triggered by "_____," Tamika, Tamyra, and Ashondra question whether the dancers understand the boundaries of personal space and whether they are able to control their bodies. The irony is that the dancers in the video and live performances are fairly virtuosic in the way that they are able to

coordinate their upper and lower bodies with each other and with the music, and their dancing therefore demonstrates a significant measure of bodily discipline and control. For Tamika, Tamyra, and Ashondra, however, this kind of skill is not as important as the skill that comes from disciplining your body to dance in an appropriate way. What the girls see as the "unnecessary" nature of the dancing trumps the skill it takes to dance that way.

It is significant that these stories were told when I asked the group of girls about how and when they learned to walk it out. Implicit in their critiques of the girls at the concert and the women at the BET Awards is the understanding that because Tamika, Ashondra, and the other girls are able to recognize the "unnecessary" movements, they wouldn't dance that way themselves. Girls' use of "_____" as a critique of other girls and women is another way of demonstrating how much they know about the dance. Tamika, Ashondra, and Tamyra use the "_____" gestures to demonstrate to one another that they understand the full meaning of the dancing. Out of control bodies (and possibly by extension, out of control personal characters) are exactly what the girls are supposed to be guarding against as they learn, in part through dancing, to take moral care of their bodies.

In the above conversation, girls used "_____" moments to refer to the dancing of women and girls outside of their social circle. However, "_____" moments are complicated by the complex network of social hierarchies that play out during the course of any given listening session. I use the following extended ethnographic story to illustrate the way in which girls relate to one *another* through "_____" moments. In this session, girls and boys compared versions of the "walk it out," but the focus of everyone's attention was Ashondra and fifth-grader Jada, two of the best dancers in the club. Throughout the session, the other girls looked to Ashondra and Jada for guidance in doing the dance. Ashondra and Jada teased each other and complied with each other's requests to try the dance in certain ways, but they did not feel compelled to listen to the other girls or oblige the less-skilled dancers in their requests for help. This listening session, like most, was playful and occasionally punctuated by bursts of laughter, yet there were still serious attempts by girls, especially unpopular fourth-grader Alana, to learn from the better dancers. Girls both verbalized their requests for help and sought assistance by quietly watching and imitating Jada and Ashondra. As the two expert dancers had fun with each other, the less-expert dancers watched and imitated not only Ashondra's and Jada's movements, but the way Ashondra and Jada had fun with movement through "_____" moments.

Walk It Out Like "_____"

On a Friday afternoon in early fall, Ashondra and Jada (two fifth-graders) walked into the Arts and Crafts Room wearing their backpacks.[9] The iPod was already on,

playing Ciara's "Get Up." A couple of girls danced at the edge of the room, while most everyone else was gathered in the small space between the tables and the desk, next to my iPod and the small speakers that sat on the teacher's desk. When Ashondra heard the music, she stopped short in the doorway and started dancing, making Jada bend over with laughter. The two girls dropped their backpacks and chatted at the edge of the room. "Walk It Out!" someone yelled, a song request directed at Rashawnna, who was in control of the iPod. Ashondra and Jada interrupted their conversation and ran over to the small space by the desk, followed by everyone else in the room.

By now close to twenty girls and a handful of boys were crowded into that small space. Many different conversations bounced back and forth from person to person, but much of the attention (including that of me and my camera) was focused on Ashondra. The request for "Walk It Out" had started a discussion on different ways of doing the dance. Hope (a sixth-grader) turned to Ashondra for assistance in doing the dance. "I be doing the 'poole palace' when you do 'walk it out,'" she said to Ashondra, referring to a similar dance. Ashondra walked it out a couple steps. "And then sometimes they be like ____," Ashondra said, most likely describing female dancers she had seen on television. She moved her arms up next to her face and then over her head while she walked it out.

Once Rashawnna found the song on the iPod, the music started. After the four-beat introduction, Ashondra, Amber (a second-grader), Tamika, and Alana (two fourth-graders) started walking it out on one end of the circle. Everyone sang along with the opening chorus of the song. *"Now walk it out, walk it out, walk it out, walk it out. . . ."* Everyone stood waiting for something to happen. Amber bounced on the balls of her feet with a lollipop in her mouth, waiting for the chorus to begin again. She walked it out for two bars, then stepped to the side to finish her candy. Ashondra picked up where she left off. She walked it out for two bars with a big grin on her face and her head swinging side to side with the beat, then she stopped and tried to get Jada to do it. Jada smiled and waited another couple bars for a downbeat. She walked it out, keeping her gaze focused on the floor in front of her. Her torso moved back and forth while her arms moved in circles at her sides. Meanwhile, on the other side of the circle, Hope watched Jada and started moving her arms in circles at her side in a more awkward version of Jada's dancing.

Alana was watching Jada, too. She looked at the ceiling, in an apparent attempt to focus on the dance. She looked at Ashondra. "It look like this, right?" she asked her. Ashondra looked at her for a second and went back to talking to Jada. "You know Tyree do like this," Ashondra said, imitating the kindergarten boy with her bottom lip stuck out and her arms moving back and forth. Jada laughed. "Do it again, do it again," Alana implored Ashondra, still trying to get Ashondra's version of the dance. But Ashondra was distracted by popular seventh-grader

Shontreal, who walked between Jada and Ashondra and was trying to encourage everyone to spread out. Alana walked it out with her elbows tucked at her sides. Tamika got out of her chair and walked it out a couple of steps, thrashing her arms and throwing her head around. Alana swatted at her, and Tamika sat back down.

"She was like this, she said _____," Ashondra imitated someone who apparently bounced up and down and moved her knees in and out while walking it out. "My cousin, she be doing it like _____," Alana said. She walked it out, throwing her torso forward and back, her braids flying across her face. "Do it again, do it again," she said to Ashondra. Ashondra stood looking at the floor, and everyone watched her as she waited for the downbeat of the second verse. Sierra, a second-grader who had been standing off to the side, jumped in the middle of the circle so that she could see better. Ashondra snapped her fingers on the pickup and walked it out on the downbeat. She moved her ribcage in circles while her arms moved in circles at shoulder level. Alana watched her, and then tried to do the same thing herself. Ashondra glanced at her sideways and smiled. Sierra tried to do what Ashondra was doing as well; she arched her back, stuck out her ribcage and moved it side to side while walking it out. Darnell, a second-grade boy, started to laugh at her, and Sierra promptly pushed him out of her way.

Alana noticed Jada dancing by herself in the cleared carpet space. "Look at Jada! Get it Jada!" she laughed. Jada ignored her. "I don't know how to walk it out," Alana said to no one in particular. "Look, is this how you walk it out?" she asked Ashondra, who watched as Alana walked it out, moving her torso side to side. But before Ashondra could say anything, Tamika jumped up out of her chair and wagged her finger in Alana's face. "Unh-uh, unh-uh," she said. "Shut up," Alana said, pushing Tamika back in her chair. Jada and Ashondra moved to the open space of carpet, away from Alana and everyone else. They traded versions of the dance, making each other laugh. First Jada did her version, moving her torso back and forth and her arms in circles at her side. Then Ashondra walked it out while punching the air in front of her. Jada laughed and started dancing again, this time with a mock-serious face. Then Ashondra walked it out with her feet as far apart as possible. She looked up at the ceiling and then down at the floor, all the while moving her extended arm above her head and in a large circle. The younger girls watched what was going on. Tamika sat in her chair watching, occasionally flailing her arms in response to Ashondra's and Jada's increasingly silly dances. Amber and Sierra responded as well, imitating what they were seeing from the two older girls. Then Alana, in an ill-fated attempt to be a part of Jada's and Ashondra's joking, interrupted everything by jumping in front of Ashondra and Jada, mugging and dancing for the camera. She succeeded in getting everyone's attention, but she killed the momentum of Jada's and Ashondra's dancing, in the process annoying the girls she had hoped to impress.

This story is an example of kids at John Avery hanging out, being silly, and sharing ideas about the song and dance. In these informal gatherings, play is productive, and girls can try out meanings associated with movement and music via their own bodies. Still, every comment and performative gesture among the twenty or so kids coming in and out of the circle was here related to the dance, the movement, or the song. Even when girls were not conspicuously on display for one another, they watched one another closely to pick up dancing skill and the ideas to which the dances related. Ashondra and Jada, considered to be among the best dancers at John Avery and certainly those who danced the most often and with the most confidence, were the center of attention. Girls who didn't usually dance picked up their cues from Ashondra and Jada. Alana was explicit in asking Ashondra to demonstrate the dance, while Tamika, Hope, and Sierra were more surreptitious in closely watching Ashondra and Jada, then trying their moves on their own.

Ashondra imitated other people's versions of the dance. She referenced the way that women and girls who were not present do the dance, using phrases such as "she said ____." The "____" in the "like ____" gestures is the subject of a conversation that moved around the group of girls and boys, a conversation controlled by Ashondra and Jada. Because Ashondra and Jada were the focus of everyone's attention, they were able to determine the meaning of "____" moments. When Ashondra poked gentle fun at Tyree ("You know Tyree do like this"), she was referencing the humor in a kindergarten boy performing a dance that is mostly the province of girls at the club. Some of Ashondra's movements, such as swinging her head side to side, moving her arms overhead, and emphasizing an arched back, index the kinds of dancing done by female dancers in the "Walk It Out" music video, which Ashondra herself described as "nasty." As emphasized above, it is not necessarily the arms and the torso movements that make a dance "nasty," but rather the association of those movements with women's other objectionable behavior in the video. However, unlike the above conversation, where Ashondra used these gestures to emphasize her distance from questionable behavior and dancing, here she and Jada frame these same gestures so that they are humorous instead of objectionable.

When Jada and Ashondra tried to make each other laugh at the end of the song, they were continuing the "like ____" conversation. What started as imitating other dancers became a conversation about what it means when the dance is done in a certain way. Versions of the dance were performed with varying levels of seriousness. Jada's and Ashondra's over-exaggerations at the end of the song were clearly hilarious to everyone watching. Meanings were less clear when Ashondra referenced other women. On the one hand, saying, "Sometimes they be like ____" indicates that Ashondra was differentiating herself from women dancers, and she would never dance that way herself. It is her interpretation of another woman's

version. On the other hand, after saying that at the beginning of the song, she took that gesture (moving her arms next to her face and over her head) and elaborated on it for the rest of the song. Even though she distanced herself from the movement by presenting it as someone else's version, she was clearly having fun doing the movement. She and Jada tried out variations of this initial exaggerated movement throughout the song, culminating in their comedy routine at the end.

The phrases that preceded each "____," such as "she said ____" or "she was like ____" are framing devices that, when followed by "____," signal a kind of reported speech, which Valentin Volosinov defines as "speech within speech and speech about speech" (115). The significance of reported speech is not limited to the words themselves, but can encompass the way the words are said (Fox). To that end, the kinds of gestures girls use determine the way "____" are framed. Richard Bauman and Charles Briggs describe framing as "the meta-communicative management of the recontextualized text" (75). Here what is recontextualized are the girls' referential "____." The movements in each "____" are taken out of their original contexts—from women dancing in a video and girls and boys dancing in the recent past—and placed in the moment for use in Jada and Ashondra's play. Jada and Ashondra, as two of the most popular girls, manage their "____" so that everyone understands when they are joking, when they are making fun of others, and when they are trying out the moves "seriously." At the same time, because they frame their gestures as humorous, Ashondra and Jada are able to try out these questionable moves in their own bodies without reprobation from anyone present. Steven Feld argues that through framing, "one engages and places an item or event in meaningful social space through ongoing interpretive moves . . . meaning is emergent and changeable in relation to the ways the moves are unraveled within situated constraints on the speakers" (14). Jada's and Ashondra's framing is a recognition of the group with whom they are dancing. As two of the most popular girls there, they are able to control the tenor of the dancing conversation and are able to dance without anyone making fun of them. Yet at the same time they recognize that they can only go so far within the boundaries of appropriate dancing at the club.

I am not suggesting that Ashondra and Jada consciously frame their performances so as to be able to try out "nasty" dancing without fear of criticism. Rather, I am suggesting that perhaps part of the reason Jada and Ashondra are so respected as dancers, and are liked by so many other girls, comes from the finesse with which they negotiate styles of dancing which are potential social risks. In their "____" moments, Ashondra and Jada are able to share their expertise about the different ways to do the dance, while at the same time trying the ways out in their own bodies. And because Jada and Ashondra experiment with the movement, other girls do as well. Whereas Jada and Ashondra try out objectionable dancing, the other girls, through imitation, in effect try out what it is like to be

Jada and Ashondra trying out objectionable dancing. The girls learn how to train their bodies to dance like them, while also learning the frames of humorous dancing.

Signifyin(g) on "_____"

Girls' "_____" moments reveal that consumption of popular media is a process that continues even when the music stops playing. The immediate reception of music, in the form of dancing and singing along, is secondary to the processes of girls integrating melody, movement, and gesture into conversation days, weeks, and months later. Here is another argument against assumptions about media users' passive consumption: Girls engage with media at the moment of immediate consumption, but they continue to engage with media beyond the initial point of contact and *change* their engagements based on the actions of their peers and adult mentors. The way they think about their engagements, in the form of dancing and singing, changes based on how they relate to more popular or less popular girls, boys, their aunts and mothers, strangers, and celebrities.

Girls' "_____" moments are multi-layered expressions that draw together many meanings—who is good or bad at a dance, who has the right to make fun of others or teach others how to dance, how the dance relates to people who are not there, including family members and professional dancers. The gestures are a more accurate, embodied, and experiential way of expressing more ambiguous meanings. Here I find Henry Louis Gates, Jr.'s concept of "signifyin(g)" particularly useful. Gates frames his theory by pointing to the Yoruba myth of Esu-Elegbara and the African American myth of the Signifying Monkey. Both are figures whose wit and rhetorical command provide "points of conscious articulation of language traditions aware of themselves as traditions" (xx–xxi). These are trickster figures, whose command over language traditions gives them the rhetorical power to manipulate the meaning of the things to which they are referring. In Gates' theory, when the Signifier (here symbolized by Esu-Elegbara/Signifying Monkey) Signifies, she calls on different layers of meaning while adding her own commentary. Through Signifyin(g), the Signifier can comment on, and sometimes critique, whole traditions of meaning. Scholars of African American music, jazz in particular, have expanded upon Gates' theory, taking it out of the realm of language and using it to theorize the significance of reference and quotation in jazz, for example (Floyd; Monson; Ramsey). In these works, the significance lies not only with musicians referencing other musicians, but also in the fact that those references are part of and comment on a larger tradition, what Gates calls "a discourse about itself" (xxi).

The idea of sly simultaneous referentiality and commentary resonates with the gesture-filled conversations and listening sessions of the girls at John Avery.

When Ashondra said, "She was like ____," she referenced a chain of signifiers, including the video, the dance, the conversations about dancing, and the idea of "unnecessary" black female sexuality. In addition to referencing all of those meanings, "____" are critical maneuvers. They demonstrate not only that girls know the dance and its multiple appearances in popular culture but also that girls recognize that there is a difference between what the dance means when performed by women in a music video and what it means when danced by girls at John Avery. Dancing that is framed as sexy or provocative in a music video is treated as ridiculous by the more discerning girls at the club, because they understand the boundaries of what is appropriate in the context of the club and their positionalities as girls and not women. When they linked the girls at the Ne-Yo concert to the women in the "Walk It Out" video, for example, the John Avery girls issued a critique for taking the dancing in the video too literally. This implies, from their point of view, not only that the girls at the concert earnestly imitated the dancers in the video, but that they also therefore seriously considered the dancers' and the video's claims of black female sexuality. I would argue that the way in which girls subtly comment on women's "excessive" dancing through these dancing conversations they have with one another is also a subtle critique of women's often "excessive" sexuality in hip-hop.

It is easy to imagine how the exaggerated movement done by Ashondra and the other girls might make its way into conversation outside of a musical event. You can imagine Ashondra and Jada talking the next day about someone in school or on the school bus and saying, as they often did, "She was like ____." In the context of their dancing the day before, and the conversations they have had about music videos, television shows, the BET Awards, that gesture has more meaning than simply that the girl was waving her arms over her head. It could mean that this girl was going too far, that she was doing something "unnecessary" in the context of the situation, or that she was trying to be like the background dancers on the BET awards or the music video—or maybe several or all of these things at once. In this way, girls bring their critiques of hip-hop into spaces outside of musical events or listening sessions. For the girls who look up to Ashondra and Jada, they learn what kinds of dancing are acceptable in the environment of John Avery, but they also learn what certain kinds of dancing mean, and how that dancing relates to their relationships with other girls. Knowing how to dance and thus how to be musical, as Gaunt suggests, is crucial to these girls' understandings of themselves as black females. "____" moments come from understandings of how to be musical as a black girl, and are an opening towards embodied communication about ideas and experiences not limited to music. Girls' use of "like ___" gestures is a process of continuous modification of meaning related to women and hip-hop. Like Gates' signifyin(g), girls critique a tradition—in this case dancing to hip-hop—while at the same time continuing to practice it.

Notes

1. John Avery calculates poverty levels based on the number of kids getting free or reduced lunch at school, which is determined by federal poverty guidelines. The 2005 poverty threshold for the 48 contiguous states was $19,350 for a family of four (U.S. Department of Health and Human Services).
2. The area has been designated a "Weed and Seed" population by the U.S. Department of Justice. "Weed and Seed" is a program designed to remove gangs, drug abuse, and violent crime while developing community services and programming. The neighborhood is also the recipient of a $35 million federal grant to replace public housing areas with apartments and houses and a $4.5 million pledge to construct an elite tuition-free charter school for Northeast Central children (Cheng; Hannah-Jones).
3. I explore this topic in depth elsewhere (see Woodruff).
4. Here I use "_____" as a stand-in for physical movement.
5. Since the song and dance have the same name, I use capital letters to refer to the song and lower case letters to refer to the dance. I also follow the kids' practice of using the name of the dance as a verb (i.e., "walking it out").
6. Interview conducted 27 Nov. 2006.
7. The concert took place 3 Sept. 2006.
8. At the time of this conversation, Michael Jackson's musical career had long been overshadowed in the popular press by rumors of multiple plastic surgeries, skin-whitening procedures, and criminal trials related to child pornography and molestation. His death has reinvigorated interest in his prodigious musical output.
9. These events took place 29 Sept. 2006.

Works Cited

Bauman, Richard and Charles Briggs. "Poetics and Performance as Critical Perspectives on Language and Social Life." *Annual Review of Anthropology* 19 (1990): 59–88.

Cheng, Vicki. "Canal Street: What Will Save This Neighborhood?" *News and Observer.* The News & Observer Publishing Company, 20 Jan. 2002. Web. 24 Aug. 2006.

DJ Unk. "Walk It Out." *Beat'n Down Yo Block!* Big Oomp Records, 2006.

Durham Office of Economic and Workforce Development. "Special Opportunity Projects: Northeast Central Durham Initiative." City of Durham, NC, 2006. Web. 24 Aug. 2006. <http://www.ci.durham.nc.us/departments/eed/sop.cfm>

Fehskens, Ted. *Durham County Nonprofit Agency Funding Application.* Durham, NC: John Avery Boys and Girls Club, 2005.

Feld, Steven. "Communication, Music, and Speech About Music." *Yearbook for Traditional Music* 16 (1984): 1–18.

Floyd, Samuel A., Jr. *The Power of Black Music: Interpreting Its History from Africa to the United States*. New York: Oxford University Press, 1995.

Fox, Aaron A. *Real Country: Music and Language in Working Class Culture*. Durham: Duke University Press, 2004.

Franklin, John Hope. *Mirror to America: The Autobiography of John Hope Franklin*. New York: Farrar, Straus and Giroux, 2005.

Gates, Henry Louis, Jr. *The Signifying Monkey: A Theory of Afro-American Literary Criticism*. New York: Oxford University Press, 1988.

Gaunt, Kyra. *The Games Black Girls Play: Learning the Ropes from Double-Dutch to Hip-Hop*. New York: New York University Press, 2006.

Hannah-Jones, Nikole. "Elite School Could Teach Durham's Needy." *News and Observer*. The News & Observer Publishing Company, 21 Feb. 2006. Web. 24 Aug. 2006.

Jones, Dorothy Phelps. *The End of an Era*. Durham, NC: Brown Enterprises, 2001.

Monson, Ingrid. *Saying Something: Jazz Improvisation and Interaction*. Chicago: University of Chicago Press, 1996.

Ramsey, Guthrie. *Race Music: Black Cultures from Bebop to Hip Hop*. Berkeley: University of California Press, 2003.

U.S. Department of Health and Human Services. "Federal Poverty Guidelines." Office of the Assistant Secretary for Planning and Evaluation, 29 Jan. 2010. Web. 10 June 2010. <http://aspe.hhs.gov/poverty/05poverty.shtml>

Vann, Andre D. and Beverly Washington Jones. *Durham's Hayti*. Charleston, SC: Arcadia, 1999.

Volosinov, Valentin N. *Marxism and the Philosophy of Language*. New York: Seminar Press, 1973.

Woodruff, Jennifer. "Learning to Listen, Learning to Be: African-American Girls and Hip-Hop at a Durham, NC Boys and Girls Club." Diss. Duke University, 2009.

Production and Technology

Remixing Educational History: Girls and Their Memory Albums, 1913–1929

Jane Greer

Much joy for thee, Sweet Graduate,
On this eventful day
We would crave earth's choicest treasures
And with flowers strew thy way.
— Elizabeth F. Boynton

This verse appeared on the first page of *A Girl's Commencement: Rosebud Memories*, one of many prefabricated memory albums in which American teenage girls could chronicle their high school years in the early twentieth century. Designed with headings in graceful fonts and lovely illustrations, *A Girl's Commencement, The Girl Graduate, School-Girl Days: A Memory Book, A Girl's Graduation Days*, and other memory albums guided young women through the process of documenting their educational careers, particularly their senior years and their graduation experiences.[1] These memory albums instructed girls to record their class mottos and colors; to solicit autographs from friends and teachers; to catalogue graduation gifts; and to preserve party invitations and dance cards. But the "choicest treasures" that girls snipped, clipped, authored, and arranged were often not what they were directed to preserve. Instead, young women seemed to view these prefabricated scrapbooks as more fluid composing spaces where the verbal and the visual could coexist; where the material artifacts of a culture and their own intangible desires could collide; and where they could resist the erasure of their experiences and compose their own educational histories.[2]

In recent years, scholars have turned to such scrapbooks to study the formation and representation of an individual's identity. Post-structuralist theory has, of course, problematized the notion of an authentic self, but as an arrangement of selected visual, verbal, and tactile artifacts, the scrapbook has been read as an individual's effort to represent her sense of identity. After examining the antebellum scrapbook of a middle-class woman living in Baltimore, Patricia P. Buckler and C. Kay Leeper conclude that the scrapbook uses "language in combination with visual and associative artifacts to represent the personality of its composer or 'encoder.' It actively incorporates scraps of fragments of the maker's external reality into an expression of her individual self" (2). Similarly, Todd S. Gernes' study of print ephemera in eighteenth- and nineteenth-century America has led him to conclude that compiling a scrapbook can be "part of a life-long process of forming an integral self" (126), and Tamar Katriel and Thomas Farrell have more generally deemed the scrapbook a "metonymic assemblage of one's social self" (5). As these scholars acknowledge, connections between self and scrapbook are powerful indeed.

I am interested, though, in reading beyond the autobiographical function of scrapbooks and positioning girls' memory albums within broader, gendered and generational histories of media production. Mary Celeste Kearney has noted that writing (e.g., diaries, letters) has occupied a central place in histories of girls' cultural productions prior to the twentieth century (30–34). The ability to write was not a universal skill among young women: Girls from racial and ethnic minority groups and those with fewer socioeconomic resources were less likely to be print literate. Because, though, writing demanded little physical effort, required no cumbersome tools, and necessitated no departure from the home, it was compatible with traditional notions of genteel femininity. Indeed, young women from the middle and upper classes in the nineteenth century "were thought to demonstrate their potential as housekeepers or mothers by keeping their writing desks in order or by writing without spattering ink on their copybooks or their bodies" (Carr 62).

With the explosive growth in the number of newspapers, periodicals, and other forms of print ephemera in the late nineteenth century, cultural pundits, educators, and parents embraced scrapbooking as another form of cultural production appropriate for young women. Nineteenth-century girls were urged to copy/paste passages from favorite texts and "scraps" produced through chromolithography into blank books or even over the pages of books whose content no longer held any value for their owners. In an 1886 essay in *St. Nicholas*, Margaret Meredith counseled young readers to keep a scrapbook of extracts from their reading, and she explained that her own "snippers" book grew out of a sewing circle where "specially fine poems or passages" were read aloud (537). Like writing, keeping a scrapbook did not seem to challenge normative constructions of femininity. Advocates like Meredith could link scrapbooking with the traditionally

feminine activity of sewing, and Ellen Gruber Garvey has suggested that keeping a scrapbook—repurposing "waste" paper and other artifacts—is aligned with notions of domestic economy and thriftiness (214; 220).

As an increasing number of girls attended high schools and media (e.g., radio, movies, women's magazines) began to address adolescent females as an audience in the early twentieth century, a distinct teenage girls' culture began to emerge (Schrum). Publishers marketed memory albums to guide young women through the process of documenting the educational careers that were newly available to them. Jessica Helfand notes that "[i]f earlier public sentiment had advocated the joy and thrift of making an album on your own, modern views of practicality, organization, and heightened efficiency privileged these newer editions . . . that classified memorable events in advance of their ever happening" (114). Helfand goes on to observe that the commercially produced memory albums "lent a tone of welcome credibility to memory keeping" and created a "practical structure . . . [for] chaotic recollections" (114). Romanticized, nostalgic, and idiosyncratic, personal memories were out of step with the drive toward automation and standardization that was beginning to shape life in the early twentieth century. Memory albums could thus be marketed as "a preprinted (and thus predefined) digest of memory's key classifications" (Helfand 115).

Not surprisingly, though, the first generations of young women who took advantage of widespread opportunities for secondary education seem rarely to have accepted the classifications and preprinted narratives that memory albums offered. Instead, young women viewed memory albums as "the original open-source technology . . . that celebrated visual sampling, culture mixing, and the appropriation and redistribution of existing media" (Helfand xvii). Girls created intriguing juxtapositions by disregarding the organizational headings printed in their memory albums. They arranged collages of snapshots and provided additional layers of meaning with their own original, sometimes enigmatic, captions. And they augmented the sensory impact and two-dimensionality of their visual and verbal displays by preserving flowers, streetcar tokens, crushed drinking cups, candy wrappers, fabric swatches, and other artifacts that could be smelled and touched. Indeed, schoolgirls' memory albums can be read as intriguing media productions that provocatively remix personal and public histories of education.[3]

According to Lawrence Lessig, to remix is to "quote . . . a wide range of 'texts' to produce something new" (69). In his 1987 study of Caribbean music, Dick Hebdige characterizes such citational practices as "an invocation of someone else's voice to help you say what you want to say. In order to e-voke you have to be able to in-voke. And every time the other voice is borrowed in this way, it is turned away slightly from what it was the original author or singer or musician thought they were saying, singing, playing" (14). In other words, the original meanings of words, sounds, images, or artifacts become leveraged in different contexts and

networks of relationships to express new ideas and emotions. For Michel de Certeau, such "procedures of everyday creativity" can allow those typically relegated to the seemingly passive role of consumer to "reappropriate the space organized by techniques of sociocultural production" (xiv).

Remix has become associated with the digital technologies of the twenty-first century. Inexpensive, easy-to-use software makes it possible to edit and recombine images, audio tracks, and video recordings without formal training or pricey equipment. But as Lessig notes, "there's nothing essentially new in remix" (82). The *papier collés* experiments of Georges Braque and Pablo Picasso in the 1910s; the lyrics of Queen Latifah, MC Lyte, Queen Pen, and Missy "Misdemeanor" Elliott and other female hip-hop and rap artists in the 1980s and '90s who sampled and recombined musical tracks to counter the hypermasculinity of male musicians; the research paper a high school student writes by linking together textual passages she has extracted from encyclopedia entries and articles in news magazines; the political poster at a campaign rally that combines images of Martin Luther King, Jr. and Barack Obama—remixing is inevitably part of how Westerners express themselves.

My primary purpose in this chapter then is to take a closer look at how the first generations of American girls to attend modern high schools remixed available cultural materials to create their own educational histories in memory albums. What types of visual and verbal artifacts were at hand? How did they choose and use these artifacts? In what ways did the technology of the scrapbook both enable and constrain their authorial agency? I also wish to suggest that the inclusion of nontraditional media productions, like memory albums and scrapbooks, can enrich narratives of educational history that have focused on girls' writing and ignored other forms of media they produced. More specifically, I will argue that girls' memory albums complicate the notion that the Progressive Era's focus on vocational education transformed young women from "female scholars" into "domesticated citizens," a dichotomy that Karen Graves takes as the title of her study of the St. Louis, Missouri school district between 1870 and 1930. While the common school movement of the nineteenth century focused on developing students' moral and intellectual capacities, the twentieth century brought with it a greater concern for vocational preparation and citizenship training for the nation's youth. Rather than enroll in the "classic" or "general" courses of study that prepared students for college, girls and boys could choose new tracks: commercial or business, which typically included courses in bookkeeping, stenography, and typing; industrial arts, which typically included courses in mechanical drawing, woodworking, and machine shop; and domestic science, which typically included courses in cooking, dressmaking, and housekeeping.[4] Though the number of young women who entered college preparatory tracks declined precipitously between 1900 and 1930, the memory albums I have studied seem to tell a more complex story about

girlhood. The ways that high school girls recorded their own educational experiences suggest they were able to move among the many positions available to them as young women. Resisting easy categorizations such as female scholars or domesticated citizens, girls used their scrapbooks in ways that both "served to legitimate traditional choices and, at the same time, celebrated new visions" (Tucker "Reading" 3). Attuned to the power of words and images, girls remixed the diverse materials available to them and deftly represented the complexities of their educational lives in their memory albums.[5] First, though, let me begin by describing three such albums produced by girls in the early twentieth century.

Girl Graduates and Rosebud Memories

Though a prolific diary-keeper, Dorothy Brown ceased writing journal entries about her life as a schoolgirl in October 1912. To document her senior year at Manual Training High School in Kansas City, Missouri, she turned to *The Girl Graduate*, a memory album designed and illustrated by Louise Perrett and Sarah K. Smith and published by Reilly and Britton.[6] Brown used this album to create a richly textured representation of her educational experiences, and it is nearly bursting with some 125 photographs of Brown and her classmates; newspaper clippings about the accomplishments of fellow students; printed programs from school plays, oratorical contests, and science demonstrations; and some of Brown's own drawings and watercolor sketches. Of the three memory albums discussed here, Brown's *The Girl Graduate* is perhaps the most self-consciously designed and aesthetically compelling. An aspiring artist, Brown was developing a sophisticated visual vocabulary, and the pages of her memory album seem to negotiate between artistic traditions of balance and order and an exuberant sense of the potential for meaning making that was available to young women armed with inexpensive cameras, paste pots, and pens.

Alice Lind took courses in stenography, typing, and bookkeeping and graduated from West Philadelphia High School for Girls' commercial track in 1925.[7] She created a history of her school experiences in *A Girl's Commencement: Rosebud Memories*, which was arranged by Elizabeth F. Boynton, illustrated by J.T. Armbrust, and published by Jordan and Company. Lind's memory album conjures a high school scene rich in extracurricular learning opportunities and social activities. She preserved and arranged membership cards from the school's athletic association, photos of student government officers, artifacts from a school trip to Washington, D.C., newspaper clippings about the school's spring circus, and dozens of autographs from peers. The album creates the impression that Lind's most significant learning experiences occurred well outside her vocationally oriented classrooms and that secondary education was for her an opportunity to become

part of an extensive network of young women who were developing expertise in various areas.

Stella Ralstin was one of nine members of the 1929 graduating class of Mullinville High School in south central Kansas, and like Brown, she used Reilly and Britton's *The Girl Graduate* to record her educational experiences.[8] In a rural school with no distinct curricular tracks, Ralstin's education was different than those of her urban-dwelling peers, and her memory album creates a sense of a more communal learning environment. Rather than dozens of snapshots of different girls, Ralstin's memory albums contains only ten photographs, most of them posed pictures of small groups of students with indistinct faces. Instead of numerous boisterous snapshots, the most striking element in Ralstin's memory album is her abundant handwriting. In longhand script, Ralstin copied into her scrapbook her class prophecy; the valedictorian speech she gave at her commencement ceremony; a series of verses that humorously chronicle the challenges students face in high school; rosters of sports teams; and lists of her classmates, her class schedules, and her teachers. And while Ralstin, like Brown and Lind, pasted numerous newspaper clippings into her scrapbook about the academic achievements of Mullinville students, school-sponsored programs in drama and music, and extracurricular clubs, the same surnames appear repeatedly (Ralstin, Sager, Miller, Hartnett, Kilgore, Allford), indicating that kinship relationships tied together the small student body. Moreover, the newspaper clippings that Ralstin preserved in her memory album suggest that the school was profoundly integrated into the social fabric of the community. Women's organizations hosted luncheons for the senior class, and the academic and athletic triumphs of Mullinville students over students from across the state were lauded not as individual achievements but as community accomplishments.

At times, Ralstin, Lind, and Brown dutifully followed guidelines printed in their albums that directed them to record the mottoes, colors, and flowers chosen by their senior classes, to collect autographs from peers and teachers, to save invitations to social events. The significance of their memory albums emerges, though, not from their compliance but from their creativity. Indeed, they remixed the available visual and verbal artifacts to create their own vibrant educational histories. In the section that follows, I focus on three particular remix strategies—juxtaposition, captioning, and augmentation—that Ralstin, Lind, and Brown deployed to varying effect in their memory albums.

Remix Strategies: Juxtaposition, Captioning, Augmentation

A technique of bringing disparate discourses into proximity with each other, juxtaposition generates narratives of incongruity. The implied contrasts between strategically selected and arranged words, images, and artifacts can reveal the stories

of how groups and individuals of differentiated social status continuously negotiate among divergent social, political, cultural, and economic agendas. Drawing upon the work of Marshall McLuhan and William Burroughs, Jeff Rice theorizes juxtaposition as a technique of the "rhetoric of cool" that he associates with new media. For Rice, print-based, logocentric forms of argumentation that rely on the sequential presentation of inferences may be inadequate in a media-saturated environment where "conflicting information is delivered rapidly and at once" (86). According to Rice, "juxtapositions not only foreground conflict but make finding *one conclusion* to a situation conflicted as well" (86). For the makers of memory albums, juxtaposing photos, drawings, artifacts, autographs, and other materials provided opportunities to represent, though not necessarily resolve, the complexities of their lives.

The opening pages of Stella Ralstin's memory album are a useful example of juxtaposition. The title page of *The Girl Graduate* features a two-color drawing of a serene young lady positioned within a beautiful bower of vines and flowers. Her dress is ruffled; her abundant hair is arranged; and her eyes are averted downward. Susan Tucker observes that such Gibson Girl-inspired images were popular in girls' memory albums. Drawn by Charles Dana Gibson and first appearing in *Life* magazine in 1890, the Gibson Girl was taller and less voluptuous than many representations of nineteenth-century women. With thick tresses and a still ample bust, she became the dominant image of the young American woman between 1895 and the first World War (Banner 154). Tucker posits that the ubiquitous presence of such representations of American girlhood in memory albums responds to a need to link visible markers of femininity with the newly emerging image of the educated girl/woman ("Reading" 7). According to Tucker, prefabricated memory albums "showed young women within a frame that made for sweetness, tidiness, and only the smallest experiment with newfound freedom" ("Reading" 9). A few pages into her memory album, though, Ralstin offers what seems more than a small experiment with freedom. She pasted in a photograph of her senior class—nine young women dressed in overalls. Arms linked together, they smile boldly at the camera.[9] To be sure, overalls were not the usual attire for these rural girls—the photo had been snapped on the day of a school picnic when the girls decided to dress like boys. The contrast, though, between the photo and the Gibson Girl-inspired images printed in *The Girl Graduate* could not be more striking. The tensions generated by the juxtaposition of these disparate images raise provocative questions about representations of the young female body, about the fluidity of gendered identities, and about girls' relationships to the natural world.

The most intriguing example of juxtaposition in Alice Lind's memory album involves President Calvin Coolidge. In October 1924, Lind, four hundred fellow students, and seventeen chaperons made a three-day trip to Washington, D.C. They visited the Capitol, Arlington National Cemetery, Mt. Vernon, and

the White House, where President Coolidge posed for a group photo that was then available for purchase. Lind, though, chose not to include a sedate official photograph in her memory album. Instead, she snapped her own photo of the president, which she arranged alongside candid shots of her classmates. In Lind's memory album, Coolidge appears slightly out of focus but smiling benevolently, and he is surrounded by photos of young women with arms around each other and friends mugging for the camera. Lind visually integrates Coolidge into her circle of high school chums, and the juxtaposition between frolicking teens and the president is startling. Rather than acquiesce to patriarchal traditions and ageist hierarchies that demand a sharp social separation between high school girls and political leaders, Lind's visual remix undermines these boundaries.

In Dorothy Brown's memory album, some of the most powerful juxtapositions are verbal, rather than visual. Brown pasted some thirty newspaper clippings into her scrapbook, positioning public documentation of girls' lives within her personal historical record. Tucker has noted that newspapers at the turn of the century began to boost their coverage of young women's lives as girls became increasingly important participants in the wider media culture and that "[n]ewspapers hired high school girls and college women to report on news from their schools" ("Reading" 11). Dorothy could turn to the *Kansas City Star* and other local newspapers to find notices about classmates like Ruth Zeigler, who won an elocutionary contest and the Herbert Seeger prize for the best essay written in German; about Ruth Borman who won the Walter Armin Kumpft contest for maintaining the highest average in physics class; and about a Latin play in which female students filled twelve of the twenty-five roles. Dorothy preserved all these clippings in *The Girl Graduate*. Such newspaper articles about girls' academic accomplishments were, though, juxtaposed against conventional notices from the society pages, including an account of a party that was hosted by Dorothy's friend, Mildred Davenport, and engagement announcements for classmates who would wed in the weeks after graduation. Though Dorothy and many of her classmates were accomplished female scholars, they were also hostesses and future brides. The presence of so many diverse newspaper clippings suggests that Dorothy was aware of the value of bringing the multidimensional lives of young women into view. By strategically positioning clippings about the scholarly endeavors *and* the social activities of high school girls into proximity, Dorothy's memory album sanctions girls' abilities to excel in various intellectual endeavors, including those associated with masculinity.

In addition to juxtaposition, captioning is another remix strategy that girls used in their memory albums to create layers of meaning. By linking the visual images and artifacts she preserves with words, phrases, and sentences, a girl could emphasize the importance of an item, ironically overturn its apparent meaning, or establish its relationship to other items in the album or to realities beyond the

page. A caption can be a simple explanation, such as Stella Ralstin's notation, "Girls Glee Club, 1925–1926," under a snapshot of eighteen young women in white shirts and dark skirts, or it might be an enigmatic emotional outburst, such as Alice Lind's exclamation, "Where I spent my happiest days!", next to a group photo of young men and women in a park-like setting. As Helfand has suggested, "caption writing introduces the authority of first-person authorship" (ix) and incarnates the maker's voice in the memory album's pages.

An avid amateur photographer, Dorothy Brown filled her copy of *The Girl Graduate* with dozens of snapshots that she captioned. Though the pictures are mostly arranged in neat rows, Brown's captions suggest that the orderly arrangement of the page is not an invitation to construct a tidy interpretation of the lives of the girls who attended her high school. One of the most visually interesting pages in Brown's scrapbook is devoted to photographs of her close friend, Helen Moffat. Underlined and in the upper center of the page is the appellation "*Renowned Elocutionist*," but on the page's right side, Moffat appears in a silent cameo available to the appreciative viewer. Under another photograph, Brown designates her friend, "Bright Eyes Scout of the Shadow Water Camp Fire," and though there is "mischief in her eye," Moffat is also gentle and shy. Brown's chum clearly moved among a variety of social roles, and in her memory album, Brown positioned Moffat as someone who could be an eloquent speaker, a demurely silent young lady, and an outdoor scout. With these nominalizing captions, Brown documents the varied roles that young women could occupy in a Progressive-Era high school.

Brown did not confine her captions to snapshots—she added lengthy captions to her own drawings. A page she entitled "The Last Trials of a Senior" features four images of a young woman in profile who seems to be modeled on the Gibson Girl. The visual logic of the page suggests a reading that begins in the upper left corner where the young woman sits hunched over a large book with dense printing. Her mouth is set in a firm line, and the caption reads, "This picture explains itself. Tragedy!" The next figure in the upper right corner of the page is captioned "Cake-baking," and the figure gestures with a stiff arm toward an empty cake pan, while she holds what appears to be a knife with a bent tip, perhaps suggesting that Brown has found domestic pursuits equally tragic. The smallest depiction of the girl is positioned in the lower left corner of the page—the figure is at a desk with pen in hand and a stack of paper to her right. The caption here explains, "Hundreds of reports and themes." Finally, in the lower right corner is the most fully realized and striking figure. The young woman is now seated at a drawing table with an open inkpot. She is still in profile but with her back slightly to the viewer, and her pen is poised above the half-finished sketch in front on her. This caption reads, "Inspirations in illustrating are elusive." Given the title and other figures on the page, the overt meaning of this caption seems to be that Brown has struggled

Fig. 12.1 Dorothy Brown's sketches of her multifaceted experiences as a high school student in 1912/13. Dorothy Thompson (1896-1994) Papers (0822kc). Used by permission of the Western Historical Manuscript Collection-Kansas City.

in her art classes to find appropriate subjects for her creative energies. The way, though, in which this most elegantly drawn figure has her shoulder turned to the viewer as if to preserve her privacy creates a space for a more coy interpretation. Could Brown be suggesting that the illustrators who have relied on the ubiquitous image of the Gibson Girl and others of her ilk are themselves lacking in inspiration and might do well to expand their representations of the American girl? While the captions in Brown's memory book are verbal commentaries on visual images, Lind's scrapbook reverses this relationship. She provides visual captions for verbal elements in her memory album. Lind filled ten pages in her scrapbook with classmates' autographs. In various inks and with a range of stylistic flourishes, friends, class officers, and teachers added short verses and other sentiments to Alice's album: "I'm sure glad, you can bet, that in our schools we met!"; "Best of luck, ever!"; "May your joys be as deep as the ocean, and your sorrows as light as its foam." Beside many of these autographs, Lind pasted a photo of the writer as a sort of visual caption. While the individual pictures do not create the same immediate sense of authorial voice that Helfand ascribes to verbal captions, the collective impact of so many tightly sutured words and pictures articulates Lind's authorial commitment to embodied memory. By captioning her classmates' autographs with their images, she points toward the inadequacy of recollections derived solely from words, and she insists upon making her classmates' bodies present through photographs of their faces.

Through captions, then, girls' voices seem most explicitly to have entered the memory albums. By commenting on the elements they preserved and arranged, they added layers of meaning to the pages of memory albums. Ironic, emphatic, explanatory, emotional, enigmatic—their captions rely on relationships to carry their messages, and the memory albums composed by Lind, Brown, and Ralstin reveal how girls harnessed this remix strategy to compose complex narratives about their high school experiences.

The final remix strategy that I wish to call attention to in girls' memory albums is what I term augmentation: the inclusion of physical artifacts—pressed flowers, fabric swatches, candy wrappers—that enhance the semantic work of the memory album with their tactile and often olfactory presence. Such *objets trouvé* no doubt served as powerful memory triggers for album-makers, helping to make the past palpable in the present while also adding evidentiary heft to the memory album (Helfand 11–12). In ways not entirely available through words and images, the scent of a dried flower from a prom nosegay or the crinkly texture of a candy wrapper can evoke both the real and the less material components of reality, including emotions and desires.

In Stella Ralstin's scrapbook, physical artifacts seem primarily to augment her sense of her accomplishment and place as a valued member of her community. For example, Ralstin saved the silky, gold-colored tassel from the program of her

induction to her school's honor society. Her album also includes a pink and silver flower fashioned from crepe paper and aluminum foil, which decorated a garden-themed luncheon that a women's club hosted to honor the class of 1929. The presence of such tactile treasures in her memory book no doubt allowed Ralstin to recall more vividly the memories of some of her most triumphant moments as a high school student. Moreover, such tangible artifacts substantiate Ralstin's status as a talented female scholar. With their sensory impact, such mementos from celebratory luncheons and honor societies leave no doubt that Ralstin's community viewed her as accomplished young woman.

The pervasive presence of Ralstin's handwriting in her memory album also augments the felt sense of her record of accomplishment as a high school student. Biting firmly into the sturdy paper of *The Girl Graduate*, Ralstin's pen created insistent ridges and valleys perceptible to even the slightest touch. Moreover, her tidy handwriting testifies to the time she invested in copying her valedictorian speech and recalling each class and teacher from her four years at Mullinville High School.

For Alice Lind, preserving physical artifacts and arranging them in her scrapbook seem to emphasize her social affiliations and the importance of her extracurricular learning experiences. Most of the items she preserved are associated with her class trip to Washington, D.C. Lind saved flowers from Mount Vernon, Arlington National Cemetery, and the White House garden—the scents of herbs and dried hay still waft from the page. She also glued a streetcar token from the trip into her album and, most interestingly, several flattened paper cups signed by classmates. A note next to one of the cups explains: "As I didn't have a book, I was forced to get autographs on drinking cups. These autographs were gotten on the train on the way to Washington, D.C. Some ride!" As with the artifacts that augmented Ralstin's status as a gifted student, Lind's pressed flowers and flattened drinking cups emphasize the importance of her school trip as well as her creative pragmatism. Her decision to preserve so many artifacts from her three days in the nation's capital highlights the importance of the excursion as part of her educational career.

While juxtaposition and captioning are techniques well deployed by twenty-first century girls who compose blogs, manage personal profiles on social-networking sites, create video mash-ups, and avail themselves fully of the rhetorical affordances of digital technologies, augmentation is a remix strategy unavailable through a computer screen. While music and video emanating from a computer can create a dynamic experience of movement and sound, other sensory impressions—touch, taste, and smell—cannot be represented in bits and bytes. Through augmentation, memory albums thus evoke emotions and engage the intellect in unique ways. Carrying their distinctive smells and textures into the covers of a memory album, physical objects, such as dried flowers, program tassels, or crushed cups, could serve as particularly potent prompts to a range of memories for an album's assembler. Such specific memories are unavailable to later readers of

the album, but the physical presence of objects amplifies encounters with the lived experience of an individual far removed in time and space. Describing scrapbooks with their objects and other physical ephemera that produce a range of tactile and sensory perceptions, Helfand suggests that the "scrapbook retains its enduring vitality, eliciting in the reader a kind of emotional response that the simple photo album, bereft of such riches, does not in fact possess" (56).

Fig 12.2 Classmates' autographs collected by Alice Lind on paper cups during her train ride to Washington, D.C. Used by permission of the University of Missouri–Kansas City Libraries, Dr. Kenneth J. LaBudde Department of Special Collections.

The memory albums of Dorothy Brown, Alice Lind, and Stella Ralstin stand then as eloquent testimonials to the creativity of schoolgirls in the early twentieth century. Their cultural output extends beyond traditional forms of writing often associated with girlhood from this period. Combining images, words, and artifacts, girls' memory albums reveal their experimentation with and mastery of

remix strategies more often associated with the digital media of the twenty-first century. Appreciating such media productions from decades past should inform on-going discussions about girls' abilities to express themselves today and to create history. Girls' memory albums can also help to complicate established narratives of girls' educational history.

Remixing Educational History

Karen Graves' meticulous analysis of enrollment records in the St. Louis, Missouri school districts reveals that the number of young women entering the classic or general track in high school declined precipitously between 1900 and 1930.[10] Instead of studying Cicero and chemistry in preparation for college, many girls found themselves debating whether "the virtues of Apple Sauce far surpass those of Banana Oil" in domestic science courses or learning stenography and book-keeping in commercial courses of study (Graves 282). To be sure, running a home and raising a family or working in an office and adapting to ever-changing technologies (e.g., typewriters, adding machines, Dictaphones, duplicating machines) requires a combination of kinesthetic skills and intellectual capacities. As Mike Rose has documented, such hands-on, practical knowledge is no less impressive or important than the academic knowledge students acquire through post-secondary education. Indeed, secondary educational institutions in the early twentieth century were well intentioned in offering young women a differentiated curriculum that prepared large numbers of girls to view their work as wives and mothers as domestic science or to support themselves in "pink collar" jobs. Turning, though, to memory albums and examining how girls constructed their own histories of high school can allow educational historians and scholars in youth studies to look beyond enrollment numbers and the aims of educational policymakers. Memory albums can serve as a site for investigating how young women experienced the educational tracks available to them.

Dorothy Brown was one of the young women who took college preparatory courses, and her scrapbook contains countless references to girls' accomplishments in the academic arena. Brown identifies classmate Nina Upton as "Our Latin Star"; labels Frances Backstrom a "Botanist"; and salutes Esther Poland for excelling in history class. But Brown and her fellow female students in college preparatory classes were not living in a feminist utopia where all options were available to students regardless of their sex. Brown's scrapbook confirms troubling trends that Jane Hunter has recognized in coeducational high schools at the turn of the twentieth century (226–34; 241–59). For example, the elected leadership of the senior class at Manual Training High School in 1913 was dominated by young men, though the majority of the student body was female; Vice President Grace Taylor was the only girl who held a class office. The programs of school

events that Dorothy preserved in her album also suggest that boys claimed the spotlight more often than girls. At an "Oratorical and Declamatory Contest," young men delivered "orations" while young women offered "readings." At a public "Chemistry Program" organized by eight male students, only one young woman participated. She delivered a "talk" on "Low Temperatures," while four boys performed "Experiments with Liquid Air."

Perhaps most disturbingly, the "Class Prophecy" preserved in Dorothy's memory album marginalizes feminist concerns through humor, a particularly potent rhetorical weapon. The prophecy's female author describes a trip around the world in 1925; she finds that during the twelve years since graduation, her classmates have become famous musicians in New York; ranchers on the Western Plains; philosophers in San Francisco; soldiers in the Philippines; and missionaries in China. Dorothy herself has become a poet living in Germany with her friend, Mildred Davenport, who has become an artist. In the prophecy, men and women alike are engaged in various professional endeavors, and the marital and parental status of both men and women is mentioned with equal regularity. But when the globetrotting prophet arrives in Africa, she writes "Here in the wilderness I found Kathleen [S.] trying to pound woman suffrage into the heads of some darkies." Similarly, Alice S. is mayor of a city in New York, but the prophet queries with seeming sarcasm whether men are allowed to vote under her governance. Though young women enrolled in the college preparatory courses at Manual Training High School had many options available to them, certain areas of inquiry (chemistry) and activities (oration) remained male prerogatives, and girls who may have expressed explicitly feminist sentiments seem to have been socially regulated via ridicule. Such disturbing elements in Brown's memory album remind us that even young "female scholars" were not entirely free to make decisions about their futures without accounting for and reproducing the restrictive gender politics of the day.

Alice Lind chose the commercial track at West Philadelphia High School for Girls, and the class schedule she pasted into her scrapbook reveals that she was enrolled in bookkeeping, chorus, English, office practice, physiology, physical training, stenography, and typing. As might be suspected given Alice's enrollment in a vocational track, she makes almost no reference to more traditional academic courses in her scrapbook. No female Latin scholars or botanists appear in her representations of life at West Philadelphia High School for Girls. But neither are there budding stenographers or nascent bookkeepers in Lind's representations of her school experiences. Instead, her album is filled with young women who are tennis players, high jumpers, field hockey goalies, and track stars. A member of her high school athletic association, Alice devoted much of her scrapbook to newspaper clippings of her school's sports teams.[11] Susan K. Cahn has noted that in the early twentieth century, "the female athlete represented the bold and energetic woman, breaking free from Victorian constraints, and tossing

aside old-fashioned ideas about separate spheres for men and women" (7). By the 1920s, the first female sports stars emerged in the mass media. Newspapers, magazines, and radio programs publicized the accomplishments of tennis players Helen Wills and Suzanne Lenglen and swimmers Sybil Bauer and Gertrude Ederle, who swam the English Channel two hours faster than all five men who had previously accomplished the daring feat (Cahn 32). The careers of such women were enabled by the same conditions that created what sports historians have dubbed "the golden age of sports": a restless American populace coping with the increasing bureaucratization and impersonal nature of economic and political life; the commercialization of leisure; new technologies of entertainment; the ascendancy of consumption over production as a social value; and the waning spirit of reform (Cahn 33–34; Dyreson 216–19). Female athletes, along with other women, also benefited from changes in sexual values and the rise of modern forms of courtship. The slim, boyish figure of the flapper emerged as the new sexual icon for women. As the flapper's daring, free spirit was celebrated in popular culture, female athletes found that their male counterparts' hold on public physicality and sports had been broken (Cahn 36).

By pasting verbal and visual artifacts from high school athletics into her scrapbook, Lind aligns herself with the sense of independence, possibility, and physical accomplishment newly available to young women. She included in her scrapbook a description of the battle between the junior and senior classes for the school basketball championship; team photographs and candid shots from a track meet; and a newspaper clipping of an acrobatic dancer. Devoting much of her scrapbook to athletic endeavors allows Lind to celebrate teamwork over individual accomplishment; kinesthetic intelligence over academic aptitude; and the freedom of the outdoors over the confined space of the classroom. Lind's extensive coverage of school sports and her trip to Washington, D.C. combines in her memory album to argue for an understanding of the empowering value of girls' extracurricular learning experiences, even if the classroom curriculum emphasized a division of academic expectations and career goals.

While Brown's copy of *The Girl Graduate* reveals the gender biases encountered by young women taking college preparatory courses and Lind's copy of *A Girl's Commencement* reveals the spaces of freedom available to young women enrolled in commercial tracks, Stella Ralstin's memory album reminds educational historians and scholars in youth studies that the differentiated curriculum did not affect all high school students in the early twentieth century. With a graduating class of nine students in 1929, Mullinville High School was a much more intimate educational environment where students were not tracked into differentiated courses of study. Over the course of their high school years, Ralstin and her classmates studied Algebra, Solid Geometry, Physics, English, American Literature, Civic Science, American Government, Public Speaking, Bookkeeping,

Domestic Science, and Music. In her neat script, Ralstin penned a portrait of her educational career in her memory album—handwritten lists of all her classmates and courses over her entire high school career, a copy of her class prophecy, and a transcription of her commencement address. Moreover, the artifacts that Ralstin preserved reinforce her status within an intimate network of family, friends, and neighbors. From Ralstin's memory album emerges then a portrait of a high school that was a vital part of the rural community it served and where all students were expected to move successfully through a well-rounded general course of study.

Conclusion

This examination of girls' memory albums from the early decades of the twentieth century yields insights into the media production of young women. *The Girl Graduate, A Girl's Commencement*, and other memory books encouraged girls to take up snips and clips from the overabundance of visual and verbal media surrounding them. From autographs to photographs, from daily newspapers to pressed flowers, Dorothy Brown, Alice Lind, and Stella Ralstin remixed the stories of their high school experiences. Though such memory books certainly guided their efforts, these girls also chose at times to disregard the implicit directions of the scrapbook headings; to place various elements in intriguing juxtapositions; to add their own captions as commentaries to direct readers' interpretations of their lives and those of their friends; and to augment the impact of their stories with artifacts that could be touched and smelled. The technology of the early-twentieth-century memory album—its title (e.g., *The Girl Graduate; A Girl's Commencement*); its headings and nearly empty pages; its suggestive illustrations—created a flexible but bounded composing space in which young women could exercise their agency as cultural producers and commemorate their interests, practices, and friends. Examining these memory albums' now brittle yellow pages and the artifacts preserved therein makes clear that girls were capable of revising the templates provided and authoring their own histories of high school, histories that resist any easy simplification of their experiences and aspirations.

To be sure, Brown, Lind, and Ralstin are not representative of all girls who enrolled in college preparatory courses, pursued commercial courses of study, or attended rural high schools, and further research is needed so that the voices of girls attending segregated high schools for African Americans, off-reservation boarding schools for Native Americans, and other types of educational institutions can enrich the conversations about girls' schooling experiences and their media productions.[12] The engaging narratives that Dorothy, Alice, and Stella have to share via their memory albums do begin, though, to disrupt the dichotomy of the female scholar and domesticated citizen explored by Graves. In their memory albums, these three young women document their negotiations between past tra-

ditions and new possibilities available to them in their high schools and through commercial forms of media production.

In addition to enriching existing histories of girls' schooling, these scrapbooks help to challenge our sense of girls' as producers—not just consumers—of media. Through their scrapbooks, Dorothy, Alice and Stella invite us to look closely at alternative forms of media production, including those based on the cooperative, collaborative notion of remix. As they compiled snippets of other published texts, visual images, and artifacts, they brought their own authorial agency to bear through strategies of juxtaposition, captioning, and augmentation. Though now fragile, these memory albums were resilient enough to contain the complexities and contradictions faced by young women who were members of the first generations of American women to graduate from modern high schools, and Dorothy, Alice, and Stella were resourceful enough to find ways to represent the richness of their experiences.

Notes

I would like to thank the superb staff, including Stuart Hinds, Teresa Gipson, and Kelly McEniry, at the Kenneth J. LaBudde Special Collections, Miller Nichols Library, for their assistance with this project and for their enduring commitment to preserving the history of girls' as readers, writers, and producers of texts in a variety of media. Staff members at the Western Historical Manuscript Collection, Kansas City, have also been tremendously generous with their time and expertise.

1. Popular publishers of prefabricated scrapbooks included: Barse and Hopkins; G.W. Dilingham; W.C. Horn; C.R. Gibson; Dodd, Mead; Lippincott; Paul Elder; and others (Helfand 116; "A Scrapbook Timeline").
2. Other scholars who have similarly observed how scrapbookers and keepers of memory albums have both complied with and rebelled against directives about appropriate authorial practices include Tucker, Brunig, Helfand, and Garvey.
3. Capacious and richly textured, schoolgirls' memory albums from the early decades of the twentieth century can be read in a variety of ways: as reflections of the rise of youth culture; as documentation of how Progressive Era girls and women increasingly availed themselves of opportunities beyond the domestic sphere; as particular moments in the popularization of modernist aesthetics and design principles, to name a few possibilities.
4. For more on the rise of vocational education in the twentieth century, see Cremin; Kantor; Kliebard; and Spring. Clifford more particularly describes the opportunities for vocational education available to young women.
5. Though I discuss high school girls and their memory books in this chapter, college women in the early twentieth century similarly used scrapbooks to

represent the complexities they encountered as educated females in a world that still defined a woman's primary vocation as wife and mother. In her survey of eleven student scrapbooks held in the Newcomb College Scrapbook Collection, Brunig notes that the women's college produced scientists, artists, civil rights activists, and teachers as well as housekeepers, debutantes, and carnival queens. The college simultaneously supported its students' career goals and reinforced traditional gender stereotypes, and according to Brunig, "[n]owhere are these inconsistencies more obvious than in the remembrances found in scrapbooks where completed dance cards and pastel drawings of hoop skirts exist alongside notations about academic study, challenges to dormitory rules, and rebellious telegrams" (1).

6. Manual Training High School (MTHS) opened its doors in 1897, and by 1913, the *Nautilus*, the school's yearbook, boasted that the school was the largest high school in Missouri with an enrollment of 1,851students. Dorothy Brown and her classmates could choose from six courses of study: college preparatory, history, science, business, commercial law, mechanic arts, and home economics. The school's 66 teachers offered classes ranging from traditional academic subjects, such as English, math, Latin, civic economics, physics, and elocution, to more vocationally oriented subjects, such as engineering, domestic science, and drawing (*Nautilus* 1913, 14; Manual Training High School Fall Announcement).

7. Like Manual Training High School in Kansas City, the West Philadelphia High School for Girls offered students differentiated courses of study. Forty-five percent of the curriculum was devoted to required classes in English, mathematics, science, social science, art and physical education, and students filled out the rest of the curriculum with electives, including vocational courses, such as stenography, typing, and bookkeeping. In 1925, the senior class at West Philadelphia High School for Girls was comprised of some 400 young women.

8. In a series of newspaper articles, Benjamin O. Weaver documented that the first tax-supported school opened in Mullinville in 1886 with two teachers and 50 students. Classes were held in a two-room schoolhouse from 1887 until 1911, when a larger grade school building was constructed. In 1912, the first high school classes were organized, and in 1925, there were sufficient numbers of students to merit the construction of a high school building separate from the grade school. In the thirty years between 1917 and 1947, Mullinville High School produced a total of 380 graduates, suggesting that Stella Ralstin's graduating class of nine students may have been just slightly smaller than average ("Kansas History . . . in the Press" 218). Ralstin and her classmates took courses in algebra and British and American literature, world history, American government, public speaking, penmanship, physics, music, psychology, physiology, and domestic arts and sciences.

9. Orval Paxton, the tenth member of the Mullinville High School Class of 1929, stands in the photograph on one end of the line of the girls. Though

he participated in senior activities with Ralstin and her classmates, he was completing high school in three years by taking correspondence courses in the summer.

10. Graves' study is consonant with educational trends that were observed across the United States in the first third of the twentieth century. Graves points to the similarities between her findings and David F. Labaree's study of Philadelphia's elite Central High School from 1838 to1939. Labaree notes that in 1894, students pursuing an academic course of study at the all-male institution dominated the student body. By 1920, over sixty percent of the students were enrolled in the newly added vocational programs of study (163).

11. Lind's focus on sports in her scrapbook coincides with trends noticed by Tucker. Only fifteen of the scrapbooks reviewed by Tucker did not contain information about sports, basketball in particular. For Tucker the focus on athletic teams reflects girls' movement away from their biological families to form peer-based communities (11–12).

12. Tucker's "Telling Particular Stories" analyzes the 1920s' scrapbook of Juanita Page Johnson, an African American high school student in Chicago, Illinois.

Works Cited

Banner, Lois W. *American Beauty.* Chicago: University of Chicago Press, 1983.

Brown, Dorothy Allen. Diary. Vol. 2. 18 July 1912–27 Apr. 1914. Kenneth J. LaBudde Special Collections. Miller Nichols Library. University of Missouri, Kansas City.

———. Scrapbook, 1913. *The Girl Graduate* (Designed and illustrated by Louise Perrett and Sarah K. Smith. Chicago: Reilly and Britton, 1910.) Dorothy Thompson Collection (0822KC). Western Historical Manuscript Collection. Kansas City, MO.

Brunig, Jennifer L. *Pages of History: A Study of Newcomb Scrapbooks.* Archival and Bibliographic Series, IV. Eds. Susan Tucker, Victoria Bricker, and Anne Daniell. New Orleans: Newcomb College Center for Research on Women, 1993.

Buckler, Patricia P. and C. Kay Leeper. "An Antebellum Woman's Scrapbook as Autobiographical Composition." *Journal of American Culture* 14 (1991): 1–8.

Cahn, Susan K. *Coming on Strong: Gender and Sexuality in Twentieth-Century Women's Sport.* New York: Free Press, 1994.

Canfield, Dorothy. *What Shall We Do Now?: Over Five Hundred Games and Pastimes.* New enlarged ed. New York: Frederick Stokes, 1922.

Carr, Jean Ferguson. "Nineteenth-Century Girls and Literacy." *Girls and Literacy in America: Historical Perspectives to the Present.* Ed. Jane Greer. Santa Barbara: ABC–CLIO, 2003. 51–78.

Certeau, Michel de. *The Practice of Everyday Life.* Trans. Steven F. Randall. Berkeley: University of California Press, 1984.

Clifford, Geraldine Joncich. "'Marry, Stitch, Die or Do Worse': Educating Women for Work." *Work, Youth, and Schooling: Historical Perspectives on Vocational-*

ism in American Education. Eds. Harvey Kantor and David B. Tyack. Stanford: Stanford University Press, 1982. 223–68

Cremin, Lawrence A. *The Transformation of the School: Progressivism in American Education. 1876–1957.* New York: Knopf, 1961.

Dyreson, Mark. "The Emergence of Consumer Culture and the Transformation of Physical Culture: American Sport in the 1920s." *Sport in America: From Wicked Amusement to National Obsession.* Ed. David K. Wiggins. Champaign: Human Kinetics, 1995. 207–24.

Garvey, Ellen Gruber. "Scissorizing and Scrapbooks: Nineteenth-Century Reading, Remaking, and Recirculating." *New Media, 1740–1915.* Eds. Lisa Gitelman and Geoffrey B. Pingree. Cambridge, MA: MIT Press, 2003. 207–28.

Gernes, Todd S. "Recasting the Culture of Ephemera." *Popular Literacy: Studies in Cultural Practices and Poetics.* Ed. John Trimbur. Pittsburgh: University of Pittsburgh Press, 2001. 107–27.

Graves, Karen. *Girls' Schooling During the Progressive Era: From Female Scholar to Domesticated Citizen.* New York: Garland, 1988.

Hebdige, Dick. *Cut 'n' Mix: Culture, Identity, and Caribbean Music.* London: Methuen, 1987.

Helfand, Jessica. *Scrapbooks: An American History.* New Haven: Yale University Press, 2008.

Hunter, Jane. *How Young Ladies Became Girls: The Victorian Origins of American Girlhood.* New Haven: Yale University Press, 2002.

"Kansas History as Published in the Press." *Kansas Historical Quarterly* 16 (1948): 215–21.

Kantor, Harvey. "Vocationalism in American Education: The Economic and Political Context, 1880–1930." *Work, Youth, Schooling: Historical Perspectives on Vocationalism in American Education.* Eds. Harvey Kantor and David B. Tyack. Stanford: Stanford University Press, 1982. 12–44.

Katriel, Tamar and Thomas B. Farrell. "Scrapbooks as Cultural Texts: An American Art of Memory." *Text and Performance Quarterly* 11 (1991): 1–16.

Kearney, Mary Celeste. *Girls Make Media.* New York: Routledge, 2006.

Kliebard, Herbert M. *Schooled to Work: Vocationalism and the American Curriculum, 1876 to 1946.* New York: Teachers College Press, 1999.

Labaree, David F. *The Making of An American High School: The Credentials Market and the Central High School of Philadelphia, 1838–1939.* New Haven: Yale University Press, 1988.

Lessig, Lawrence. *Remix: Making Art and Commerce Thrive in the Hybrid Economy.* New York: Penguin, 2008.

Lind, Alice. Scrapbook, 1924/25. *A Girl's Commencement.* (Arranged by Elizabeth F. Boynton and Illustrated by J.T. Armburst. Chicago: Jordan and Company, 1916.) Kenneth J. LaBudde Special Collections. Miller Nichols Library. University of Missouri, Kansas City.

Manual Training High School Fall Announcement. 1912–1913. Dorothy Thompson Collection (0822KC). Western Historical Manuscript Collection. Kansas City, MO.

Meredith, Margaret. "Keeping the Cream of One's Reading." *St. Nicholas* 13 (May 1886): 537.

Miller, Stella G. Ralstin. Scrapbook, 1929. *The Girl Graduate*. (Designed and illustrated by Louise Perrett and Sarah K. Smith. Chicago: Reilly and Britton, 1910.) Kansas State Historical Society. Topeka, KS.

Nautilus. Manual Training High School Annual. 1913. Kenneth J. LaBudde Special Collections. Miller Nichols Library. University of Missouri, Kansas City.

Ott, Katherine, Susan Tucker, and Patricia P. Buckler, eds. *The Scrapbook in American Life*. Philadelphia: Temple University Press, 2006.

Rice, Jeff. *The Rhetoric of Cool: Composition Studies and New Media*. Carbondale: Southern Illinois University Press, 2007.

Rose, Mike. *The Mind at Work: Valuing the Intelligence of the American Worker*. New York: Viking, 2004.

"A Scrapbook Timeline." *Tulane.edu*. Tulane University, n.d. Web. 24 Mar. 2009.

Schrum, Kelly. *Some Wore Bobby Sox: The Emergence of Teenage Girls' Culture, 1920–1945*. New York: Palgrave Macmillan, 2004.

Spring, Joel H. *Education and the Rise of the Corporate State*. Boston: Beacon Press, 1972.

Tucker, Susan. "Reading and Re-reading: The Scrapbooks of Girls Growing into Women, 1900–1930." *Defining Print Culture for Youth: The Cultural Work of Children's Literature*. Eds. Anne Lunden and Wayne A. Wiegand. Westport: Libraries Unlimited, 2003. 1–26.

———. "Telling Particular Stories: Two African-American Memory Books." *The Scrapbook in American Life*. Eds. Susan Tucker, Katherine Ott, and Patricia P. Buckler. Philadelphia: University of Temple Press, 2006. 220–34.

Girls Talk Tech: Exploring Singaporean Girls' Perceptions and Uses of Information and Communication Technologies

Sun Sun Lim and Jemima Ooi

Singapore is a highly mediatized society where the government has avidly promoted the adoption of information and communication technologies (ICTs). It has the world's highest broadband Internet penetration rate, at 99.9 percent (W. Tan), and mobile phone subscriptions stand at over 5.9 million (Infocomm Development Authority), exceeding the country's population of 4.6 million (Statistics Singapore). Within Singapore schools, ICT use is incorporated into 30 percent of curriculum time through its use in instruction, online learning portals and interactive educational games (Koh). The vast majority of schools are state-run, coming under the purview of the Ministry of Education, which promotes ICT use in schools by providing network infrastructure, hardware, and curricular support. Math and science are heavily emphasized in Singapore's national curriculum, and female university enrollment in such disciplines as computing and engineering does not lag behind male enrollment as compared to other countries, such as Australia, New Zealand, and the U.S. (Galpin).

To support the growing adoption of information technology (IT) in Singapore's rapidly modernizing economy, the government has sought to incorporate IT training into schools, from primary to tertiary levels. Computing facilities are comprehensive, with the ratio of pupils to computers at 6.6:1 in primary schools and 5:1 for secondary and pre-university schools, respectively (Ministry of Education). Teachers are also encouraged to actively use ICTs as a teaching and learning tool by involving students in more participatory and collaborative media

environments, such as video production, Second Life, blogs, and wikis. While IT is already heavily utilized in Singapore schools, the plan is to further deploy IT through digital textbooks, multimedia field trips, and 3D interactive educational games with simulations (Infocomm Development Authority).

Studies of computer and Internet usage amongst Singaporean youths have found little evidence of a digital access divide, much less one which is drawn along gender lines (Jung, Kim, Lin, and Cheong; Lim and Hang; Tang and Ang). Similarly, there is little evidence of differences in home computer usage amongst Singaporean males and females (Teo "Attitudes"). Indeed, a study assessing computer skills in Japan, South Korea, and Singapore found that of the three countries, Singapore experienced the least gender inequality vis-à-vis computer skills (Ono). Compared to their male counterparts, Singaporean women can type better and are equally experienced in computer usage. Against such a backdrop, how do Singaporean girls perceive ICTs, such as mobile phones, digital cameras, video game consoles, computers and the Internet? To what extent, if at all, are their perceptions of such consumer technologies gendered? Before delving deeper into this issue, this chapter will review extant literature on technology and gender, and the role of media representations in influencing gendered perceptions of technology, paying special attention to studies of magazine content. The chapter continues with an explanation of the research methodology before undertaking a thematic analysis of the findings.

Technology and Gender

Feminist scholars have long argued that technological prowess is too closely intertwined with dominant conceptions of masculinity. As Cynthia Cockburn asserts, "[F]emininity is incompatible with technological competence; [for] to feel technically competent is to feel manly" (12). For males, this association not only deepens entrenched views of technology as an extension of the self (Faulkner) but also regards female involvement in technology use as an emasculatory intrusion, to the point that "women often feel as welcome as a system crash" (Kantrowitz 50). For females, "if technical competence is an integral part of masculine gender identity, why should women be expected to aspire to it?" (Wajcman 22). Yet, as technology becomes a societal mainstay and its adoption is widespread amongst both males and females, many observers in the 2000s increasingly consider gender a peripheral issue in understanding technology trends (Selwyn 526).

Neil Selwyn asserts that this disregard for gender vis-à-vis technology is misplaced because studies of technology use demonstrate the influence of gender on individuals' attitudes towards or engagement with technology. An early study of students' use of pseudonyms in online discussions had found that many female students believed that a male pseudonym lent them greater credibility (Pag-

nucci and Mauriello). Disquietingly, females' personal perceptions of their own computer efficacy levels have also been found to be gender-biased. A survey of Iranian college students' attitudes towards computers found that while women more strongly perceived gender equality in computer-related competencies, paradoxically, they expressed low confidence in their personal ability to work with computers (Shashaani and Khalili). Similarly, a study of undergraduates in the United States found that while there were no significant gender differences in the use of ICTs, females did *not* regard themselves as competent users of digital technology (Madigan, Goodfellow, and Stone). Scholars argue that such gendered attitudes towards technology have negative societal ramifications in the form of low female participation in technical specializations and the consequent production of technological innovations that are not sufficiently empathetic to women's concerns or lifestyles. Indeed, it has been observed that females tend to disparage technology-intensive industries as being low in social engagement (Gannon) and "nerdy" (O'Keefe).

The negative perceptions that females hold of technology have been attributed to the absence of role models as well as to media portrayals (Kirkup; Thomas and Allen). It has been argued that media representations operate as socializing agents, whether intentionally or not, molding reality through the portrayal of oversimplified stereotypes and the simultaneous denial of other narratives through their selectivity (Gannon; Shade; Van Oost). Studies of the developmental experiences of girls contend that media content influences cultural conceptions of what it means to be a girl. These studies have centered on magazines, television programs, movies, and, increasingly, Internet content (Mazzarella, "Introduction"). Given the scope of the present study, extant research on the influence of magazine representations on girls is of particular pertinence. Besides focusing on the influence of magazine representations on girls' weight or body image (Cusumano and Thompson; Utter, Neumark-Sztainer, Wall, and Story), personal hygiene (Merskin; Carrington and Bennett), self-esteem (Durkin and Paxton) and relationships (Mazzarella, "The 'Superbowl of All Dates'"), academic attention has increasingly focused on the influence of magazine representations on girls' perceptions of technology.

Academics investigating this field have noted a reduction in "overtly sexist texts" but maintain that hegemonic discourses remain (Johnson, Rowan, and Lynch 1). It has been noted that while females are granted access to technological products through advertisements, they are paradoxically being forced into stereotypical notions of exaggerated incompetence (Gannon). In this regard, analyses of magazine representations of women's use of ICTs have found some salient commonalities across countries and magazine genres. In a study of home computer magazines published in New Zealand and Australia during 2003 and 2004, Nicola Johnson, Leonie Rowan, and Julianne Lynch concluded that women were predominantly "positioned as incapable and impotent users of computers" (1).

In the same vein, Eva Turner and Fiona Hovenden's British study found that computing advertisements depict female users as passive and construct computers as machines which possess the very skills that women lack. Apart from the prevalence of such biased representations, other studies have found the omission of particular representations to be salient. For example, Nicola Döring and Sandra Pöschl's content analysis of mobile communication systems advertisements in German magazines noted that while females were featured, it was never in the context of technology use. The depiction of girls' computer use was also completely absent from popular teen girl magazines, as observed in Catherine Lang and Toby Hede's study of American teen magazines. Similarly, Mary Celeste Kearney's study of *Sassy*, an American teen girl magazine popular in the 1990s noted the rarity of articles that encouraged girls to embark on careers in cultural production. According to Candace White and Katherine Kinnick, these absences and exclusions communicate subtexts by implying that females do not belong in the technological domain.

Another discernible thread in representations of women's ICT use is the emphasis on particular dimensions of technology and technology use. Notably, women and girls are scripted to be more preoccupied with the appearance rather than the functions of technological products. Susanne Gannon's study of laptop advertisements in Australia detected a distinct absence of technical specifications in advertisements targeted at female audiences, with references to product functionality being couched in aesthetically and emotionally appealing terms. Technology is also depicted as a tool for social engagement and to fulfill social roles. Rachel Campbell's study of North American teen magazines found that technology advertisements promote their products and services as keys to popularity and as integral tools for managing inter-personal relationships. These are just some dominant themes with which technology is framed for girls.

Research Questions

Within the Singapore setting, research on gendered perceptions of technology, such as computers and the Internet, is growing (e.g., Teo "Attitudes"; Teo and Lim "Factors"; Teo and Lim "Gender") but still limited, thus offering opportunities for further sustained investigation. Although an earlier study by Thompson Teo and Vivien Lim ("Gender") found that Singaporean males heavily dominated Internet usage, this gender disparity has since been bridged as a consequence of rapid diffusion of the Internet through the Singapore population. A more recent study by Timothy Teo ("Attitudes") found that post-secondary students' attitudes towards computers varied not by gender but by home computer ownership, attributing the "gender equality" in such attitudes to the increased use of computers in schools. Notably, too, although the study found that gender differences

in computer attitudes were not significant, the mean score for overall computer attitude was higher for males than for females. This study seeks to supplement the predominantly quantitative findings on the subject through a qualitative exploration of Singaporean girls' usage of and attitudes to ICTs and how these may be shaped by media representations. Specifically, it seeks to understand how they use ICTs in their daily lives and how they perceive ICTs. In addition, it also investigates how, if at all, their perceptions of ICTs are gendered, as well as how they perceive gendered media representations of technology.

Methodology

Data for the study were collected through five focus group discussions conducted in July 2009. These discussions were held at meeting rooms in a large local university. During the discussions, participants were asked to share their experiences of their use of ICTs, including but not limited to mobile phones, computers, and game consoles, as well as services such as email, instant messaging, blogging, text messaging, and mobile phone games. Participants were also asked to talk about technological products and services that they aspired to own or use. Finally, they were shown articles and advertisements from teen magazines that relate to ICT devices and services and were asked for their views on these materials. More details about the magazine articles and advertisements are provided in the "Materials" section below.

Participants' Profile

The focus group participants were recruited via an email advertisement that was forwarded to author Ooi's circle of contacts as she is active in youth social outreach activities in Singapore and thus has an extensive network of youth contacts. Recipients of the email were also encouraged to forward it to friends and contacts who met the criteria for the required sample. A quota sampling method was utilized to gather a more representative sample based on the educational level of young female Singaporeans aged between 15–23 years. Discussion groups were conducted for students of three different age categories: two groups of upper secondary students aged 15–16; two groups of junior college/polytechnic students aged 17–18; and one group of university students aged 19–23. Each of the five discussion groups comprised six participants, resulting in a total of 30 participants.

Materials

Apart from the discussion questions, the participants were also presented with a range of visual stimuli, including magazine advertisements and articles that feature technology products and services. In recent years, Singapore has seen a shift from

advertising on traditional platforms, such as television and newspapers, to that of magazines and social media (L. Tan; Audit Bureau of Circulations Singapore). This phenomenon is especially evident among younger audiences. Magazines are increasingly becoming the medium of choice for marketing because they allow advertisers access to a well-defined target audience and are also particularly popular amongst adolescent females (Al-Olayan and Karande; Evans et al.). In light of these trends, this study collected one year's supply of four of Singapore's leading youth-oriented magazines: *Lime, Seventeen, Teenage,* and *teens. Seventeen,* the only published title in the country dedicated to female teens aged 13 years to those in their early 20s, has a circulation of 40,000 per issue and a readership of 62,000 according to the 2008 Nielsen Media Index (Singapore Press Holdings). *teens* and *Teenage,* the next most popular titles amongst female adolescents, enjoyed a circulation of 33,500 and 28,180 per issue, respectively, in 2008 (Audit Bureau of Circulations Singapore). All issues of each magazine published from January to December 2008 were collected, resulting in 48 issues in total. In an effort to understand the aspirational dimensions of ICT ownership amongst focus group participants as well as their familiarity with ICTs as a consumer product, the other visual stimulus employed in the focus groups was a "shopping list," which featured photographs of different technological products of varying brands, prices, and functionalities. The shopping list contained a total of twenty-four products, three each from the following categories: smartphones, portable video game players, video game players, netbooks/mini PCs, laptop computers, MP3 players, mobile phones, and digital cameras. Participants were asked to indicate which three gadgets they would most like to own.

Procedure

Institutional review was sought and granted for this study. Parental consent was obtained for participants aged eighteen and below, and all participants were provided with a Participant Information Sheet that informed them of their rights as participants in this project. To make the discussion setting more comfortable for the young female participants and thereby facilitate discussion, author Ooi conducted the focus group discussions as she is closer in age to the participants than author Lim is. Given Ooi's experience in working with youths in various social outreach activities, she can also relate well to young Singaporean females. All the discussions were conducted in English as it is the dominant language used at work and in schools in Singapore. Hence English was the first language for all participants. Apart from the discussions, the participants were also requested to fill in a brief survey form that solicited information on their demographic profiles and experience with using technology. At the end of each discussion, participants were each given a book voucher as a token of appreciation. The discussions were

audio recorded with each session lasting about two hours and generating, on average, transcripts of at least 100 pages.

Data Analysis

Transcripts were first analyzed using the "meaning condensation" approach (Kvale), where large amounts of interview text were first compressed into brief statements representing the various themes raised during the interviews. Interrelations between the various themes were mapped out manually with pen and paper and reorganized so that some themes were gazetted as meta-themes and others, sub-themes. These themes were then used to classify the text by appending them to the margins of the transcripts. Different portions of text labelled with the same themes were then grouped together using Microsoft Word so that trends and divergences could be noted and analyzed.

Discussion

The findings will be discussed according to the three meta-themes that emerged from our analysis: technology incorporation, gendered attitudes towards technology, and media representations of technology.

Technology Incorporation

The findings suggest that the girls in this study have actively incorporated ICTs into their lives and from a very early age. All of them had been using the computer since they were in primary (elementary) school, and almost all of them have owned personal mobile phones since early secondary (high) school. Without exception, all the girls had access to home computers, if not their own, then one that was shared with parents and siblings. This finding is consistent with the high computer and mobile phone ownership rates in Singapore, as was explained earlier. The three products which participants most often cited as being indispensable were the television, mobile phone, and computer. The girls watched television on an almost daily basis, for entertainment and to keep up with the news. As for the mobile phone, they used it to send text messages, make phone calls, take photos, listen to music, and play games. Their favorite uses of the computer and Internet included instant messaging, email, surfing for information, checking their Facebook and Friendster accounts, and watching online videos. They also used MP3 players to listen to music and to watch movies while commuting or during their downtime. The digital camera was another popular device, frequently used to photograph friends and interesting experiences before posting them onto personal blogs or Facebook accounts, with many participants using the term "camwhoring" to describe this activity. For personal devices such as laptop computers,

mobile phones and MP3 players, the brands which the girls favored included Apple, Canon, Creative, LG, Nokia, Motorola, Panasonic, Samsung, and Sony. In addition, they played computer games on the Internet as well as dedicated game machines, such as the Nintendo Wii and Microsoft XBox.

In light of their active use of technology, participants spoke about technology as autonomous and efficacious adopters, rather than as individuals who merely used devices that had been foisted upon them. Hence, they had clear conceptions of what they demanded of the technology products that they currently used and what they expected of technology that they aspired to own. They were also cognizant of how they wanted these products to support their lifestyles and to meet their information, communication and entertainment needs:

> Marina (15, secondary school student): . . . the iPhone, like I want an all-in-one kind of gadget, so I don't have to carry many things, which is very troublesome. Like on the MRT [subway], you must carry your MP3 player to listen to music. And then if you want to use your phone for something else, you have to take out two gadgets and then when the bus is jerky, you're like, "Oh no!"
> . . .
> Violet (19, junior college student): Everyone loves Wi-Fi. I remember the past few times when I switched (to new) phones my friends would always ask me "Has your phone got Wi-Fi? How many mega-pixels is the camera?" So these features are quite important. It's very convenient to surf the net on your phone because even laptops are quite bulky to carry around as compared to your phone, and at the same time people always like to Bluetooth photos to each other,[1] like after you take so many photos with your handphone camera, obviously you would want to share them.

Participants' knowledge of consumer technology was good, often even extensive, and they were also *au fait* with current technology trends. Their familiarity with technology products was not limited to a mere awareness of the image and cachet of particular brands but also extended to the technical capabilities and specifications of particular products. Notably, when presented with the "shopping list" of technology products, which included only the names and photographs of gadgets, one participant protested emphatically: "You never gave us the specs [technical specifications]! Specs are important!" (Mui Leng, 21, university student). Indeed, participants often spoke with authority on the technology products and were able to comment on the products' functionality, appearance and image amongst their peers, as exemplified by the following quotes:

> Moderator: OK! Besides all the gadgets you've chosen here, what other gadgets are considered must-haves by you and your friends?
> Agnes (15, secondary school student): The iPod Classic.
> Moderator: Is that considered a must-have?

Tricia (15, secondary school student): I think iPod in general. The [iPod] Classic's memory space is so big.

Agnes: iPod Classic is like 120GB! It's really worth it. Like the iPhone is only like 8 GB? 16 GB?

Tricia: Yeah! Actually I wanted the Classic instead of the iTouch 'cause of the (memory) space, but I don't know what I need so much space for. It's just the number! 120! Haha.

Agnes: I would upload movies into it and then I can watch movies on the (subway) train and all. How cool is that?

. . .

Shueh Ling (18, junior college student): [T]he special thing about the Nintendo Wii is the "action thing," right? Like your whole body moves? It's like the newest thing in the market. XBox360 & PS3 have very good graphics but they're still controller games, really like one player RPGs [Role Playing Games]. They're quite boring whereas like the Nintendo Wii, you get to exercise, you can keep fit and you can bond with your family and lose weight, too.

These quotations typify views exchanged across the different focus groups. Participants were never reticent but were often very enthusiastic about discussing different technology products and their affordances. The familiarity and confidence with which these girls spoke of technology products indicated that technology was an essential part of their lives, seen as neither foreign nor extraneous, but which offered them considerable practical, functional, and symbolic advantages.

Apart from the clear functional benefits that technology afforded the participants for information and communication, the findings suggest that the nature and extent of the participants' technology appropriation was also shaped by social norms shared amongst themselves and their peers. Significantly, technology was widely perceived to serve a critical role in facilitating and enhancing social interaction. To this end, the participants utilized a wide variety of products and services, from games machines to digital cameras to social networking sites:

Winnie (15, secondary school student): I find that it's [online gaming] also a way to socialize, like other than shopping or chatting. You can talk in the game and on the game so it's also social. You can also de-stress.

. . .

Stella (18, junior college student): I guess it's the way it works now. Like with everything now, like, Facebook . . . everything, it's easier, so much easier to upload all your photos and it's becoming a part of life . . . it's almost like SMS-ing [Short Message Service, i.e., texting]. As in you just take the photos and then the next day you upload it. So I guess it becomes like a so-called essential. Also it's a function that we need nowadays for social networking.

With the growing salience of such social norms influencing the use of media in social interaction, the girls found it difficult to resist particular types and/or specific uses of technology. Hence, the infusion of Singaporean teen girl culture with

these gadgets and services serves to entrench the position of technology in their daily lives, encouraging and perhaps even compelling adoption and usage.

Gendered Attitudes Towards Technology

As evidenced by the high levels of incorporation of information and communication technologies into the lives of our research participants, Singaporean girls do not regard technology as superfluous or as belonging to the exclusive realm of males. In this regard, the overall level of technology adoption within Singapore and the country's gender parity in this respect contribute to a significant presence of female role models in the technology realm. Given that the participants' mothers were often themselves avid technology adopters, they did not have to look far for these role models. The findings demonstrate that the participants' knowledge of and attitudes towards technology have been shaped by observing friends and family members:

> Moderator: Which product would you most like to have?
> Terry (15, secondary school student): Blackberry Bold . . . 'cause the first time I saw it, I was like really "wow" and still am. Blackberrys are really user-friendly and the emailing functions are very fast. My mom looks very classy when she holds it.
> Moderator: So you want to be like your mom?
> Terry: Haha! Yeah . . .
> . . .
> Aleena (22, university student): I would agree that the Blackberry is very masculine, but then I have quite a few female relatives who use the Blackberry, and they're very high-flying executives.

Participants who perceive gender parity in technology adoption in Singapore appear to be influenced by the overall perception of gender equality in the country.

> Dora (21, university student): In Japan, they have the male chauvinist idea that guys all like engineering and technology stuff, whereas in Singapore, OK, it's true that guys tend to prefer technology stuff as well. But there are a lot of girls here who also like technology stuff. It's because of the society that we've been brought up in. In Japan, girls are meant to be very submissive to men . . . Whereas in Singapore, I don't think girls think that guys are any more superior or more intelligent, and that hence all the technology should belong to them. That's why I think it's more even and split in Singapore.

While they do not feel that technology is the preserve of Singaporean males, a majority of the participants agreed that males tend to be more adept at technology. Notably, they attribute male superiority in technology not to inherent ability but to males' greater exposure to technology—a result of their paucity of interests and

limited avenues for societal endorsement. The following extracts from the discussions with the secondary school and university students, respectively, drew broad agreement from all participants:

> Winnie (15, secondary school student): Guys only have one thing to be interested in. And that's technology. [Everyone laughs.] OK, maybe not, there's sports also, but like they're always into it?
> Jessie (15, secondary school student): Yeah they always seem so intrigued by it they never seem bored . . .
> Moderator: So you guys think the majority of the males are more competent in technology because they are more interested? Are there any other reasons?
> Rosie (15, secondary school student): Like we said before, girls, we have more things to do like shopping. For guys it's more limited, they only have a few things they can do.
> . . .
> Mui Leng (21, university student): I feel it's a social thing. When girls want to fit in, and want to be cool, what do they do? They wear branded clothes; they carry branded bags. But for guys right, what do they do?
> Ling Hwee (22, university student): Technology stuff.
> Mui Leng: Yeah, they carry branded gadgets. So for guys, I feel that there is no other way that they can show they are cool other than having good gadgets and be very technology savvy.

Nonetheless, irrespective of how the participants rationalized the cause of male superiority in all things technological, it is important to note that the majority of participants do believe that males are more technologically adept than females.

Gendered conceptions of technology also manifested themselves in the form of participants' perceptions of which technological products and services were more suitable and appealing for males and which for females. In this case, the participants attribute the gendering of technology to companies' strategies to cater to the needs of different market segments, and the participants also reveal their conventional notions of what is deemed masculine and feminine:

> Moderator: Why do you think Sony Playstation is associated with guys?
> Sherry (19, junior college student): More because of the games.
> Violet (19, junior college student): Most of the games are catered to guys.
> Sherry: Very violent.
> Chai Leng (19, junior college student): Violence and gore.
> Sherry: And all the girls are very sexy and everything, so all the guys would be like "wow."
> Violet: Yeah girls with boobs bigger than their faces. [Everyone laughs.]
> . . .
> Gerry (22, university student): It's also how they market the product and how they design the product. Like I feel Apple is very smart, they do it in a unisex way. If you look at the Blackberry, it feels very masculine . . . maybe the Sony

Playstation also looks quite masculine. But other things, for example we were talking about the Nokia Le Amours phone, it's like it's catered to women. I don't think men would ever get it. Even the design looks so girlish.

These quotes exemplify a common thread running through the discussion groups, where the participants recognize when technological products are gendered by marketers, but do not necessarily resist such tactics. Instead, many participants welcome the feminization of technology, for example, in the form of brightly coloured devices with feminine motifs, or game players, such as the Nintendo Wii, which offer "cute" and non-violent games, like Cooking Mama. An awareness and appreciation for the gender scripting of technology by marketers and product designers (Shade; van Oost) in fact constitute an important facet of consumer discernment, which some of our participants do appear to possess.

Media Representations of Technology

The study also delved into the participants' perceptions of media representations of technology by paying special attention to its appearance in teen magazine content. Unlike Lang and Hede's study of teen girl magazines, which found no depiction of computer use, the four Singaporean magazines which we analyzed each had a special section dedicated to reviews of ICT products and services—*Lime* (Tech), *Seventeen* (Gizmos), *teens* (Tech), and *Teenage* (Tech). The magazines featured a wide range of technological devices in both advertising and editorial content, reflecting the importance of technology in the lives of young Singaporeans.

To understand how gendered media representations of technology are received and perceived by young Singaporean females, we showed our participants advertisements and editorial content from teen magazines which adopted highly feminized approaches to framing and presenting technological products in line with the findings from Gannon. For example, the participants were shown an advertisement of a digital camera that had the tagline "Cute is me," and was illustrated with cartoon sketches depicting a young woman who is checking her appearance, having tea with her friends, thinking of her secret crush, and trying on fashion items which she covets, with the digital camera as her reliable companion in all her exploits. The advertisement drew a mixed response with almost half the participants finding its advertising slant girlish and appealing. However, participants in the remaining half were extremely averse to the crude depiction of females and saw it as reductionist and patronizing, as exemplified by the following quotes:

Sally (15, secondary school student): I don't like the way they portray girls. It's very irritating. [Everyone laughs.] It's like saying they're all so girly and it's just disgusting! . . . it's more like insulting us you know!

. . .

Chai Leng (19, junior college student): Er . . . It's OK, but it looks a bit plastic. It makes girls look very fake. Like all the things they draw here are all very superficial aspects of life, like cosmetics and lingerie and boyfriends, shoes. . .

. . .

Dora (21, university student): I HATE these advertisements because they stereotype females.

At the same time, participants who liked the advertisement felt that it would have no bearing on their decision to buy the product, claiming that they would still base their decisions on the products' specifications, capabilities, and price.

Participants were also shown a review of a Samsung mobile phone, which stated: "The thing which stands out most with this cool phone is the mirrored surface. If you ever need to touch-up your lip gloss, or re-powder your nose, this is the handiest gadget to have around. . . ." The review then went on to pay equal attention to the phone's functions. Participants were also equivocal about this review. While some of them felt that the reference to the phone serving as a mirror was relevant to females, others found the review presumptuous and deficient in not providing more comprehensive technical specifications:

Maria (15, secondary school student): I won't buy it. 'Cause it's [the review] only focusing on it being a mirror! If it's a handphone, it should be talking about the functions itself. Why do they only want to keep emphasizing that it can be a mirror for girls and stuff?

Two other highly feminized representations of technology elicited similarly ambivalent reactions. One advertisement depicted a set of headphones as a "Deliciously sweet" dessert by placing it alongside a fluffy creamcake, pastel-coloured macaroons and strawberries, with no mention of the price or technical specifications whatsoever. Another was a product review which lamented that the pink LG E200 notebook "uses the less powerful Pentium Dual-Core processor" but mollified readers by concluding that the laptop "is so pretty, it's a slight we're willing to overlook." While many participants admitted that as consumers, the form and appearance of technological products were not irrelevant to them, they took issue with representations that assume that aesthetics are the be-all and end-all for technological products that are targeted at females.

Overall the findings suggest that although the target audience of such media representations may consider feminized frames an affront and therefore resist them, it is also likely that some consumers will find them appealing and identify with them. This finding resonates with earlier observations that females have complex relationships with gendered media and marketing representations (Andrews

and Talbot; Carter; Nava) wherein they find themselves negotiating between defying and acquiescing to these dominant discourses.

Conclusion

This study has sought to understand young Singaporean females' perceptions of technology. The findings suggest that the girls have incorporated ICTs into their lives from a very early age and find such gadgets as the computer and mobile phone indispensable. The girls come across as confident and avid users of functional software as well as entertainment and social networking services, and are *au fait* with current technology trends. They also have clear and well-defined notions of which technology products suit their lifestyles and which they are prepared to forego. Notably, while some of them believe that males are more adept at technology, they attribute this male superiority not to their inherent ability but to their having few other interests and diversions. Be that as it may, gendered conceptions of technological prowess persist, with the majority of our participants believing that males *are* more skilled and sophisticated in their technology adoption. This finding resonates with Selywn's assertion that gender has hardly faded from the picture despite the widespread diffusion of technology. Indeed, while our participants maintained a healthy level of circumspection about gendered media representations of technology, and the gendering of technology by developers and marketers, they also seemed all too willing to subscribe to the notions perpetuated by such gendering practices. Despite the fact that adoption of and access to technology in Singapore is broadly gender-neutral, the persistence of such gendered perceptions of technology does not bode well for the future trajectory of technology adoption and innovation in the country. Instead, as Singapore intensifies its efforts to develop into an information-based economy, it is critical that Singaporean females see themselves as being equally empowered and efficacious vis-à-vis the use of information and communication technologies.

Notes

1. The majority of electronic devices sold in Singapore comes equipped with Bluetooth technology, which enables electronic devices to communicate wirelessly with one another, thus enabling users to send audio, visual, or textual information from one device to another instantly.

Works Cited

Al-Olayan, Fahad S. and Kiran Karande. "A Content Analysis of Magazine Advertisements from United States and the Arab World." *Journal of Advertising* 29.3 (2000): 69–82.

Andrews , Margaret R. and Mary M. Talbot, eds. *All the World and Her Husband: Women in Twentieth-Century Consumer Culture.* London: Cassell, 2000.

Audit Bureau of Circulations Singapore. *ABC Audited Publications as of September 2009.* Audit Bureau of Circulations Singapore, 2009. Web. 28 Dec. 2009.

Campbell, Rachel. "Teenage Girls and Cellular Phones: Discourses of Independence, Safety and 'Rebellion.'" *Journal of Youth Studies* 9.2 (2006): 195–212.

Carrington, Kerry and Anna Bennett. "Girl Mags and the Pedagogical Formation of the Girl." *Feminisms and Pedagogies of Everyday Life.* Ed. Luke Carmen. New York: State University of New York, 1996. 147–66.

Carter, Fan. "It's a Girl Thing: Teenage Magazines, Lifestyle and Consumer Culture." *Ordinary Lifestyles: Popular Media, Consumption and Taste.* Eds. David Bell and Joanne Hollows. Berkshire: Open University Press, 2005. 173–86.

Cockburn, Cynthia. *Machinery of Dominance: Women, Men and Technical Know-How.* London: Pluto Press, 1985.

Cusumano, Dale L. and Kevin J. Thompson. "Body Image and Body Shape Ideals in Magazines: Exposure, Awareness, and Internalization." *Sex Roles* 37.9 (1997): 701–21.

Döring, Nicola and Sandra Pöschl. "Images of Men and Women in Mobile Phone Advertisements: A Content Analysis of Advertisements for Mobile Communication Systems in Selected Popular Magazines." *Sex Roles* 55.3–4 (2006): 173–85.

Durkin, Sarah J. and Susan J. Paxton. "Predictors of Vulnerability to Reduced Body Image Satisfaction and Psychological Wellbeing in Response to Exposure to Idealized Female Media Images in Adolescent Girls." *Journal of Psychosomatic Research* 53.5 (2002): 995–1005.

Evans, Ellis D., et al. "Content Analysis of Contemporary Teen Magazines for Adolescent Females." *Youth Society* 23.1 (1991): 99–120.

Faulkner, Wendy. "The Technology Question in Feminism: A View from Feminist Technology Studies." *Women's Studies International Forum* 24.1 (2002): 79–95.

Galpin, Vashti. "Women in Technology Around the World." *SIGCSE Bulletin* 34.2 (2002): 94–100.

Gannon, Susanne. "Laptops and Lipsticks: Feminizing Technology." *Learning, Media and Technology* 32.1 (2007): 53–67.

Infocomm Development Authority. *Annual Survey on Infocomm Usage in Households and by Individuals for 2007.* Infocomm Development Authority, June 2008. Web. 1 July 2008.

Johnson, Nicola F., Leonie Rowan, and Julianne Lynch. (2006). "Constructions of Gender in Computer Magazine Advertisements: Confronting the Literature." *Studies in Media and Information Literacy Education* 6.1 (2006): 1–9.

Jung, Joo-Young, Yong-Chan Kim, Wan-Ying Lin, and Pauline H. Cheong. "The Influence of Social Environment on Internet Connectedness of Adolescents in Seoul, Singapore and Taipei." *New Media and Society* 7.1 (2005): 64–88.

Kantrowitz, Barbara. "Men, Women, and Computers." *Newsweek* 16 May 1994: 48–55.

Kearney, Mary Celeste. "Producing Girls: Rethinking the Study of Female Youth Culture." *Delinquents and Debutantes: Twentieth-Century American Girls' Cultures.* Ed. Sherrie A. Inness. New York: New York University Press, 1998. 285–310.

Kirkup, Gill. "The Social Construction of Computers: Harpsichords or Hammers?" *Inventing Women: Science, Technology, and Gender.* Eds. Gill Kirkup and Laurie S. Keller. London: Open University Press, 1992. 267–81.

Koh, Thiam-Seng. *The Use of ICT in Singapore Schools.* Ministry of Education, 11 Nov. 2007. Web. 28 Oct. 2008.

Kvale, Steinar. *InterViews: An Introduction to Qualitative Research Interviewing.* Thousand Oaks: Sage Publications, 1996.

Lang, Catherine and Toby Hede. "Gender and IT: Do Stereotypes Persist?" *Human Perspectives in the Internet Society: Culture, Psychology and Gender.* Eds. Konrad Morgan, Carlos A. Brebbia, José Sanchez, and Alexander Voiskounsky. Southampton: WIT Press, 2004. 287–96.

Lim, Cher Ping and David Hang. (2003). "An Activity Theory Approach to Research of ICT Integration in Singapore Schools." *Computers & Education* 41 (2003): 49–63.

Madigan, Elinor M., Marianne Goodfellow, and Jeffery A. Stone. *Gender, Perceptions, and Reality: Technological Literacy Among First-Year Students.* 38th SIGCSE Technical Symposium on Computer Science Education, March 2007, Covington, Kentucky. New York: Association for Computing Machinery, 2007. 410–14.

Mazzarella, Sharon R. "Introduction: It's a Girl Wide Web." *Girl Wide Web: Girls, the Internet, and the Negotiation of Identity.* Ed. Sharon R. Mazzarella. New York: Peter Lang, 2005. 1–12.

———. "The 'Superbowl of All Dates': Teenage Girl Magazines and the Commodification of the Perfect Prom." *Growing Up Girls: Popular Culture and the Construction of Identity.* Eds. Sharon R. Mazzarella and Norma O. Pecora. New York: Peter Lang, 1999. 97–112.

Merskin, Debra. "Adolescence, Advertising, and the Ideology of Menstruation." *Sex Roles* 40.11–12 (1999): 941–57.

Ministry of Education. *Masterplan for IT in Education: Computers and Notebooks.* Ministry of Education, 2004. Web. 10 Mar. 2009. <http://www.moe.gov.sg/media/parliamentary-replies/2008/08/financial-assistance-schemes-f.php>

Nava, Mica. *Changing Cultures: Feminism, Youth, and Consumerism.* London: Sage, 1992.

O'Keefe, Brendan. "IT Demand for 'Soft' Skills Rise." *The Australian* 26 Jan. 2005: 24.

Ono, Hiroshi. "Digital Inequality in East Asia: Evidence from Japan, South Korea and Singapore." *Asian Economic Papers* 4.3 (2005): 116–39.

Pagnucci, Gian S. and Nick Mauriello. "The Masquerade: Gender, Identity, and Writing for the Web." *Computers and Composition* 16 (1999): 141–51.

Selwyn, Neil. "Hi-tech = Guy-tech? An Exploration of Undergraduate Students' Gendered Perceptions of Information and Communication Technologies." *Sex Roles* 56 (2007): 525–36.

Shade, Leslie R. "Feminizing the Mobile: Gender Scripting of Mobiles in North America." *Continuum* 21.2 (2007): 179–89.

Shashaani, Lily and Ahmad Khalili. "Gender and Computers: Similarities and Differences in Iranian College Students' Attitudes Toward Computers." *Computers and Education* 37 (2001): 363–75.

Singapore Press Holdings. *Seventeen Singapore*. Singapore Press Holdings, 2009. Web. 28 Dec. 2009.

Statistics Singapore. *Key Annual Indicators*. Statistics Singapore, 2007. Web. 20 May 2008.

Tan, Les. *The Slow Decline of Newspapers and Television*. Red Sports, 30 Oct. 2008. Web. 28 Dec. 2009.

Tan, Weizhen. "Singapore Is Most Wired Nation." *The Straits Times*, 19 Feb. 2009. Web. 19 Feb. 2009.

Tang, Pui See and Peng Hwa Ang. (2002). "The Diffusion of Information Technology in Singapore Schools: A Process Framework." *New Media and Society* 4 (2002): 457–78.

Teo, Thompson S. H. and Vivien K. G. Lim. "Factors Influencing Personal Computer Usage: The Gender Gap." *Women in Management Review* 11 (1996): 18–26.

———. "Gender Differences in Internet Usage and Task Preferences." *Behaviour and Information Technology* 19.4 (2000): 283–95.

Teo, Timothy. "Attitudes Toward Computers: A Study of Post-Secondary Students in Singapore." *Interactive Learning Environments* 14.1 (2006): 17–24.

Thomas, Theda and Alesha Allen. "Gender Differences in Students' Perception of Information Technology as a Career." *Journal of Information Technology Education* 5 (2006): 165–78.

Turner, Eva and Fiona Hovenden. "How Are We Seen? Images of Women in Computing Advertisements." *Women in Computing*. Eds. Rachel Lander and Alison Adam. Wiltshire: Cromwell Press, 1997. 60–71.

Utter, Jennifer, Dianne Neumark-Sztainer, Melanie Wall, and Mary Story. "Reading Magazine Articles About Dieting and Associated Weight Control Behaviors Among Adolescents." *Journal of Adolescent Health* 32.1 (2003): 78–82.

Van Oost, Ellen. "Materialized Gender: How Shavers Configures the Users' Femininity and Masculinity." *How Users Matter: The Co-Construction of Users and Technology*. Eds. Nelly Oudshoorn and Trevor Pinch. Cambridge, MA: MIT Press, 2003. 193–208.

Wajcman, Judy. *Feminism Confronts Technology*. Cambridge, UK: Polity, 1991.

White, Candace and Katherine N. Kinnick. "One Click Forward and Two Clicks Back: Portrayal of Women Using Computers in Television." *Women's Studies in Communication* 23.3 (2000): 392–412.

Surveilling the Girl via the Third and Networked Screen

Leslie Regan Shade

A humorous and irreverent episode from the debut of the popular Showtime television series *Weeds* (2005–current) illustrates well the increasing use of digital technologies to monitor and track the movements of young people in the new millennium, whether covertly or not. Neighbors Nancy and Celia are talking in Nancy's suburban kitchen. Celia is concerned that her teenage daughter Quinn is planning on having sex with Nancy's son, Silas, under Nancy's roof. She asks Nancy to put a pink "teddy cam" in her son's room, so she can surreptitiously video-record her daughter. The two mothers squabble about the ethics of spying on their kids, with Nancy arguing that you need to trust your kids. Quinn and Silas enter the kitchen with take-out pizza and, seeing the bear, Quinn asks if it is the same one that was in their kitchen cupboard. She asks her mother if she can take it home to her bedroom: "I miss that bear." The concluding scene shows Celia hooking up the teddy cam to the television. Unbeknownst to her, the teddy cam has literally been turned on its head, with Quinn having deployed it to spy on her father having sex with his tennis instructor. Then Quinn appears in the footage, flipping her mother off and repeatedly mouthing "Fuck you!!!" to the camera.

The protected child may indeed be an intrinsic facet of middle-class millennium parenting in North America, exacerbated by the sheer intrepidness of many young people's use of digital and mobile technologies for self-expression, communication, and the creation of fluid identities and autonomy outside of parental or

school-based boundaries. That young people are avid users of social network sites (SNS), such as Facebook and MySpace, as well as enthusiastic cell phone users can be troubling for adults who find the literal mobility afforded by these technologies threatening.

This chapter examines the new regime of domestic surveillance with a particular focus on how promotional and media discourse posits the young girl in need of safe technological spaces, using the example of the cell phone and social network sites that utilize GPS or biometric technologies to monitor, control, track, and otherwise contain young people's communicative practices.

A veritable industry has developed to allow parents to surveil their children under the guise of protecting them from peer harassment or influence, sexual predators, or strangers. That the discourse disproportionately focuses on young girls is not surprising. Generations of adults have demonstrated particular concern regarding the influence of new technologies on young women's access to sexual knowledge and their ability to interact with the opposite sex, whether it be fears emanating from the telephone at the beginning of the twentieth century, film in the 1930s, or the popularization of the internet in the mid-1990s (Shade "Contested"; Cassell and Cramer). Girls' studies scholars need to critically assess this public discourse and its gendered dimensions and reconcile the protectionist rhetoric with the reality of the very active roles young girls are assuming as consumers and creators of digital and wireless communication.

Gen Txt

In March 2009 Canada's national newspaper, *The Globe and Mail*, reported that high school students in British Columbia, upon learning that their principal had jammed their cell phone connections while at school, boycotted classes in order to impress upon the administration its illegality under Sections 4 and 9 of Canada's Radiocommunication Act. Said Amber Wright, a Grade 12 student: "We did our research on the internet . . . breaking the law is not a good way to send a message" (Moneo). The principal argued that he was "looking for a solution to a problem"—that of excess use of digital technologies, including iPods and phones, in the classroom, and concerns by teachers over texting and potential cheating on tests. Wright, who has had a cell phone since she was 14, retorted, "It's our right to have them."

Are these young people entitled, spoiled, or within their legal rights to possess a cell phone on their body at all times, with the caveat that they understand and respect the appropriate etiquette while on school property? Blog responses to the *Globe* article highlighted the generational divide, with posters either condemning or commending the students for their pluckiness in identifying an illegal activity and taking action. This incident highlights how unassuming and axiomatic cell

phones have become for middle-class young people in North America in their everyday lives. IDC, a technology research firm in Massachusetts, projects that 31 million new young users will join the mobile market from 2005 to 2010 (Carvajal). They further report that "revenue from [cell] services and products sold to young consumers or their parents is expected to grow to $29 billion in 2010, up from $21 billion in 2005" (Holson, "Text"). Tracy Kennedy, Aaron Smith, Amy Tracy Wells, and Barry Wellman in examining cell phones and Internet in the U.S. household describe their use as "family technologies," citing an increased use by married families with children compared to couples without children or single-person households. Connected lives epitomize the family today: "89% of married-with-children households own multiple cell phones, and nearly half (47%) own three or more mobile devices. Children in these households are somewhat less likely to own a cell phone than they are to go online: 57% of these children (aged 7–17) have their own cell phone" (Kennedy et al. 29).

Much research has focused on the use of cell phones by young people for establishing and maintaining connections within peer circles and their family (Ling; Stald). The cell phone enables constant connectedness via texting and chatting, and has become an intrinsic facet in youth's everyday lives: its functionality fuses with identity formation and friendship safeguarding. Social network sites (SNS) are also a heady locus for youth participation and a tangible and popular way for youth to establish and play with their identity. The "articulated social network of these systems" (Ellison et al. 6) that facilely renders digital representation and contacts with a network of friends and social relationships possible has made SNS a pervasive facet of young people's lives. SNS provide a tangible space for the creation of what the MacArthur Foundation Digital Youth Research Project refers to as networked publics: "a space of relative autonomy for youth, a space where they can engage in learning and reputation building in contexts of peer-based reciprocity, largely outside of the purview of teachers, parents, and other adults who have authority over them" (Ito et al.). The Pew Internet and American Life Project estimates that 75% of young adults aged 18–24 use SNS (Lenhart) and 70% of teens use SNS (Rainie). Updating profiles, posting personal and social information, uploading and distributing creative content, facilitating social connections, and often mobilizing for community events or political activism, are just some of the many uses youth deploy on and with SNS.

The integration of SNS and cell phones is the latest trend, with MySpace collaborating with Nokia and Palm to integrate faster uploading of digital photos and content onto SNS platforms, and other cell manufacturers and SNS sites developing products to allow for easier data capture-and-share possibilities (Prodhan). Such convergence is a potentially lucrative market, especially for the hearts and pocketbooks of youth, who have (unjustifiably or not) been rejoiced by some media pundits as pioneering content creators, activists and digital deni-

zens (Tapscott). As Lev Manovitch cautions, however, basic questions surrounding the political economy of the consumer electronics industry and the SNS firms (entrenched as they are in larger structures of media power and concentration) with their inherent goal of revenue accrual through various marketing schemes and third-party advertising need to be critically addressed before we can blithely celebrate young people's ostensible agency and autonomy in using such technologies (321).

"The Internet Has Punctured That Sense of Safety": The Continuing Discourse of Prevention and Safety Online

In a PBS Frontline production entitled *Growing Up Online* that aired in 2008, a suburban mother expressed trepidation about the security and safety of her daughters online: "I have two very attractive daughters," she said, and "the Internet has punctured that sense of safety." The mother's fears are countered by one of her daughters, who comments: "I'd rather not use my own computer, but use it when I'm at my friend's house, than have my mom go into my personal things and like my private life, and like take charge of it, it's my own stuff" (*Growing Up Online*).

Adult fears surrounding security and safety of children online have been a feature of popular media discourse since the popularization of the Internet in the mid-1990s. A veritable industry of online child safety experts and the creation of technological remedies, such as filtering software, have developed to assuage parental and adult fears. Now, with the popularity of SNS and cell phones amongst young people, a renewed moral panic has precipitated calls for policy intervention alongside the growth of companies touting technological safety devices. Rarely do the media report positively on youth participation; instead, a hyper discourse on cyber bullying exists, now replaced by reports on "sexting" (sending sexually provocative photos over cell phones) (Bielski, "Check Out"). And when nuanced scholarly research on the everyday lives of young people online is reported, it is dismissed, as this editorial from *The Globe and Mail* on the release of the MacArthur Report illustrates: "Set researchers loose for three years on a study of young people's use of digital media, and don't be surprised when they claim to have discovered deep meaning in hours spent in semi-literate blather with friends or the playing of online games" ("Wishful Thinking"). Such condescending crankiness belies the importance of this research, which highlights the vitality of online spaces for youth in their creation of networked publics and communities of interest, for solidifying their social ties and contributing to social cohesion, and for shaping their identity formation.

But fears of cyber-stalkers, sexual predators, and strange adult males maliciously hitting on young people, particularly young women, persist even though,

as the MacArthur Report emphasized, "the vast majority of teens use new media to reach out to their friends; they overwhelmingly define their friends as peers they met in school, summer camps, sports activities, and places of worship. Even when young people are online and meet strangers, they define social network sites, online journals, and other online spaces as friend and peer spaces" (Ito et al. 19).

Several pieces of legislation specifically targeting SNS have wound their way throughout the corridors of the U.S. Senate and Congress. The Deleting Online Predators Act (DOPA) of 2006 would have required that all public libraries and schools receiving federal funding block access to all social networking sites, chat sites, and potentially (according to one interpretation of the Act) all blogs. DOPA was superceded by The Protecting Children in the 21st Century Act, introduced by Senator Ted Stevens of Alaska in 2007 and passed in U.S. Senate in 2008 ("Protecting Children"). The Center for Democracy and Technology critiqued the bill for its exaggeration of online risks and dangers for children arguing that "the great majority of children have rich, rewarding, and safe—and completely lawful and constitutionally protected—online experiences" (Center for Democracy and Technology 6). The bill passed the Senate in 2008 but did not reach the House for a vote. So far, there have been no attempts to resurrect the bill.

One initiative arising from concerns over SNS and safety was the Internet Safety Technical Task Force, charged by the Multi-State Working Group on Social Networking (comprising fifty state Attorney Generals, and MySpace/News Corporation), to investigate viable tools for combating online safety risks. While optimistic about technological fixes, the group's final report expressed caution against its over-reliance, emphasizing a need instead to consider parental intervention, online safety education, law enforcement strategies, and SNS and ISP policies, balanced with the privacy concerns of youth information (Internet Safety Technical Task Force 6, 23).

But task forces, policy legislation, and entreaties for online safety literacy do not address empirical evidence which concludes that "online interpersonal victimizations seem to occur to a lesser degree in social networking sites than other places online where youth communicate with other" (Ybarra and Mitchell 355). Janis Wolak, David Finkelhor, Kimberly Mitchell, and Michele Ybarra also concur in their 2008 study, where they remark that "the research about Internet-initiated sex crimes indicates that the stereotype of the Internet 'predator' who uses trickery and violence to assault children is largely inaccurate" (Wolak et al. 112). The MacArthur Report conferred, stating: "We saw almost no evidence that youth were engaging in risky behaviors online, and their online communication is conducted in a context of public scrutiny and structured by well-developed norms of social appropriateness, a sense of reciprocity, and collective ethics" (Ito et al.).

"Peace of Mind": The Children's Online and Cell Phone Safety Industry

> Like they don't understand that I've spent like since second grade online, and
> I know what to avoid, and I pretty much know what can happen, and I think
> sometimes they forget that because they like didn't . . . grow up online.
> —Teen girl, qtd. in *Growing Up Online*

Just as the last few years have witnessed a palpable gendering of the cellphone though design and the adoption of various accoutrements that feminize the phone (Shade "Feminizing"), the cell phone through its augmentation via technological modes of surveillance has now become a device to allow for remote parental control and monitoring (Richtel). In many instances promotional discourse on cell phone safety is gendered, while in the case of SNS, it is indeed young girls who are those most cited as in need of safe spaces free from cyber-bullying and (male) sexual predators. As Sherry Turkle describes it, cell phones can cushion transitional mobilities of children; parents and children are both literally "on tap" and the child is "tethered," without "the experience of being alone with only him or herself to count on" (127). If the digitally "tethered child" is unique to the millennium North American family, it is also because hyper-vigilant parents are coddled (or exploited!) through an array of new products and services that both monitor and discipline the child's online or mobile behavior.

Integrating GPS (global positioning system) renders the cell phone as "technological nanny" (Rizzo). Verizon's Family Locator allows for the coordination of family locations, arrival and departure updates, scheduled updates verifying a family member's delineated geographical location, and family messaging (Verizon Family Locator). ACE*COMM's Parent Patrol® imposes limitations on children's phones "so they do not interfere with school or homework," such as restricting time-of-day, service, specific phone numbers, total talk time and mobile Web content filtering. Marketing discourse typically uses gendered scripts as positioning devices, as in Sprint's Family Locator: "Keep up with your family's busy life," a female voice says. "You can quietly keep track of your busy family without bothering them throughout the day. If you want to make sure that Carolyn made it to morning band practice without interrupting the music you can run a quick location check from either your phone or your home or office computer" (Sprint Family Locator Video Demo).

RADAR's My Mobile Watchdog allows parents to set up pre-approved contacts for their children's caller list through the online "My Mobile Watchdog Data Center." Parents are notified via a text message or online if an unauthorized or suspicious person attempts to call or text their child. Content, including images, can then be printed out and passed on to law enforcement or school officials. Said

Bob Lotter, founder and CEO of eAgency, the parent company for My Mobile Watchdog, "the surveillance gives teens a 'social out' from bad behavior: [they can say]: 'Hey, don't send me pictures like that, my Mom monitors everything.' . . . At first there's a protest, and then they just chill out because the bottom line is they want their phone" (qtd. in Bielski, "Big Mother" L3).

New iPhone "apps" for parental monitoring and blocking of their children's browsing include Mobicip, iWonder Surf, and Safe Eyes Mobile. Remote access allows for real-time blocking and unblocking of sites; iWonder provides the ability to find out what specific MySpace pages their children have viewed; and Safe Eyes sends an email to their parents if an attempt is made to access a restricted website (Wortham).

These early twenty-first-century parental concerns surrounding their child's unmonitored or potentially wanton communication with strangers are similar in many ways to parental concerns in the mid-twentieth century that arose with the domestic popularity of the telephone and its avid uptake by teen girls. As Mary Celeste Kearney chronicles, for the post-war American teen girl the telephone served as an empowering tool for sociability and communication with the opposite sex. Yet, the telephone also subjected her to domestic containment through its placement in public rooms in her house where her conversations could be supervised and monitored by her parents:

> Affording middle- and upper-middle-class female youth the opportunity to transcend their familial roles and spaces, the telephone nevertheless encouraged such girls to locate themselves within the domestic sphere when not at school or work, thereby contributing to their supervision by parents who worried about their daughters' friends, paramours, and reputations. (Kearney 588)

Designing and marketing cell phones specific to young children, with kid-friendly cool gizmos and parental controls are other trends. The Firefly, introduced by Cingular Wireless and Firefly Mobile, Inc. in 2005, is one such device. Specifically designed for children aged 12 and under, design features include a key pad with five keys in lieu of a regular dial pad, the ability for parents to enter via a private PIN up to 22 outgoing numbers into the phone, with speed-dial keys for "Mom" and "Dad." Caller ID and an optional call-screening feature allow the phone to accept incoming calls only for pre-programmed numbers. A more recent flyPhone also allows parents to restrict texting (Firefly Mobile). TicTalk is an "age appropriate" mobile phone that features parental controls including permission-based times, control of incoming and outgoing calls, pre-programmed numbers, a reward system that allows children to play games with the LeapFrog learning game system, while also offering sound, light and vibration alerts, the ability to record songs and ringtones, and a stopwatch (TicTalk).

Monitoring social network sites is a selling point of spy software eBlaster:

Are Your Children:
Visiting inappropriate web sites?
Chatting with child molesters online?
Spending too much time on MySpace?
You have the RIGHT TO KNOW!
eBlaster gives you the power to uncover the truth . . .
It's as easy as checking your mail. (eBlaster, emphasis in original)

The software records all email received, monitors incoming and outgoing chats, keystrokes typed, and MySpace activities (account logins, profile changes, pictures added, messages sent to users), and captures peer-to-peer downloads. Says one testimonial from a father: "I own eBlaster and its use saved my daughter from every parent's worst nightmare, a sexual predator. You have no idea how thankful I am for this product" (eBlaster).

Subscription-based SNS sites have been specifically developed for tween girls and have a purported educational, entertainment, protection and empowerment mandate. Two examples include Girl Ambition, created by three "working moms" ("Girl Ambition Launches"), and Anne's Diary, under exclusive license to Anne's World (a private Canadian company and part of the Logica Holdings Group).

Girl Ambition is self-described as "the on-ramp to the internet for girls," featuring "an inspirational online show, games, contests and other activities that promote self-esteem and teach girls life skills, with a focus on the safe way to be on-line." Its avowed "tweenized social networking environment" touts safety features (instant messaging with a parental-controlled buddy list, email restricted to parental-approved addresses, online safety information for children and parents) and content that "develops a healthy self-image by focusing on building self-esteem . . . emphasizes that every girl is special by encouraging girls to combat distorted images in the media" (Girl Ambition).

Anne's Diary boasts that its company is "Setting New Standards in Online Safety" through the use of biometric identifiers to verify the age and identity of girl subscribers. It is inspired by *Anne of Green Gables,* the Canadian classic series of novels by Lucy Maud Montgomery. Eight novels were published between 1908-1921, featuring the plucky and resourceful orphan Anne Shirley, and set in Prince Edward Island, Canada. The Anne's Diary subscription-only site is for girls aged 6–12, and Anne's Teens for girls aged 13–15. In Anne's Diary, a screen shot opens up on a girl's bedroom, where users can click on icons for a book club, diary, chat and message room, homework help, fun space (games, wallpaper displays), shopping and a policeman icon to "report irresponsible behavior." Anne's Teens allows for the creation of a profile, blogging, uploading of video and photos, and shopping. Chat rooms are monitored by staff for inappropriate content.

Biometric log-in kits allow for fingerprint authentication via a keypad instead of password authentication. Biometric technologies identify individuals based on intrinsic physical (DNA, iris scans, fingerprints) or behavioral traits (walking style). While biometrics have developed steadily in commercial settings with increasing sophistication, there are still many false positives associated with them. Their use to identify and monitor children in school settings has come under intense focus, specifically in the UK, where they are increasingly used to check on daily enrollment and to check out library books (Thomas). Utilization of biometrics in young people's daily lives leaves many privacy advocates fearful for its normalization as young people mature and accept it as a mundane and uncontested facet of conducting their everyday business.

Until recently Anne's Diary was one company within Logica Holdings, a diversified company whose focus was on e-commerce and the information technology sector. Acquiring Dolphin Digital Media in 2009, it now positions itself within the larger panoply of Dolphin Entertainment, which controls the international distribution of children's television programming, including Nickelodeon's popular series *Zoey 101* (2005–2008) and *Ned's Declassified School Survival Guide* (2004–2007), as well as *Roxy Hunter* (2007–2008), a mystery movie franchise. The biometric identifiers are now branded as Dolphin Secure™, and they boast that their aim is to "create one of the world's safest and potentially largest children and tween on-line social networking communities" (Dolphin Digital Media).

Anne's Diary joins other kid-centric branded children's online play spaces, such as Neopets (parent company Viacom) and the MMORP Club Penguin (parent company Disney Corporation). These sites brag about their child safety features; in the case of Club Penguin this includes an "Ultimate Safe Chat" mode where users are limited to particular phrases in a list, the blocking of profanity, a prohibition on inappropriate usernames, and paid moderators who police the game for infractions.

The Terms and Conditions of Use as stated on Anne's Diary are written in a lengthy legalistic prose that the average 12-year-old girl (let alone adult) would find difficult to decipher. It is also highly unlikely they would read about the limitations of liability and indemnity, and understand that the company owns all the intellectual property rights related to content created on the site by its subscribers. What is a stunning omission is in their privacy policy, where nary a mention is made about how the biometric database is managed! The purported safety features of the site are contradicted by the Terms and Conditions wherein the company casually accedes any control over the use of user information and links by third party sites:

> From time to time the Site owner will make available to the User links from the site to third party sites. These sites are not in any way approved, checked, edited,

vetted or endorsed by the Site owner and the User agrees that the Site owner shall not be responsible or liable in any way for the content, advertising or products available from such sites, the quality, functionality, suitability or legality of such sites or for any dealings that the User may have, or the consequences of such dealings, with such third party site operators. (Anne's Diary)

That a private corporation socializes young women into fingerprinting their entry into a "safe space" amidst a "scary and dangerous" SNS world "out there," while also owning the creative and random content contributed to the site and allowing unnamed third parties to mine said content for surveillance-based marketing is unnerving. Commenting on successful ways to reach the lucrative mobile youth generation, Fareena Sultan and Andrew Rohm urge the intersection of mobile and internet-based technologies and marketing, admonish companies to understand the drivers and obstacles to mobile marketing acceptance, and "devise permission-based strategies that build trust and deliver market-specific content that people will value" (41). And, what goes without saying, to convince parents to buy into an illusion of security.

Taking Back the Txt and Reclaiming the Wall

A public service announcement produced by the Ad Council in conjunction with the Family Violence Prevention Fund targets middle-schooled young people in order to educate them about cell phone and SNS harassment (Clifford). In one 30-second video posted on the website Thatsnotcool.com and also available on YouTube, a young man appears dressed as a cell phone, surreptitiously following and verbally mimicking his texts to his girlfriend throughout the day:

> Young girl in bed: Good morning Sunshine, Wake-y Wake-y, Text Me . . .
> Young girl eating breakfast with family: Are your parents home later? We can hang out . . .
> Young girl walking in school gym: I really love you!
> Young girl walking home from school: Call her back, Call her back, Call her back
> Young girl watching TV in home rec room: Are you with your friends? That's lame. We're in a huge fight right now . . .
> Young girl brushing teeth: Was it something I said? Nude pics. Send me some. Text me!
> Tagline: When Does Caring Become Controlling? (That's Not Cool TV)

Concerned about digital dating violence, the Fund's campaign website, Thatsnotcool.com, uses videos (sock puppet narratives, a few user-generated videos) to discuss "textual harassment," the ethics of sexting, how to stop digital and text rumors, and how to control one's digital privacy on SNS and on cell phones.

But are media reports on sexting exaggerated and just the latest in a cycle of moral panics about sexualization, new technologies and young women? Sexting as a pervasive pastime circulated in the news in late December 2008 when the National Campaign to Prevent Teen and Unplanned Pregnancy released a study wherein 20 percent of a total of 653 polled teenagers reported posting "nude or seminude pictures of themselves at least once via computer or cell phone" (Berton). Pointing out that 80 percent of teens who owned cell phones did not then engage in sexting, Deb Levine, the executive director of the San Francisco-based Internet Sexuality Information Service (ISIS) remarked: "This shows us that the majority of teenagers understand this is not the best place to snap a photo and send it out there . . . the teenage years are years of sexual curiosity, and there are various ways people act out on their curiosity. This is just one of them" (Berton).

The marketing of GPS cell phone devices and subscription-based SNS sites to nervous or concerned parents illustrates how surveillance technologies have become normalized and domesticated. Baby monitoring devices, home security systems, nanny cams embedded into teddy bears, houseplants, mantel and wall clocks, networked IP cameras, eldercare medical devices, and smart appliances that integrate internet and security video monitoring are a routine feature of many North American households.

The fine line between surveillance and security coupled with the increase in technological solutions to often very social problems is compounded by prevalent uses of cell phone and SNS which can, especially for youth, engender and encourage a compliant culture of "friending" and self-disclosure. Valerie Steeves reminds us that "online surveillance is not based on the collection of core biographical details. It is in fact the mundane information that emanates from online interactions that allows others to create detailed profiles of the online behavior of the people being watched" (341). Young women's perceptions of online and cell phone privacy, their knowledge of both third-party marketing and the intellectual property rights of their user-generated content within these privately owned digital spaces deserves further research in girls' studies. In one study, Canadian young women expressed a nuanced yet often contradictory view on the privacy issues at stake; while implicitly trusting Facebook's privacy settings, for instance, they were also concerned with parental and school administrator stalking of their profiles as well as the tracking of their personal information by marketers (Shade, "Internet").

Susannah Stern notes a lively girls' studies scholarship that highlights "the ways in which girls' internet practices allow for identity play, impression management, personal reflection, civic participation, and peer networking" (85), which counters the prevalent media and public discourse that typically positions young girls as vulnerable and passive users of digital technologies.[1] Unfortunately my interrogation in this chapter reinforces how media and public discourse still, with a few rare exceptions, constructs young women as susceptible to cyber-bullying, on-

line sexual predation and therefore in need of technological solutions to assuage their parents' fears surrounding their mobility. Girls' studies scholars can remedy this narrow perspective through qualitative research that facilitates the voices of young women to be heard in media discourse and in policy formation. Research on young women's use of SNS and cell phones can investigate: their perceptions of privacy and how they control and manage it; their sensibility toward "risky" behavior; their limits of personal self-disclosure; their ethical behavior towards friends and colleagues; their knowledge of third-party marketing; and their negotiations with parents over trust and mobility.

Many young people perceive access to SNS and cell phones as an inherent, yet also innocuous, communication right. This pluckiness is characterized well by Destiny Harmon, one of the co-organizers of the high school protest over the jamming of their cell phones: "On the first day, we thought the Telus tower was down. On the second day, we suspected the jammer. On the third day, we had the protest" (Moneo).

Notes

1. See also Harris, Mazzarella, Mitchell and Reid-Walsh, Sweeney, Thiel-Stern, and Willett.

Works Cited

"Anne's Diary: Terms and Conditions." *AnnesDiary.com.* KOINI.COM 2010. Web. 8 Feb. 2010.

Berton, Justin. "Are Lots of Teens 'Sexting'? Experts Doubt It." *San Francisco Chronicle* 21 Mar. 2009. Web. 3 Feb. 2010.

Bielski, Zosia. "Big Mother is Watching You." *Globe and Mail* 24 Feb. 2009. Web. 3 Feb. 2010.

———. "Check Out My Hot Bod . . . Wait, I Can Get That Back, Right?" *Globe and Mail* 5 Mar. 2009. Web. 3 Feb. 2010.

Carvajal, Doreen. "Concern in Europe on Cellphone Ads for Children." *New York Times* 8 Mar. 2008. Web. 3 Feb. 2010.

Cassell, Justine and Meg Cramer. "High Tech or High Risk: Moral Panics About Girls Online." *Digital Youth, Innovation, and the Unexpected.* Ed. Tara McPherson. John D. and Catherine T. MacArthur Foundation Series on Digital Media and Learning. Cambridge, MA: MIT Press, 2008. 53–76.

Center for Democracy and Technology. "Written Statement of the Center for Democracy and Technology to the U.S. Senate Committee on Commerce, Science, and Transportation. Hearing on Protecting Children on the Internet." 24 July 2007. Web. 3 Feb. 2010.

Clifford, Stephanie. "Teaching Teenagers About Harassment." *New York Times* 26 Jan. 2009. Web. 3 Feb. 2010.

DolphinDigitalMedia.com. Dolphin Digital Media, Inc. n.d. Web. 8 Feb. 2010.

eBlaster.com. SpectorSoft Corporation 1999–2009. Web. 3 Feb. 2010.

Ellison, Nicole B., Cliff Lampe, and Charles Steinfield. "Social Network Sites and Society: Current Trends and Future Possibilities." *Interactions* (Jan./Feb. 2009): 6–9.

FireflyMobile.com. Firefly Communications, Inc. 2010. Web. 8 Feb. 2010.

Girl Ambition. Gabo Media 2009. Web. 8 Feb. 2010.

"Girl Ambition Launches as Girls' On-Ramp to the Internet." *Business Wire* 15 Jan. 2009. Web. 3 Feb. 2010.

Growing Up Online. Prods. Rachel Dretzin and John Maggio. PBS Frontline 22 Jan. 2008. Web. 3 Feb. 2010.

Harris, Anita, ed. *Next Wave Cultures: Feminism, Subcultures, Activism*. New York: Routledge Education, 2007.

Holson, Laura M. "Text Generation Gap: U R 2 Old (JK)." *New York Times* 9 Mar. 2008. Web. 10 Oct. 2009.

Internet Safety Technical Task Force. Enhancing Child Safety and Online Technologies. Final Report of the Internet Safety Technical Task Force to the Multi-State Working Group on Social Networking of State Attorneys General of the United States. Feb. 2009. Web. 3 Feb. 2010.

Ito, Mizuko, Heather Horst, Matteo Bittanti, danah boyd, Becky Herr-Stephenson, and Patricia G. Lange. "Living and Learning with New Media: Summary of Findings from the Digital Youth Project." John D. and Catherine T. MacArthur Foundation Reports on Digital Media and Learning, Nov. 2008. Web. 3 Feb. 2010.

Kearney, Mary Celeste. "Birds on the Wire: Troping Teenage Girlhood Through Telephony in Mid-Twentieth-Century U.S. Media Culture." *Cultural Studies* 19.5 (2005): 568–601.

Kennedy, Tracy L.M., Aaron Smith, Amy Tracy Wells, and Barry Wellman. "Networked Families: Parents and Spouses Are Using the Internet and Cell Phones to Create a 'New Connectedness' That Builds on Remote Connections and Shared Internet Experiences." Pew Internet and American Life Project, 19 Oct. 2008. Web. 3 Feb. 2010.

Lenhart, Amanda. "Adults and Social Network Websites." Pew Internet and American Life Project, 14 Jan. 2009. Web. 3 Feb. 2010.

Ling, Rich. "Children, Youth and Mobile Communication." *Journal of Children and Media* 1.1(2007): 60–67.

Manovitch. Lev. "The Practice of Everyday (Media) Life: From Mass Consumption to Mass Cultural Production." *Critical Inquiry* 35 (Winter 2009): 319–31.

Mazzarella, Sharon R., ed. *Girl Wide Web: Girls, the Internet, and the Negotiation of Identity*. New York: Peter Lang, 2005.

Mitchell, Claudia, and Jacqueline Reid-Walsh, eds. *Seven Going on Seventeen: Tween Studies in the Culture of Girlhood*. New York: Peter Lang, 2005.

Moneo, Shannon. "Students Boycott Class After Principal Jams Cellphones—Illegally." *Globe and Mail* 31 Mar. 2009. Web. 3 Feb. 2010.

Prodhan, Georgina. "Social Networks Are Telcos' New Best Friend." *Reuters* 20 Feb. 2009. Web. 3 Feb. 2010.

Protecting Children in the 21st Century Act. S.49. A Bill to Amend the Communications Act of 1934 to Prevent the Carriage of Child Pornography by Video Service Providers, to Protect Children from Online Predators, and to Restrict the Sale or Purchase of Children's Personal Information in Interstate Commerce. Introduced into U.S. Senate 7 Jan. 2007. Web. 3 Feb. 2010.

Rainie, Lee. Teens and the Internet: Presentation to Consumer Electronics Show, Kids@Play Summit. 9 Jan. 2009. Web. 3 Feb. 2010.

Richtel, Matt. "Selling Surveillance to Anxious Parents." *New York Times* 3 May 2006. Web. 3 Feb. 2010.

Rizzo, Sergio. "The Promise of Cell Phones: From People Power to Technological Nanny." *Convergence: The International Journal of Research into New Media Technologies* 14.2 (2008): 135–43.

Shade, Leslie Regan. "Contested Spaces: Protecting or Inhibiting Girls Online?" *Growing Up Online: Young People and Digital Technologies.* Eds. Sandra Weber and Shanly Dixon. London: Palgrave, 2007. 227–44.

———. "Feminizing the Mobile: Gender Scripting of Mobiles in North America." *Continuum: Journal of Media and Cultural Studies* 20.3 (June 2007): 179–89.

———. "Internet Social Networking in Young Women's Everyday Lives: Some Insights from Focus Groups." *Our Schools/Our Selves* (Summer 2008): 65–73.

Sprint Family Locator Video Demo. *Nextel.com.* Sprint 2010. Web. Feb. 2010.

Stald, Gitte. "Mobile Identity: Youth, Identity, and Mobile Communication Media." Ed. David Buckingham. *Youth, Identity, and Digital Media.* Cambridge, MA: MIT Press, 2007. 143–64.

Steeves, Valerie. "If the Supreme Court Were on Facebook: Evaluating the Reasonable Expectation of Privacy Test from a Social Perspective." *Canadian Journal of Criminology and Criminal Justice* 50.3 (2008): 331–47.

Stern, Susanna. "Girls as Internet Producers and Consumers: The Need to Place Girls' Studies in the Public Eye." *Journal of Children and Media* 2.1 (2008): 85–86.

Stone, Brad. "Report Calls Online Threats to Children Overblown." *New York Times* 13 Jan. 2009. Web. 3 Feb. 2010.

Sultan, Fareena and Andrew J. Rohm. "How to Market to Generation M(obile)." *MIT Sloan Management Review* 49.4 (2008): 35–41.

Sweeney, Kathleen. *Maiden USA: Girl Icons Come of Age.* New York: Peter Lang, 2008.

Tapscott, Don. *Grown Up Digital: How the Net Generation Is Changing Your World.* Toronto: McGraw-Hill, 2008.

TicTalk.com. Modeci, Inc. n.d. Web. 8 Feb. 2010.

That's Not Cool TV. "When Does Caring Become Controlling?" Developed by the Family Violence Prevention Fund in partnership with the Department of Justice Office on Violence Against Women and the Advertising Council, 2009. Web. 8 Feb. 2010.

Thiel-Stern, Shayla. *Instant Identity: Adolescent Girls and the World of Instant Messaging.* New York: Peter Lang, 2007.

Thomas, Kim. "School Puts Brave Face on Biometrics." *The Guardian.* Guardian News and Media Limited 2010, 5 Mar. 2009. Web. 3 Feb. 2010.

Turkle, Sherry. "Always-on/Always-on-you: The Tethered Self." *Handbook of Mobile Communication Studies.* Ed. James E. Katz. Cambridge, MA: MIT Press, 2008. 121–37.

"Verizon Family Locator." *Verizon.com.* Verizon Wireless 2010. Web. 8 Feb. 2010.

Weeds. "You Can't Miss the Bear." Season 1, Episode 1. Dir. Brian Dannelly. 7 Aug. 2005.

Willett, Rebekah. "Consumer Citizens Online: Structure, Agency and Gender in Online Participation." *Youth, Identity, and Digital Media.* Ed. David Buckingham. Cambridge, MA: MIT Press, 2008. 49–70.

"Wishful Thinking on Internet Use." Editorial. *Globe and Mail* 9 Dec. 2008. Web. 3 Feb. 2010.

Wolak, Janis, David Finkelhor, Kimberly J. Mitchell, and Michele L. Ybarra. "'Online Predators' and Their Victims: Myths, Realities and Implications for Prevention and Treatment." *American Psychologist* 63 (2008): 111–28.

Wortham, Jenna. "Helping Parents Snoop on Kids' iPhone Habits." *New York Times* 28 Mar. 2009. Web. 3 Feb. 2010.

Ybarra, Michele L. and Kimberly J. Mitchell. "How Risky Are Social Networking Sites? A Comparison of Places Online Where Youth Sexual Solicitation and Harassment Occurs." *Pediatrics* 121.2 (2008): e350–7.

Branding the Post-Feminist Self: Girls' Video Production and YouTube

Sarah Banet-Weiser

A YouTube video posted July 25, 2008, is titled "i kissed a girl" (kpal527). In the video, two young white American girls, 12 to 13 years old, dance and sing to the popular hit song by teen idol Katy Perry, "I Kissed a Girl," in what looks to be a typical middle-class teenage girl's bedroom, with a bed and dresser in the background, toys, books, and pink blankets strewn on the floor. The video was filmed using a webcam, with a fairly low-quality image and no close-ups or any camera movement. The girls, wearing shorts and t-shirts branded with popular commercial logos, are clearly having fun in front of the camera—at times the dance turns silly, they giggle throughout, interrupting their own singing, making faces to the camera. At the time of writing, there were 42 comments evaluating the dance performance in the feedback ("text comments") section of this YouTube video. One comment, from sophieluvzu, stated: "LMAO! I can't say anything bad about them, because I remember when I was this young I made dances up like this but suppose its for fun, although I didn't know what youtube was back then J."

This amateur video is one of thousands posted on YouTube featuring adolescent or teenage girls dancing and singing to popular music, referencing commercial popular culture, and presenting themselves for display. YouTube has clearly established itself as a place for the posting of videos that chronicle everyday life. A website with which many individuals around the world are now familiar, YouTube was the most popular entertainment website in Britain in 2007, and it was consistently in the top ten most visited websites globally in early 2008 (Burgess and

Green 2). Of course, YouTube is not only a video site for youth video exhibition; the site is a platform for audiovisual content of all kinds, from user-created videos to broadcast media content to presidential addresses.

YouTube was launched in 2005 as a user-friendly site to upload, store, and share individual videos. It was acquired by Google in 2006 for $1.65 billion and has expanded to become a primary commercial venue for marketing music, movies, and television, while retaining its original identity. As Jean Burgess and Joshua Green state, YouTube is a "particularly unstable object of study," in part because of its "double function as both a 'top-down' platform for the distribution of popular culture and a 'bottom-up' platform for vernacular creativity" (6). While it is beyond the scope of this chapter to analyze YouTube in general terms as a medium and cultural space, I argue that the website's "double function" as a platform for both commercial and vernacular creative content offers an opportunity to think critically about the ways in which YouTube is a site for self-promotion or the creation of the "self-brand." In particular, I examine user-created YouTube videos that specifically invoke what might be called the "post-feminist" self-brand, as these videos, like "i kissed a girl" mentioned above, both support and perpetuate a commercial post-feminist discourse in which girls and young women are ostensibly "empowered" through public bodily performances and user-generated content.

The transition of YouTube from its earlier incarnation as a personal "digital video repository" to its now well-known function as a place wherein one can "broadcast yourself" is not simply an effect of the expansion of Web 2.0 technologies (Burgess and Green 5). "Broadcasting yourself" is also a way to brand oneself, a practice deployed by individuals to communicate personal values, ideas, and beliefs using strategies and logic from commercial brand culture, and one that is increasingly normative in the contemporary neoliberal economic environment. Additionally, public self-expression and self-branding are validated by the cultural context of post-feminism, which, among other things, connects gender empowerment with consumer activity (Hollows and Moseley; McRobbie, *The Aftermath*; Tasker and Negra). These entangled discourses of neoliberal brand culture, Web 2.0 interactivity, and post-feminism all rely ideologically and materially on individuals becoming what Nikolas Rose might call the entrepreneur of the self (Rose). The ideals and accomplishments of the post-feminist subject—independence, capability, empowerment—are also those that define the neoliberal subject (Gill). These, in turn, are supported and enabled by similar ideals and assumptions about the contemporary interactive subject who realizes her individual empowerment through and within the flexible, open architecture of online spaces.

YouTube is but one cultural space located at the nexus of these discourses, but because of the site's dynamic capacity for individual public performances and viewers' comments and feedback, it has become an ideal space to craft a self-brand. Of

course, my focus on girls' post-feminist self-branding on YouTube indicates that I am looking at only one kind of production practice out of the multitudes that take place via digital media and only one subgenre of video that is posted on You-Tube. There are many different kinds of girls' media production in online spaces, as well as on YouTube itself, so user interactivity and the space of the Internet as one of possibility need to be analyzed in particular, specific terms. For this study, I examined amateur videos that feature young girls dancing, singing, or "vlogging" (video blogging) to the camera about mundane activities, found using such search terms as "girls dancing," "girls singing," "girls playing around." While thousands of such videos come up when using these search terms, I examined approximately 100 videos and focus here on a small group that exemplify some of the strategies involved in self-branding, paying particular attention to the feedback that accompanies these videos.[1] Viewer feedback on YouTube videos establishes a kind of relationship between the posted video, the videomaker, and viewers, much like the way consumers comment and evaluate on products they purchase.

In the following pages, I will first offer a brief discussion of the contemporary rhetoric that shapes cultural notions of online user interactivity, focusing specifically on YouTube's role in this rhetoric. I will next turn to the ways in which contemporary relationships between girls and identity-making have been framed, especially in terms of post-feminism. Then, I will discuss neoliberalism and brand culture, as a way to provide a framework for analyzing girls' self-branding practices on YouTube. Finally, I offer an analysis of user feedback, arguing that this component of online activity is crucial to the logic of self-branding.

"Living Online": Online User Interactivity and YouTube

A recent 2009 Nielsen Online study confirmed what is for most middle-class Americans a truism already: "kids are going online in droves—at a faster rate than the general Web population—and are spending more entertainment time with digital media" (Shields). The report continues by stating that as of May 2009, the 2- to 11-year-old audience had reached 16 million, or 9.5 percent of the active online universe. Kids, the report claims, "are all but living online" (Shields). This notion of "living online" has generated speculation about its meaning, with scholars, educators, and parents debating the effects of online activity (Goodstein; Montgomery; Palfrey and Gasser; Tapscott). Much of the discourse surrounding the Internet focuses, from a range of negative and positive vantage points, on its democratizing potential. There are multiple reasons as to why the Internet is understood as a democratizing space: to name but a few, its flexible architecture, the relative accessibility of the technology, the capacities for users to become producers, the construction of the Internet as participatory culture (boyd; Burgess and Green; Castells; Jenkins). To these more optimistic characterizations of the Inter-

net, challenges have been launched, especially those focusing on the multitude of ways the market has and continues to shape what content is on the Internet, the labor that produces this content, and the conditions of possibility for future content (Andrejevic, *iSpy*; Dean; Schiller; Terranova).

Because of a previous historical context that situated girls and their practices as outside, both literally and intellectually, the realm of technology (usually because of girls' assumed "natural" deficiency when it comes to technological acuity), the ever-increasing presence of girls online—and what they do when they are there—has been the particular focus of recent scholarly analysis (e.g., Dobson; Kearney; Mazzarella; Stern, "Expressions"). Much of this work has challenged traditional communication research that links technological use (ranging from watching television to participating in chat rooms) to harmful social effects, and thus has opened up scholarly and activist discourse about the potential benefits, especially for girls, for exploring the Internet as a space in which creative identity-making, among other things, might be possible. This work has detailed not only the various ways in which girls participate in online practices but also the increase in video production by girls in the last several decades (Kearney).

Indeed, the fact that kids, and girls in particular, are using social media in increasing numbers raises a number of questions about empowerment, voice, and self-expression, but the answers are not simple. Not all online spaces are the same or contain the same possibilities for self-presentation and self-expression. Personal home pages, blogs, diaries, and self-produced videos all capitalize in different ways on the flexible architecture of the Internet as well as on its potential for user interactivity. Girls' self-presentation online is a contradictory practice, one that does not demonstrate an unfettered freedom in crafting identity any more than it is completely controlled and determined by the media and cultural industries. As Marc Andrejevic has pointed out in his work on surveillance and corporate control in an online era, "the point of exploring the ways in which the interactivity of viewers doubles as a form of labor is to point out that, in the interactive era, the binary opposition between complicit passivity and subversive participation needs to be revisited and revised" ("Watching Television" 32). In particular, focusing on the opposing forces of passive and active participation distracts us from the ways in which consumption and production are imbricated practices, rather than isolated, discrete activities. That is, as Mary Celeste Kearney argues, focusing on the ways in which consumption and production activities form a kind of *relationship* allows scholars to resist theorizing about girls' cultural activities within binaries of "production/consumption, labor/leisure, and work/play in their everyday practices" (5). Kathryn Montgomery echoes this notion in her work on youth, digital media, and civic engagement, where she argues, "Interactive technologies have created capabilities that alter the media marketing paradigm in significant ways, extending some of the practices that have already been put in place in conven-

tional media but, more important, defining a new set of relationships between young people and corporations" (26).

This "new set of relationships" includes the relationship between the self and the brand. The market forces of neoliberal brand culture do not just capitalize on participatory culture or online identity making, in other words, but circumscribe and shape what we have come to know as "participation" and "identity." As Anthony Giddens has characterized individual identity-making in modern society, identity is not understood or experienced as organic or static but rather as a "project of the self," where the crafting of one's self is a constant dynamic, one that relies on media and other cultural spaces as a way to be "self-reflexive" and constantly work on, update, and evolve the construction of the self (5). David Buckingham characterizes this "project of the self" in the specific context of youth and digital activity as one in which individuals "have to create biographical 'narratives' that will explain themselves to themselves, and hence sustain a coherent and consistent identity" (9).

The construction of the self is not an insular, isolated activity but is rather situated in a media and cultural context that involves a dynamic between the self and others, or in the case of YouTube, between video content and user feedback. Of course, this is not only a generational dynamic but also a gendered one. That is, if kids are "living online," part of this everyday life means, among other things, negotiating power relations and crafting gendered identity. In particular, the practices of "living online" are often similar to those central to post-feminism: Empowerment and constraint need to be understood in the particular context which not only validates their specific logic but indeed makes specific definitions of power and constraint legible in the first place.

Broadcasting the Post-feminist Self

As a mainstream commercial website that often functions as a promotion vehicle, YouTube distributes videos that frequently rely on familiar commercial narratives about gender identity and the feminine. The videos I examined are part of what might be called post-feminist media culture, in which young girls are engaged in visual and virtual performances of "public femininity" (McRobbie, *The Aftermath* 60). This kind of public femininity is clearly evident in a recent YouTube video by Uzsikapicics called "13 year old Barbie Girls," which had, at the time of writing, 777,085 views and 1226 feedback comments. The video, featuring six 13-year-old white girls, opens with a shot of a Barbie and Ken doll (and a tube of toothpaste adorned with images of Disney princesses) arranged on a chair. A young girl sits on the dolls, nonchalantly fastens her shoes, stands up, turns on the stereo and begins to dance. She moves to the front door, opening it to two other girls, dramatically involved in putting on lipstick and other make-up.

The girls, clearly mocking celebrity as well as beauty culture, air-kiss each other and also begin dancing to the song. The camera pans to two other girls, both of whom are actively involved in feminine grooming practices: one girl is looking at a teen magazine with Paris Hilton on the cover, while the other is occupied by dramatically brushing the hair of a small toy dog. In the next shot, the five girls sit together on a couch, performing a choreographed routine of crossing and uncrossing their legs. Another girl enters the room, and with a dramatic gesture sprays the girls with a spray can, who then collapse on the floor. As they get up together, they begin singing the commercially popular song by Aqua, "I'm a Barbie Girl," with one girl brandishing what looks like a steak knife. The video ends with a last shot of the Barbie and Ken dolls, with one exception: Ken's head has been cut off, the aforementioned steak knife sticking out of his neck. The vaguely political ending of the video—chopping Ken's head off clearly calls into question his role as a crucial part of Barbie's world—is offset by the silliness of the girls, who are obviously having fun, and demonstrates a central contradiction to this kind of "public femininity."

It is certainly true that YouTube affords girls, such as the "13 year old Barbie Girls," an opportunity to film themselves crafting gender identity through particular performances. And, it is clear that the technological space of the Internet is also a cultural and social space, one that is potentially expansive in terms of reimagining gender identity. Being in charge of one's own identity development is clearly powerful, and new media seem to provide spaces to bring girls' identities "into being," or again, to "live online." Exploring the challenges involved in being a "Barbie Girl" through a playful and parodic video, for instance, allows girls to both perform gendered identity and to point out its contradictions (through the song, which satirizes the "Barbie Girl," as well as cutting off Ken's head). As many scholars have pointed out, online spaces provide a potentially expansive opportunity for girls to explore gender and sexual identities, through girl-oriented websites, home pages and personal profiles, and YouTube videos (Dobson; Grisso and Weiss). As Susannah Stern points out about girls' home pages on the Web, girls often use these spaces as "a forum of self-disclosure, especially as a place to engage in self-expression" ("Virtually Speaking" 224).

Certainly, YouTube videos can be understood as spaces for self-disclosure or self-expression; one of the most desirable features of the site is that users can bypass the control of media gatekeepers by producing and distributing their own media images. Sandra Weber and Claudia Mitchell have recently argued that youth productions online are examples of "identities-in-action," where young users combine old and new images in creative ways of establishing multifaceted identities. Like other scholars investigating identity-making online, Weber and Mitchell see youth online productions as self-reflexive, where media made by youth are also viewed by those youth, so that users constantly revisit their own

web productions and update them, as well as see how many "hits" or response messages they might have generated. The fact that young people producing media online are their own audience demonstrates, for Weber and Mitchell, a "conscious looking, not only at their production (themselves), but how others are looking at their production" (27).

It is clear from this comment that online "production" can be collapsed with "self-production," thus complicating a consumption/production binary. But who, or perhaps, what, is the girl "self" in YouTube videos? One way to address this question is to situate it within the context of post-feminism. Indeed, many of the videos I examined on YouTube are legible within the broader cultural context of post-feminism, a context which is animated and enabled by neoliberal capitalism and the discursive space of participatory culture that structures much online activity. While post-feminism has been theorized as a practice, a set of representations, and an economic formation, I find Angela McRobbie's recent formulation the most useful: In the late 1990s and early twenty-first century, post-feminism forms a kind of "cultural space" that reflects "a field of transformation in which feminist values come to be engaged with, and to some extent incorporated across, civil society in institutional practices, in education, in the work environment, and in the media" (*The Aftermath* 15). McRobbie calls this engagement of feminism by contemporary culture "feminism taken into account," because it is a process in which feminist values and ideologies are taken into account only to be found dated or old-fashioned and thus repudiated. McRobbie characterizes this dynamic, between acknowledging feminism precisely as a way to discount it, as a "double-movement," noting the paradox of how the dissemination of discourses about freedom and equality provides the context for the retrenchment of gender norms and traditional gendered relations (*The Aftermath* 55).

Those ideals shaping the discursive and ideological space of the Internet (including creating and posting videos on YouTube)—freedom, equality, innovation, entrepreneurship—are the same discourses that provide the logic for girls' post-feminist self-branding, a practice that situates girls and young women ever more securely into the norms and values of hegemonic gendered consumer culture. This kind of self-branding is thus not just a tired re-hashing of the objectification of female bodies but rather a new social arrangement, one that relies on strategies for identity construction that get their logic from more progressive ideals such as capability, empowerment, and imagination. Like the "new category of womanhood" McRobbie describes (*The Aftermath* 56), or what Anita Harris has called the "can-do" girl (13), the self-branded girl is encouraged to be self-reliant and empowered, especially within a consumer context. Indeed, she is encouraged to *be* a product within a neoliberal context; she authorizes herself to be consumed through her own self-production.

The video "13 Year Old Barbie Girls" makes sense only because Mattel's Barbie brand and its related discourses and ideologies are so recognizable. Even as the girls are acting out the "Barbie girl" by potentially challenging its limitations (indicated by chopping off Ken's head), the Mattel brand structures, and thus limits, the kind of self-presentation that takes place. Although consumers have redeployed Barbie in many contexts as a way to resist or redefine the image of femininity validated by the doll's popularity, even these subversions emanate from Barbie's particular brand of femininity (Kearney; Rand). In other words, the girls in the video are not creating an entirely new image of gender using a fresh imaginative script but rather working within and against a cultural definition of the feminine offered to (and recognized) by girls who have purchased and played with Barbie dolls. It is certainly true that appropriating and reworking material available in popular culture is a familiar practice for consumers, and one that does not necessarily function simply as a kind of economic practice.[2] However, many YouTube videos by girls depend upon gendered brand contexts that are commercially produced for profit in the media industries and emphasize hegemonic female sexuality: Disney Princess representations are featured prominently in girls' bedrooms and on clothing; girls dance to songs by Beyoncé, Jennifer Lopez and other pop stars; posters on the walls in girls' rooms depict popular heteronormative teen celebrities, movies, television programs, and retail outlets, such as Abercrombie and Fitch. The performances of the girls in the videos are also familiar, where the girls display and self-objectify the body through suggestive dance moves and clothing (often recognizable from MTV and other music video television channels).

In addition to the self-brand, the presence of commercial brands as structuring narratives for YouTube videos, then, indicates that self-disclosure, or self-presentation, does not imply simply *any* narrative of the self, created within an endlessly open cultural script but one that makes sense within a cultural and economic context of recognizable and predetermined images, texts, beliefs, and values. The fact that some girls produce media—and thus ostensibly produce themselves through their self-presentation—within the context of a commercially-driven technological space is not only evidence of a kind of empowering self-work but also a way to self-brand in an increasingly ubiquitous brand culture. In other words, the kind of branded visibility that often guides YouTube videos has historically engaged a kind of double mobilization, in which media producers create and make visible identities for the market, and individuals identifying with those representations recognize themselves (often for the first time) within the powerful media system. Branded post-feminism has only intensified in the online era, because it is supported by the contexts in which consumers are both more in control of their own productions and also increasingly under surveillance by media industries. This dynamic structures, for example, many YouTube videos in which girls perform dances to songs that have an "empowering" post-feminist

message, such as "I Kissed a Girl" (Katy Perry), "All the Single Ladies" (Beyoncé), or "I Will Survive" (Gloria Gaynor). Traditional questions, therefore, raised by adolescents of "who am I?" become more about "how do I sell myself?" in a twenty-first-century commercial context that valorizes selling oneself—especially for girls—precisely as a process of figuring out personal identity (Stern, "Producing Sites"). As Amy Shields Dobson points out in her work on CamGirls (personal web sites that include video of their female owners captured via web cams) the contemporary cultural environment encourages girls to "become successful and powerful by means of opportunism, ingenuity, and self-promotion—through selling themselves" (139).

Brand Culture and the Practice of Self-Branding

YouTube videos, then, do not exist in a social or cultural vacuum; they are posted on a site with the trademarked tagline "Broadcast Yourself," and one that features advertising, in the form of banner ads posted on the site as well as more embedded forms of advertising found within the videos themselves. As Alison Hearn points out, "Work on the production of a branded 'self' involves creating a detachable, saleable image or narrative, which effectively circulates cultural meanings. This branded self either consciously positions itself, or is positioned by its context and use, as a site for the extraction of value ('"Meat"' 164–5)." The YouTube videos I analyzed provide this "detachable, saleable image," and viewers' comments on the videos determine (at least in part) the "value" of the image; this dynamic becomes "a validation of worth" (Dobson 127).

In other words, to return to the notion that middle-class American kids are "all but living online," I want to suggest that this "life" is one that is often intricately linked (albeit in different ways) to the culture of branding. Broadly defined as the deliberate association of products and trademarked names with ideas, concepts, feelings, and relationships, brand culture creates a context within which consumer participation is not simply (or even most importantly) indicated by purchases, but by brand loyalty and affiliation, linking brands to lifestyles, politics, and social activism. Developing a self-brand on commercial social networking sites, such as YouTube, means that girls reference brands not simply as commodities but as the context for everyday living. Even more specifically, this branded context for living supports practices by which individuals craft identities "as products capable of catching the attention and attracting demand and customers" (Bauman 6). These self-brands—the self-as-product—on the YouTube videos I examined rely upon and validate post-feminist practices, in which particular narratives that connect individual empowerment and creativity with gendered consumption practices, such as displaying the hypersexualized body, particular beauty practices, and performances of stylized heterosexuality, are repeatedly circulated in ways that sup-

port normative gender relations rather than challenge them (Hollows and Moseley; McRobbie, *The Aftermath*).

And, indeed, social networking sites, such as MySpace and Facebook, have been positioned recently (by scholars and marketers alike) as particularly powerful promotional spaces for this kind of self-branding; adolescents can develop a personal "brand" on these sites through video, textual information, media productions, and so on (boyd; Hearn, "Meat"). Unlike MySpace, Facebook, or other social networking sites, YouTube does not prominently feature complex user profile pages complete with personal information, such as "likes" and "dislikes," popular cultural affiliations, and public listing of "friends" (although personal profiles are possible on YouTube). I nonetheless argue that YouTube may function as a kind of social networking site. While YouTube is also a space for commercially produced videos, as well as a place in which the videos that are posted are not always created by the person featured in the video, the site does allow Internet users with the means to make and upload videos to share these videos with friends, to establish links with other online sites, and to create "playlists." The comments, both text and video, posted below videos, are valued for their quantity, as the number of these comments relates to the value of the video, a practice similar to accruing MySpace or Facebook "friends."

Online self-branding (such as YouTube videos) utilizes the labor of consumers in re-imagining a "product" *as* the self. Indeed, the kind of technological convergence witnessed in online spaces that has been celebrated for its flexibility and malleability makes it an especially fertile ground for self-branding. Branding management strategies have also capitalized on this flexibility and have recognized the active, engaged online consumer interactivity as a way to "off-load" corporate labor, such as promoting a hit Beyoncé single or endorsing the brand image of Barbie (Andrejevic, *iSpy*). Within contemporary neoliberal society, where culture is seen as an economic resource, and brand culture in particular validates and supports shifting boundaries of what can and cannot be configured as a "product" to be sold, the "self" is branded, managed, and distributed within a cultural marketplace. And in some ways, the girls in the YouTube videos I examined perform what Maurizio Lazzarato and Tiziana Terranova have called "immaterial labor," where the branded performances of the adolescent girls do a kind of promotional work. Immaterial labor, however, is not just the unpaid (and unrecognized, at least *as* labor) labor consumers do for corporations, but also the affective labor that produces not simply conventional products, but immaterial products such as knowledge, emotion, or relationships between producer and consumer in the self-brand.

Indeed, an entire industry has emerged around how to best craft this relationship: trade books with titles such as *Be Your Own Brand: A Breakthrough Formula for Standing Out from the Crowd* (McNally and Speak), *U R a Brand! How*

Smart People Brand Themselves for Business Success (Kaputa), and *Make a Name for Yourself: Eight Steps Every Woman Needs to Create a Personal Brand Strategy for Success* (Fisher-Roffer) are situated alongside "how-to" forums online on the dos and don'ts of self-branding. Self-branding strategist Catherine Kaputa argues in her book, *U R a Brand!*, that while all people need to be self-brand "builders" in the contemporary marketplace, this is particularly true for women and girls: self-branding "is especially for women, women like myself, who were told as children, 'Don't upstage your brother' or 'It's not nice to call attention to yourself.' The truth is, if you don't brand yourself, someone else will, and it probably won't be the brand you had in mind" (xvi). This sentiment taps into post-feminist discourses of empowerment, acknowledging that there have been historical obstacles for women to be independent, but that in the contemporary context, it is up to women to carve out space for themselves—and the best way to do this is to develop a brand. And, as most marketers who specialize in self-branding agree, within the current economic climate, it is imperative to utilize the strategies once reserved for branding products for the branding of oneself: "You'll learn how the branding principles and strategies developed for the commercial world may be used to achieve your business and personal potential. In short, you are a brand" (Kaputa xv). The brand context of YouTube thus anticipates particular performances, attitudes, and actions of girls' videos, seen through the musical choices of the girls, the commercially recognizable dances performed, the popular cultural references, the clothing worn—and the feedback that then functions to give these performances value.

To take just one example, the YouTube video titled, "13 year old miSS Dalazee Dancing to Single Ladies" features a 13-year-old African American girl wearing a hot pink t-shirt, black cargo pants, and flashy jewelry, dancing to Beyoncé's "All the Single Ladies" in what looks to be her bedroom, as there are posters on the wall, and a bed, dresser, and TV in the room (MissDalazee). The girl follows Beyoncé's video routine carefully, ending the dance, as Beyoncé does, by pointing to her ring finger on her left hand. While the video itself is legible only within a certain commercial popular cultural vocabulary (a recognition of not only the song but the dance as well), the feedback on the video situates it as a self-branding exercise. For example, one of the twenty-one comments states: "you are a very cute girl and you can dance very well. Ue seem a little camera shy but ii hope that you will get over that. Ii love the cargos & ii could like to see more videos from you. Hoping you get discovered with both hands & feet crossed!!—Pretty&Not paid." This comment, as well as hundreds of others on similar YouTube videos, explicitly makes reference to the function of YouTube in "getting discovered," ostensibly by the commercial media industries, and gives a certain "value" to the YouTube brand. Indeed, talent agencies for kids now often specialize in making kids online stars (often through social networking sites), thus institutionally con-

stituting and legitimating YouTube and other social networking sites as lucrative venues for self-branding. As but one example of this kind of legitimation, on the popular "how-to" website, eHow.com, there is a listing on "How to be a star on YouTube," with one "step" in the path to YouTube stardom being: "Come up with a concept that others will become addicted to when watching. It must be presentable as a series. It should be controversial, sensational or shocking. If it isn't any of these then inject it with your sex appeal, your incredible sense of humor or be bizarre. Each episode must terminate in suspense."

While the YouTube videos that girls create, such as "13 year old MiSS Delazee," are important forms of independent production, there nonetheless remains a predetermined cultural and economic script that structures such videos and the feedback that accompanies them, a script that is formulated within the vocabulary of self-branding and "how to be a star" (Dobson). The discourse of "how to be a star" is clearly available only to those who have resources, a fact which is obfuscated by the neoliberal "openness" of sites such as YouTube. That is, the notion that there are clear—and accessible—steps one can simply follow in order "to be a star" renders invisible how bounded those steps are in terms of age, race, and class. Individuals who are culturally marginalized (through law, policy, media representation, etc.) because of race or class, for instance, do not have the same access to the practice of self-branding as white, middle-class girls and women. What is at stake here, then, is that the normalization of self-branding necessarily relies on particular practices of exclusion.

Who's Buying? The Role of Feedback

Performances on YouTube videos are validated by the number of views and comments the videos receive, which is in turn crucially significant to self-branding. Feedback is crucial to creating a self-brand; in order to sell oneself in a particular way, there must be a conscious recognition of the fact that other users are "buying," even if feedback is negative (the logic of "all press is good press"). Feedback functions on YouTube as a way to create a continuous dynamic between a consumer/user and producer. This dynamic is neither top-down nor bottom-up but ostensibly a meeting between the two, and thus *implies* a nonlinear power distribution from producer to consumer, no system or space controlling another.

Media production and feedback are more complicated than this optimistic view, however, and can also be considered as strategies of surveillance, judgment, and evaluation—practices signaling consumer agency but simultaneously disciplining and constituting subjects. Just as all online media productions are not the same nor have the same purpose, not all feedback is the same. Feedback on girls' YouTube videos functions more often than not as a neoliberal disciplinary strategy, where videos are judged and gain value according to how well the

girls producing them fit normative standards of femininity. YouTube feedback is part of a subgenre of online user activity that is often positioned by marketers as "evidence" of user interactivity: ranking products (such as customer rankings on Amazon.com), individuals (such as the website "Hot or Not," the logic of which is self-explanatory), and media texts (such as those found on the TV review website Television Without Pity) (Andrejevic, "Watching Television"). Posting a video on YouTube is both an explicit and implicit request for this kind of feedback, and situates videos as products to be evaluated by "customers." As Hearn argues about self-branding on social network sites, "outer-directed self-presentation . . . trades on the very stuff of lived experience in the service of promotion and profit" ("Variations" 207–8). Importantly, feedback on YouTube forms a crucial element in the relationship between consumer and producer, so that judgment, ranking, and evaluation make the self-brand legible.

For instance, on the aforementioned "13 year old Barbie Girls" video, feedback ran the gamut from the creepy "I love all of u young girls" to the more embracing "LOL 13 year old boys aren't like this! Women are just too sweet-hearted. Makes me sad to think of the way women are treated in this world." Others commented on the high number of views: "763,292 views!!!! Anyway the girls are cute . . . but 763,292 views!!! For God sake the video is so stupid . . . sorry this is my opinion." Most feedback on girls' YouTube videos comments on normative physical appearance, "hotness," and dancing skill. Comments ranging from "Damn girl, keep them coming" (signed "Stair Dance") to "excellent body" (Lissawentworth) to "god help me & have mercy on my soul, this is so goddamn hot" (irisverygood) and "I wanna do these little snots" (coolcokeify) exercise a kind of control over the self-branding process of the girls' self-presentations, situating videos squarely within a familiar script of objectifying the bodies of girls. Indeed, feedback for these videos does not invoke interactive dialogue so much as works to establish the girls in the videos as more or less successful (in commercial terms) self-brands. (This is especially evident in those amateur videos that continue as web serials, or "webisodes.") For example, a very popular webisode star is iJustine, the online persona of Justine Ezerik, who has made more than 200 videos and posted them on YouTube, including satires of television shows, interactive skits, and dancing in Apple stores. She has her own channel on YouTube, where she is a self-proclaimed "lifecaster." Her video about wanting to order a cheeseburger got over 600,000 YouTube views in one week, and at the time of writing, had over 2 million views (iJustine).

Consider also in this regard the YouTube video: the video "me & Nicole.. crazyyy" features two teenage white girls (approximately 14 to 16 years old) wearing shorts and bikini tops, singing and dancing to the song "I Will Survive" by Gloria Gaynor (sofijakos465865). The girls are dancing in what is obviously one of their bedrooms, which includes bright pink walls, a white bed with stuffed animals on

it, and posters of young male celebrities and retail stores on the walls. The video, which at the time of writing had 539,243 views and over 400 comments, seems to be a fairly typical teenage girl scenario—two friends dancing and singing to a popular song. Some of the comments on this video were quite engaged:

> wtf was that. Seriously. I'm so tired of these girls thinking that putting up videos of them acting a fool is cute when its not. Its sad bc majority of the time they can't dance and lack rhythm . . . just telling the truth here. U all know it but don't say n e thin. And for the ones that do, I'm right there with ya. (cutie1472)

Others were simpler evaluative statements: "they really hot" (kaeben93) and "cheap, your 14!!" (woutvsas). Indeed, like this last comment, many videos posted by adolescent girls garnered judgmental comments about the age of the participants, so that along with comments that reduce girls to sexual objects are those that chastise girl producers for being too young either to be posting videos of themselves online or to be asserting themselves sexually.

Notes

I would like to thank a number of people who generously gave me feedback on this article and the ideas that initially shaped it: Josh Kun, D. Travers Scott, Laura Portwood-Stacer, Inna Arzumanova, Melissa Brough, Alison Trope, and Mary Celeste Kearney.

1. This kind of feedback works to legitimate YouTube as a site for self-branding as it also contains girls and their gendered self-presentations within normative standards of judgment. Many YouTube videos, like personal home pages or diaries, are both a public and private performance; public because they are displayed on a globally public social networking site, and private because they can answer the intensely personal question of "who am I?" But this narrative crucially depends on the dynamic of feedback, which provides a context fertile for self-branding. That is, if self-branding is part of a "project of the self," then the conceptual crux of this project is feedback: evaluating or commenting on others' self-disclosures "empowers" one as a consumer-cum-producer of content, yet it also reproduces normative identities and relations. Self-branding, much like the branding of products, is dependent upon the capability of ranking the product, in this case an adolescent girl, who is judged and produced as a subject. To be authorized to reconstitute someone *as* something—including something deviant, abnormal, or pathological—is as much a telling of one's own story as a judgment of another's. Self-branding does not merely involve self-presentation but is a layered process of judging, assessment, and valuation taking place in a media economy of recognition, such as YouTube, where everyone has their "own" channel.

The promise of media interactivity is not only the promise of collapsing power relations between those who control information and those who consume it; it is also the promise of a new imaginative script, where subject formation can take place on a different kind of playing field, one with new conditions of possibility for thinking about identity formations, such as the gendered body. However, within commercial social networking sites, such as YouTube, the playing field is fraught with contradictions. Self-disclosure in one context can be empowering for girls and, in another, be a form of self-branding that is prescribed by a limiting cultural script. It is clear that there are spaces online in which gender identity is actively re-imagined; these spaces need to be placed in critical conversation with other spaces, such as YouTube, as a way to formulate a more complex, even if contradictory, understanding of not only media "interactivity" but also the increasingly normative practice of the post-feminist self-brand.

For the purposes of this chapter, I focus on gender in terms of the post-feminist self-brand, though it is clear that the videos I studied make particular statements about race and class also. For instance, most of the videos were filmed in what looked to be middle-class homes, indicated by the private bedrooms of the girls, the particular popular cultural displays on posters, music choice, branded clothing, etc. For more on girls' bedroom culture, please see Baker; Dobson; McRobbie, *Feminism*; and Montgomery. Additionally, the practice of self-branding is clearly racialized; the post-feminist idea of "empowerment through the body," which includes overtly and at times ironically sexualizing the body, is a racially informed idea. That is, the bodies of girls of color and working-class girls have been already pathologized as hypersexual through policy, law, and media representation (among other things). So the rhetoric of "empowerment" through a sexualized body is not available in the same ways to all girls and women.

2. It is also the case that girls have a limited range of resources available for cultural production, one that is determined by not only material resources and class status but also generation. For more on this, see Seiter.

Works Cited

Andrejevic, Marc. *iSpy: Surveillance and Power in the Interactive Era*. Lawrence: University of Kansas Press, 2007.

———. "Watching Television Without Pity: The Productivity of Online Fans." *Television and New Media* 9.1 (2008): 24–46.

Aqua. "Barbie Girl." *Aquarium*. MCA Records, 1997.

Baker, Sarah Louise. "Pop in(to) the Bedroom: Popular Music in Pre-teen Girls' Bedroom Culture." *European Journal of Cultural Studies* 7.1 (2004): 75–93.

Bauman, Zygmunt. *Consuming Life*. Cambridge, UK: Polity Press, 2007.

Beyoncé. "Single Ladies (Put a Ring on It)." *I Am . . . Sasha Fierce*. Columbia Records, 2008.

boyd, danah. "Why Youth (Heart) Social Network Sites: The Role of Networked Publics in Teenage Social Life." *Youth, Identity, and Digital Media.* Ed. David Buckingham. Boston: MIT Press, 2008. 119–42.

Buckingham, David. "Introducing Identity." *Youth, Identity, and Digital Media.* Ed. David Buckingham. Boston: MIT Press, 2008. 1–22.

Burgess, Jean, and Joshua Green. *YouTube: Online Video and Participatory Culture.* Cambridge, UK: Polity Press, 2009.

Castells, Manuel. *Communication Power.* New York: Oxford University Press, 2009.

Dean, Jodi. "Communicative Capitalism: Circulation and the Foreclosure of Politics." *Digital Media and Democracy: Tactics in Hard Times.* Ed. Megan Boler. Cambridge, MA: MIT Press, 2008. 101–22.

Dobson, Amy Shields. "Femininities as Commodities: Cam Girl Culture." *Next Wave Cultures: Feminism, Subcultures, Activism.* Ed. Anita Harris. New York: Routledge, 2008. 123–48.

Fisher-Roffer, Robin. *Make a Name for Yourself: Eight Steps Every Woman Needs to Create a Personal Brand Strategy for Success.* New York: Broadway Books, 2000.

Gaynor, Gloria. "I Will Survive." *Love Tracks.* Polydor, 1978.

Giddens, Anthony. *Modernity and Self-Identity: Self and Society in the Late Modern Age.* Stanford: Stanford University Press, 1991.

Gill, Rosalind. "Postfeminist Media Culture: Elements of a Sensibility." *European Journal of Cultural Studies* 10.2 (2007): 147–66.

Goodstein, Anastasia. *Totally Wired: What Teens and Tweens Are Really Doing Online.* New York: St. Martin's Press, 2007.

Grisso, Ashley D. and David Weiss. "What Are gURLS Talking About?" *Girl Wide Web: Girls, the Internet, and the Negotiation of Identity.* Ed. Sharon R. Mazzarella. New York: Peter Lang, 2005. 31–50.

Harris, Anita. *Future Girl: Young Women in the Twenty-First Century.* New York: Routledge, 2004.

Hearn, Alison. "'Meat, Mask, Burden': Probing the Contours of the Branded 'Self.'" *Journal of Consumer Culture* 8.2 (2008): 163–83.

———. "Variations on the Branded Self: Theme, Invention, Improvisation and Inventory." *The Media and Social Theory.* Eds. David Hesmondhalgh and Jason Toynbee. New York: Routledge, 2008. 194–210.

Hollows, Joanne, and Rachel Moseley, eds. *Feminism in Popular Culture.* New York: Berg, 2006.

"How To Be a Star on YouTube." *eHow.com.* eHow, Inc. n.d. Web. 30 July 2009.

"iJustine." *YouTube.* YouTube, LLC, 6 May 2006. Web. 1 Sept. 2009.

Jenkins, Henry. *Convergence Culture: Where Old and New Media Collide.* New York: New York University Press, 2008.

Kaputa, Catherine. *U R a Brand!: How Smart People Brand Themselves for Business Success.* New York: Nicholas Brealey Publishing, 2009.

Kearney, Mary Celeste. *Girls Make Media.* New York: Routledge, 2006.

Kpal527. "i kissed a girl." *YouTube*. YouTube, LLC, 25 July 2008. Web. 8 July 2009.

Lazzarato, Maurizio. "Immaterial Labor." *Radical Thought in Italy: A Potential Politics.* Eds. Paolo Virno and Michael Hardt. Minneapolis: University of Minnesota Press, 1996. 133–46.

Mazzarella, Sharon R., ed. *Girl Wide Web: Girls, the Internet, and the Negotiation of Identity.* New York: Peter Lang, 2005.

McNally, David and Karl D. Speak. *Be Your Own Brand: A Breakthrough Formula for Standing Out from the Crowd.* San Francisco: Berrett-Koehler Publishers, Inc., 2002.

McRobbie, Angela. *The Aftermath of Feminism: Gender, Culture and Social Change.* Thousand Oaks: Sage, 2009.

———. *Feminism and Youth Culture: From* Jackie *to* Just Seventeen. 2nd ed. London: Routledge, 2000.

MissDalazee. "13 Year old MiSS.Dalazee Dancing to Single Ladies." *YouTube.* YouTube, LLC, 30 Jan. 2009. Web. 16 July 2009.

Montgomery, Kathryn C. *Generation Digital: Politics, Commerce, and Childhood in the Age of the Internet.* Cambridge, MA: MIT Press, 2007.

Palfrey, John and Urs Gasser. *Born Digital: Understanding the First Generation of Digital Natives.* New York: Basic Books, 2008.

Perry, Katy. "I Kissed a Girl." *One of the Boys.* Capitol, 2008.

Rand, Erica. *Barbie's Queer Accessories.* Durham: Duke University Press, 1995.

Rose, Nikolas. *Governing the Soul: The Shaping of the Private Self.* London: Free Association Books, 1999.

Schiller, Dan. *How to Think About Information.* Champaign: University of Illinois Press, 2006.

Seiter, Ellen. *Sold Separately: Parents and Children in Consumer Culture.* New York: Rutgers University Press, 1995.

Shields, Mike. "Nielsen: Kids Flock to Web." *Adweek.* Nielsen Business Media Inc, 6 July 2009. Web. 22 July 2009.

Sofijakos465865. "me & Nicole.. crazyyy." *YouTube.* YouTube, LLC, 4 June 2007. Web. 22 July 2009.

Stern, Susannah. "Expressions of Identity Online: Prominent Features and Gender Differences in Adolescents' World Wide Web Home Pages." *Journal of Broadcasting and Electronic Media* 48.2 (2004): 218–43.

———. "Producing Sites, Exploring Identities: Youth Online Authorship." *Youth, Identity, and Digital Media.* Ed. David Buckingham. Boston: MIT Press, 2008. 95–117

———. "Virtually Speaking: Girls' Self-disclosure on the WWW." *Women's Studies in Communication* 25.2 (2002): 223–53.

Tapscott, Don. *Grown Up Digital: How the Net Generation Is Changing Your World.* New York: McGraw-Hill, 2008.

Tasker, Yvonne and Diane Negra, eds. *Interrogating Postfeminism: Gender and the Politics of Popular Culture.* Durham: Duke University Press, 2007.

Terranova, Tiziana. "Free Labor: Producing Culture for the Digital Economy." *Social Text* 18.2 (2000): 33–58.

Uzsikapicics. "13 Year Old Barbie Girls." *YouTube*. YouTube, LLC, 31 Aug. 2007. Web. 9 July 2009.

Weber, Sandra and Claudia Mitchell. "Imaging, Keyboarding, and Posting Identities: Young People and New Media Technologies." *Youth, Identity, and Digital Media*. Ed. David Buckingham. Boston: MIT Press, 2008. 25–47.

Contributors

Sarah Baker is a Lecturer in Cultural Sociology at Griffith University, Australia. She has held research fellowships at The Open University and University of Leeds, UK, and the University of South Australia. She is the author of numerous refereed journal articles on the cultural practices of pre-teen girls and young adults and is co-author, with David Hesmondhalgh, of *Creative Labour: Media Work in Three Cultural Industries* (Routledge, 2010).

Sarah Banet-Weiser is an Associate Professor in the Annenberg School for Communication and the Department of American Studies and Ethnicity at the University of Southern California. She is the author of *The Most Beautiful Girl in the World: Beauty Pageants and National Identity* (University of California Press, 1999) and *Kids Rule! Nickelodeon and Consumer Citizenship* (Duke University Press, 2007), and co-editor of *Cable Visions: Television Beyond Broadcasting* (New York University Press, 2007). She has published articles in *Critical Studies in Media Communication*, *Feminist Theory*, and the *International Journal of Communication*, among others, and her book, *Authentic™: Political Possibility in a Brand Culture*, is forthcoming in 2011 from New York University Press.

Catherine Driscoll is an Associate Professor of Gender and Cultural Studies and the Associate Dean for Research (Faculty of Arts) at the University of Sydney. She works in a range of fields, including modernism, cultural theory, online culture,

girl culture, and rural studies. She is the author of *Girls: Feminine Adolescence in Popular Culture and Cultural Theory* (Columbia University Press, 2002), *Modernist Cultural Studies* (University Press of Florida, 2009), and *Teen Film: A Critical Introduction* (Berg, forthcoming 2011). Drawing on two Australian Research Council grants for research into country girlhood and country towns, she is currently writing a book on Australian country girlhood.

Sandra Grady recently completed her Ph.D. in the graduate program in Folklore and Folklife at the University of Pennsylvania. Her dissertation is an ethnographic study of the practice of adolescence among the Somali Bantu, an ethnic minority population from East Africa whose life cycle rituals have been disrupted by flight from southern Somalia, displacement in refugee camps for over a decade, and subsequent resettlement to the United States. She currently teaches in northwest Ohio.

Jane Greer is an Associate Professor of English and Women's and Gender Studies at the University of Missouri, Kansas City. She is the editor of *Girls and Literacy in America: Historical Perspectives to the Present Moment* (ABC-CLIO, 2003), and her work has appeared in *College English, College Composition and Communication,* and numerous edited collections. She currently serves as editor of *Young Scholars in Writing: Undergraduate Research in Writing and Rhetoric,* and she teaches composition classes as well as courses on the rhetorical performances and literacy practices of girls and women.

Rebecca C. Hains is an Assistant Professor of Communications at Salem State University. Her research explores girls' engagement with media culture from a feminist cultural studies perspective. Her recent publications include chapters in *Geek Chic: Smart Women in Popular Culture* (ed. Inness; Palgrave, 2007) and *Women in Popular Culture: Meaning and Representation* (ed. Meyers; Hampton, 2008), as well as articles in *Popular Communication, Girlhood Studies,* and *Women's Studies in Communication.*

Kristen Hatch is an Assistant Professor in the Department of Film and Media and the Visual Studies Program at the University of California, Irvine. She is currently completing a manuscript on pedophilia and performances of girlhood through the 1930s.

Yuka Kanno is a researcher at the Institute for Research in Humanities, Kyoto University. She received her Ph.D. in Visual Studies from the University of California, Irvine in 2010. She has published articles on queer and lesbian representations in Japanese films in *Over the Rainbow: Reading Lesbian, Gay, and Queer*

Films (Nijino kanata ni: rezubian, gei, kuia eiga o yomu) (ed. Izumo Marou; Pandora, 2005), as well as *ICONICS* and *Chuo Review*. Her research interests include Japanese visual culture, girls' culture, discourse of the actress, and queer film criticism. Currently, she is working on a book on female-female intimacy and lesbian representation in Japanese cinema.

Mary Celeste Kearney is an Associate Professor of Radio-Television-Film at the University of Texas at Austin. She is author of *Girls Make Media* (Routledge, 2006), and editor of the *Gender and Media Reader* (Routledge, forthcoming 2011). Her essays on girls' media culture have appeared in *Camera Obscura, Cultural Studies, Feminist Media Studies*, and the *Journal for Children and Media*. Her next monograph, *Making Their Debut: Teenage Girls and the Teen-Girl Entertainment Market, 1938–1966*, is in progress. She is also founding director of Cinemakids, a program for inspiring youth media producers, and manages the *Girls Make Media* website <http://girlsmakemedia.blogspot.com>, a resource for girls' media production.

Dafna Lemish is a Professor of Communication and the Chair of the Department of Radio-Television at Southern Illinois University Carbondale and founding editor of the *Journal of Children and Media*. She is author of numerous books and articles on children, media, and gender representations, including: *Screening Gender on Children's Television: The Views of Producers Around the World* (Routledge, 2010); *Children and Television: A Global Perspective* (Blackwell, 2007); *Children and Media at Times of Conflict and War* (co-edited with Götz; Hampton Press, 2007); *Media and the Make-Believe Worlds of Children: When Harry Potter Meets Pokémon in Disneyland* (with Götz, Aidman, and Moon; Lawrence Erlbaum, 2005).

Sun Sun Lim is an Assistant Professor in the Communications and New Media Programme at the National University of Singapore. She studies technology domestication by youths and families in Asia and has conducted fieldwork in China, Japan, Korea, and Singapore. She has lectured and published widely, including in the *Journal of Computer Mediated Communication, New Media and Society, Communications of the ACM*, and *Telematics and Informatics*. She is a member of Singapore's National Youth Council, which advises on the country's youth-centered policies.

Sharon R. Mazzarella is Professor and Director of the School of Communication Studies at James Madison University. Her research interests are in girls' studies and the representational politics of mediated portrayals of youth. She is editor of *Girl Wide Web 2.0: Revisiting Girls, the Internet, and the Negotiation of Identity* (Pe-

ter Lang, 2010), *20 Questions about Youth and the Media* (Peter Lang, 2007), *Girl Wide Web: Girls, the Internet, and the Negotiation of Identity* (Peter Lang, 2005), and co-editor of *Growing Up Girls: Popular Culture and the Construction of Identity* (with Pecora; Peter Lang, 1999).

Sarah Nilsen is an Assistant Professor of Film and Television Studies at the University of Vermont. Her book, *Projecting America: Film and Cultural Diplomacy at the Brussels World's Fair of 1958*, is forthcoming from McFarland. She has published articles on race and ethnicity in film and television, and is currently writing a cultural history of *The Mickey Mouse Club*.

Jemima Ooi graduated with honors from the Communications and New Media Programme of the National University of Singapore. She works actively with underprivileged youths and has a keen interest in youth-oriented research.

Kirsten Pike earned her Ph.D. in Screen Cultures from Northwestern University in June 2009 and is currently a Visiting Faculty Member in the Department of Film, Television, and Theatre at the University of Notre Dame. Her dissertation, *Girls Gone Liberated? Feminism and Femininity in Preteen Girls' Media, 1968-1980*, explores how TV shows, films, teen magazines, and advertisements depicted second-wave feminist ideals for preteen audiences and readers during the women's liberation era.

Shiri Reznik is a Ph.D. student in the Department of Communication at Tel Aviv University in Israel, researching the role of media in the construction of romantic love among girls. Parts of her MA thesis on television humor in mid-childhood were published in *Girlhood Studies* in 2008.

Leslie Regan Shade is an Associate Professor in the Department of Communication Studies at Concordia University in Montreal. Her research concerns social and policy issues related to information and communication technologies, with a particular focus on gender and youth. She is the author of *Gender and Community in the Social Construction of the Internet* (Peter Lang, 2002), and co-editor of *Feminist Interventions in International Communication* (with Sarikakis; Rowman & Littlefield, 2008), two volumes in *Communications in the Public Interest* (with Moll; Canadian Centre for Policy Alternatives 2001, 2004), and *For Sale to the Highest Bidder: Telecom Policy in Canada* (with Moll; CCPA, 2008).

Shayla Thiel-Stern is an Assistant Professor at the University of Minnesota School of Journalism and Mass Communication whose research covers the intersections of gender, new media, identity, and youth. Her book, *Instant Identity: Adolescent*

Girls and the World of Instant Messaging, was published by Peter Lang in 2007, and she has published work in *The Responsible Reporter* (ed. Evensen; Peter Lang, 2009), *Women in Mass Communication* (eds. Creedon and Cramer; Sage, 2007), *Girl Wide Web* (ed. Mazzarella; Peter Lang, 2005), and the *Girlhood Studies* journal. Previously, she served as editor of the *Journal of Communication Inquiry*.

Angharad N. Valdivia is Research Professor and Head of Media and Cinema Studies and Interim Director of the Institute of Communications Research at the University of Illinois. She has published on gender and popular culture and has a current emphasis on Latina media studies. She is author of *Latina/os and the Media* (John Wiley and Sons, 2010) and *A Latina in the Land of Hollywood* (University of Arizona Press, 2000), and is editor of *Latina/o Communication Studies Today* (Peter Lang, 2008), *A Companion to Media Studies* (Blackwell, 2003), and *Feminism, Multiculturalism and the Media* (Sage, 1995), as well as the *International Companion of Media Studies*, forthcoming from Blackwell. She is also editor of *Communication Theory*.

Jennifer Woodruff is Visiting Assistant Professor of Music at Bates College. She received her Ph.D. in Musicology from Duke University. She teaches courses on popular music, music and identity, and musical theatre. Her research interests include children and the media, black popular culture, and the politics of listening. She is also active as a singer, specializing in contemporary concert music and musical theatre. She was the recipient of a Charlotte W. Newcombe Dissertation Fellowship from the Woodrow Wilson National Fellowship Foundation.

Index

mediated youth

Sharon R. Mazzarella
General Editor

Grounded in cultural studies, books in this series will study the cultures, artifacts, and media of children, tweens, teens, and college-aged youth. Whether studying television, popular music, fashion, sports, toys, the Internet, self-publishing, leisure, clubs, school, cultures/activities, film, dance, language, tie-in merchandising, concerts, subcultures, or other forms of popular culture, books in this series go beyond the dominant paradigm of traditional scholarship on the effects of media/culture on youth. Instead, authors endeavor to understand the complex relationship between youth and popular culture. Relevant studies would include, but are not limited to studies of how youth negotiate their way through the maze of corporately-produced mass culture; how they themselves have become cultural producers; how youth create "safe spaces" for themselves within the broader culture; the political economy of youth culture industries; the representational politics inherent in mediated coverage and portrayals of youth; and so on. Books that provide a forum for the "voices" of the young are particularly encouraged. The source of such voices can range from in-depth interviews and other ethnographic studies to textual analyses of cultural artifacts created by youth.

For further information about the series and submitting manuscripts, please contact:

SHARON R. MAZZARELLA
Communication Studies Department
Clemson University
Clemson, SC 29634

To order other books in this series, please contact our Customer Service Department at:

(800) 770-LANG (within the U.S.)
(212) 647-7706 (outside the U.S.)
(212) 647-7707 FAX

Or browse online by series at WWW.PETERLANG.COM